MORE PRAISE FOR *TO PAINT HER LIFE*:

"With her powerful writing, her majestic command of the sources and her unconventional presentation of 'personified history,' Felstiner, like Salomon, has left us what seems to me a masterpiece. . . . One of the most powerful and moving books I have ever read."
—Leila J. Rupp, *The Women's Review of Books*

"Charlotte Salomon emerges in this book as one of the most remarkable of all Holocaust witnesses. Her powerful pictorial narrative, completed just before her death, depicts her own life and the broader experience of German Jews with heartbreaking insight, courage, and humor. Felstiner shows us how Salomon confronted, and artistically re-created, everything—her family's epidemic of suicides, her personal terrors, the cruelties of the Nazis, and the deceptions and self-deceptions of both Nazis and victims. Movingly and skillfully, Felstiner conveys the full truth of Salomon's declaration, 'I am going to live for them all.'"
—Robert Jay Lifton, author of *The Nazi Doctors* and *The Protean Self*

"Mary Felstiner's deeply moving story brings the extraordinary artist Charlotte Salomon to life, from troubled childhood to exile and persecution. Felstiner manages to anchor this individual tale firmly in the historical setting and to give it transcendent meaning as a parable of innocence and betrayal, trust and lies. A beautiful book."
—Gerda Lerner

"In *To Paint Her Life*, Mary Felstiner weaves history, biography, and visual narrative into a work of striking power and originality. A sensitive and highly accomplished contribution to the literature of the Holocaust."
—Whitney Chadwick, author of *Women, Art, and Society*

"A painstaking evocation of the obliterated life of Charlotte Salomon . . . showing—albeit in extremis—the necessity of biography to illuminate the art that survives the artist."
—Richard Lingeman, *The Nation*

"Salomon's artistry...is paralleled by her biographer's layered and complex and thoroughly wonderful recreation of a personal and social history created out of Salomon's text, careful historical research and extraordinary interviews."
—*Lilith*

"A compelling drama. The author's interpretation and presentation of the methods and madness of the Nazis have an unusual perspective."
—*Jewish Book World*

"Confronts one with some of the lesser known—and most uncomfortable—truths of the Holocaust. . . . It is a true achievement of Mary Felstiner that we finish the book with a sense of personal loss."
—*Trenton Times*

TO PAINT HER LIFE

Charlotte Salomon
in the Nazi Era

MARY LOWENTHAL
FELSTINER

 HarperPerennial

A Division of HarperCollinsPublishers

A hardcover edition of this book was published in 1994 by HarperCollins Publishers.

HarperCollins books may be purchased for educational, business, or sales promotional use. For information please write: Special Markets Department, HarperCollins Publishers, Inc., 10 East 53rd Street, New York, NY 10022.

First HarperPerennial edition published 1995.

Designed by Nancy Singer

The Library of Congress has cataloged the hardcover edition as follows:

Felstiner, Mary Lowenthal, 1941–
 To paint her life : Charlotte Salomon in the Nazi era / Mary Lowenthal Felstiner.—1st ed.
 p. cm.
 Includes index.
 ISBN 0-06-017105-7
 1. Salomon, Charlotte, 1917–1943. 2. Expatriate painters—France—Biography. 3. Watercolorists—Germany—Biography. 4. Holocaust, Jewish (1939–1945) in art. I. Title.
ND1954.S24F45 1994
759.3—dc20
[B] 93-44646

ISBN 0-06-092628-7 (pbk.)
95 96 97 98 99 ❖/RRD 10 9 8 7 6 5 4 3 2 1

For Sarah and Alek

CONTENTS

III

TOWARD PITCHIPOI

Illustrations follow page 146

PROLOGUE

⌐

"THE WAR RAGED ON AND I SAT BY THE SEA AND SAW
DEEP INTO THE HEART OF HUMANKIND"

CHARLOTTE SALOMON, 1942

She passed the last year painting her life in more than seven hundred scenes. Now in the final one she showed herself holding a paintbrush in her hand, facing out to sea. She filled her back with a blaze of color and added a German title in strong lines: *Leben oder Theater?* "Life or Theater?" A taped-on caption carried her closing words: "Out of this arose *Life or Theater???*" Out of her past arose this painted play—but three question marks left the life story in doubt.

Charlotte Salomon was twenty-five when she made this portrait of herself by the French Mediterranean coast. Day after day as the war raged on, she kept painting the life she'd rescued from Nazi Germany. She had built her skills at age nineteen in the Berlin Art Academy, where she was almost the sole Jewish student allowed under Nazi rule. Before that, she had seemed so lacking in promise, so indistinct, that one friend of hers said she had no qualities at all. As early as age eight, when her mother died, solitude had taken hold of her. Still alone in 1941, she took up her paintbrush and worked her way back to the dark of an earlier war—to 1917 when she was born.

What came out of her memory was a line of ordeals. She'd gone through girlhood in a house of suicides. She'd done her schooling in a fascist state. She'd spent her fruitful years in exile. All this pressed so hard on her that these words came out in paint: "If I can't find any joy in my life and in my work I am going to kill myself."

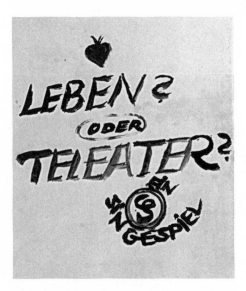

Title page of *Life? or Theater?*
An Operetta.

Charlotte Salomon faced a possibility of death and still told a story of growth. In the thick of the fear, she created the most penetrating visual record we have from the Nazi era about a single life. Rare among memoirs, and even rarer during a war, it pushed deeply into events, but long before their outcome could be known. Situations that no one shared were placed with events that everyone did, to create an album of the era—in case she failed to make her way past it. She never imagined how far this album would reach after the war: It went on view in Holland and in France, in the U.S. and Germany, in Israel and Japan; it was published in four languages with over 700 color plates, abridged in several catalogs and discussed in a book on war; it was brought to life in four films after her time.

She knew herself only as a Jewish artist with no place to go. She knew that this work designed for viewing was destined for hiding. She only *guessed* it would give vital knowledge past its time, saying to a friend when she packed it away, *"Keep this safe. It is my whole life."*

The whole life of Charlotte Salomon was painted in just over a year, in 1941–42, as "the war raged on and I sat by the sea and saw deep into the heart of humankind." From the rage and recoil she came up with an art form, a way of telling life history never tried before or since. She composed 765 paintings and several hundred caption sheets as a type of *Singespiel*—"songplay"—an antique form of operetta she spelled slightly wrong. She turned real persons into characters

with made-up names, like the bracing one *Charlotte Kann*—in English *Charlotte Able*. She set the stage with startling colors and wrote the lines in sardonic, longed-for German, the language of an exile. Each of her scenes is a ten-by-thirteen-inch gouache (a kind of thick water-color), stacked in an unbound script. Some are bold and active, some spare and dark; some fill the space with figures, others leave large unsettled blanks.

The first painting announces a formal title, *Life? or Theater? An Operetta*, inviting a viewer into a new performing art, one that mixes pictures and music and talk: Your eyes take in the images, page by page, then read the words, while you imagine the melodies suggested in the scenes. You get to know the main character, "Charlotte Kann," through the comments of other characters, but you never hear the artist speaking in a first-person voice. Only an offstage narrator, a kind of ironic chorus, keeps the story moving along.

It's not just the narration that shows the artist's skill, or the clever naming or the musical scheme. It's the semi-transparent tracing paper taped to the left-hand side of the pictures, covering them from edge to edge. You can see the action through these overlays, then fold them aside like gauze curtains. On them the artist wrote out the char-acters' speeches and the narrator's comments and the lyrics of tunes to be heard while the scenes go by. Overlays are purely Charlotte Salomon's invention—a unique storytelling site. They let you imagine you're watching a play while the script scrolls in front of the stage, on a scrim. The overlays keep reminding you that these pictures are not the life she lived but the one she thought about for years.

No artwork or artifact has ever looked like this one. An autobiog-raphy without an *I*, a chronicle with visuals, an operatic memoir: "Something so wildly unusual," as Charlotte Salomon called it, leaves most of those it touches simply amazed. Whatever possessed this per-son to bring into being such a work?

No one knew much about the person when her paintings first came to me in an out-of-print book called *Charlotte: A Diary in Pictures*. The first time I showed slides of her work, in 1979, a woman shouted out, "Why haven't I ever heard of this?!" That remark, often repeated, catches her intimate call to an audience: viewers still address her art-work as if they're on speaking terms with it. Wherever it appears around the world, people talk as if they know her, as if her name is

native to their language. Some say it the proper German way: Char-
lotte as "Charlotteh" in three syllables and Salomon as "Zahlomohn."
Most simply call the artist by her first name—though they'd never
say "Pablo" or "Jackson"—yet this closeness keeps the work the way
she meant it. She meant to have less than the last word or even the
first. Right from the question marks in the title—*Life? or Theater?*—she
handed the main task to viewers: Unravel this story. See if it's true.

To detach the person who grew up in Nazi Germany from her
created character, I refer here to the real-life one as Lotte (pro-
nounced "Lotteh")—the nickname everyone called Charlotte Salomon.
The made-up character is always Charlotte, both in the artwork and
in these chapters. And the artist who remembered and painted her life
in 1941–42, I name CS—the only signature she used in the scenes. In
every line CS wrote, her voice was speaking through the "Charlotte"
character or the story's narrator or the other roles. "I was all the char-
acters in my play," she said, "and thus I became myself."

She wrote directly of her life only once ("and thus I became
myself"), in a twelve-page postscript to *Life? or Theater?*—but even this
postscript left problems unsolved. How true to life was the tale she
told? Did she turn creative to avoid going crazy? How could she
focus a thousand pictures on herself as the SS closed in and her peo-
ple's history looked likely to end? What made her safe enough to
sketch when most Jews weren't safe enough to live? Why was this
woman *painting* while the war raged on?

For answers, the original paintings are clearly the place to start. In
Amsterdam the Jewish Historical Museum archives hold the Char-
lotte Salomon collection: the 700-odd paintings she chose for *Life? or
Theater?* plus more than 500 sheets—studies, captions, overlays, and
postscript, which have not been on exhibit or in print—and finally,
all of her words.

On my first trip to see the originals in 1981, a snapshot caught me
clutching my yelling infant in front of Charlotte Salomon's face: two
portraits oddly joined. I kept wondering what experiences had created
a face so spare of trimming, so hard to take. But nothing about the life
that produced *Life? or Theater?* was easy to find out. The author had kept
to herself while growing up, and the Jewish culture that shaped her
had been ripped out of records of the past. Even the primary source on
her experience—the artwork—called itself a play. In its plot, the

"Charlotte" character finds a way out of hopelessness through paint-
ing. But in the private postscript the real-life artist confesses that she
might kill herself.

To look into the person, past the pictures, I had to search in
Europe, Israel, and the U.S. for sources and informants. Not many
who survived the war could describe one solitary girl, and she herself
committed no public acts, produced no private files. So I had to find
other ways of recapturing what she was. I followed leads from her
visual memoir, with its total recall of faces, events, and states of mind.
I tracked down the people she portrayed. Wherever they could be
found, they worked to bring up memories, and just as usefully, they
dealt with me the way they'd treated her. For instance her step-
mother, Paula Salomon-Lindberg, was by turns generous, loving, out-
spoken, judgmental, and directive whenever I visited her over the
course of a decade—just the way she'd acted toward Lotte years
before. Finally, to approach the inventor of this unique work, I had to
re-create the matrix where her memoir took place and search after
signs of her themes: suicide, secrecy, theatricality. In the end, archival
records revealed the ground she lived on, though she herself had
barely left a scuff.

Because she made a memoir in the very midst of the Nazi era, her
private graphic record serves as an exhibit, so to speak, in court.
Because Charlotte Salomon lifted her life to view, it becomes easier to
see how Jews withstood malice, how women endured exile. It looks
possible to read history from the colors and shapes of her paintings,
the way pathologists read disease from tissues of living organisms.
Her words can tell how a Jewish woman's consciousness progressed
through a period that left few voices as striking as hers. Her states of
mind make visible the inner stages of a huge historical process—
stages identified in my chapters as secrecy, obsession, tenacity, deso-
lation, premonition, and more. I call my approach personified history,
a way of embodying an era's irony and tragedy, its surge of suicide
and genocide, within a few uncommon lives.

Partway through her own life, a figure of reckless force, unknown
to her and far away, began to overshadow her world. Alois Brunner
was born a farmer's son in rural Austria just five years before Charlotte
Salomon was born a professor's daughter in the cultural heart of
Berlin. They both belonged to a generation making its way in a

shaken social order after World War I. While she turned to art school, he turned to the SS, keeping his work so secret that I had to pull it from archives and interviews one small strand at a time. Both Charlotte Salomon and Alois Brunner revealed themselves during the same critical events. Both recorded their own life histories—hers in vivid reflective color, his in blunt black and white.

Nothing suggested that one of them would become a great painter within the shadow of the other—but it came about, and that is the story this book brings to light.

I

IN THE GERMAN REICH

1933

1

SECRECY

(1917–1929)

~

Charlotte Salomon's life burst into images and lyrics on the French Riviera in 1941. There she carried her sketchpad out of doors, folded her legs under her, and took a long look outward to sea, "into the heart of humankind," and then backward to Berlin.

The Berlin she remembered had the ordered look of homes where Jewish families blended into German ways of life. Three generations before, her great-grandmother made sure one son married a dowry and one daughter a doctor. So in 1889 her grandmother Marianne Benda married Herr Doktor Ludwig Grunwald for his unobtrusive Jewishness, his fine profession, his beard of Prussian cut. Like many German Jews, the Grunwald grandparents filled their household with a lot of good books and a few carefully raised children. Well-off but not wealthy, they spent vacations hiking in the mountains or enjoying the fine arts in Italy. Because Marianne Benda Grunwald was brilliant and because she was a Benda—a member of an intellectual clan—she thought she was doing everything right. Settling in central Berlin, she and her husband bought stiff-backed sofas for themselves and charming clothes for their daughters Fränze and Charlotte, born at the end of the century.

Everything depended on those daughters. Their upbringing had to brace them for a world that kept girls from knowing as much as boys, a world that faulted Jews for being too different from Germans,

then too much alike. It took a surge of family energy to carry the two girls through all this, and finally the spirit of the younger one, the one named Charlotte Grunwald, collapsed.

A generation later, in 1942, when Charlotte Salomon imagined her relatives straining to be German and correct, her words, as always, kept her sharpness almost out of sight:

> They [the Grunwalds] and their children [Fränze and Charlotte] lived a life full of energy, work, and beauty. Each hour of the day was carefully planned and nothing unexpected was allowed to disturb the sacred daily routine. They raised their children as best they could with the strictness and kindness required. The children were good and . . . showed early lively interest in their parents' enthusiasm for Greek history, Goethe, and Schiller. Nothing disturbed the peace of the cozy family circle until suddenly one day the younger daughter killed herself.

It was 1913 when eighteen-year-old Charlotte Grunwald drowned. No one spoke of it as suicide. The older sister Fränze pulled herself together after a year by turning her hand to medicine in the war. If one woman died, another would make something of her life. A nurse—a *Schwester* (the same word as "sister" in German)—would be ready the next time to rescue. In 1915 Fränze met a war surgeon and married him the next year, against her parents' wishes, for he came from the provinces with only the hope of being a professor in Berlin. While Dr. Albert Salomon finished his service, his new wife Fränze waited in their apartment for the arrival of their child.

From the day of Charlotte Salomon's birth, on April 16, 1917, till she was twenty-two, she lived in that apartment at 15 Wielandstrasse in Charlottenburg, a lively part of western Berlin where trees shaded the side streets and cafés brightened the boulevards; the great Jewish department stores and the synagogues stood solid and steady a walk away. Like most Berlin apartments, 15 Wielandstrasse had a modest street entrance; there were four flights of stairs to climb and a carved door leading into rooms a professional would be pleased with: separate spaces for each person except the wife, a bright nursery, a tiny cook's room, a study and consulting room for the husband's medical practice, a blue parlor with a piano. And windows on both sides. Looking down on the street, the family could see friends coming, and

later Nazis marching past. To the inside they faced a courtyard of trees that turned spindly when Central Europe's winters set in.

All her life Lotte Salomon remembered Berlin as a city across a sill, and could still see her mother as a body blocking the window frame. For in the winter of 1925–26, Fränze Grunwald Salomon, wife of an aspiring professor, mother of an eight-year-old, suddenly could do nothing but stare outside. Something had gone wrong with her, and one day she threw herself out the window to the ground. Why she killed herself, as her sister had before her, no one really knew. Her husband took one view of what happened, her parents another, and her society imagined something else.

Sixty years later Lotte Salomon's only living relatives—two distant cousins and her stepmother—told all they could of this family tragedy. A cousin had watched the elder Grunwalds "mourning forever their daughter Charlotte's death. Even if they didn't talk about it, they carried it with them wherever they went." Overwhelmed by losing one daughter, they'd failed to show love for the other, so Fränze had always looked slight and sad. A schoolmate of Fränze's remembered how "delicate and fragile" she was. Everyone called her by a diminutive, "Fränzchen," and recollected a woman always at home and never at ease.

They also recalled Albert Salomon as withdrawn and quiet, perhaps from years of belonging to no one. His mother had died at his birth, and his father not long after. With no family behind him, he struggled to enter the faculty of Berlin University's Medical School. There he made just enough money to keep an apartment near good public schools and maintain a social life among professionals like himself. One acquaintance from those days called him an "introvert, very quiet, a nice man"; another noticed that he "made a cool impression"; another that he had "a certain dignity." A cousin called him "taciturn, sensitive, shy, not a great talker. He and his wife were *both* melancholic."

Everything else that is known comes from the artist herself. In 1941 the only child of Albert and Fränze Salomon found herself possessed by the women in the family, and by the windows. She tried to guess what had caused their suicides, and chose the word *Leben* to start her title: real life. But she put a question mark after it. Any cause of her mother's death, fifteen years after it, had to be made up by herself.

A drama could do this. An artist like CS could invent a play and put the whole family into it, giving each of them a fictional name (on a playbill page): "Doctor and Mrs. Knarre, a Couple" (Ludwig and Marianne Grunwald, the grandparents. *Knarre* means a rattling sound, with hints of the German *narren*, "to fool." They were also called Grosspapa and Grossmama in real life and the play); "Franziska & Charlotte, Their Daughters" (Fränze and Charlotte Grunwald); "Doctor Kann, a Physician" (Albert Salomon); and "Charlotte Kann, His Daughter" (Charlotte Salomon, called Lotte by her family and friends). Now the stage was set, the curtains pulled aside, and CS ready to show those two suicides in Germany through an artist's eyes.

"Am I the one to blame for her death?"

The backdrop is dark: night in a city. The date "1913" appears above the scene. A barely visible figure steps out of a house, moves toward a body of water, and hurls herself in. As the young woman's face submerges in blue, another face, her sister's, comes into view and cries: "Am I the one to blame for her death?"

Before the audience catches a breath, the backdrop flashes "1914," and the older sister, "Franziska," announces to her horrified parents, "I must become a nurse," in the middle of a war. As "1915" flashes over the stage, a tale of two sisters shades into a history of their time. It is a year of frightful casualties when Franziska finds herself assigned to a surgeon, "Dr. Albert Kann." These two come together not in a crowd of relatives and friends but alone beside a blood-soaked surgery. Suddenly the efficient nurse assists her operating surgeon by wiping his nose. Enter the Father, the Healer, center stage, sneezing.

The story moves briskly in cartoonlike repetitions across each page, with all the words on the overlays. One year later, as "1916" comes up at the back, Albert Kann is calling on Franziska's parents for permission to marry her. But they "upset him," and their home "strikes him as *unheimlich*"—unhomelike, sinister. Then the audience (but not Albert) finds out why. Years before, Franziska's uncle began having "unprovoked bursts of laughter" that finally led to suicide. Then Franziska's grandmother tried repeatedly to take her life, and then of course the younger sister grew "*ach*, so sad," and drowned. In a home that held the dead against the living, Albert certainly looks "upset."

"But this reflection comes too late," says the artist-narrator, and marries him to Franziska anyway. From the start, the narrator casts doubts over the marriage, noting that the "wedding feast . . . is first-rate, and nothing calls to mind the raging war"—nothing, that is, except this comment. As the newlyweds enter their hotel suite, it looks mauve and unlit, like a crypt, and "heavy windowpanes cast a shadow over the bed."

Nine months later, when this pair bring a child to life, they name her Charlotte in memory of the sister who died.

That name forecasts a tragedy, but at first the scenes deny it. They show the birth card (cut out and pasted on, as a real card) circled by a heart, then the baby circled by a hug, the infant by her playpen, the toddler by two adoring parents. In the primary colors of a child's world, brighter than anywhere else in the play, the whole family takes vacations in the German mountains that spiral around a lake. The holiday train that chugs across the top shoots home across the bottom. Everything comes full circle. All of life revolves around a little girl—until she is seven, and then the change is too abrupt for her to grasp.

Suddenly "Franziska can find no more joy in anything, for reasons incomprehensible" to a child. But the artist gives the audience some second looks: Franziska so fragile she seems to float; Franziska rigid in lace collars; Franziska at the piano performing for the family; Franziska hovering over life like a mere survivor of her sister's death. In one view she is an angel in the house; in another, as ungrounded as a bubble. Her husband seems to have no time for her. When she lifts Charlotte into her arms, he just looks on. As Grossmama watches them, her words (on the scrimlike overlay) pry him apart from the mother and child. "The only thing he ever thought about was his career," Grossmama says, and thinks Franziska "could never be happy—not with that kind of man, not with that kind of child."

That kind of child gets "on her mother's nerves" and sticks out her tongue at her mother's touch. Franziska turns for comfort to her husband, but he jerks his head from his books, then covers his ears. "I *will* become a professor. Don't disturb me, just don't disturb me," he says and turns his face away, while Franziska stares out day after day, dress after dress, *her* face overexposed. The border between man and wife is sealed. Even when they are together, all dressed up for a family walk,

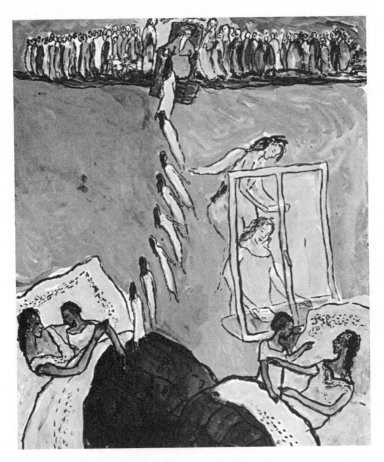

"Franziska often...told of an afterlife in heaven that she had a
terrible yearning for." Her going up is mirrored in her coming back
(even the quilt's lines merge).

her hand reaches out but can't break into her husband's grip. Her
other hand fails to hold Charlotte, a lively girl venturing right out of
the frame. Franziska consoles herself that "I'll be a professor's wife,"
but her husband won't let her in his room; her own mother says, "I
would love to have had a son"; her child turns on her or breaks away.
The family she strives for snaps apart.

So Franziska ends up "yearning and dreaming" at a window, her
wrists reaching over the sill. Only one desire draws her out of herself,
and the script shows how it sounded to the little girl:

Franziska . . . often took the child into bed and told her of an after-
life in heaven that would be just splendid and that she had a terrible
yearning for. And she used to ask Charlotte, wouldn't it be beautiful
if her mother turned into an angel with wings? Charlotte did think
it would be beautiful, but asked her mother not to forget to deliver
a letter—in person like an angel—to Charlotte's windowsill, saying
what it looked like up there.

In their shared fantasy Franziska ascends to heaven, then drops down
with a letter, making an easy switch from life to afterlife. A mother
slips away but pays calls later on, and an eight-year-old denies dead
loss. But the narrator's words about "an afterlife that she had a terrible
yearning for" warn that something will break Charlotte's childhood
circles, her geometry of return.

The stage goes dark again. Franziska enters her husband's room,
raids his medical bag, pilfers opium, gets into their bed, and tries to
end her life.

Abruptly her father and husband and a psychiatrist stuff their way
into her room. "But what kind of business are you acting out for us?
How could anybody poison herself?" The psychiatrist gestures at her,
his hand larger than her small, sad face. Behind her back the three
men diagnose "temporary irrationality," then lead her away from her
child, for "better care in her parents' home." A nurse is set to watch.
Franziska questions herself (as she did when her sister died): "And my
husband—who doesn't love me. And my child—who doesn't need
me. What for, what am I staying alive for?" Behind the words, the
mouth locks open. Her face looks absolutely flat: no space extends
behind it for forming thoughts. The husband and daughter project
from each side of her head, with the borders among them painted
lightly, like makeup. There is no Franziska untenanted by them, no
Franziska left standing if they take off.

Her last words enter her body through the neck, moving down
her central column, letter by letter to the ankles: "I cannot bear it
anymore," and then in tiny faint words whispered to herself, *"Ich bin
doch so allein,"* "I am so very alone." A thickening background floats her
to a window we see from outside. On the scrim the narrator says,
"The nurse leaves the room, which Franziska makes use of for this:
namely, to plunge out the window." Franziska hurls herself through

"Now she's no longer standing there. Ach, she's passed to another place."

the window frame that is also the painting's frame—toward us and toward the painter who steps back just enough to leave her room to fall.

But Franziska's little daughter sees nothing of this end. She simply stays onstage as a watchful child, keeping an eye on the woman at the window till the window frame—tilted upward from a little girl's height—goes abruptly blank.

"Charlotte got the impression that her mother died of influenza." And no one undoes this vast untruth. She becomes a believing child, putting a note on the grave so her mother will leave a letter on her

windowsill with full details. She becomes an inconsolable child who pitches from bed to window seventeen times in the night.

"Why isn't she coming, my mommy? She promised."

"A hex"

Lotte Salomon was twenty-two and far from home when she finally learned the truth. She found she was heir to a great misfortune: Four women and two men in her mother's family had killed themselves. This legacy was locked away by the surviving relatives for thirteen years, till her grandfather spilled it out in 1939. Two years

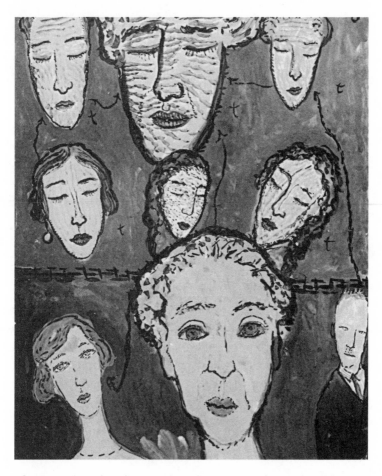

"One two three four five six, does this mean we have a hex?"

Lotte in a school picture, with the
same look as in portraits she
created later from memory.

later the artist painted death-mask faces of her great-grandmother,
great-uncle, aunt, mother, and two more relatives, then counted them
in a song: "One two three four five six, does this mean we have a
hex?" A little arrow skips from one to the next, then jumps to the sur-
vivors—her grandmother, her father—and ends up pointing to her-
self.

Chances were, whatever took them would take her too, unless she
worked the chain of suicides into a new design. But she lacked factual
details and had to make up a cause, at least for her mother's death.
She imagined her father's detachment damaging his wife beyond
repair. She thought her mother's lot so hard that ending it could not
be mad. In maternal madness she found reason: the loneliness of
women's lives, the misuse of their minds, the disregard by relatives
they were meant to love. This was her gift of insight to the mother
who left her behind.

In the real life of this family, it was the grandmother who took the
blame when each of her daughters died. She wanted all the suicides
kept quiet, and Albert Salomon, her son-in-law, gave in to her. So the
relatives never said one true word about Fränze Salomon's death. Even
the obituary (in the artist's version, painted fifteen years after) pushed

questions away: "After a short period of suffering, our beloved daughter, wife, and mother, Franziska Knarre Kann, passed away. We ask that you abstain from condolence visits." This version copied almost to the letter (minus one vital word) the actual notice placed by the family in the *Berliner Tageblatt* on February 25, 1926: "After a short but difficult illness our most dearly beloved and cheerful wife, mother, and daughter, Fränze Grunwald Salomon has left us. . . . We ask that you abstain from condolence visits." Cheerful?

What was this shroud of secrecy for? The artist never said. No direct evidence remains. But the family's concealment hints that suicide carried risks in their society, risks that came to haunt the artist. She never once, for instance, put down her real name—simply signed the scenes CS, hid behind a narrator, and gave herself an alias, Charlotte Kann. The CS who looked back on the real-life Lotte and painted her into Charlotte formed a story about secrets—having been formed by them.

"Free death"

Her family had hushed up Fränze's suicide as if it were taboo. But this seems strange, for suicide resounded through the Weimar years

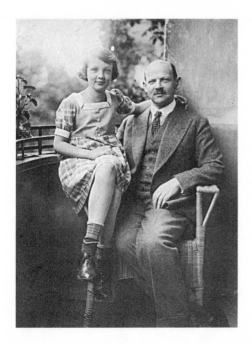

Lotte in a summer dress, with her father in a respectable suit, around 1927.

(1918–33). Whoever went to films, as Lotte and her family did, watched characters lift up their lives by taking them. The popular theme of *Selbstmord*—"self-murder"—revived a death wish long part of German culture, from Goethe's "Werther suicide" to Wagner's famous *Liebestod*, "love-death." In the Weimar years even dissenting writers submitted to a cult of suicide. One man of the hour, in Brecht's *Whither Germany?*, condemned capital and then threw himself out a window. Another, in Ernst Toller's *Hoppla! Such Is Life*, likened "the world and a madhouse nowadays," then hung himself: "*I jump off.*" A feminist heroine, Vicki Baum's *Helene*, mastered her life but allowed that "it's beautiful to leave it of one's own free will." Tough-minded arguments came out everywhere. The odds against a decent life in Germany—defeat in 1918, inflation and violence afterward—made a case for Nietzsche's honored "free death which comes to me because *I* want it."

Years later the painter who lost her mother saw with irony that "free death" had become the norm. One of her captions says: "Franziska had a marked partiality for philosophy with a Nietzschean bent. You will see that such things are not always in the best interest of the person concerned." The Nietzschean bent, the whole cultural bent, made allowances for Fränze Salomon's fall. At that time in Germany actual deaths matched fictional ones. The German suicide rate took fourth place in the Western world, and Berlin ran ahead of other cities by hundreds of cases a year. From 1925 to 1927, a capital of 4,000,000 people lost 5,053 to suicide, with Fränze Salomon just one of them. Suicide lodged in the city's nicest quarters, among intellectuals and professionals more than anyone else. And every year in the mid-1920s, the German Statistical Office reported about five hundred suicides among women in Berlin, almost the same as men. In the province of Prussia surrounding the capital the Jewish rate outdid the Christian by more than 200 percent. So Fränze Salomon's suicide took place in a nation with one of the highest suicide rates in the world, in a province and capital with the highest rate in the nation, in a city with the highest ratio of female suicides, in a class with the highest rate among classes, in a faith with the highest proportion among faiths. Her suicide was not anomalous, it was *exemplary*.

But the relatives never explained any of this to her daughter Lotte.

"Suicide epidemic"

It seems they were protecting, year after year from 1926 to 1939, more than the one girl. Though the commonness of *Selbstmord* muffled Fränze's fall, this family's suicides stretched back three generations, and that made theirs a stranger case. German doctors were "proving" at the time that certain bloodlines must break down. Dr. Albert Salomon specialized in systemic diseases and knew that "degeneration in fine old families" intrigued all his physician friends. One of them, Dr. Kurt Singer, had published a well-known study in 1926, finding that "psychopaths usually descend from psychopathic parents" and that women are more disordered than men, due to their "instinct of subjectivity." Some months before Fränze Salomon took her life, the government proposed to sterilize psychopaths, and not by choice. As her relatives knew perfectly well, the family pattern looked like pure disorder—just the kind eugenicists called a menace to public health.

So many suicides in a family left one tricky thought—why theirs?—and then another: what's happened to the Jews? Their suicide rate in Prussia had shot up elevenfold during the previous seventy years. Their migration to German cities seemed to ruin older ways of life and make the migrants wreck themselves. By the 1920s this object lesson hit its mark: You Jews who take modernity's prize, you pay its price. Even statistics wholly neutral about *Selbstmord* put in an exclamation point:

Suicide Rate per Million Inhabitants [Prussia], 1923–27

Catholics 135	Protestants 280	Jews 530(!)

Jews took that punctuation to heart. Theirs was a small and defensive group in which news of suicides spread fast: Jewish families talked to Jewish families. They learned of a "suicide catastrophe" among Berlin Jews in "hazardous occupations" like commerce. Their journals warned, "Such an appalling increase has not been noted among any other civilized people." Their demographers sent out alarms. Their leaders put most of the blame on the Jews' own "growing alienation from traditional ways." Their writers asked: How do we contain the "suicide epidemic among the German Jews"?

One large Jewish welfare society, B'nai B'rith, called an assembly in Berlin to address the matter, two weeks before Fränze Salomon took her life. Albert Salomon, active in B'nai B'rith like many professionals, almost certainly took part (his wife had recently attempted suicide) or got word from the Jewish press that the speakers said: "We accuse ourselves of letting arise in our German Fatherland a dejudaized Jewishness, which held out no hand to those stumbling in despair." But this could not have helped Albert Salomon, who welcomed the chance to blend into non-Jewish Berlin.

No one figured out why more Jewish women were taking their lives each year, though the rate for Jewish men stayed fixed, or why Protestant women had only half, and Catholic women a quarter the rate of female Jews at just the time when Fränze died. Since women lost no more Jewish customs than men, and no more jobs (just 25 percent of them *had* jobs, and only 1 percent in "hazardous" commercial posts), religion and economics made no sense of their deaths.

Someone should have listened to the women themselves describing their long probation in German society. More educated as a group than other women (CS showed Franziska with her philosophy circle reading Nietzsche), they nonetheless gained bourgeois status by staying home (where Franziska stands at the window, "yearning and dreaming"). In the genteel German world they were dying to join, women were not to work. It fell on men to strive against inflation, recession, and quotas on Jews (this is why Albert Kann says, "I *will* be a professor. Just don't disturb me"). But it fell on Jewish women to brace the whole family against these odds (and this is why Franziska feels worthless when she thinks "my husband doesn't love me, my child doesn't need me").

CS the artist brought all this out, after many years, whereas Jewish men in Fränze's day slipped into faulting femaleness itself: "The relatively high suicide rate of Jewish women stems from their inability to adapt to a difficult situation" or from "physiological processes in the female organism." What impressed everyone was the fact that women entered mental hospitals more than men; women who were Jews more than other women; and alarmingly, "Jewish lunatics" more than "Christian lunatics." Someone should have related those higher numbers to the routine detention of unruly women and to the high ratio of hospitals in reach of where Jews lived. But the idea that just

being Jewish led to mental breakdown took such a grip on Jews, to say nothing of anti-Semites, that the only issue was why.

German doctors of the 1920s claimed they knew: Those who inbreed, decline. Jewish marriage within the faith (Marianne and Ludwig Grunwald, Fränze and Albert Salomon) wears down the stock, leads to craziness, then to suicide. Too much integration or too much inbreeding—either way—turns Jews into misfits. So they have done this to themselves!

In the Weimar years, when Germans started ranking everyone by race, it was *Selbstmord* that betrayed each group's mental and moral flaws. If this family admitted its suicides, the pattern would prove the degraded fiber of all Jews. It would bolster the old belief (now enhanced by science) that craziness runs through the blood, and watch out for the female line. In the world of 1920s Berlin, suicide passed judgment on everything the family was tied to and troubled by—its women, its bloodline, its racial stock. Only silence would fend off a sweeping conviction of guilt.

"She imagines a terrible thing"

For years and years this family took on the chores of secrecy. First the relatives had to create a working lie: Theirs worked because the phrase "your mother died of influenza" made it easy to deceive. Influenza had killed a quarter million Germans in 1918–20 (as many as seventeen hundred Berliners in a day), so no one thought to question one more death. When the epidemic ebbed away, the memory of it became a medium for lies. However much these protected a family, they also promoted fear, for "influenza" touched on German dread of germs, which touched on German dread of Jews.

Only with a lie, Lotte's relatives had reasoned, could this child live. Otherwise she might have taken the blame for a suicide just the way her mother had. But the effect of their deception was to upset her anyway. It made everything look make-believe.

In the scenes the family looks strange and unreal to the eight-year-old child. Her father's head is scratched by his fingernails, her grandparents keep her home during the funeral; they react "oddly" when she announces, "Mommy is now an angel in heaven"; they cheer her up though they look truly crushed. The child cannot read

these clues, but from the secrecy she gets a vivid sense of peril: "Whenever she has to walk through the endless, broad, high, dark hallway in her grandparents' home, she imagines a terrible thing, with skeleton's bones, that has something to do with her mother."

When the terrible thing came out at last in 1939, it stirred up deep doubts in Lotte's mind: *Who had she been* all those years, from age eight to twenty-two, that she was judged too fragile for the truth?

2

AFFILIATION

(1930–1936)

⌐

As far back as Lotte Salomon recalled, her own nature seemed a solitary one. Whether her father noticed her alone, whether he knew that nannies were slapping her, he still attached himself to work and was no help. So losing her mother was like losing a filament to the world. How this girl would know who she was, and whose, how she would recover from loss, became the riddle of her teenage years—and of the early Nazi years for any Jew in Germany.

Lotte wanted someone to take care of her, and gradually she found two women who would. One was a nanny who taught her the way to dip a brush and paint. As soon as the little girl of the scenes shows "a gift for drawing," she feels for the first time a "whole future" before her, and in this joyous moment her father and grandparents are as absent as can be: no thanks to them for starting her off.

Another woman changed the real-life Lotte even more, a singer who captivated Albert Salomon a few years after he lost his wife. Lotte felt bound to Paula Lindberg right away, for Paula had been an orphan too: After her rabbi-father died, Paula set out from her small town on her own, to be a governess all day, a voice student at night; by the time she finished the Academy of Music in Berlin, she'd abandoned her father's Jewish name (Levi) to be reborn as Lindberg, and begun a remarkable career as a mezzo-soprano, famous for opera and for Bach.

When such a star came off the stage into Lotte's living room—sometimes into her own room, sometimes turning up on outings with her father—these became the first glorious days of a long enchantment. But when Albert Salomon married Paula Lindberg in 1930, Lotte at age thirteen had to stay home with her grandparents, just as she had during her mother's funeral—once more kept from the rituals of family life. From then on, Lotte never let this new mother out of sight.

"Thank God I started to sing early"

When Paula Salomon-Lindberg was asked in 1984 if she would talk of her stepdaughter and the razed world of Jewish Berlin, she said of course she'd talk, and signed her first letter Paulinka. "Paulinka" (meaning "little Paula") "Bimbam" (like "dee-dum" in folk songs) was the affectionate, leveling role-name CS had given her stepmother. Well into her eighties at our first interview in Amsterdam, with hair swept back from her head and not a doubt on her face, she sat nobly in a corner serving strong coffee and Viennese cakes on embroidered linen. Right nearby stood a grand piano she still used for teaching voice. In another corner, fresh flowers, a photograph of her husband Albert, a self-portrait of her stepdaughter Lotte: the altarpiece.

Paula Salomon-Lindberg had plenty to say. Every once-lived moment was a story to her: no wonder CS surrendered so many scenes to that voice. She spoke in long cadences without needing a breath, and after any new question or phrase, her entrances were sharp and dramatic: "Ach!" or "Nein!" or "Natürlich!" Listening to her lyrics about people she'd known in Berlin—their histories, brilliance, admiration of her, and their many flaws—it was impossible not to be fascinated, and frightened, by that voice. Sometimes it gently urged a guest to stay at her flat, then gave staccato orders what to eat, what time for bed—which reduced the guest to a child or a sneak (a clue to Lotte's life with her). Sometimes her voice brushed questions away—"But my darling child, you don't understand those times." In many interviews over the years, certain stories came around almost word for word—and so they had for Lotte. But every once in a while a question took her by surprise, and then her face rolled back as if scenting a fresher past than she meant to. She did not always welcome new memories, and as her story unfolded, she made clear why:

I used to work with Clara Zetkin and later in Berlin with Käthe Kollwitz, creating a speaking chorus of a thousand workers. In those days Hindemith was a friend of mine. He always asked, "Can an alto sing that?" and I would say, "No, much too low!" We often made music at Siegfried Ochs's house, and Albert Schweitzer came too; he liked to hear me sing. Eventually, I sang under Otto Klemperer, Bruno Walter, Furtwängler. I sang Wagner at Bayreuth, but I had to stop with Wagner later on—not permitted for Jews. Thank God I started to sing early, for otherwise I couldn't have done anything. When I was thirty-five years old my career was over!

She had been a rising star whose arc stopped in midair. At our first coffee in her flat, Paula sadly refused a gift, a vocal recording, a new release—for she had no record player, no records, no tapes. "The old recordings were all broken in Germany, and they were never made again. I don't want that anymore." It was clear why CS tucked this woman's memoir inside her own. She heard the note of forfeit in

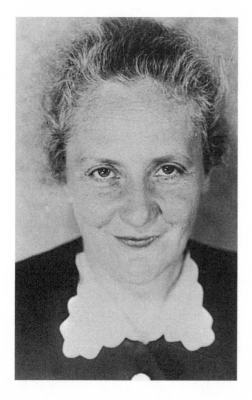

Paula Salomon-Lindberg
(in a 1930s photo for emigration
papers) with the lively hair,
upward eyes and almost smiling
mouth of CS's Paulinka.

those stories and repeating them, tried to give back to Paula her German life.

The most puzzling story Lotte heard was that of Paula Lindberg and her friend Kurt Singer, another sparkling student at the Academy of Music. Kurt Singer had expected Paula to be his wife, and he captivated everyone—legions of German Jews and even a few anti-Semites. At forty-five he had dramatic looks, with a surge of gray hair rippling back from his forehead, an imposing lithe figure, a wickedly seductive face. He was a physician, psychiatrist, hypnotist, professor, director of the Berlin Municipal Opera, and much-published musicologist. All this he had accomplished before 1930, when Paula Lindberg decided to marry someone else. Paula remembered Lotte always trying to figure out "why I hadn't married Kurt Singer" instead of Lotte's father.

Why *had* such a radiant woman settled for a man CS colored drab? The artist tried to explain this by letting "Paulinka Bimbam" tell her own life story in twenty-five scenes. In this memoir within a memoir, Paulinka rejects Kurt Singer—renamed "Dr. Singsang"—because she imagines "a man like that would expect a dutiful woman to devote her entire time to him," which would make her evaporate from the opera stage (and fall in droplets off the painting's frame). In the figure of Paulinka, CS brewed up an antidote to her own mother's helplessness. "Paulinka gave her hand to Professor Kann . . . who, as we know, had gotten his promotion." That last phrase came from Fränze Salomon's child, letting no bygones go by.

Five decades later Paula Salomon-Lindberg's cappuccino voice, still savory from her performing career, lightened whenever she said "my husband." In her words he was goodness visiting this world.

> He was a simple man, an angel. Because his mother died he said: "I will be a doctor so no mother will die again." At the University Hospital Albert performed the first breast cancer operations and thought only of cancer research. When Lotte used to pass him on his way to the clinic, she would call out "Good morning, Professor." "Good morning," he would answer quite without interest, he was so absorbed in his work. Of course she laughed about that. She was fond of her father, but he was so seldom home—and even at home, he was not always *here*. So she often said she couldn't understand why I had married him.

Then CS figured it out: Paula Lindberg had simply chosen her "duty to this man and this child."

Duty? Why did she think that?

"Because we always behaved distantly toward each other so as not to irritate her. We never hugged in front of her. Once at a party Lotte told someone we weren't really married. I didn't laugh—I was touched. She had to have the feeling that I loved her as much as him. She was always jealous of Albert, so I acted the same to each of them. I had to protect her from separation."

"Love is a rebel bird"

So quickly did Lotte cross the lines of loyalty and pledge herself to Paula that she called her love a "rebel bird," from the famous *Carmen* aria that Paula once recorded. Her rebel love resisted what every German pupil learned from Grimm: The stepmother must order the child (Gretel) to the woods, or to the scullery (Cinderella), or to be killed (Snow White), because no stepmother, Grimm said, can "bear the thought that anyone might be more beautiful than she." Of course the despised daughter always ousts the stepmother in return.

Testimony at last against those myths of female spite, *Life? or Theater?* brings women nowadays to tears. *This* fairy tale has a girl rushing "to be tenderly hugged by the much-loved figure" of her second mother. Sweetly the sleeping (or pretending) girl waits for her and for her heartfelt goodnight hugs. Bravely every day at school the girl "thinks only of her." "Everyone loves her" there amid crowds of admirers, "but no one the way I do." Not once envying her, this girl "even envied—this sounds laughable—her father." *This sounds laughable:* the artist knew she'd upended a myth.

Stepdaughter and *stepmother* were simply not their words. People who knew Paula Salomon-Lindberg before the war had heard her talk over and over about "our daughter Lotte." And Lotte had called her new mother a sweet syllable—"Moo." (Remembering this name made a light come and drain from Paula's face.) "In those days Lotte went to all the concerts where I sang. Kurt Singer [CS's 'Dr. Singsang'] was almost always there—she had such a crush on him! Lotte was always jealous." And maybe with cause. Kurt Singer's daughter recalled that

"Paula was much nicer with us than with Lotte. The way she loved us children made me conclude how much she loved our father."

One "memorable day," in one memorable painting, Dr. Singsang's visit to Paulinka interrupts Charlotte's plan to give her stepmother a birthday gift, and the girl's rude gesture sets off "their first quarrel." Hothead colors, savagely applied, show the moment still scorching CS's mind. Neither figure budges till Paulinka's hands close on Charlotte's neck, stroking and strangling at the same time. Afterward Charlotte locks her door and crimps her body, while Paulinka breaks in on her husband, "who at that moment was adrift in the upper reaches of Goethe," to complain about his child. But the girl soon pulls up to her knees, hearts blossom from her head, and the theme song fills the overlay: This "love is a rebel bird," making the kind between husband and wife a safe second choice.

As the figures of Paulinka and Charlotte draw close, the vibrant scenes bring out a bond found in families everywhere, but not explored in art till *Life? or Theater?* There Charlotte is shown drawing portraits of Paulinka that rise to the occasion of love. In real life it was Albert Salomon who first showed Lotte colors and designs from his collection of baroque pictures and Persian rugs. But the girl of the pictures is prompted by another passion. She twists and aches with the need to set down her stepmother's face.

Sketching Paulinka becomes her hobby because it lets her be solitary and romantic, which is what she wants at age fifteen. "Charlotte has reached a melancholy age. . . . She lets her hair grow and stands for hours in front of the mirror. She likes to read romantic stories. . . . Drawing is one of her favorite occupations . . . [Meanwhile] her friend Hilde has found another friend who's prettier than Charlotte, and during recess she now goes around with Marianne while Charlotte tags sadly behind."

"A melancholy age"

The real-life Lotte in those days was "withdrawn, serious, pale, tall and nondescript," recalled Kurt Singer's daughter—"a girl you would never look at twice." Paula recalled her "more like her father, happiest alone and thinking—a very introverted, difficult child. Lotte did not have a lot of friends. Lotte had us." One young man who

knew her then said, "Lotte's relations with me were, shall I say, ice-cold?" Another called her "uncommonly inarticulate." As for girl-friends, they left Lotte trailing behind. The one named Marianne, "who's prettier than Charlotte," when found and interviewed fifty years later, raved about the talents of other students at her school—but Lotte Salomon? "She had no definite characteristics at all." And what about Lotte's "friend Hilde," mentioned in the pictures too? Marianne Schlesinger remembered one girl named Hilde who left for London when Hitler came to power. In London it took asking an encyclopedic scholar—Did he know of any Hilde from Berlin (last name unknown)?—to come up with a single name to try.

"Lotte Salomon! Whatever became of her? An artist? But she had no talent at all. The gifted one was Edith Simon. Come over. I'll show you my album from school." Hilde Littauer's album led to students in Europe, the United States, and Canada, who had been to school with Lotte in the thirties. Most of them recalled a girl without a mother—not that she ever talked about it—but they knew little else. "Her friend Hilde" walked home with Lotte every day and never got invited in. Another student with a sharp memory of classmates had no image of her at all. Another, the artist Edith Simon, described "a quiet girl, even somewhat lethargic. Her art was not too much in evidence then." And another, Igna Beth, "had no idea she was even interested in art. Everyone liked her but she was so very withdrawn, just like a shadow—*there* but not in her body. A nonperson, like a little lamb."

These were Lotte's peers at the Fürstin Bismarck School in genteel Charlottenburg near the Salomons' flat—a girls' public school that wanted every graduate to take a higher degree, even when 85 percent of university students were of the other sex. Over the school gate Athena's stone arms beckoned girls into a modern academy, where philosophy dug into Nietzsche, drama meant Brecht and plays about World War I—*French* plays—and religious education covered both Christians and Jews. The hallways looked important (and still do), with plaster friezes of Woman as bearer of the culture, teacher of the young, rescuer of the wounded—this last copying the Pietà statues so common after World War I. Fürstin Bismarck was a training ground for humanists, and if they happened to be Jewish girls, like half of Lotte's class, the principal would say, so what? *"Ja, und?"*

In school photos Lotte Salomon is always the one staring into

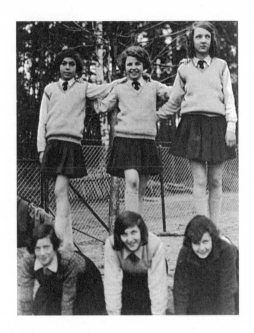

Students at the Fürstin Bismarck
School around 1931
(*top row from left*: Hilde Littauer,
Marianne Schlesinger,
Lotte Salomon).

space and on the edge of the group, outsize and stringy as if glued to
the ground and pulled from the top. Girls at that school learned a
confident step that left her far behind. A middling student, nothing
special, her best grades were "good," in religion, German, drawing,
and sports, while in the other eight subjects she earned "satisfactory."
Her work in drawing promised nothing much, and besides, "the art
training at the school was just no good," everyone said. This was a
place that turned students smart, comradely, merry—and Lotte
slumped through it in solitude.

Yet something was germinating in that frail seedling. Behind the
joyless look, "Lotte liked poetry, Goethe's poems," Paula recalled.
"She read Hesse, naturally, and Döblin, Remarque. She was interested
in Nietzsche." While others thought her a "nonperson," she was
shielding her fragile core—the loss of her mother, the hush around
it—and brooding her way forward. Beneath blank surfaces, young
minds absorb the world. Hers must have been a photographic plate
during all those years her parents found her portentously alone.

Her solitary nature came from her mother's family (Albert tells
Paulinka in the scenes), and he sets in motion a terrible charge. He

blames Grossmama for having "smothered every natural urge in her children by bringing them up with stiffness and formality, imposing her example of perfection. . . . [until] they could only free themselves through death. Paulinka cannot get rid of the thought that someday little Charlotte, faced with the same doubt, might also plunge out the window." Impulsive and swift, Paulinka punches out a letter to Grossmama, saying the unsayable: You are the "murderer of your children." But *this* child, she writes, "will be protected by *me;* you won't get her." From Paulinka's head balloons a tiny window with Charlotte vaulting out. Through her stepmother's mind the artist first pictures the odds of her own suicide.

But it never took place that way, according to Paula Salomon-Lindberg in later years.

Did you actually write that letter, Paula?

"Nein, nein." So it appears CS invented a defender.

Did you hope to tell Lotte the truth?

"I always wanted to tell Lotte about her mother's suicide. Grossmama said no, and therefore we couldn't. Grossmama came from a fine family, and she was very intelligent, but a hard woman."

The paintings follow the imagined letter—"murderer of your children"—to its arrival, and register in slow sequence how Grossmama opens the envelope, spreads out the paper, puts on her glasses, and sinks, stricken, out of the frame. The artist has the grace to give her privacy, leaving her "alone awhile with her astonishing pain," to "turn back to our lovers, who in the meantime have made up again."

Our lovers: Paulinka and Charlotte. Their simple approach toward each other breaks into component parts across the page, slowing down to yield its intricacy. Will Paulinka hold the girl? She might. She will! The girl leans back, then seals her eyes, then turns Paulinka's color, then reaches with forgiving arms. But at the same moment the grandmother "has wholly withdrawn," blaming the family and Albert and fate. She is given a chance to narrate her "tragic, stirred-up life in her own poetic form," and her 48 scenes close the 144 paintings of Act I. Folding Paulinka's and Grossmama's memoirs into her own, CS looked back with them and pushed away the pain at hand.

So far in this play, the audience has heard only the word of

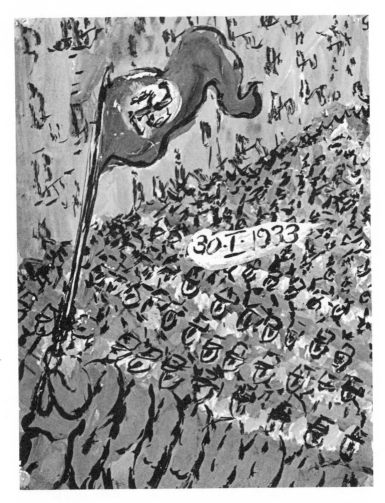

CS's backward swastika on "The day for freedom and for bread,"
when Hitler becomes chancellor.

women. After an intermission the page turns, the script scrolls across
the overlay, the self-conscious figures exit, and eyeless masses come
onstage.

"German men and women—take your revenge"

A swastika cuts into *Life? or Theater?* as it cut into Lotte's life. In
1933 this emblem thrilled many Germans embittered by defeat, infla-
tion, joblessness, and fear. In shrunken, ailing Austria, Adolf Hitler
and Adolf Eichmann came of age, saw nothing for themselves, looked

to the swastika, and found a race to blame. Of the Nazis who eventually followed their call to expel the Jews from Europe, the most typical were young Austrians like one named Alois Brunner. Born in 1912, Brunner took a few years of schooling, then slipped from job to job till he found training in a regional police academy. At the age of nineteen he joined a smalltown Nazi troop whose struggle to exist in Austria's disorder matched his own. By 1933 he was just the type of Nazi that CS always depicted without a face. In her cavernous need to know what had happened to her life in Germany, CS explored the appeal of Nazism to men of Brunner's sort.

Two scenes of *Life? or Theater?* work out that appeal. As they look down on a Nazi parade the day Hitler is named chancellor in January 1933, their images and words tell how a marginal movement purloined central power.

As these two scenes show, first the Nazis uniform the crowds so that men can lose themselves in a numberless mass: All the ranks turn brownshirt color as far as the eye can see. Then Nazism saturates them with symbols until the tedium retards all thought: One crowd looks stupefied by a swastika banner, another by a poster with the features of the so-called Jewish face.

Then Nazis deflect the crowds' resentments: These scenes quote outrageous charges from the Nazi journal *Der Stürmer*—"The Jew has just made money from your blood! The Jewish bosses financed the World War!"—while on the backdrop, crowds loot small shops with Jewish names. In fact, whole groups skidding in the inflation and depression after World War I (by 1932, 6.5 million were short of jobs) dream they will advance once they clear away "the Jew."

Nazism mobilizes vengeance: Slogans like "Avenge Yourselves!" (underscored in red) shame Germans into violent acts they call revenge. CS quotes: "1 April 1933. Boycott the Jews. Buy from a Jew and you're a pig too."

The Nazi Party manipulates gender: banners in the scene call for "German men and women" to serve the new régime. When it decides to empty every Jewish shop and ostracize each Jewish child at school, a lot of German housewives carry out the job.

The Nazis eroticize violence: For men the party pushes brutality as lust. From verses of the Nazis' "Horst-Wessel" anthem, CS prints the one which makes "spurts" the active verb: *"Denn spritzt vom Messer*

Judenblut . . . " ("When Jewish blood spurts off the knife, that's when you get more kicks from life").

The Nazis playact politics: Her vast torchlit tableau catches their scheme of putting masses into performances. The swastika flag dominates the space like a big prop.

But backwards. Scores of swastikas are stamped into CS's paintings—all in reverse. A graphic artist's mind, a mind in command of the "Horst-Wessel-Lied," could not have failed to notice swastikas kicking clockwise. Her inversion meant to defy that manly symmetry. Her downward angle of observation diminished the violent surge below. In perspective began identity: To belong with Jews meant to look down on the world warily, as Jews did from the windows in their flats. The straight sight of streets was lost to them.

"Human-Jewish minds"

Suddenly Lotte, like other German Jews, had to work out her ties to a Jewishness that Nazism forced on her. One solution was to make use of models right in her home. Her father had rejected Orthodox Judaism long before, when he wrote a scientific dissertation in 1905, yet signed it "Albert Salomon, of the Jewish faith." When that little tag got him fired in 1933, he worked energetically in the Jewish hospital of Berlin, the Weissensee Krankenhaus, while Lotte's aunt did charity work for Jewish families, and her cousin Helene Salomon assisted a clinic for poor Polish-Jewish children. Whenever a relative died, the whole Salomon family sat *shiva*, the traditional seven-day mourning time, when Albert used to stroke Fränze's hand. Keeping women Jewish in their charities, keeping rituals Jewish in the hour of death: here was a modest form of affiliation that Lotte had learned at home.

Even less came from her mother's family which had shed all Jewish signs. Fränze Salomon's holy day had been Christmas, when she sat at the piano leading "Silent Night." Her fantasies featured angels and the bearded God of folk Christianity. Fränze's parents were "as German as could be, and practiced nothing Jewish," a relative recalled; they loyally chanted "Deutschland, Deutschland, über Alles" up through 1932.

But when Paula Salomon-Lindberg took over Lotte's home in 1930, things changed: To be Jewish meant to act it. She performed at

the B'nai B'rith Lodge, a Jewish fraternal order which she and Albert supported for years. "Friday nights we lit Sabbath candles, Saturday morning and festival days we went to synagogue. Usually Albert had his work, but Lotte went along with me." As Paula told it, every year people asked Rabbi Leo Baeck, the leader of Progressive Judaism in Berlin, "Where do you have a seat for Yom Kippur?" "Wherever Paula's singing Kol Nidre, of course"—the Jews' holiest prayer. Under Paula's influence Lotte even had a bat mitzvah, a modern ceremony in German, with her reading parts in Hebrew and writing her own speech.

All such events failed to appear in CS's version of her life. The scenes do fasten Stars of David to Paulinka, Hebrew letters, Yiddish songs—but all tiny, dull in color, not meant to advertise. One view alights, distantly, on Paulinka singing in a synagogue, and one quotation from the Psalms and Job ("What is man that Thou art mindful of him?") enters as an epigraph, an elective link with Jewish tradition, almost the only one. In Lotte's experience Jewishness meant a religion to keep up or discard. After 1933 it meant a race—indelible—and this change in definition was one she resisted firmly in her life.

None of the examples from her family quite worked for her. CS had to make up a phrase to describe German Jews like herself: they had "human-Jewish minds," one caption says. Her phrase "*menschlich-jüdischen*" (broader than "German Jewish") hyphenated what Nazis thought a contradiction in terms. Yet some Jews held it as an ideal. "If anyone asked me where I belonged, my answer would be: a Jewish mother brought me into this world, Germany has nourished me, Europe has educated me, my home is this earth, and the world my fatherland" (Ernst Toller). "The Jews have an important mission—to fight nationalism in all its forms" (Arnold Zweig). German Jews cherished the genre of biography: they liked weighing singular spirits, nationality aside. In the midst of the Nazis, one young Jew began to weigh herself as a few endangered people dared to then: *Because* I am Jewish I belong to the world.

"They were all let go"

In the scenes only sarcasm on CS's part could describe the senselessness of 1933: "Just at this time, many Jews who . . . are perhaps an intrusive and demanding race, found themselves in government and

other senior positions. After the Nazi takeover of power they were all let go without notice." In reality Jews comprised only a decimal in Western European populations, with the largest group (525,000) in Germany, less than 1 percent of the nation. Though Jewish families could be seen in certain districts like Charlottenburg, where one in eight residents was one of *them*, they made up only 5 percent of Berlin. Almost no Jews occupied "senior positions" in the domains of politics and administration, the military, industry, or mining. But they did introduce the changes in retailing that jostled small merchants, and movements in journalism and theater that left old fashions behind. Whereas an eighth of the whole population practiced the professions, one-third of the Jews did, though in 1933 they still totaled only 11 percent of Germany's doctors, and 16 percent of its lawyers. Nazi propaganda leaped from the small sample to the large lie about Jewish power, and the artist's ironic comment about "a demanding race" caught the lie in midair and left it there. Nazis rarely appeared in her scenes, maybe because she couldn't respond to their fabricated reasons for firing Jews.

Paula Salomon-Lindberg was among the first to go. "At first people never knew I was 'Salomon,' only Lindberg. 'She's Jewish?' 'She's Christian?' Even the Nazi newspaper said 'the real Christian was the alto.' Only later the critics called me 'this *Judenschwein*,' 'Jewish pig.'" Then Paula was attacked onstage, and CS painted it: right at the crescendo of an aria, the audience shrieks *"RAUS."* Out! In another scene Dr. Kann is literally and ruthlessly crossed out in the midst of surgery, and there was some truth in this too. The professorship that Dr. Salomon won in 1926 at such cost to his wife was grabbed back in 1933. All those who invigorated Berlin culture were spitefully excised from it—Paula Lindberg and Albert Salomon and Kurt Singer and every Jew in their kinds of work.

At this juncture Kurt Singer took action to form a Kulturbund, a Jewish Cultural Association. The scenes show "Dr. Singsang" in the Ministry of Culture and Propaganda with a parade of corrupt figures presented in the merciless manner of Georg Grosz, each proud of breathing air "unpolluted by Jews." An official with highlighted crotch and red eyes (probably Goebbels, the minister of propaganda) is so impressed by Singsang as to imagine him "an honorary Aryan" and approve his plan.

In bringing Kurt Singer to center stage, CS caught the start of a sea

change in Jewish identity that few are aware of today. The idea was to answer anti-Semitism with massive Jewish attention to the arts. By means of "endless visits to the government, the police, the Gestapo," all apparently recounted to the Salomons and lodged in Lotte's memory, Kurt Singer convinced the Nazis to permit a separate creative space, "a kind of haven for Jewish artists," Paula Salomon-Lindberg said, where they could "perform for an exclusively Jewish public in community centers, in synagogues, and sometimes in private homes."

At that moment, like her elders, Lotte lost her fastenings to German life. In September 1933 she left the Fürstin Bismarck School, though none of the students quite knew why. Igna Beth could not remember Lotte leaving: "She didn't make a ripple." Was she pushed out like her parents? Or had she made up her mind to quit? The girl in the scenes swears, "I won't go back to school. You can do with me whatever you want. I won't go back to school." She stands before her father, arms braced across her chest, adult to adult for the first time. On the overlay the words swell inside her body, fill it out. Swastikas spike the surface of the scene.

And in fact the Fürstin Bismarck school compromised its motto ("To Unite You Not in Hatred but in Love") as soon as it imposed classes like "Race Science" that fell under the shadow of *Mein Kampf*: "All education must have the sole object of stamping the conviction into the child that his own people and his own race are superior to all others." Girls were taught to fear degeneration, as Nazi women pronounced: "If we remember the . . . Law to Prevent Hereditarily Diseased Offspring, then we know how very much importance this State must attach to the training of suitable women." A teacher once fond of Jewish students suddenly made hurtful remarks, and a few mothers cut off their daughters' Jewish friends. Lotte's friend Hilde Littauer had nightmares about school chums betraying her. Other students woke up when "we had to bring baptism certificates of four grandparents to school. That's how a lot of girls found out they were Jews." Oddly unaware they were; but then, 40 percent of Jewish men and a quarter of Jewish women had been marrying outside the faith and raising most of their children Christian—children born around 1917, Lotte's cohort. Now one of them visited an Orthodox couple every Saturday to learn the religion the Nazis assigned to her.

But Lotte did not see, or tell, the fact that her school also resisted

the new racial rules. The biology teacher mumbled his eugenic terms. A language teacher took Jewish girls on outings, which earned him a transfer to eastern Germany. "Our school supported Jewish children," one classmate insisted. "I stayed on and wasn't kicked out." So it is a puzzle why Lotte left in 1933. Only after 1934 did other girls begin to go, though numbers stayed. In the next years Jewish students walked out on an anti-Semitic speech and fought back when they were harassed. Kurt Singer's daughter recalled the girls' courage: "The Zionist youth movement children would stand in the street, and when the Nazi children would come by, there was street fighting. Every day I came home with a torn dress. The nanny was upset, but my father didn't know." If Jews were to be kept from the school's country cabin, the whole class would refuse to take the trip. When one teacher derided a Jew, a Christian girl stepped in: "How could you say such a thing! Her father died in the war." When the "Horst-Wessel-Lied" was played, most declined to sing. When ordered to hail the Rhineland reoccupation in 1936 with a right-arm salute, the girls at Fürstin Bismarck hiked their left arms up. If only German citizens had taken their cues from teenage girls like these!

Since then, most schools have erased their Nazi stains. The principal of the school that remains on Fürstin Bismarck's site wrote that during World War II most records were destroyed, and no information about lesson plans, teachers, philosophy of the school in those days was still extant. But pushed by a visit, he found the records of Lotte Salomon, whoever she was, though he declared them private and daubed white-out on her grades. Once this was scraped off, the records showed she left after six years "to receive private instruction. . . . Her behavior was completely unobjectionable." She was not expelled.

Out before she had to go, Lotte lost all chance of university, but so what? A Nazi decree kept Jews at 1.5 percent of the student body, and female graduates hardly got jobs now that women's education was called a "Jewish-intellectual" misdeed. Mainly Lotte quit at age sixteen because *any* Nazi sign offended her. It was a principled and crucial move.

"I'll learn to draw"

The end of her schooling was the end of her girlhood. As the young woman in the scenes thinks about her next step, she hunches

over an unformed sketch. Then: "I'll learn to draw, because God made that calling for anyone—why not me?" and this reverie ("why not me?") brings about a bristling, arm-flexing exchange with Paulinka, who knows the arts are closed to even the most talented Jews. Charlotte's nose and chin jut up, Paulinka's point down like a wicked stepmother: "You can learn fashion design, because you can earn money at that, and you know I only value someone who can earn money."

"She's not really very gifted, but she ought to learn fashion drawing," Paulinka tells the director of a design school run for Jewish girls, who ridicule Charlotte's dowdy dress, till at home she grips her head in pain. Her father confides in Paulinka:

"She worries me. You already know why." His "why" means her family legacy, her solitude, the ties she fails to form ("Charlotte tags sadly behind"), the ones she puts aside ("I won't go back to school"), the unrealistic dreams, the hopes revoked. Finally she stands in yellow space without coordinates, enclosed by a dotted line—the overlay punctuates that line—like a figure to be cut out and stuck anywhere.

Then her grandparents draw her out of this void. They invite her to spend her seventeenth birthday in Rome, where her mind will have a place to stretch. CS's ten images of Rome suddenly have depth and periphery after the tightness of every scene in Berlin. A palette of olives and mustards and browns shifts to reds and blues and marigolds. All the lines take freer curves. Aryan straits snap open into pagan ruins, Christian churches, architectural miscegenation. (The only reminder that Nazi bias has slipped south occurs in a public audience with the pope, who says, "What are these little Jews doing here?" and these absurd words on the overlay march down his holy garb to poke the girl.) Before a Pietà, Grossmama's skin tone matches the Virgin's, and Charlotte learns that art speaks back each person's tragedy. When she finally has to leave Rome's "blue for Nordic gray," she is prepared to live for art.

But back at the Fashion Design School the teacher turns juror, and the verdict points mercilessly at Charlotte: "Drawing is a difficult art. One has to have a little talent for it, and sad to say, you don't." Charlotte thinks—and it takes seven faces to form the thought—"I refuse to get stuck with this stupid beast." After Rome,

learning fashion design just because the design school takes Jews, debases her. So she approaches a building so imposing it squeezes empty space from the scene: the Art Academy. A Nazi flag and huge doors shut out the little figure pumping herself up: "Only by daring can you win, only by daring can you—begin." Inside she stoops before a huge official.

"I am Herr Schmidt of the Academy, doing whatever they tell me to. Heil Hitler!"

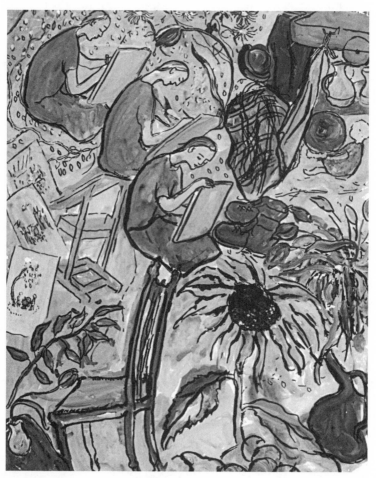

The chair, shoes, fruit, and sunflower make this picture an homage to Van Gogh.

"Do you also take Jews?"

"You're not actually a Jew!"

"Of course that's what I am."

"Well, we're not so correct here. Come and take the entrance test."

Of course that's what I am: "*Natürlich bin ich das.*" Just saying it her body straightens up, and this confession fastens on her painting arm, for good.

She takes the admission test, but so does a Nazi in insignia—and he'll make it and she'll fail. A desperate rhyme tumbles down the overlay: "*Nie, Nie, Akademie*" (Never to be—the Academy). At home she leans against her father: Could she have an art tutor at least?

Paulinka replies like a wary realist: "I don't understand spending all that money. She really doesn't have a gift for drawing."

Albert answers as a despoiled liberal, hoping training will still count for his child: "If she wants it that much, she should take lessons. All you can give your children these days is a good education."

They have the means to engage an art tutor, but the tutor thinks the pupil is obtuse. See this cactus plant? Count the leaves! "Now, that's much better!"—after many tries. "I must say you have a nice gift." Years later in memory, the cactus sprouts a wild overlay, with leaves upon leaves breaking from a little succulent in free green strokes. Another painting flouts the courteous "nice gift" with a wild assemblage—sunflower, shoes, chair, fruit, vase, sky—an homage to van Gogh (also told he had no talent), as if to say, We two can paint anything.

So when a well-trained Charlotte tries for the Art Academy again, this time the students take note of her work, even the Nazi at the end of the row. Her second test features a live model, nude and male, and while other applicants just stare, Charlotte takes his measure, sighting down her arm. The accompanying tune, "*Allons enfants de la patrie,*" marches right past tyranny. "This time [she says to herself] I've got it!"

She's got it, all right. By age nineteen she's learned to stand up to her parents, leave school, and fix on what she wants, even if it's out of reach. Through with being neutral, she names herself a Jew. Not just a prey of Nazism, she perches to look down at it. Lately an outsider, now she counts on belonging with artists—nowhere less.

"The full Jew Fräulein Salomon"

Some sense of special grace told the real-life Lotte she belonged in art school, though the test alone, however competently done, could not have gotten her in.

The year was 1936. The Nazis had defined "non-Aryans" as those with a Jewish grandparent, and the world-famous State Art Academy in Berlin had fired them, and then employees *married* to them—at least

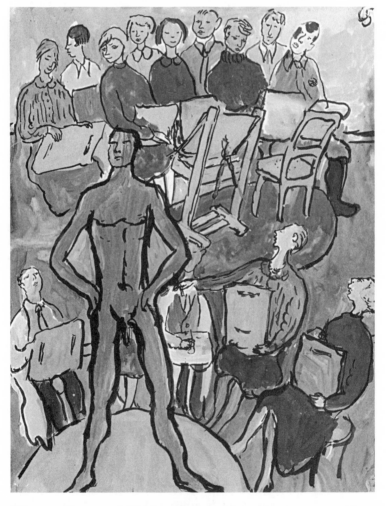

"This time I've got it!" Charlotte (*top row*, *left*, and *bottom row*, *second from the right*) at the entrance exam for the academy.

one hundred professors and students. The academy director, Max Kutschmann, saw little point in having any Jews, since the artists guild would never license them. Still, Nazi policy allowed Jewish admissions up to 1.5 percent of the school, and favored those whose fathers had fought for Germany. Paula Salomon-Lindberg thought that if Lotte got in, they would have to thank "the Iron Cross of my husband, from the First World War." But it was a different loophole that opened, and left a little clue to secret grids of race and sex.

Of course she never knew what went on behind her back. Counting non-Aryan students by the fraction of their Jewish blood, the director brought the total to .63 percent of his student body—a bit below the 1.5 percent quota—and reported he could admit a Jew or two. But on what grounds this one "full Jew"—all four grandparents— namely Lotte Salomon? Here are the Admissions Committee minutes, February 7, 1936:

> The artistic abilities of the full Jew Fräulein Salomon are beyond doubt. Her behavior also is recognized to be modest and reserved. There is no reason to doubt her German attitude. In spite of this, Herr Scheunemann [a Nazi student leader] protested on principle the admission of non-Aryan female students [the handwritten draft says "Jewish female students"] because they present a danger to the Aryan male students. [The next phrase in draft—"Professor Bartning tried to refute this reason by referring to the students' characteristics"—was altered to more personal language.] Professor Bartning, however, pointed out that this danger does not apply in the case of Fräulein Salomon because of her reserved nature.

In the winter of 1935–36 a new name appeared at the bottom of the enrollment list: Fräulein Salomon.

It seemed to her that she had done it all herself. But in fact, her "reserved nature" around the higher sex proved her only asset to the Nazis. Even their art schools took up the racial future of the continent, and started to subdue, in ways that Lotte could not grasp, the erotic and fertile potential of every Jewish girl. So dowdiness and diffidence—traits that had submerged her at home and school—started lifting her toward the surface after all.

3

OBSESSION

(1937-1938)

～

The whole progress of Charlotte Kann from birth to art school
stands back now as a "Prologue" in her play. A new character steps
onstage, with the lustrous name of "Amadeus" and the imagined
"Toreador Song" from *Carmen*. This "Main Part" promises a grand
show: a toreador will change his slightness into strength. The artist
lavishes 467 scenes, more than half the operetta, on "Amadeus Daber-
lohn, prophet of song."

Daberlohn was modeled on a musician named Alfred Wolfsohn,
age forty-one at this moment in the fall of 1937, and more troubled
than anyone Lotte knew. When he had been twenty like her, he'd suf-
fered shell shock in the trenches of the Great War. Then, amid the
dislocations of Weimar Germany, he had worked as a bank teller, rent
collector, pianist for silent movies, singer at synagogue funerals, and
finally voice teacher who quoted Nietzsche: "Learn, O my soul, to
sing!" Wolfsohn became Lotte's hero by enduring every hardship in
order to do the work he had a calling for.

But this hero was also a Jew and out of a job. All musicians in the
Third Reich were required to show proof of not being Jewish in order
to work. "A Jew," as defined by 1935 laws, was "a person descended
from at least three grandparents who were full Jews by race," or if
fewer than three, a person belonging to the Jewish community or

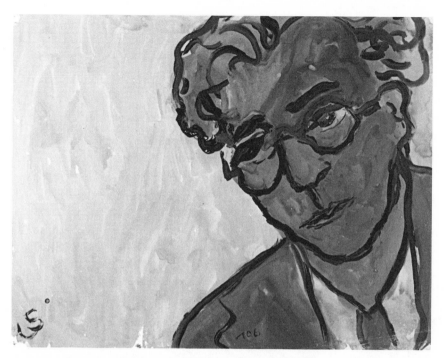

Amadeus Daberlohn, "prophet of song."

married to a Jew. A "Jew," even if Christian for half a century, had no right to be a citizen of Germany, to marry or have sex with "Aryans," to gain entry to a training school, or to hold a professional or public job; not even partial or estranged Jews escaped these rules. To survive meant to work in the Jewish subeconomy, which was why Alfred Wolfsohn needed Kurt Singer's help.

In CS's scenes the character "Amadeus Daberlohn" seeks a permit from the Kulturbund, the Jewish Cultural Association, where "Dr. Singsang" holds sway. Dr. Singsang dispatches him, clutching a letter of introduction, to Paulinka Bimbam, who should conjure up some work. Heroes made humble entrances in those days—delivered to the door by Nazi decrees.

"And now our play begins." It starts with the moment Daberlohn moves toward Paulinka across the stage. The audience will have new forms to deal with: duets between Paulinka and Daberlohn; then trios for matched voices, as Charlotte joins in, with three melodic lines

crisscrossed. Daberlohn's part begins when his eye catches a divine woman up the stairs, and he halts before her feet. "This might as well be heaven above," he says.

When Paulinka takes him to her piano, the toreador makes his first move: "You used to sing much better."

"Those were much, much better days," Paulinka says back.

"By rehearsing with me, you'll make strides yet."

"How conceited," she thinks, "can someone get?"

Daberlohn at home sinks into a daydream, while the backlighting throbs yellow and orange. "This woman I met today . . . I'll make her into the greatest singer of all. . . . One condition—she has to love me!"

Then the narrator puts in a word. "Here you see him standing at the window like any woman—dreaming—longing." He looks like Franziska in a man's body. Attachments with Charlotte are fated to occur.

Next morning the toreador tries to turn Paulinka around. "You

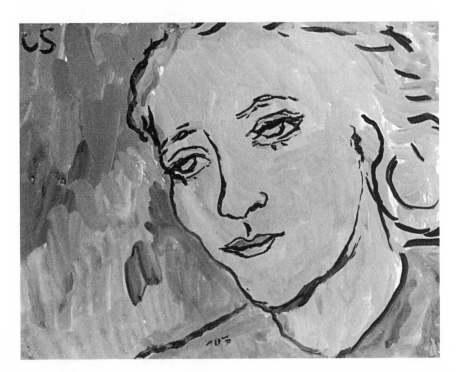

Paulinka Bimbam, Daberlohn's "Madonna."

have a husband you respect but do not love. . . . You sing only for the public, yet your technique and voice would make you the greatest singer on earth. . . . With all your duties you have forgotten there is something called freedom," and his arm inches toward her, taking over the space. "Art . . . must flow from real life. When it does—go ahead and laugh—you can become a genius."

She does laugh, thinking art must flow from discipline. She decides to get him a teaching certificate: "I can pass a few of my students to you." Captivated, Daberlohn calls her "my Madonna and my singer." Alone, he confesses, "If I look deep into her eyes, I see only my own face reflected there."

He goes at her again: "You cannot possibly lead the kind of life you do without harming your soul."

"What makes you imagine your job is to enlighten me? . . . You rely totally on people like me and Dr. Singsang."

"Keep loving me and you'll have your reward," he says by way of prophecy. "Dearest Madonna, let me shape you, let me form you."

"Art is deeply united with love"

When Amadeus Daberlohn puts forward his ideals, CS lets them serve his desires. "Art is deeply united with love," he tells Paulinka; "all paintings of Madonnas are portraits of mistresses," and a singing lesson should be like a "night making passionate love."

At each word he says Paulinka's face softens until it confesses freely across the page: "I think you are dangerous, my young friend. . . . If this wasn't clearly nonsense, one might just believe in it." She admits even more: "You are very hot-blooded, and that is catching," but CS left this line out of her selections for *Life? or Theater?* In the final work Paulinka refuses to take Daberlohn to heart, which CS judges both a failing and a strength.

When the script delivers Daberlohn to Paulinka, the narrator's lines twist with irony. They tease the audience about "Charlotte Kann—whom you will recall" and poke at all the characters. Daberlohn has a fiancée whose photo at age ten is all that interests him— not the person, just the Sleeping Beauty ideal. When he loses the fiancée's ring, Paulinka jumps in to replace it, saying no one will "notice the deception." At dinner with the Kanns, where Daberlohn

hides his passion for the hostess, Charlotte gets to meet him finally, and her first look eagerly takes him in. He soon takes them all in too. Making excuses to his fiancée, he whispers to his Madonna, "Wait for me in the café." At every stage, one question drives the plot, from the family's secrecy about suicide to these new whisperings: Who gets fooled?

Charlotte tells Paulinka after Daberlohn leaves, "Among all your friends he's the only one who talks sense."

"Yes, you match each other just right; he's as crazy as you are."

Is he crazy, as Paulinka says, or inspired? Why not let the audience judge? Multiply his face on swatches of color, then with endless flowing letters, supply his speech. No less than 135 faces of Daberlohn speak through the first nine sheets of the Main Part, while the words feed off his blue outlines. The faces change in rapid animation: heads tilt, eyes open, eyes close, hair streams. In this face-voice invention, colors copy thoughts, turning dark bronze where he

Daberlohn says, "...So look on me as the sacrificial animal ready for slaughter, to bring this singer back to herself."

"With freedom and beauty Paulinka sings" Orfeo, a male role scored for a female voice.

describes "my nights of blackness," passing from copper to olive-gray where he says, "My knowledge was born of unspeakably heavy dark hours, and that's why I know it is true." To measure the color swatches for each speech, CS must have let his lines run again and again through her voice.

The lines are monologues of an obsession, Daberlohn's obsession with death, as known by Orpheus and Faust. These are his guides in entering the underworld "to create the world anew from the depths" (a phrase that comes back to conclude CS's whole play). Daberlohn desires Paulinka to be sucked down from her level surface too, for "I

want everybody I love to have hard experiences so they will be compelled to take a path into their depths." Paulinka will reach those depths, he thinks, in singing Orfeo (the male role of Orpheus scored for mezzo-soprano) in Gluck's opera *Orfeo ed Euridice*. Orfeo demands staunchness in trespassing the underworld to see his beloved Eurydice, cleverness in bringing her back to life, breath-catching grief when he loses her again, and sings *"Che farò senza Euridice?"* ("What will I do without Eurydice?"). The music lifts Paulinka to the crest of her power and inflames her voice coach too. This Orpheus, he says, "is none other than herself, who has suffered such a loss of soul that now she must descend into her own being to find herself again." Daberlohn gives his all to help Paulinka and to get what he wants: "The singer's emotional life must be powerfully affected," he insists, "so look on me as the sacrificial animal ready for slaughter, to bring this singer back to herself."

Through Daberlohn's impassioned eyes Charlotte sees her stepmother's grace as she performs Orfeo with head thrown back, hair streaming, voice filling the air in curving broad waves, figure cropped at the shoulders, all throat. Even the conductor imagines Paulinka's Orfeo "on the world's greatest stage!"—except that this prediction is squeezed for space, and Paulinka's sad smile shows that she guesses what will become of her talent in the Nazi Reich.

After the concert, late at night, Daberlohn comes to Paulinka, and though she looks exhausted, she reaches from her bed to hold his hand and head.

"Oh Madonna, I bless you," says the prophet of song. "It was splendid."

"Is it jealousy or something else?"

At age twenty Charlotte finds an ally at last, someone else who loves Paulinka, someone who acts out that love. But she stands awkwardly outside their circle in these scenes. If she can only draw his interest her way, she can adore Paulinka and replace Paulinka too. The lines of this complex geometry show up first "not through her own eyes but through the other ones."

"She's fallen for me—that's all I needed!" Daberlohn tells Paulinka one day.

"That's just incredible."

Charlotte, caught between watching them have each other and wanting to have them both, decides to meet Daberlohn at a café. He says right off, "I assume you said nothing at home about meeting me?"

"No! Of course I didn't."

"Maybe you're not as shy as you seem, maybe you're a very dangerous girl! . . . *Are you actually in love with* me?"

The question comes at her like a high wind, almost pushing her face out of the frame, while his profile thrusts forward for an answer. In another minute she looks depleted. He has stripped her cover. Fortunately the narrator steps in. "Charlotte isn't sure just what she's feeling. Is it jealousy or something else growing inside her?"

If "jealousy," she's jealous of Paulinka for possessing Daberlohn, jealous the other way round, and jealous of counting second for either one. If there's "something else growing inside her," it holds her in their triangle: her rigid sideways glance has to face one way or the other. Bit by bit Charlotte rotates away from Paulinka and toward Daberlohn, toward deception. In one scene she ushers Paulinka and Albert out their door with one hand and him in with the other.

They talk, they kiss, he tells her, "You look more reasonable than your mama" (meaning more responsive to his moves). He tells her, "You're such a baby" (the baby had turned twenty-one): "Come give me your hand."

"Now I'm going to come upstairs with you," he says.

"Oh, no, you're not."

"You'll see."

"What do you want up there?"

"You've got a carpet up there with flowers all over it. I want to lie down and imagine it's a meadow."

He has his arms around her now. One color swatch, finally, encloses them both, and another tints the room to the edge. As she settles in his meadow, he asks, "Aren't you scared of me? I'm a strange man for you." What strange man, she must have thought, when they both loved the same woman and ideal?

Ich liebe dich, she says at last.

That makes him whisper in her astonished face that she looks "like Botticelli's Venus! What a forward step! I knew you were gifted"—gifted at being an erotic woman in a work of art. Then all her words

Charlotte and Daberlohn on a park bench in Berlin.

and his words and the narrator's vanish, to release their first embrace. She holds his face and stares at him with painter's eyes.

As the two of them start meeting secretly, sometimes they stand on nothing but pure color, lost to all surroundings. But mostly these are paintings about place, about trespassing everyplace: on Albert's carpet, at Paulinka's doorstep, in a Berlin café, on a park bench. If we pried those two lovers off the bench, we'd see a stenciled sign their backs concealed: FOR ARYANS ONLY.

And this, for Charlotte, was the allure: the dangers Daberlohn made her overcome. "To live life a man must be courageous!" he says—courageous enough to telephone Paulinka while Charlotte's in

his arms, to send daring ideas sluicing through her wide-open mind. Courageous enough to escape "the dreary hardness of daily life" by drifting in his little boat in a forbidden place, a lake called Wannsee, near Berlin.

There he has a "discovery." "Junior, as he has dubbed her, referring to his relationship with Paulinka" resembles Michelangelo's *Night*, and "that," he says, makes her "my new religion." Needless to say, a quick ascent into Renaissance sculpture stiffens her, but she too has a discovery. She can make two separate beings fuse. At Wannsee the borders around each figure dissolve, the outlines cross, the bodies blend into the bright gold beach until they have no volume, no force, and in Charlotte's case no separate will at all. With one of them pressed flat under the other's hips, the narrator feels a need to intervene: "Charlotte is lying there as if she never caused this fiery stream."

In a deleted text CS blames herself and the women in her family for a passive streak: "Charlotte does not move. He has never seen anything like it in his long years of practice. He feels something cold, deathlike, and he's surprised, intrigued." But CS's final version blames him more than herself. As "he tries hard to confer something of himself on her," the "flaming current" from his body turns her face away.

Much that was joyless came into these scenes of love. Daberlohn's eyes, bespectacled even at the beach, seem always ready to scrutinize Charlotte's work and face, to rearrange them into a theory of his own. But she loved, really loved, his mouth—the words pouring out like breath, the life and texture of his tongue, the bite of Berlin off his lip. CS kept pressing words against that mouth, somehow never close enough. Maybe she should have licked the paint onto his face.

Park bench stamped,
FOR ARYANS ONLY.

In a final image on the beach Daberlohn wraps Charlotte in a towel, and she is wholly held, the way children are if they are loved—and try to be at least one time again.

"See, child? That was charming! . . . So good-bye, my child. Let me remind you again of my birthday present!" And to himself: "Funny creature, this Junior."

"Between being alive and dying"

CS created Amadeus Daberlohn out of Alfred Wolfsohn, four years after she met him, at a time when her version could have distorted his traits. It takes other sources to know why he became Lotte's mentor and lover, and why his Orpheus myth obsessed them both.

Paula Salomon-Lindberg talked about Alfred Wolfsohn from the moment she started helping him with papers and money, and passing a student to him. When this student, Alice Croner, spoke of Wolfsohn fifty years later in her London living room, she was nearing ninety, as intrigued as ever with the man that she and Paula and Lotte knew in 1938 Berlin.

Each woman recalled her own Wolfsohn, but they all said this: He'd never had a boyhood, then lost his youth in the 1914–18 war.

Alfred Wolfsohn, age forty-one in 1937 (with his fiancée?).

From age ten, when his father died, he helped care for his two sisters; his two older stepbrothers had vanished and a third committed suicide. So in 1914, when he was drafted at age eighteen, he had nothing good to bring with him from home. The boy without a boyhood matriculated at St. Quentin, where the German Army deployed his age group like rations to be minced.

Wolfsohn wrote about his own descent to hell on the Western Front in a 1937–38 memoir called "Orpheus or the Way to a Mask":

> Barrage all around me. . . . From somewhere I hear a voice shouting: "Comrade! Comrade!" I close my eyes, shaking with terror, thinking: how can a human voice utter such a sound? A voice in extremis! Grenades whistle, a voice implores, I curse God. I hear His scornful laughter in an infinite space, the earth is ripped open, the sky a fiendish backdrop, realm between being alive, only just, and dying. What continues are the automatic movements of my body, that is all, and the unceasing question: Why? For what?

Through Wolfsohn's "Orpheus," World War I reached Lotte and then *Life? or Theater?* Several unnumbered scenes (those edited out of the work) show Charlotte staying up all night to turn its pages, till crowds start off to work, and only then she yawns, stretches, puts it down, and lets her room fill with a goddesslike figure of Night. Reading his war memoir, she enters its images, sometimes even covering her ears against the barrage, as if she'd been stationed at the front three years before her birth. Helmeted men encircle her, one of them saving himself by clutching the back of her chair.

What Wolfsohn learned in that war—how to survive senselessness—CS reported in the next, for his memoir touched the darkness in her own mind. "War neurosis" had struck him after the defeat: He lost his memory to block out cries of a comrade he hadn't risked himself to save. Shaking with seizures, he was sent for psychiatric care. But no psychiatrist was able to excise four years' torture in the trenches—that much his "Orpheus" made clear. "The doctor—either in heaven or in the center of our being—who wants to cure me must first cure the whole world." So amid extreme suffering and with no help, "I began to study myself."

This study had to involve Wolfsohn's voice, for he'd lost the power to sing until his mind could hear his comrades' screams again.

Then he began to treat himself, and eventually others, for damaged vocal (that is, mental) apparatus. One student he treated was Alice Croner, who had tried to study voice with Paula Salomon-Lindberg. At the Salomons' flat in 1937 Alice had seen Lotte looking "fragile and delicate, very slim and pale and aristocratic"—a look she recognized, having known Lotte's mother Fränze at about the same age. Now, under Wolfsohn's teaching, Alice faced a startling task: "Do you remember your dreams? Write them down. I'd like to see if the development of your dreams parallels the development of your voice." She did as told, convinced by him that her gift could be to narrate dreams. "He sensed in each person," she recalled fifty years later, "possibilities they never knew about themselves."

But the Wolfsohn that Paula Salomon-Lindberg saw in 1937 (through eyes accustomed to Kurt Singer's accomplishments) had few of these features at all. After half a century she spoke of Wolfsohn like this:

"He was a really gifted man but a dangerous dilettante. He missed his education in the war, he lost his memory, even his name, for a year. His method of singing did damage, because he made conclusions about other voices from his own. But with the young ladies he was an angel."

A dangerous dilettante but an angel?

"Yes, he had influence because in those times none of the young people had enough from their parents, not Lotte either. Parents had no time and too much *angst*."

So you trusted him with Lotte?

"I was happy she was interested in him. When Lotte came home five minutes late from the academy, we went out to look for her. Here was a man who did not say every day: Where is this person or that person? He had time. The young people had nothing in life, nothing. They couldn't go to the theater or concerts. Friends could not come. He had the courage to go on the streets."

To visit you.

"I was always telling him to go away, but Lotte said no, I couldn't do that. I always quarreled with him, always."

About?

"About his telling me to dig deep under the earth in order to sing. About Orpheus, which I said involved humanity and he said dealt

with love. I thought I'd done all I could for him, passing him a pupil, telling fairy tales about his teaching so Kurt Singer could get him Kulturbund work papers. But he wanted more. He told me I must go alone in the world, perhaps preach to people with my singing. Nonsense."

Your singing never changed with his influence?

"Ha! He had no idea of my singing. He had no idea of my family. He was a dreamer, a fantasy man. He said I should not go help a poor man or woman all the time. I said, 'Who will do it? You will do it? No? So!'"

Then why did Lotte see him as her ideal?

"My dear, she was a child. He was the first man who came into her life and paid attention to her. She was never with young students, he was much older, and she was a fan of his, an enthusiast. Lotte was with him alone perhaps three times."

Three times. In your house?

"In my house or in a café."

You think the paintings are a fantasy.

"Dreaming. She is dreaming."

"The Orpheus path"

Was it a dream, then, or was it a fact that Wolfsohn and Lotte became lovers? Paula spoke of Lotte's scenes as flights of fancy. "Lotte calls it *Life? or Theater?*—that is very important. In her mind, two times two is five, or sometimes six! When you do something creative, then your spirit at the moment, the condition of your soul, gets mingled with the memories. With Daberlohn she painted what she wanted it to be." On the other hand, Wolfsohn did get involved sexually with protégées—at that time with Alice Croner—and CS did reveal other secrets, so why not her own erotic quickening?

Enough love scenes came out of her that she deleted some: Charlotte putting her arms around Daberlohn while he points upstairs to her stepmother; visiting his room where a bed dominates the space; sitting on his lap at the beach, looking like a child except that her suit's pulled down; embracing him naked in the water and swimming over on top of him. All very anatomical, but dreamy too, with grayed-down colors, and what's a cupid-like heart doing next to

them? These fanciful scenes were the ones CS left out in favor of the sexually realer ones.

Lotte's vital discovery of her desires was simply denied ("she is dreaming") by a family fearful of her nature. In contrast Wolfsohn's "Orpheus" threw open the cellar doors of the psyche and unashamedly rooted around. Lotte could hardly get enough of it. When she read straight through Wolfsohn's manuscript, beginning with "Dear Reader, If you are indeed there, I will gratefully tell you a secret: this book is exclusively about myself!" she was holding in her hands the license for *Life? or Theater?* When she read, "I see myself as a little boy in the music room . . . I see myself at the seaside . . . I see myself during the last year of the war . . . I see myself in the consulting room of a psychoanalyst . . . I see myself in a singing lesson," she was learning to recall a life by visual scenes. What gave her courage (a few years later) to retrace her mother's death, not to step back from it, was the hubris of Wolfsohn's Orpheus in the underworld. Orpheus had to enter the realm of death as a way of "searching for his soul," which Wolfsohn called Eurydice. His courage moved Lotte so powerfully that a few years later she made the opera *Orfeo* a key musical motif and took its mythic journey as her course. Any danger, any loss, could be transformed by traveling straight on toward it.

This was the "Orpheus path" Wolfsohn urged on her and on "Professor Y., a well-known physician" in his manuscript: "Before starting a day's work, you would sit for some time before your carpets and paintings, quietly absorbed in contemplation . . . [and] struggling with the forces of life and death." "Dr. Y." exactly matches Albert Salomon—who, however, did "not agree with" Wolfsohn's view of Orpheus. But how could he? Albert Salomon had suffered the real death of a wife, not the loss of his soul. He was physician to a crushed community, not a man after his own salvation.

The Orpheus path seemed a strange obsession to Albert and Paula Salomon, who valued the path of Kurt Singer toward artistic leadership. Lotte absorbed some of Paula's attitude, letting Daberlohn look all too self-important, but finally *Life? or Theater?* devoted most of its space to his ideas. Lotte could not reach Paula's classical standards—not under Paula's eyes and not under Nazi rules. Wolfsohn, on the other hand, promised a shy young woman that she could act like Orpheus. This would mean crossing borders, traversing high notes to

low, the way Paula sang Orfeo. His manuscript explained: "The story of Orpheus and Eurydice could be seen as a classical example of Jung's theory of the anima. . . . That which does not develop in one-self, i.e. the female elements in a man and the male elements in a woman—one recognizes and seeks in the other." Maybe this sort of androgyny promised space to grow in the constraints of Nazi Berlin. In any case Lotte did not seem troubled that it offered a man self-completion through a woman—a Eurydice, a Madonna—while it left women without a means to gain the power of men. Wolfsohn wrote, "How was it possible to discuss the woman's rights question with such heat [rather than] the question of Mankind's rights?" and he spoke with dread of "the struggle between men and women, the sex battle." By the time his male-female version of the Orpheus myth enthralled Lotte, the "sex battle" was lost for women, and all that was left of feminism, so vibrant a decade before, looked worn out. Brigades of German feminists had silently accommodated Nazism, while Jewish feminists focused every spark on welfare for the Jews. Where no hope of equality by sex or race found voice in German society anymore, spiritual androgyny was the best a woman could expect.

Yet it stalled CS's progress toward knowing herself. It detoured her vision through Wolfsohn's eyes. When a painter was a woman, she was not just a searcher but the object of another's search. This painter slipped from Orpheus to Eurydice every time she let her mentor speak, excessively, for her. She painted 1,387 portraits of his speaking face. She took so seriously every insight he could remember having had that years later she could repeat his "Orpheus," thought for thought, in 75 separate scenes. Deep in the center of *Life? or The-ater?* pieces of his manuscript were written out like excerpts of a sermon. Inadvertently they show not only his ideas but the very form and feel of her attachment to them.

Long after meeting him, still trying to be what he wanted and say what he meant, CS let her scenes about obsession grow obsessional themselves. At their best some of the 467 Daberlohn scenes keep irony running alongside gratitude. But often they stop to defend Daberlohn, maybe against Paulinka, and they come out static, didactic, and devoid of CS's voice.

The voice of Wolfsohn that filled her memory ranged through opera, film, art, Jung, dreams. His leaps of mind demanded a preter-

"A man stands near the sea, encircled by young people. He speaks and they listen": Lotte called her 1938 etching of Wolfsohn "The Prophet."

naturally patient listener. That was Lotte. She always listened, making herself impassive. Years later Wolfsohn reflected that it was "the wall she erected" that made him "go on speaking, letting my words unwind endlessly and sharing every deep perception of my own experience, while all I wished to do was help a little. Somewhat embarrassing, isn't it?"

Though he tried to help Lotte, his power to judge added to Paula's. His concurrent passion for both of them left her confused. His interest made her hopeful yet dependent—which came out in a 1938 etching of a prophet. *Life? or Theater?* ascribed it to Charlotte's

"deep subconscious" obsession with Daberlohn: "A man stands near the sea, encircled by young people. He speaks and they listen." But he looms too large, and his disciples lean inward as if their breath relied on him. Wolfsohn later wrote, "I saw one drawing of hers which touched me to the heart." It was an exposé of himself, he was sure, but then decided Kurt Singer must be the prophet she'd had in mind. The etching "still isn't right," thinks Charlotte in the scenes, but the original (of which a photo remains) *is* just right, a perfectly ambivalent view of power.

"To make his prophecy come true"

In *Life? or Theater?* the disciple with faith in the prophet lets him be her judge. Charlotte bends over a letter from Daberlohn (sent to her in Italy, where she is meeting her grandparents again), literally holding her fate between her hands. He writes: "In my judgment you are bound to create something above average" (*über den Durchschnitt*). That's enough to elate her, and she begins painting the meadow where she reads his words, deciding suddenly "to make his prophecy come true." In a lovely self-portrait she settles into the posture that becomes her signature—legs folded on the ground, back turned so the focus goes to the sketch. The judgment shimmers on the horizon: "ABOVE AVERAGE." Up till now she has seen herself as a student. In this moment she decides to be an artist.

But the transformation—which becomes the Main Part's theme—takes a tricky course. She almost loses her newfound self when she shows Daberlohn more of her work. He absorbs her paintings till "he himself almost becomes a tender young girl," seeing youth as her signal strength (which she then cannot give up). His hands rest casually beside one painting, drape over another, and take possession of a third. Hers cross, hide, recross, clutch her elbows, a painter's strong hands barely holding her parts in place. Nothing breaks his judicial sway—until of course this painting's late critique of it. Charlotte decides to prove her skill by creating illustrations for his birthday and finds that if she keeps her eyes closed, head and body blank, then her impulses pass directly to her images. In awe of him and in spite of him, she gradually arrives where anything she tries to paint she paints.

What a shock then, when she stands eagerly before him with the birthday paintings tucked under her arm and hears him say, "I'll just take a look later," too busy to open a gift six months in the making. Suddenly her "grief mixed with rage" blurs his words and drives her to a window, where she starts throwing coins to the ground. "As a matter of fact, I'd just like to throw myself out too." For a moment she comes

Daberlohn looks at "Death and the Maiden," while Charlotte protects herself: "I have no idea what you see in this but if you want I'll lend it to you."

into the abject state that brought her mother to that window eleven years before, but then Charlotte hurls down a jeer, because "this guy's not worth it." And besides, she's dying to "find out how he liked the illustrations." These words encase her, keep her straight.

Because for Daberlohn "art can come about only through touching," his aspiring friend is seized with a need to touch him then and there. But he is out with her parents, toasting "our young artists of the future." Charlotte waits, tormented by an urgency that everyone impassioned knows: to "talk to him, even if I have to stay out all night on the street." Neither of them should be out all night in Nazi Berlin, yet at last they are together at a café, discussing her paintings and his Orpheus, the two of them illuminated in burning outlines. And he is saying what she waited for: "You know, my child, some of your drawings are really excellent."

That an unnoticed art student now believes herself an artist is a stunning transformation she ascribes to Daberlohn. He's the one whose "hopes rest on the character of future young women who are willing to follow the way of Christ, the Orpheus way, to their inner selves." His claims of genius, his assumption of suffering, his aesthetic plea for sexual desire, his self-announced status as judge of art and soul, his reduction of reality to his own views, his insistence on saving everyone, his encouragement of deceit—all this, far from repelling Charlotte, precisely *appeals* to her. Now that Nazi rules keep her in bounds, it is her need to transform herself by mind alone that makes his trick of mythmaking look true.

"Someday people will be looking at the two of us"

Lotte's obsession with Orpheus gave her somewhere else to focus while German Jews had all necessities stripped away—livelihoods, legal rights, elementary safety in the streets (though not yet life and limb). She endured the pain of 1938 Berlin by reentering with Wolfsohn the demonic depths of 1914, bearing in mind that Orpheus finally comes back to the light. No matter if Wolfsohn foresaw disaster, he'd *known* disaster and cured himself. That boded well. That was his promise.

He said he could see mankind's fate, and she believed him a visionary. Claiming as ancestor a wonder-rabbi of Odessa, he felt the

future in his hands: they'd stroked wounded soldiers in the trenches and afterward eased joint pains that doctors could not touch. Since his father was a carpenter, Wolfsohn called himself "the other carpenter's son." When Good Friday came he always felt downcast and once at Easter saw stigmata on his palms. He named a manuscript "Christ 1938," because (as one friend of his put it) "the concept of crucifixion is strong in the human psyche, and 1938 was a crucifying year." To update the image, CS renamed it "Christ 1940" and let Daberlohn align with Christ as well as Orpheus. Though her early etching of "The Prophet" took issue with his power, she always portrayed him as a universal seer.

In actuality a forecast by Wolfsohn could make each person's hopes take hold. He predicted Alice Croner would grow "lively and jolly when over eighty," which she did, "an old woman whose advice and understanding people will seek." Lotte Salomon would rise "above average." He knew she would, the moment he saw a picture called "Death and the Maiden," which she painted in 1937–38. Its title came from a Schubert song Lotte loved hearing Paula sing, while picking out the piano part herself. It needed a female-male voice, like Gluck's Orfeo, to cross from the Maiden's lightness to deep Death. Of Lotte's picture "Death and the Maiden" Wolfsohn later wrote: "From the deeply moving expression of the girl I feel that the death's-head holds none of the usual horror for her. . . . Maybe this is the reason why the expression of Death betrays so much softness, tenderness, almost defeat. To me he appears hypnotised as he bends down to the proud, upright girl before him." This picture came to play a crucial part in *Life? or Theater?* Daberlohn pores over it, asks to borrow it, and says of the two figures, "That's the two of us." Many scenes later, toward the end of the work, Charlotte's eye happens to fall on "one of her old drawings of Death and the Maiden. And all at once she knew two things: first that Daberlohn's look seemed to be saying, Death and the Maiden—that's the two of us; and second, that she loved him now as much as always. And if he was Death, then everything would come out right." If he dared become the tender Death of her picture, well, then, *she* could become the bold Orpheus of his myth.

Profile to profile, fingers against fingers, Charlotte and Daberlohn stretch his most compelling forecast between them: "Someday people will be looking at the two of us." By this time it is past mid-

night and past 1937 and they are unwanted in their city. Yet: "Some-day people will be looking at the two of us." Only the little "CS" over Charlotte's head and the little page number perched over their hands call to mind that *she* was the one who bothered to record this prophecy, absurd as it seemed for two Jews in 1938 Berlin, and make it true.

Her mentor, her double, her lover, her seer, born into loss and dread, knew the need for a journey down to one's unlit core. Without him Lotte Salomon would surely have been a painter, but not of *Life?* *or Theater?*

TENACITY

(1938)

⁓

At the start of 1938 twenty-year-old Lotte Salomon was secretly meeting Alfred Wolfsohn in cafés and painting at the Art Academy for her second year; Paula Salomon-Lindberg was making music with Kurt Singer; Albert Salomon was performing surgery in the Jewish Hospital—a whole Jewish family still at work in Germany five years after Hitler came to power.

Also at work in Germany in those years were two committed Nazis who had moved from Austria: Adolf Eichmann and Alois Brunner. They met each other in a guerrilla training camp near Munich. At age twenty-six in 1938, Brunner aligned himself with men who called for the expulsion of Jewish families like the Salomons. But no one yet knew how far such men would go, so the Salomons were standing fast in Germany.

If hindsight allows a judgment against Jews who stayed after Hitler came to power, it takes CS to show why they fastened to a setting like Berlin. As her paintings progress, the city sucks the figures in, the free-floating characters all stick together, and we watch one family and its friends fight against being forced away.

"Here—Heil Hitler—I feel so right"

The need for a place where she can paint holds Charlotte at the Berlin Art Academy. The scenes show how carefully she sketches live

"I am Barbara, loved by all," says Charlotte's academy friend.

models, works on calligraphy, practices geometry, and tries to fit in without calling notice to herself. ("Modest and reserved" was the phrase Professor Bartning had used to admit "the full Jew" Fräulein Salomon.)

One of CS's portraits shows a professor with Ludwig Bartning's recognizable face preaching to his students: "A priceless legacy is our German fairy tale"—an innocent yet *volkisch* point. One of them responds, "Here—Heil Hitler—I feel so right." In scenes of the academy the artist's lens slides into rooms as if invisible, and plants itself so close to the students that they're cropped by the frame. This

is not the vantage point of a fellow artist welcomed by others at work. Its interest feels illicit, peeking up their pencils at them. And what are they like, this cohort of Aryan artists-to-be? They look splendid and self-endowed, while Charlotte keeps herself undefined—not Aryan, not non-Aryan, and barely female at all.

To feel part of the academy, Charlotte attaches herself to a student named Barbara. One overlay script after another says her name: "Barbara! Such a beauty our Barbara is!" "I am Barbara, loved by all." What appeals so much in CS's portraits of Barbara (besides long-necked Modigliani charm) is a look of secret knowledge shared by artist and subject. A tiny label gives a hint of this: *"Nur ein Kuss,"* Barbara confides, "only one kiss and they stuck me in a convent." Charlotte repeats each word in small-print whispers, "Only one kiss, and they stuck you—" then keeps mum about her own affair. As they walk home together "in silent conversation," Berlin suddenly stretches out as if it might belong to them. Through Barbara, Charlotte holds onto what's no longer hers.

Fifty years later, Barbara Frisch Petzel, still long-necked and romantic, recalled their walks, their one-way talks, and Lotte Salomon's matchless gift for drawing any face while keeping *her* face blank: "She was not the kind of person you could ask: Well, Lotte, we are always talking about ourselves here; why don't you tell us something for a change? She just went off to the Zoo Station, though she didn't live there, walking like a gloomy November day . . . always wore gray clothes too. We all knew she was Jewish, but we didn't use her last name. We just called her Lotte. Lottchen most of the time." Decades after the thirties Barbara found it odd and sad that Lotte wore gray and never told her closest friend where she lived or whom she met with near the Zoo Station (no doubt Alfred Wolfsohn, in one of their cafés). But plainly Lotte no longer even owned her name.

When Barbara and Lotte illustrated fairy tales in Professor Bartning's class, Lotte's came out free-flowing and mystical, a bit expressionist. Barbara, for her part, decided to sketch charming incidents from her youth, some twenty illustrations in watercolor and pen-and-ink. "Lotte was so moved by my childhood pictures, made on our shared drawing table" that she stored their technique of sequenced scenes narrated on the backs—but she forgot about the charm.

It must have seemed pointless to keep painting the way she was

taught, long after she had lost access to the art school. Her exclusion started with a competition that stayed in Barbara's mind:

> One day Bartning said: now you all draw a picture to exhibit—it should be a still life. Our products were hung, the door was closed, and the professors began the selection. There were no names on the pictures, and I guess they chose Lotte's. But when the name became known, they told her casually that I had received the prize. I believe they didn't award Lotte because if her name appeared in the press, a lot of things would have come out. Bartning was deeply concerned . . . but the students said: "Well, well, so you have a little Jewess in your class, and she should have received the award—and now you got it instead." That was a kind of reproach to me. But it wasn't my fault!

After the prize incident Lotte was barred from mixing with other students. ("Since they forbid her to work there during the day, she works at night," one of CS's captions says.) Finally, by the summer term of 1938—that is, after Hitler's Degenerate Art Show passed through Berlin—her academy studies came to a stop.

"Appalling visual defects"

"Degenerate Art" (*Entartete Kunst*) was a huge Nazi exhibit that displayed 650 confiscated works of modern art, to teach contempt for the shapes and colors of the great expressionists. Lotte's friend Barbara managed to attend the famous exhibition during spring 1938 when it arrived in Berlin: "I certainly assume Lotte saw it too."

With three million spectators crowding in, it had the highest turnout of any modern art show in history. What drew twenty thousand each day was the way the Nazis treated the artworks—labeling their cost in inflated currency, placing them next to asylum artifacts, and tagging them with prickling images of sex. A "syphilis of [Jewish] intellectualism" infects modern art, producing "bastardizations in Berlin-gone-Syrian," wrote Nazi ideologue Alfred Rosenberg. Nazis claimed that "modern German art is Jews, nothing but Jews," even though 95 percent of the "degenerate artists" in the show were nothing but Aryans.

Entartung, "biological degeneration"—the word that scared Lotte's family into secrecy about suicide—now guided state policy toward

art. As the machinery of confiscation rolled through museums, about sixteen thousand works disappeared from view, with five thousand burned in Berlin like effigies of those who made them. Hitler's stated aim was to purge the academies and to "forestall any further *hereditary transmission* of such appalling visual defects" by means of a "merciless war of destruction against the last remaining elements of cultural disintegration . . . [who] will be picked up and *liquidated*" [italics added]. This savage solution for "visual defects" made art the testing ground for genocidal violence by the state.

To object was deeply dangerous. The president of the honorific Prussian Academy of the Arts resigned in 1933, stating that "neither politics nor racial descent has anything to do with art." When this famous painter, Max Liebermann (the pride of Grossmama's kin, and German as German Jewish could be), died in 1935, only a handful of artists dared attend his funeral, among them his dauntless friend Paula Salomon-Lindberg, who sang at his grave. In a regime where 10,500 "Aryan" painters had to join the Reich Chamber of Visual Arts in order to find work, the Art Academy trained students to obey and be afraid.

All the genres taught to Lotte there—illustration, landscape, figures, still life, portraiture—were meant to imprint an antimodern stamp. One glance at Nazi-favored paintings shows the hardness of Aryan man before woman's lures (a favored subject was "Mars and Venus") and the duty of Aryan woman to hatch offspring into the world. In two years at the academy, Lotte learned she could never meet its terms. The wonder is that she taught herself new ways to paint, for her scenes defy all the academy lessons in proportion and respect. They inflate some figures and unbalance others, they take liberties with color and cropping, they show a thirstiness for caricature and non-*volkisch* folk art. *Life? or Theater?* paraded its affinity with every style the Nazis were working to suppress.

For her great innovative work, 1936 through 1938 were Lotte's absorbent years. "We had no access to modern painters" at the academy, Barbara recalled, "but we had a beautiful library which I used a lot." Surely Lotte visited the academy library too, and the modern art wing of Berlin's Nationalgalerie, which featured Vincent van Gogh (the one painter CS named in her notes), Amedeo Modigliani (CS's portraits of Barbara resembled his women), and

Otto Dix (whose caricatures seemed to interest her). The Nationalgalerie placed in her sightline the surprising colors, flat planes, and heavy outlines of Max Beckmann, Ernst Ludwig Kirchner, and Henri Matisse, as well as the earthy folk-art profusion of Max Pechstein, who taught in Berlin till he was fired in 1933. Before the modern wing closed in October 1936, Lotte could have surveyed all these painters, then five years later convened elements of their work in hers.

Even when the academy no longer let her in, Lotte studied "the many art books we had at home," Paula Salomon-Lindberg remembered, "because my husband was very interested." Albert may have shown Lotte the flushed tones and floating figures of Marc Chagall, so suited to Franziska in the early scenes. And maybe the translucent paper covering the plates in those old art books gave her an idea for the overlays.

Above all, Paula emphatically recalled "our exhibits in the Jewish community" under the Jüdischer Kulturbund, the Jewish Cultural Association headed by Kurt Singer. His long-held love for Paula (portrayed with such sympathy in *Life? or Theater?*) had an unforeseen effect: it placed Lotte Salomon's household at a new nerve center of the arts.

"Jewish Art Just for Jews"

Kurt Singer, who'd directed the City Opera before 1933, not only took care to mount fine productions now, but as a psychiatrist, he believed the arts would help Jews "wake up from our depression and isolation." Under his charge seventy thousand Jews joined thirty-six Kulturbund branches in forty-nine locales, with twenty thousand members and a spacious theater in Berlin alone. By 1938 seventeen hundred employees around the country were staging up to fifty events each week, with fantastically ambitious repertoires. Nineteen different operas got produced—"virtually everything except Wagner," Kurt Singer said.

In this "cultural island of relief from the pressure and misery of life" (as Kulturbund leaders called it), Alfred Wolfsohn's teaching and Paula Salomon-Lindberg's singing went on in spite of all. A flyer of May 1934, miraculously preserved, shows Paula cast in the role of "an Israelite" in Handel's opera *Judas Maccabaeus*, sponsored by the Kultur-

Dr. Singsang: "I'll write down [Kulturbund] regulations and take them right to the Ministry."

bund and offered practically free. It was conducted by Kurt Singer with his Kurt Singer Chorus, his Berlin Doctors' Chorus, his Jewish Chorus, his Kulturbund Orchestra and Opera Chorus: the range gives some idea what he kept going in Berlin. In the Kulturbund's brave playbills, Jewish merchants took out so many ads that they reversed the Nazi slogan "Never buy from Jews." Members got tallied, sponsors named, productions announced. Just as the anti-Semites feared, Jews formed a communal bond that braced them up again.

Kurt Singer was clever enough to keep the Nazis squared by tour-
ing the government till he found Hans Hinkel, a fanatical SS segrega-
tionist in the Propaganda Ministry, who expanded the Kulturbund as
a way to increase his own command. Hinkel began proclaiming
proudly, "Jewish Art Just for Jews"—which meant for Singer the
embrace of Jewish art by Jews, and meant for Hinkel the quarantine
of German art from Jews. Any Aryan word in a script or libretto had
to be removed ("blond"), and any title in which the word "German"
sat too close to "Jew" had to be changed ("Cultural Association for
German Jews" to "Jewish Cultural Association"). Any Aryan music
with a Judaic phrase eventually had to be renamed (*Judas Maccabaeus*
to *Der Feldherr*, "the General"). "We were no longer allowed to perform
anything 'German,'" Paula recalled, "but we got around that some-
times by choosing Schubert or Schumann songs with texts from 'non-
Aryan' poets like Heinrich Heine or from the Old Testament. We
could sing English, French, or Italian composers," or Gluck's *Orfeo ed
Euridice*, a non-Aryan theme in a non-Germanic tongue. Even Mozart
squeezed by as an Austrian till Austria's annexation in 1938 turned
him into a *verboten* "German" too. By censoring every lyric Paula
Salomon-Lindberg sang, by keeping Jewish mouths from ravishing
German words, the Nazis warned that the quarantine was not just
cultural, as Jews imagined, but biological.

Kurt Singer as Kulturbund
conductor with Paula
Salomon-Lindberg as
soloist (below his stand).

To put up with such humiliation, Kulturbund activists like Kurt Singer and Paula Salomon-Lindberg made the most of "Jewish Art Just for Jews," reviving non-German works Singer thought would provide "enough material for ten years." "My father, so imbued by German culture," his daughter recalled, "introduced Yiddish art in the Kulturbund." Paula Salomon-Lindberg recorded lovely Yiddish songs (which CS quoted from) and applauded when "Kurt Singer brought a Russian theater to do Yiddish plays. Lotte was very excited." While the Nazis spilled out spurious answers to the question What is Jewish about Jewish art? the Kulturbund took the issue to heart. Kurt Singer seemed almost elated as Nazi strictures showed him something new: "Who knows, one day we might succeed in playing a one-act piece by Bialik, first in German and afterwards in Hebrew, and reach out to the sources of literary creation—the language. . . . A road of a hundred years lies before us; it ends where all Jewish culture must begin: in Eretz Israel." Against all odds he pulled together Germany's Jews and held his own with the SS. Jewish press around the country reported his words; full-page ads celebrated his fiftieth birthday in October 1935; brochures featured that intense and masterful face. In 1938 Paula wrote a poem by hand in his honor which was slipped between Kulturbund programs and found fifty years later during research for this book. Her poem praises his "hard concerts" that "livened the world," and rises to this:

> *Chorus of Kurt Singer,*
> *You beauty-bringer*
> *Keeping us free,*
> *Work ever onward,*
> *Fortune fare forward,*
> *High Jubilee.*

It *was* fantastic, between Jewish assimilation and Nazi persecution, to invent a Jewish national art. But "enough material for ten years"? "A road of a hundred years lies before us"? Singer was carried away by the force of his own success.

Yet his charisma troubled Lotte because she knew its effects ("Such a crush she had on Kurt Singer," said Paula). Later she managed to record the self-importance that slanted Singer's foresight, saying "Dr. Singsang . . . has meantime been promoted in his circle to a god."

"Everyone in illegal work has to live three lives"

Under Nazi eyes Kulturbund leaders ran the dangerous game of complying and resisting at the same time. Openly they provided welfare to artists, with Paula Salomon-Lindberg in effect resuming her father's rabbinical rounds. "I helped someone morning and evening my whole life. We needed to get clothes for people, and there were cases like Daberlohn [Paula always called him by CS's fictional name] where they had no certificate. We had a house where musicians could eat, and I gave out food." But covertly Paula was helping musicians and pretend-musicians to emigrate, placing violins and clarinets in hands that never held them before, gathering funds and permits for the Palestine Philharmonic. This was a Kulturbund performance Herr Hinkel was not allowed to see. But neither was Lotte. "We could not tell Lotte—we tried to spare all the young people. Everyone doing illegal work had to live three lives."

CS's unnumbered paintings—those edited out of *Life? or Theater?*—ruefully scatter Paulinka about the streets on endless errands her daughter did not understand. Faulting Paulinka's performances now for putting the audience to sleep, one nasty caption takes her to task and Dr. Singsang too:

> She's got an exalted opinion of herself, shared by everyone else (except Charlotte, who's beginning to suffer under her regime). . . . Though she never neglects a housewife's duties to her husband and child, or her lady-bountiful activities, she is rushed to pieces; her splendid voice no longer possesses the warm, expressive tone it used to have . . . (regrettably noticed by no one, for Dr. Singsang, who in his circle was meanwhile promoted to a god, had as many obligations as she did).

Lotte simply failed to imagine how deeply Paula was disrupted by expulsion from the German musical world, how draining it was to sing censored music for cordoned audiences, how confounding to stay true to herself but still tolerable to Nazis—and never to let any of this affect her very breath, the height and depth of her contralto voice.

All Paula could do was hold on, while the SS proved that segregation worked. But once the Nazis had taken credit for the Kulturbund,

they ditched the whole experiment. In spite of the Jews' tenacity, very little of the Kulturbund lasted after 1938—unless we count one late-born product: *Life? or Theater?*

The Kulturbund had given Lotte access to the only art and music a Jew could take at ease. "She came with me to the Kulturbund opera," Paula recalled, and "especially loved *Der Freischütz* because she heard me work with pupils on it. *Orfeo* too I performed in the Jewish opera." Kulturbund programs invested Lotte with musical themes that she could hear no other way in the Nazi years: *Der Freischütz* (Franziska's motif), *Eine Kleine Nachtmusik* (Dr. Singsang's), *Carmen* (Daberlohn's), *Orfeo ed Euridice* (Paulinka's). Kulturbund operas enveloped the audience in sight and sound, transported it into an alternate world—which CS wanted for everyone stepping into *Life? or Theater?* The way Kulturbund audiences fixed their eyes on the stage gave her hope that someone might gratefully receive the work of a Jew. Above all, the Kulturbund taught her to use art as a source of morale, a proof of viability, a means of self-expression where no other is allowed.

"As long as we are needed, we can't leave"

What urged the Nazis forward was a fantasy that one day they would have their Reich swept clean of Jews. Each phase of that escapist plot bore down on the Salomons: In 1933 they were fired from their jobs; then squeezed into segregated space in 1934—Albert in the Jewish hospital, Paula in the Kulturbund, Lotte in the Fashion Design School; then excluded from citizenship and public work in 1935; then barred from institutions like the academy in 1938. Most of Lotte's "non-Aryan" schoolmates had left Germany by that point. Hilde Littauer headed for Switzerland and Hilde Goldmann too, though she returned in 1938 for her mother, who thought, "What would they want with an old lady?" and was picked up by the Gestapo anyway. Marianne Schlesinger settled in Geneva, but her father, returning to help her brother, was deported to a ghetto where he died.

By 1938 it was almost too late to leave. Everywhere immigration tightened. The United States refused to fill its quota of 25,000 Germans a year, the British limited Jewish entry to Palestine, the Evian

Conference set up an Intergovernmental Committee on Refugees but failed to open any country's doors. The Third Reich (which included Austria by spring of 1938) insisted on despoiling anyone still able to leave.

In August 1938 the Reich's first Office of Jewish Emigration opened in Vienna, with Adolf Eichmann in charge; he called in a younger colleague he knew from Munich, Alois Brunner. These two obscure men helped to shape a complex "emigration" policy of forcing most Jews out while shutting some Jews in. Their superiors even made plans to catch one group of Jews—the doctors—in a draft. Paula knew "the Nazis would not let surgeons leave, because if war came, they might need surgeons." Other professionals got out early, but physicians like Albert Salomon slipped from state posts to Jewish ones, where two out of three stayed on. Paula remembered how "everybody thought, let's get the young people out as fast as possible—we others are sure to survive. My husband made certain his assistants, the young nurses, got out. By 1938 it was too late for us. We had already lost our passports." Suddenly the Salomons were bottled up in a country that had done all it could to force Jews out.

The question is not why they had trouble emigrating in 1938. Everyone had trouble. But why hadn't they left earlier? In Paula's words, "The people who only lived among themselves, the Orthodox, they left earlier, for they had no connections. But we who never asked—are you Protestant, Catholic, Jewish, or what are you?—it was much harder for us, we were much more stupid!" German Jews stayed because they couldn't imagine Hitler would last, or couldn't afford to go, or couldn't find sponsors abroad, or couldn't give up what they had, or couldn't get papers for anywhere.

But another motivation, less acknowledged, comes to the surface in this family's tale. In Paula's words, "My husband is a surgeon in the Jewish hospital, and I have my work with the Kulturbund. As long as we are needed here, we can't leave, we said." Albert stayed to care for Jewish patients, Paula to perform and help others emigrate, Wolfsohn to support his frail blind mother and his sister—all stayed as long as they were needed, along with an astonishing three-quarters of Germany's Jews.

After the first surge of emigrants in 1933 and 1934, when Lotte's grandparents headed right to Rome, the number from Berlin dropped

Grossmama in 1933: "Not a minute longer will I stay here. I'm
telling you let's leave this country as fast as we can; my judgment
says so." Her husband almost loses his head.

to about 7,500 each year. There Jews still moved about unrecognized;
there Lotte and Wolfsohn still met in cafés, and Paula still gave con-
certs. No emergency calls were issued by the mainstream Jewish
groups, for mass flight would strand those left behind and teach other
states to eject their Jews. Perhaps it would take twenty years to com-
plete the exodus. In defending German Jews on German soil, groups
like the Kulturbund rejected the official plot—a *judenrein*, a Jew-free
Germany.

But from the moment Hitler came to power, the women in many

Jewish families started pushing to leave. In CS's story Grossmama nags her husband in 1933: "Not a minute longer will I stay here. . . . Let's leave this country as fast as we can." In another Berlin Jewish family, a girl of Lotte's age (who also sat through "Race Hygiene" classes where Jewish children had to show their noses—"we were the living examples"—and also refused to go back to school) recalled: "My mother wanted to leave Germany in 1933, but my father didn't want to leave his livelihood, his apartment." Women had fewer careers to save, no trench-comrades to call on, they saw less to stay for, and helped train others for jobs abroad, particularly in Palestine. If they had run the major Jewish agencies (but typically, forty-four of forty-seven Kulturbund national officers were men), maybe they would have called for urgent evacuation. Maybe Paula Salomon would have told Kurt Singer to send girls out as soon as boys, to send Lotte along with his daughter to Switzerland and from there to Palestine, where she might learn graphic design and find a job in Tel Aviv.

Lotte was not sent to Palestine in the early Nazi years or even in 1938 like Kurt Singer's daughter. She wanted to stay with the people she loved and gave no sign she would thrive alone. Then all at once, on November 9, 1938, the Salomons lost the chance to hold on to each other or Berlin.

"The German people will have their revenge"

Cowardly devious Jewish murder abroad. Jew Grünspan steals into the German Consulate and shoots German diplomat. . . . The German people will have their revenge. German men and women: our patience with the Jewish criminal world power is now at an end.

Packs of faceless heads cheer this vile bulletin from the Nazi paper *Der Angriff*, iron arms thrust salutes toward a backward swastika, wild hands smash glass or strangle Jews, and in the foreground of this ferocious wide-angle scene, storm troopers kick victims forward with their goose-step. That the state set up this "spontaneous" outburst on November 9th 1938 was never lost on Lotte Salomon.

This was *Kristallnacht*, terrifying to witness even from the angle of an upper window. The fiercest pogrom since medieval days broke out when a German diplomat was killed in Paris by a youth whose par-

ents were among eighteen thousand Polish Jews deported from Germany to stables and pigsties on the Polish border. The Germans took "revenge" for this one death by smashing thousands of shops (hence the Nazi term *Kristallnacht*, "night of glass"), then torching more than 200 synagogues, some of them where Paula and the Kulturbund performed. On the streets Jews begged firemen to save the synagogues, but the orders were to shield the German shops nearby. Inside the gutted buildings SS men beat up Jews, then forced them to stamp on Torahs and stand at the altar chanting from *Mein Kampf*.

Some Germans awoke next day and saw with shock what they had allowed. On the way to the Fürstin Bismarck School, just blocks from Lotte's street, students walked by posters showing beheaded Jews. "When class started, nobody spoke, some wept. One teacher finally said: 'We will have to suffer for this.'" A young German wrote that day to a friend: "I hope to be sent directly to the front when war comes. I am going to shoot backward. I swear it."

For the Nazi rank and file, however, *Kristallnacht* came as no sur-

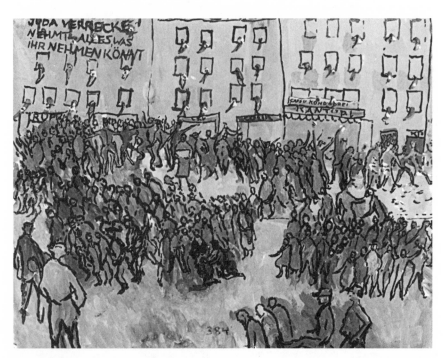

Kristallnacht crowds shout, "Death to Jews! Grab everything you can!"

prise. November 9, already an anti-Semitic fête, marked Germany's 1918 surrender and the 1923 failure of Hitler's Beer Hall Putsch. This time, street violence was thought too tame, and by early morning on November 10, the SS took charge of German "revenge." By nightfall ninety-one Jews were dead and thirty thousand on their way to concentration camps.

From a Jewish point of view *Kristallnacht* arrived like a tidal wave—the Jews in CS's scenes look buffeted and drenched. It overwhelmed the Kulturbund "island of relief," the whole segregated settlement. On *Kristallnacht* Kurt Singer happened to be in New York trying to transfer his performers to the United States. He turned around, fully aware of mass arrests, and headed straight for Berlin, "but his friends in Rotterdam persuaded him to remain in Holland," as he explained later to Albert and Paula Salomon. His SS boss Herr Hinkel ordered him to come back, but *Kristallnacht* finally taught Kurt Singer that his plan for Jewish arts was through.

"Enough of this life, too much of these times"

To record what lasted of that night and the next day, CS painted the swift valor of her parents, whose first thought was to help the wounded. Paulinka bustles Albert to his hospital, even though their cook says bluntly, "You have to hide, Professor. They already picked up half the Jews in the city." Charlotte's face swivels back and forth at high speed: Which woman's advice makes most sense? Dr. Kann sets off for the hospital, minutes before two plainclothes types come for him and bully his daughter. Albert is caught soon afterward, and Paulinka, her face an angel's portrait, says gently to Charlotte who is about to double over: "You go to police headquarters and ask if you can bring your father a few warm things." Once there, Charlotte is forced to join all the Jewish women calling out, "We want to know where our men are." The towering elegant officers spit back: "How should we know where your men are? Go home or we'll catch you too. Go home, you little pig of a Jew."

Paulinka's tragic chiseled face gathers itself: "I'll pull every string to get him freed. I need a visa, I'll get one. What good is my charm unless I get a hold over men of that sort?" In a fetching hat, twenty-two faces of Paulinka push through the scene, seizing the space to get

her way. This is a moment, often lost in typical accounts of Jewish helplessness, when women proved their nerve.

As Paulinka rushes about, Daberlohn slows to a stagger. His surface flourish falters. He spends his days at Charlotte's household in a trancelike state, prophesying, "Only a few will survive, yet for them, suffering is the fastest beast to carry them to perfection. My next book will be *Christ 1940*." Stumbling over ghosts from the last war and loose beams of the crucifix, he strains inside a nightmare, and faith in suffering doesn't spring him free. When Paulinka comes home, he forgets to console her about the arrest: "I've been waiting so long for you! Meanwhile I've kept myself entertained with your daughter."

For the first time, the triangle of Charlotte, Paulinka, and Daberlohn faces the collapse of its inner support—Albert's trust in them all. In an operatic trio, Daberlohn grabs Charlotte and chants from Goethe, "The Eternal Feminine draws us on," while Paulinka, missing this, sings out, "At least there are people to rely on in this frightful time." Charlotte's lyrics shift for the moment to disgust: "Let me go, I think you're repulsive." Repeat: "People to rely on in this frightful time," "Eternal Feminine," "Let me go, I think you're repulsive."

In fact they can no longer listen to each other.

Daberlohn to Paulinka: "It's a sort of panic. They practically threw me from a moving train."

Paulinka full blast at Charlotte: "Your standing around like that gets on my nerves."

"I can stand here as long as I want."

"If you keep on being rude to your mother, I'll box your ears."

"Since when are we so familiar with each other?"

Paulinka: "That was too sharp, my friend, but everyone feels tense right now."

The joints of the triangle finally snap. Charlotte spins away. But which one should she come back to? "No, I won't wait for him. I'll go to a café. But the signs all say 'Entrance Here Forbidden to Jews.' I'll go in anyway. I'm not that obviously Jewish."

Paulinka rushes out to look for her, in fear of mobs or something worse. She "suddenly recalls Charlotte's unsound maternal legacy, and searches the streets, terrified that the girl might do herself harm." Paulinka chases Charlotte, and her words chase CS's memory—"You stupid woman, . . . it's not the time to run away and leave me all

alone"—until Charlotte turns back and folds Paulinka into her silhou-
ette. She whispers, "Oh, forgive me!"

But Paulinka has guessed right. Charlotte is filled with thoughts
of death that can't be voiced: her hands block her mouth. "I've had
enough of this life, I've had too much of these times."

"Papa"

No use clinging to the academy, or to the Jewish Hospital, or to
the Kulturbund anymore. *Kristallnacht* pried Jews loose. Once arrested,
they were carted to the camps of Dachau and Buchenwald, and
beaten while made to sing "Wandering Is the Miller's Joy" (a Schubert
song of freedom that CS attached to her joyful scenes). Prisoners
only consoled each other that "we were not going to the camp at
Oranienburg; there it would have been much worse." Months before
the pretext of a diplomat's death, the SS prepared a camp called Sach-
senhausen at Oranienburg, about fifteen miles from Berlin. On
Kristallnacht nine thousand Jews were pressed through its gates
between lines of SS guards who beat them till "their skulls smashed," a
London paper said. Standing unfed on the freezing ground the whole
first day, they spent the night in barracks so jammed that "if one man
turns over in his sleep, 175 others have to turn with him." Sachsen-
hausen was "much worse" because the SS kept prisoners sprinting in
circles or digging senseless ditches all day long.

A man bends low over a shovel in a sequence CS called *"Papa."*
"Dr. Kann, onetime professor, is forced to do hard labor" and the
audience is forced to witness it. "You're here for working—not for
loafing. You've loafed enough in your life," growls the guard to the
man whose never-ending work gave cancer patients a chance to live.

In scenes of Sachsenhausen, unlike any so far, the painter hits the
paper with a flat swab of color and casts rough hasty lines over it—
her memory cannot dwell on her papa's pain. A new palette seeps
in—that of the mud where he digs. Bent half the height of the man
with the whip, his feet disappear and his head sinks below the brown
swab it ought to fill. The guard is all symmetry, like his lies. The Jew
has only mass, disintegrating downward.

His stoop in the scenes told the literal truth, for Sachsenhausen's
rules said diggers must never straighten up. Its Kommandant

Camp guard: "You're here for working—not for loafing."

announced: "This concentration camp is not a rest home. It is a center for National Socialist education. The Jews need simply to learn how to behave toward their hosts"; otherwise, he explained helpfully, "they will receive twenty-four blows hanging by their arms upside down." Such a Kommandant would have a future: His name was Rudolf Höss.

Hearing about the camp later from her father, Lotte saw perfectly that the elite SS shifted unruly anger about rank onto race. Those most honored before were the ones guards tortured most deliriously

now. Jewish lawyers had to say, "I am a low perverter of justice and a miserable bloodsucker." Those most decorated in the First World War were killed most ferociously now, one of them literally crucified, as if serving the Fatherland was treason in a Jew. Wretched Albert Salomon with his Iron Cross First Class!

After weeks of torture most of the prisoners found ways to leave the camp and then the Reich, but more and more got away by taking their lives. The main Jewish cemetery in Berlin had buried 465 suicides in Hitler's first five years, and many others went uncounted, for the Gestapo outlawed reports; so now more than one family had suicides to hide. A 1938 critique of the Reich noted its "absolute condemnation of suicide. . . . As far as the public are concerned, people do not kill themselves in authoritarian states."

When this state freighted thirty thousand Jews to concentration camps, it hardly needed to explain why it sent only men. If Jewish men were not pushed out—every Nazi was sure of this—they would act on their plan to expel Aryan men and take Aryan women as a prize. But in the camps each Jewish man was thinking solely of the woman he depended on—the one outside police headquarters bringing provisions for him. Only if he got a visa could he get out of camp, and he owed it to a woman's enterprise. "This was the time when our womenfolk rescued the men and tried to save them," one witness at the Eichmann trial recalled. "Our womenfolk stood in long queues outside the various foreign consulates . . . [on] a planet without visas."

This was the time when CS's Paulinka (chest out, chin up) rallied "enough charm and intelligence to succeed" in rescuing her husband. In one scene she cajoles an enormous officer, "It would be so important for me if he could be let out right away," till a skeletal figure with a pale flaccid skull hears the camp guard shout, "You're discharged." Her performer's charm still worked in 1938 because the regime only meant to give Nazi men know-how and force Jewish men, still at a run, out of the Reich.

Jewish families sent off husbands and sons to escape arrest, establish a base, and find a job. Those still in Germany after 1939, mostly women (123,104 Jewish women, 90,826 men), were not abandoned there—just deferred, with no way to know they'd be sent out in a year or two, to camps in Poland run by the SS.

Paulinka: "I'll pull every string to get him freed. What good is my charm unless I get a hold over men of that sort?"

"Back a thousand years"

Did Paula ever lose heart when her husband was in Sachsenhausen? This question came up in our talks almost fifty years after *Kristallnacht*.

"I learned to *concentrate*. I was running to this person and that person all day, forging dates on a release form, contacting colleagues in the underground, and with their help I got two people out—my husband and a lawyer who lived on our street."

Colleagues in the underground?

Albert returns home from Sachsenhausen, starved and ill.

"I say it. You hear it. Forget it," she said, as if what's covert must always be so, as if the danger's never over. "I got false papers that permitted them to leave the camp but not to board a train. So they walked home. The other man died from the strain. Albert was so weak he stayed in bed for four weeks."

In a silent scene Dr. Kann arrives at his door and grasps Paulinka, while his daughter knows to wait her turn. The whole room takes on his near-death pallor. Paulinka leans over his head, bent on nursing him back.

Did she understand they had to leave, that there was no time to lose?

Paula grew impatient at being asked a question like that. "My husband had lost half his body weight. He had to lie in bed, and we had to give him something every twenty minutes." Leaving was out of the question for a while. "My darling child, nobody knew then. There was no model for what was happening. You would have had to go back a thousand years to find something that you could have learned from."

And that was the trouble. If Jews tried going back to find something to learn from, they learned the wrong thing—that persecution ends in a stretch of exile. For families like the Salomons, *Kristallnacht* seemed a terrible throwback to the past, not the first night of something new.

5

EXPULSION

(1938–1939)

❧

66 I must say, it sounds wonderful," said Hermann Göring, two days after *Kristallnacht*, when high-ranking Nazis met in Berlin to chart ways of clearing Jews from the Reich. The meeting's minutes say these men were told about Austria's "complete plan for expulsion"—at which point Göring swore to "put it into practice right away" in Germany. Then Reinhard Heydrich (head of the SS Security Service and the Gestapo) boasted of Vienna's Zentralstelle für Jüdische Auswanderung, the SS-run "Central Office for Jewish Emigration, through which we forced at least 50,000 Jews out of Austria, while in Germany in the same period only 19,000 Jews were made to leave." Now these officials would look to Vienna when they brutalized the Jews of Berlin.

After the Reich annexed Austria in March 1938, Austrian Nazis hounded Jews out of their houses, grabbed their businesses, revoked their citizenship, compelled older Jews to do calisthenics, younger ones to clean full latrines with their bare hands or scrub streets with toothbrushes and acid, beat men to death while crowds cheered, urinated on women, thrashed children, and stripped homes till not one cloth was left to bandage the wounds. Eight months later, when *Kristallnacht* reached Austria—ferocious beyond even German belief—680 Viennese Jews committed suicide within a few weeks, after 578 from the months before. As viciousness exploded from the

center, Jews dreamed of the borders, begged the embassies for visas, then fled helter-skelter from their homeland. The SS in Germany was impressed: "The Viennese have managed to do overnight what we have failed to achieve in the slow-moving, ponderous north up to this day."

Vienna's Central Office for Jewish Emigration owed its speed to Adolf Eichmann. After training in Germany with the SS and working for the SD (Nazi Security Service), he had come back to Vienna in 1938 to set up systems for expelling Jews. Thanks to Eichmann and his twenty-six-year-old assistant Alois Brunner, almost as many Jews (120,000) left Austria in one year as had left Germany (140,000) in five. When Brunner committed himself to the Central Office, he helped shape what Eichmann called the crucial "example of Vienna." The fact that three-quarters of German Jews were still at home goaded Germany to match Austria's pace, and Lotte Salomon's family felt the push.

Just days after *Kristallnacht* Brunner filed an application to join the SS. It's revealing to read his résumé as a personal memoir, meant to highlight his features within an abstract Nazi force. Deciphered like a code, this memoir exposes the making of an SS man.

A life history for the SS

Name: *Brunner, Alois*

Age: 26

Profession: *Employee, Central Office for Jewish Emigration*

Voluntary activities: *None*

Status: *Single*

Religion: *Believer*

Church marriage: *None*

No wife, no church, no debts—Brunner's answers on the entry form affiliate him to nothing but the Nazis. Their man. When the SS probes his bloodline—any non-Aryans? any suicides?—Brunner leaves all suspect questions blank. For each male relative's occupation he writes "farmer," a good background for the SS, meaning soul of the

land. Women's occupations are not asked. In the required *Lebenslauf* or curriculum vitae, he works well within the questionnaire's tight space, fitting his nature to the SS form.

CURRICULUM VITAE *(TO BE HANDWRITTEN IN DETAIL IN INK)*

I was born on April 8, 1912 in Rohrbrunn, Burgenland, as son of the farmer Josef Brunner. Attended the elementary school in Rohrbrunn from 1918 to 1925, where for the first two years instruction was given in the Hungarian language; from 1925 to 1927 I completed three grades in the middle school in Fürstenfeld and on September 1, 1927 I became an apprentice with the merchant Loidl, Fürstenfeld. During this time, I also attended a two-year trade school. Upon completion until October 19, 1932 I was employed in Loidl's store as salesman and decorator.

On May 29, 1931 I joined the Fürstenfeld local chapter of the NSDAP [National Socialist German Workers Party: the Nazis] and received the party number 510.064. I have been a member of the SA [storm troops—the largest militant corps of the Nazis at the time] since December 6, 1931. I had to resign my position in the Loidl store because of my active membership in the SA.

From October 20, 1932 until January 17, 1933 I attended the private police academy of Dr. Albert Langer in Graz. From January 18, 1933 until March 1933 I worked as county manager of the Graz Savings and Loan Association in Hartberg. Since the Savings and Loan liquidated, I again had to find employment and leased the café restaurant "Wien" in Hartberg from May 1 till August 31, 1933, whereby I lost my entire inheritance from my father's side. In September 1933, following orders of my county commander, I went to the Old Reich [Germany] to join the Austrian Legion, where I remained an active member till August 24, 1938. There I was on duty as chief of the signal corps and after 1936 as staff officer of the communications battalion. I received the SA decoration of the Reich postal service and the SA communications service.

From July 23 till November 15, 1938 I worked as branch office manager of the agricultural association for the Eisenstadt and Oberpullendorf farmers federation.

This was the life history Alois Brunner wrote on November 15, 1938, inside SS headquarters in Vienna, just when Lotte Salomon stood outside SS headquarters in Berlin asking where the Jewish men had vanished to. Set against her vibrant self-description, Brunner's tedious recital of dates and sites appears constructed solely for SS ends: every detail directs his wavering course toward the elite corps.

Yet his first elaborately written *"Ich bin"* sets off an autobiography, fixes a life in place. In just four paragraphs Brunner presents a quest so clear that the form proves eloquent after all.

"I was born in 1912 in Burgenland" starts the tale when Hapsburg Austria still possessed the primary empire in Europe, before it lost vast territory during World War I. Burgenland was the heartland, the empire's traditional, nationalist, Catholic center, until land loss left it so close to the new eastern frontier that some parts fell out of Austria. "Attended . . . elementary school in Rohrbrunn . . . , where . . . instruction was given in the Hungarian language" refers to the town where the Brunners had settled two hundred years before, a town lost after World War I to Hungary—a non-Germanic, briefly Soviet-style republic, partly guided by Jewish intellectuals. Rohrbrunn's right to rejoin Austria was won only in 1921. For Austrian nationalist eyes a simple clause about Hungarian language was all Brunner needed to write. "I completed . . . middle school in Fürstenfeld and . . . became an apprentice with the merchant Loidl" tells the SS that this applicant took more schooling than most farmers' sons yet had to stop at age fifteen, thereby joining the aspiring small-towners that Austria's Nazi Party and its militant SA and SS counted on for their recruits.

The second stage presents Brunner clinging to groups moving up, the ones he cared about. "On May 29, 1931, I joined the . . . NSDAP. . . . I have been a member of the SA since December 6, 1931." In these specific dates he takes pains to certify his militance before the Nazis' 1933 victory in Germany: joining in 1931 at age nineteen made him an early scrapper in the fight. And he had his youth to prove him fit. In 1938 three-quarters of Austria's SA and SS were under twenty-five, and the Austrian Nazis' average age was twenty-nine. In contrast the Social Democrats had only 6 percent of their members in that cohort and looked too stiff to lead new troops. This was a generation young enough to be enraged at elder statesmen who had lost their empire, yet too young to have served at the front and learned why wars grind to a halt.

"I had to resign my position in the Loidl store because of my active membership in the SA" establishes a valued act of sacrifice, confirmed by a Nazi recommender who called Brunner "tireless," "my most dependable colleague," the "main support of the Fürstenfeld SA,"

an "enthusiastic fighter for the idea," a man who "sacrificed his entire free time to the movement."

The third stage of the *Lebenslauf* settles Brunner among the wrongfully deprived. "I attended the private police academy . . . in Graz" shows he had to find a police job in a town where half the population lacked work; but because Graz police were known as Nazis from the early days, the applicant rewrites neediness as zeal. "Since the Savings and Loan liquidated, I . . . leased the café-restaurant *Wien*." The SS would pick up all the references. In 1931 an Austrian Rothschild bank failed and dragged other finance centers down, forcing men like Brunner into service jobs. His café, named "Wien" (Vienna), signaled nostalgia for the prewar capital, but the café failed too. As country folk saw it, their resources were drained by a bloated urban sponge whose bureaucrats had nothing left to run and whose residents—only 10 percent of them, in reality—had Jewish names. After all, it was Vienna that gave Hitler a formative shock: the imperial center filled with beards and Yiddish babble! "I lost my entire inheritance from my father's side" says literally and means figuratively that the rightful patrimony of an Austrian farmer could not pass to his son, not when Vienna's Jews sold the empire and sucked the nation dry. Brunner implies that his legacy now is his bloodline. If parentage comes to count more than profession, then an Austrian Aryan will have his future assured.

Fourth stage: the resolution. "In September 1933, . . . I went . . . to join the Austrian Legion, where I remained an active member till August 24, 1938." This needed no spelling out, for the Austrian Legion attained mythic status by 1938. Five years earlier, when the Nazi party got so rowdy that Austria's law-and-order government banned it, the most militant fifteen thousand members gathered in Germany to drill for an invasion of their native land. In the Austrian Legion, stationed around Munich, Brunner trained in anti-Semitic ideas and guerrilla tactics, then met mentors like Adolf Eichmann and Ernst Kaltenbrunner who moved into the elite SS. Now the lesser men like Brunner followed suit. Dating his "active" membership in the Austrian Legion up till "August 24, 1938," Brunner makes it clear that his post as "Employee, Central Office for Jewish Emigration" started when it opened on August 26. Phrases like "I was on duty," "I was

active," put across the one acquired trait the SS cared about. All the rest was race. Saying that "till November 15, 1938" he worked in a provincial office highlights the date of his switch to the SS. November 15, 1938, would be taken to mean: as soon as possible after *Kristallnacht*.

Reparations

However flat and formulaic, this autobiography has a strong structure, leading from Brunner's legacy to his loss, through his militance to a reparation of identity. Along the way it even gives clues how someone came to hate the Jews so much that only the SS would do. It introduces him as a schoolchild in a region where the "Jewish" murder of Christ was linked with other secularizing crimes, from France's Revolution to Marx's call for revolution. It casts him as an employee where everyone blamed setbacks on the "Jewish" retail

Alois Brunner's 1938 SS photo shows the slight build so noted by his peers.

trade. It places him in the borderlands where the Germanic popula-
tion dreaded losing its identity to Slavic and Romany elements. It fea-
tures the Austrian Legion, which derided Austria's postwar reparations
to the Allies as signing "our own death warrant," committing suicide,
"bartering away" the nation "to international Jewry."

This SS applicant had lived out the crushing aftermath of the
Great War. So had Lotte Salomon, but Lotte had Paula Lindberg and
Albert Salomon and Alfred Wolfsohn as powerful models of recon-
struction when the social order came apart, whereas Brunner simply
demanded reparations for the trauma of his times. A cataclysmic fall
in pride made for prejudice. Self-doubt and its defenses fused in a
mind like Brunner's when it contemplated itself at all. As the elite
turned racial in the thirties, not social and not cultural, he found a
way to recoup his losses at last. If he let the SS possess him, he could
possess its power.

More clues to Brunner's anti-Semitism filter from SS application
photos that made sure every man's physique looked the opposite of
"Jewish," "Gypsy," or "Slavic." Just at the time Brunner applied,
requirements relaxed to bring more members in: height and weight
were given a quicker look, though race held firm. At five foot nine
and 123 pounds, Brunner just made it into the corps. But he suffered,
it might be said, from the lack of manly stature that counted so much
in SS imagery.

Many who dealt with him over the war years remarked on what
an underling he looked. "Brunner had an insignificant physique: small
in size, poorly built, puny, with an expressionless look, wicked little
eyes, and a monotonous voice." He appeared "small, dark, nervous,
[with a] long and pointed nose, slightly bow-legged, slightly hunch-
backed." "Physically he is not at all the German type." "To judge from
his features, he could be Jewish." With his "bad posture, black kinky
hair, dark eyes, thick lips, hook nose, Brunner obviously had some
Gypsy blood." "Among his SS cohorts Brunner had the nickname *Jew
Süss,*" the sleazy protagonist of the Nazis' favorite film. Possibly Brun-
ner repaired his image by excising whatever seemed submasculine and
counter-Aryan. After all, removing these elements from the Reich was
the mission of the Central Office of Jewish Emigration, where he
made his mark.

Adolf Eichmann fancied this mission as a technical novelty, a

"conveyor belt": "The initial application and all the rest of the required papers are put on at one end, and the passport falls off at the other end." What Eichmann did not bother to say was how much Jews had to load on to the belt to make the passport fall off: the emigration tax, the Jewish tax, all real estate, and every other asset. "The Central Office for Jewish Emigration was a first in the German administrative machine," he noted with pride. "The Prague Central Office ... simply followed the example of Vienna." Eichmann announced the founding of a Berlin Central Office "based on the example of Vienna," while Heydrich recommended Vienna-style offices in other German cities. It was the influential Eichmann/Brunner experiment, watched wolfishly by the SS, that shaped the fate of families like the Salomons.

"Charlotte sings the song of farewell to her native land"

In January 1939, the last new year before the war, Lotte Salomon and 78,000 Jews left Germany, pushed westward by the windstorm from Vienna. After all Jewish economic and cultural activity had shut down, after every park bench and movie house and library was marked "For Aryans Only," after Lotte had been excluded from the academy prize and then the academy, after Albert Salomon and 30,000 Jewish men had been tortured in concentration camps—then a Jewish panic to exit matched for the first time a Nazi passion to expel.

In CS's outraged pictures about this period, the German Jews look "so self-concerned that a silent observer feels a dinner party is a goose pen." At Paulinka's table they recount their plans—one wants Australia, one the United States, one to become a sculptor, another a musician—whereas Paulinka has to stay in Berlin, a great singer who spends her days helping others leave, and whose husband, a great surgeon, can hardly sit up. Their daughter's displaced contempt will last years. She knows that if she has to leave Germany, this awful party could also be her last look at Daberlohn. Brightly, his fiancée announces he'll come by to see Charlotte again, to which he answers true to form, "That's not sure yet. You must think I'm having an affair with the young lady!" At last they all leave and Charlotte sits deso-

late, hand over her mouth. Even the narrator, so quick with comment, has nothing to add.

Years later Paula Salomon-Lindberg had many sharp words to say of that terrible time when she had to break her family apart:

> Lotte was not involved in political things, so she was not in favor of having to go away. But she understood that when we got permission she might no longer have a passport. She absolutely didn't want to leave us. We really had to explain this to her well, that none of us will get away. She had to leave before her [twenty-second] birthday, because after that she would need a passport too. The people I worked with always had to check—how does it look today? Who's on duty? There was this awful man who didn't let you take out so much as a fountain pen. Lotte couldn't take much, just "Carmen" and one record of Schütz dedicated to me—she was very proud the publisher printed that on it. She had a few drawing materials with her, too. We had arranged letters about her sick grandparents, false letters, so she would be permitted to spend a weekend with her grandmother in southern France. But of course she stayed on there.

A series of scenes called *The Departure* leave the young woman alone and trace what goes on in another room, a wrenching confession from Paulinka, re-created by CS after the fact.

"Nothing but bother," says Paulinka to Daberlohn, "nothing but irritation. Well thank God she's going away in three days. Her grandmother will have to bother with her now."

An even harsher scene was omitted from *Life? or Theater?* in which Paulinka says to Charlotte, "God knows, I've done enough for you. Now you want me to pack all your things."

"It's not going to kill you. Just do it."

"How can you be so rude? I am so sick of you."

Then with Daberlohn, Paulinka weeps: "That's the kind of thanks I get."

"Don't cry. Your reward will come later."

One last time Daberlohn claims the power to foresee Charlotte's fate. He tells Paulinka, "I've been busy going to the station with people of all ages and occupations. . . . Whoever observes how they behave when they . . . go toward a new life in a strange unknown

land, could turn into a prophet. . . . So if you want to know whether your daughter has a chance of becoming a sensible human being, just tell me when her train is about to leave."

Paulinka agrees, "since I know she has a weakness for you."

Daberlohn looks Paulinka straight in the eye: "She may even be in love with me."

Suddenly he realizes what this departure must feel like for Charlotte. "Poor child," she'll tumble from her stepmother to her grandmother. So he invites her to come say goodbye, and she summons a last lie about where she's going (in small, ashamed letters), while Paulinka (in large red ones) complains that Charlotte's leaving her with all the work to do. Rushing to Daberlohn's room, Charlotte lies naked with him in a wash of color, indivisible. The next scene has them just the same but dressed, as if the memory of their last time together seemed just half real. Then Daberlohn holds her shoulder as she kneels, and his words travel down his body and then hers: "I beg you not to forget that I love life and say yes to it over and over. To love life wholly maybe you also have to embrace and grasp its other side, death. I hope you never forget that I believe in you."

These are her last hours in Berlin. As Charlotte "starts to sing the song of farewell to her native land," CS asks the viewer to hear all over again the music from the early scenes, to recall the circles and ruptures of love, to hold in mind the home where Charlotte's whole life has been lived, first with Franziska and her father, then with Paulinka, now with Daberlohn who spends his days there. Like a hand-held camera, CS's memory flows behind her character, starting in Albert's room where he offers a picture of himself and speaks bravely from his sickbed ("My little monkey, so you are really going to leave us in three days"), then through the dark and empty living room once resonant with music, and into her own bedroom with the hollow suitcase on the bed, the shoes empty on the floor. There she comes to a still point exactly at the middle, while her hands cover her mouth to relieve it of saying anything. Her weightless form looks about to float away, but a continuous blue line ties her to vital objects, though it's too thin and fluid to hold for long. She stares at the open suitcase, wondering what she will need from Germany, and its vacancy makes a recess for her memory.

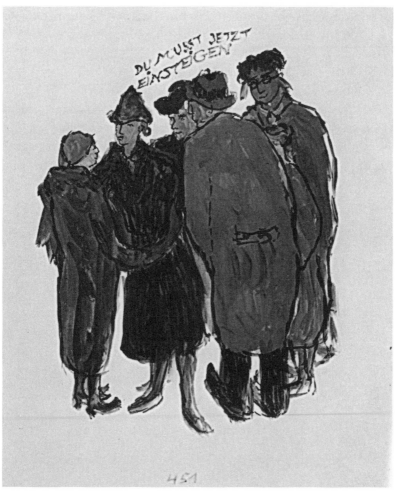

"You have to get on the train now." Lotte leaves Berlin in 1939.

Too soon her reverie is broken. She is bustled into a taxi and out to a railway ramp. There she holds her breath beside Paulinka while a Nazi officer hovers on a train nearby. The moment has great tension. Suddenly the figure of Daberlohn looms up from the painter's direction, as if delivered just in time. For one instant, the train, the Nazi on the track, Berlin itself vanish, and our human figures are standing unfixed in space. Then the context reappears: a man hawking a Nazi newspaper, two big officers, Daberlohn studying how she says goodbye, Paulinka alone and tilting toward the train. Too fast Berlin is

swept into specks. In the next instant the artist's imagination leaps back to the two beloved figures on the ramp. Paulinka turns to Daber-lohn:

"Now then, what are your observations?"

"The most auspicious you can imagine, Madonna."

What Lotte's prophet predicted after the coach steamed out, she had no way of knowing. She simply slipped an omen into the script ("the most auspicious you can imagine") to propel her through the years of separation, after her last look from the window of the train.

II

On the French Riviera

6

DESOLATION

(1939–1940)

～

Two months after Lotte left Germany in January 1939, Albert and Paula Salomon got out too, with plans to meet her in France once they had emigration papers for all three of them. They carried false passports from Berlin and nothing else. Paula recalled:

> We headed to Amsterdam because there we had Jewish friends and since we could only take handbags, no money, we needed friends. There was an Aryan Swedish man in the underground with me, always at Göring's trying to find things out, especially from Mrs. Göring—he was a real seducer! He got us false passports, then got on a plane with us, but we pretended not to know him. When we arrived in Amsterdam, he took the passports and went back on the next plane. Kurt Singer was waiting for us on the runway. If we hadn't gotten those passports we would have perished, but there was no way to know these things. I didn't want to understand, and I hope I never understand. Only if those times ever start to come back, I will taste it on my tongue.

As Paula and Albert Salomon settled for the moment in Amsterdam, Lotte lived without their guidance, or their doubts, for the first time. If she floated free awhile—none of the new scenes in France even mention them—she soon got dragged down by her grandparents.

They had taken the first steps into exile back in 1933, after

watching Nazi parades with an American friend they'd met in their travels, a wealthy woman of German descent named Ottilie Moore. Hitler could never last, of course, but just in case, said Mrs. Moore, they could stay at her villa near Nice anytime. After a year in Rome the Grunwalds tentatively took up her invitation, arrived at the villa "l'Ermitage" ("the Hermitage") in Villefranche, set out their paintings and books, their portable German culture, and slowly learned they would not be going back.

While other Americans took relief in being far from Europe during those years, Ottilie Moore just wanted to stay there and help out. In 1928 she and her husband had taken her family fortune to the village of Villefranche, a few miles east of Nice on the Côte d'Azur. After he fell (or jumped) to his death during a violent argument with her, she began acting as guardian of forsaken souls, taking in orphans and exiles. To put it simply, she gave a refuge to the Grunwalds and their granddaughter that saved them all from Germany.

What happened to these three in France after January 1939 was recorded by CS in a twelve-page private postscript left with *Life? or Theater?* and in the 102 last paintings she called the "Epilogue." The Epilogue opens with the questions posed to herself after losing her German life. "Foam, dreams—my dreams against a blue background. Why do you build up each time, renewed and clear, out of so much suffering and sorrow? Who granted you the right? Dream, speak to

Lotte with her grandparents at l'Ermitage around 1939.

me, and whose servant are you? What are you preserving me for?"
"Foam, dreams" (*Schäume, Träume*) fuse by rhyme, as if to say that her
dreams evaporated until she called on them to open up a new source
for her art.

In France, at first, Lotte (like her persona) felt "renewed and clear,
out of so much suffering and sorrow": this was the impression she
gave a family friend, a German émigré named Emil Straus. Fifty years
later in his Nice apartment filled with works of art, he spoke of Paula
Lindberg in Berlin, the Grunwalds in Villefranche, and Lotte furious
with all of them—but since he shouted throughout our interview, it
was hard to tell whose fury was being expressed. He had not forgiven
Paula for deleting some observations from his 1963 introduction to
CS's pictures: that Lotte wanted to keep her distance from her parents
and that they too wanted to stay as far away as Amsterdam from
Nice. Of course, they also had no passports, no money, no way of
knowing war would break out so soon, and no safer place than where
they were.

One other friend of Lotte's stayed in Villefranche after the war.
Annie Nagler had arrived there in 1939 when forced out of Vienna as
a Jew. She eventually accepted Villefranche because her son had
come with her and was still living nearby, which was to say, *living*. She
easily recalled the many months she and Lotte and Alexander Nagler
(her husband's brother) spent at Mrs. Moore's villa, l'Ermitage. Annie
Nagler was the kind of woman who was enchanted to be told some-
one's inner thoughts, so when she claimed she'd heard all Lotte's con-
fidences—about the grandparents and a *grand amour* elsewhere—she
surely had. She described Lotte as "the perfect German type: red
cheeks, blue eyes, tousled hair. No one would have thought her Jew-
ish. She never wore makeup, and her feet were never on the ground."

Also at l'Ermitage in those years was a nephew of Ottilie Moore's
who was said to have settled in Washington, D.C. When many phone
calls finally located him, his assistant barked, "Stand by. Mr. Moore
will make contact with *you*." We finally met in his cozy house in Vir-
ginia, where Wally Moore's Vietnamese wife told of escaping her
country by boat, then harboring other Vietnamese refugees with
Wally's help: a strain of rescue clearly ran through his family tree.
Though only eleven at the time, he later had an astonishing and item-
ized recall of life at l'Ermitage, describing his aunt Ottilie's leftist poli-

tics, her "weakness for strays," her refugee lover, her faith in Lotte's genius. Later Wally Moore made his career in Army Intelligence, in spying tools. No need to question his sharp eye for detail. He'd seen exactly what Lotte was like before *Life? or Theater?* "She was not of this world," he said.

"Deeper into solitude"

In every case she preferred to be by herself and sketching. Of her own free will, she never spoke out, not once. She came to no activities Mrs. Moore arranged; as soon as they started, she hid. If a child addressed her, she would turn scarlet. If one passed her in the garden and called out *"Bonjour, Lolotte,"* she would turn away. Behind her back Wally Moore and other children at the villa nicknamed her *the Mute:* "We heard her voice only when she argued with her grandmother."

Her grandmother was always scanning for symptoms of the family disease, trying to pull Lotte from the place where she was determined to secede. Her postscript says: "I had to go deeper into solitude entirely apart from others—then maybe I could find—what I had to find!" That deeper solitude also impressed the Grunwalds' friend Emil Straus, who got through to Lotte only "when she learned that I had known her stepmother," or when he asked about her art. Then she began visiting him, though every chat they had on painting or music he remembered as a "one-way street": "She detested having to talk, and especially answering questions about herself. Her grandparents thought her stupid and sullen but that was not the case. . . . I discovered not only a profound lover of painting and music, but also an uncommonly intelligent and independent-minded young girl." Given time and attentiveness, "she opened up," and not only to Emil Straus. Lotte confided in Annie Nagler too, who was quick to see the conflict with her grandparents: "Lotte was always polite and very much alone," whereas they were "genteel and Prussian, courteous and cold."

All through 1939 the Grunwalds made dutiful gifts to their hostess from their store of jewelry and artifacts, always worried at what point their goods and their welcome would wear thin. By all reports Grossmama pretended to be visiting the villa like an esteemed guest, faulting the noisy children harbored by Madame Moore or deriding

Grosspapa and his sweet tooth. As Grossmama gradually descended from houseguest to tenant, she held to her *politesse*, expecting everyone to show up for meals on time, refusing to empty her plate even with food rationed, looking down her nose at Ottilie Moore. The fact was, without Mrs. Moore they might not make it through, and that fact was sickening to Lotte. Her private postscript said, "I could not bear to live with my grandparents, to see them accept everything from this woman and at the same time hear them say the vilest things about her." To find a foothold the Grunwalds committed the worst trespass she could imagine: "They made the same mistake here that all people make all the time: seeing things only from their own point of view. . . . They disregarded that woman's capacity to be motivated by true kindness. . . . My grandparents [treated her] with ingratitude contempt and scorn!"

The ways of this household isolated every person there. Not even exile could glue these people to each other. "The old lady really was a terror," according to Wally Moore. Grosspapa began to hide from his wife in the garden, where he slipped candy to young Wally and his playmates. A nice old fellow, the children thought. Lotte got lost with her sketchpad among the orange trees. A zero, they thought.

Grosspapa and Wally Moore at
l'Ermitage.

"Grossmama, look at the sun"

"The only thing that absorbed her for the moment was the southern landscape," Emil Straus recalled. "All day long she sat in the garden, drawing and painting. . . . Sometimes she fell asleep, and awoke drunk with happiness."

"Are you only in the world to paint?" Grossmama scolds in the scenes, and diagnoses "a case study in melancholia. . . . Look at her. She needs a man." Melancholia? Grossmama is the one who crouches with her arms around her knees, warding off the news. From her radio comes "Frightful excesses against Jews in Germany." From her memory, suicides by her daughters—both of them. The paintings suspend her in shadowless spaces, tint her moribund colors. A brilliant 1939 line drawing, of which a photo remains, catches her in fragile repose, fingers on her forehead as if to keep in touch with her mind. Whenever she walks, her hands reach for her pockets; wherever she sits, one hand or foot shields the other. She looks petrified by her thoughts: "The world is filled with pain, stricken with horror. Reason and virtue rule the land no more."

In actuality every day away from home, Grossmama felt more useless, foreign, and female. As France became a catchment zone for refugees, only twenty in a hundred, arriving like the Grunwalds in 1934, were women. French officials had little use for them, and the economy had just one, but it would never do.

"Why shouldn't she become a maid like everyone else?" Grosspapa asks in an angry scene—angry that Charlotte spends all her time with her paints.

"Because at all costs, if at all possible, I want to prevent that," replies Grossmama, turning snobbish whenever she's scared. After a time, all her armor seems to uncouple and expose her fragile core: "The severe suffering that pursued her through life, till now somewhat submerged in her depths, seems called up by the raging war, and appears fully before her recollection, so that she feels her sharp intelligence and her self-control—what made her life worth living—breaking to pieces against something too strong for her." Something too strong for her comes from Germany. As it seizes more of Europe in September 1939, Grossmama ties a noose around her neck. In a dreadful scene Charlotte finds her in the bathroom just short of dead.

Right then and there, Lotte Salomon started making art about the family past. She put together "a little tale in pictures from my grandmother's stories, for her fiftieth wedding anniversary"—October 30, 1939—a tale of handsome Ludwig Grunwald courting brilliant Marianne Benda. "Was ever a woman wooed in such a mood?" the artist sang, while painting the "charming couple" with two pretty children

Line drawing of Grossmama around 1939.

Charlotte sings to her grandmother, "Joy, thou spark from flame immortal, daughter of Elysium," while drawing her face.

at their side. In this storybook the artist first linked words with pictures, lifted the viewpoint above the scenes, designed a wedding banquet (later transferred to her parents), and traveled a backward path, away from the shocks at hand. It was her first move toward *Life? or Theater?* The storybook ended by trying to cheer Grossmama up: "Let art and nature help you overcome each difficulty."

But Grossmama keeps pleading through the scenes of *Life? or Theater?* "Let me die, oh let me die, for I feel it, I cannot live longer. Oh let—"

"Grossmama, look at the sun, how it's shining."

"I see the sun shining."

"Look at the flowers over the meadow. So much beauty, so much joy."

"I see the flowers blooming, so much beauty in the meadow."

As the two women offer an antiphonal hymn to nature, the tempo of the scenes picks up. Head thrown back like Paulinka, Charlotte starts singing Beethoven's Ninth Symphony, from Schiller's "Ode to Joy": *"Freude, schöner Götterfunken,/Tochter aus Elysium"*—"Joy, thou spark from flame immortal,/daughter of Elysium"—till her rising voice and arm draw Grossmama right up from her bed.

Grosspapa listens to them and says, "What's all that junk supposed to mean?"

It's supposed to mean that art will keep these Jewish exiles sane. Against their desolation Charlotte pours out the huge familiar chorus like a restorative from German humanism. Over it runs a duet, with Grossmama's part small and shaky, Charlotte's lettered large like a voice of authority. She sings on: "We shall enter, drunk with fire,/Holy One, your sacred realm."

In reality the Grunwalds, like other refugees, were growing panic prone. As they focused their fears on Ottilie Moore, "the discord became worse and worse." Lotte admitted in the postscript that Mrs. Moore "lost interest for a while in the two old people" and "turned to other things," namely Alexander Nagler, a newer arrival. Yet Lotte blamed herself alone for uprooting Grossmama from the safekeeping of l'Ermitage. "I knew how to manipulate my . . . grandparents ever so well. I appealed to their sense of honor for being kept by a person they despised. And so we moved away." Early in 1940 the three of them left "their own house in her wonderful garden where they lived for three years [actually five] surrounded by consummate beauty. . . . I had the instinctive feeling that this circumstance and the parting from that human being gave my grandmother the last push to do—what she was destined to do."

The Grunwalds resettled with Lotte in an old quarter of Nice on the Rue Neuscheller, an uphill lane of worn mansions, a hard climb for people well into their seventies. No doubt they hardly left their flat. After this second uprooting, Lotte felt bound to find her grandmother a detour around despair. Then all of a sudden *she* was the one who needed it.

Soon after Grossmama's suicide attempt, Grosspapa spilled the secret kept for thirteen years, not caring how it hurt. In this family of yours, he tells Charlotte in the scenes, every single person commits suicide:

Grosspapa: "Now you and your future are her only concern....
She's the only one to thank for having you with us where you
can lead such a pleasant life."

It went worst with Grossmama's mother. Each day for eight years
she tried to slip away from the custody of two nurses in order to
take her life. . . . The troubles of those eight years, in which our
children were born, remain for Grossmama indescribable. . . . Not
long after, her sister and her sister's husband took their lives, also
from a nervous disease. In the meantime our children were growing
up . . . but for reasons we have never been able to grasp, our
Lottchen drowned herself. . . . At the same time Grossmama's niece

took her life with Veronal. Then you were born. A great misfortune still awaited us, the death of your mother, also incomprehensible, for naturally we don't blame your father in any way, but by now your grandmother could endure no more. She didn't want to go on living. Then 1933 came and she compelled me to leave Germany right away. . . . Now you and your future are her only concern.

As he delivers the shock of Charlotte's life, the grandfather's words snake around him, till *deine Mutter,* "your mother," stops just over his head. His face—then six of them, twelve, twenty—turn to gray slabs, show up tragic, then malevolent, then drain blank. While his lament goes on, Grossmama veers, disjointed, off the bed, and Charlotte sheds all identity of her own, down to two colors and an outline, as deprived of features as she had been of facts. In this unguarded state, like a blank surface waiting to be etched, she has to absorb the family legacy.

"I knew nothing of all that."

Now she knew. The traumatic revelation out at last.

Suddenly Charlotte has her mother's fate, her grandmother's, and her own to worry about. At first bare backgrounds hold the two women apart, but gradually through forty-six rescue scenes Charlotte's voice stitches closed the space in the middle. Soon her figure stretches over Grossmama's; single brushstrokes do for both their shapes, outlines cross, and colors liquefy between them; the same circulation runs through both their bodies. They become so interchangeable that the "you" in "The sun is going to heal you" means either one. To keep her grandmother alive has come to mean saving herself.

But how? "Then she remembers Daberlohn and starts her therapy." A "proposal" inspired by him is going to set them free: "Instead of taking your life in such a gruesome way, you could apply the same power to describing your life. . . . There will surely be something to interest you, something that presses on you, and as you write it down, you free yourself and maybe even render a service to the world." This vital idea sets both of them moving. Grossmama begins her life history, and Charlotte starts knowing herself through another woman's body and mind. As the postscript makes plain, "I was my mother my

Grossmama to Charlotte: "I'll go to your room and then you go strangle him. Ah his eyes are such a lovely blue."

grandmother, yes I was all the people in my play. I learned to walk all paths and I became *myself*."

But not even Charlotte can save Grossmama from her past—from her mother's suicide attempts and her daughters' suicides. One night she babbles, "My poor child in the pond. . . . Oh, it's too late! There's my mother sitting on a rock wagging her head. I strangled them both." Her mind careens through tangled channels till it reaches her husband at last.

"You go strangle him," Grossmama whispers in Charlotte's ear. "If you don't want to, I'll do it myself right away."

Grossmama's words terrify Charlotte in the lurid frenzy in the scene, for they confirm a psychiatric formula of the day: "No one kills [her]self who has never wanted to kill another." Grossmama's madness suggests a world in which murder and self-murder cross. All Charlotte

can do is beg Grosspapa to get his wife morphine, though the doctor in Villefranche advises against it. Instead Grosspapa leaves the house to get some air. In that one instant Grossmama hurls herself from the window, like her daughter before her.

Seeing the bloodied body on the ground, Charlotte knows at once how her mother was torn apart; in one vision she grasps two fatal falls.

At first she tries to blanket herself in Daberlohn's last words— "Never forget that I believe in you"—but Grosspapa interferes. "So she did it no matter what!" he says to her abruptly, and then to himself: "Most likely I'll live to see the one in the next room lay hands on herself now." In the next room Charlotte is pressed to her bed. "I'm afraid it's starting with me too. Dear God, just let me not go mad." *Lieber Gott, lass mich bloss nicht wahnsinnig werden.*

Her words from the work's most anguished scene emerge deep ocher from an incinerating orange background. *Nicht* ("just let me *not* go mad") is placed apart, distinct in size and color—her last-minute amendment to the other wish. *Wahnsinnig,* "insane," just manages to keep in line; the painter of this scene is not yet mad. But the window beckons. The figure stiffens. Only the sketchpad on her kicked-out leg keeps the woman from the window's lure.

"I will create a story so as not to lose my mind"

From that moment Charlotte starts muttering through her days and nights, "I hate them all!" and she is not referring to the fascists. No one in her family has ever trusted her—she knows that now—certainly not her parents whose condolence note looks "utterly ridiculous." In the painting, it reads: "Dear Grosspapa . . . We are shocked by your news and will do all we can to assist Charlotte, the only heir of your dear departed, and lead her on the right path. Our most heartfelt sympathies to you both. Albert and Paulinka."

In fact Albert and Paula Salomon did write Lotte from Amsterdam, where they had been living for a year, since February 1939. They urged her to wait till they joined her in France, and not to worry about the family legacy. Her maternal line had "degenerated," as her father would show her in medical books one day, but she should remember she inherited vigorous stock from him. That was all

the consolation they offered to the last one left, and they'd kept it to themselves for fourteen years. Anxiously they showed her letters to psychiatrists in Amsterdam who told them to send supplies so she could paint. In a letter just before invasion cut them off in May 1940, Lotte answered for herself: "I will create a story so as not to lose my mind."

That story put its stress on women's grief and wartime dread, never on genetic flaws. When CS pointed out "a family resemblance" between her grandmother and herself, "resemblance" meant their shared dilemma: whether to stay alive in a world they could not bear. When one of them died within that world of exile, no obituary appeared in the newspapers; no one kept paying the cemetery; soon no trace remained of the grave. In her death certificate even the names of her esteemed relatives became "not known."

> 20 March 1940, Marianne Benda died in her home, Villa "Eugénie," Avenue Neuscheller; born in Berlin, Germany, on 24 July 1867, daughter of George Benda and of a mother whose names are not known; wife of Grunwald whose first name is not known. No other information.

"Breaking to pieces against something too strong for her"

It was plain that Grossmama's death followed the family pattern but just as plain that it belonged to a larger pattern of the time. Early in the war, suicides in France escalated among the elderly, the women, the "nonresidents," the Germans in exile. Not many remember this. The leviathans of war and genocide have swallowed up the remains of suicide.

CS painted the threat to life as it was felt at the time. With indistinct tones like orange on brown or blue on blue, with featureless faces and evacuated backgrounds, she left nothing situated, nothing resting on anything else. She made the characters all sound desolate: "I cannot live longer," "Her self-control was breaking to pieces," "A great misfortune still awaited us," "Oh it's too late." Rescue from suicide failed in exile. It was hopeless there.

This haunted score in pictures and words marked a time when more and more German refugees were voicing thoughts of *Selbstmord*.

"We shall see a whole series of suicides," predicted exile satirist Kurt Tucholsky, who pledged not to write in German till Hitler's collapse, then swallowed poison kept on hand. Leaving the mother tongue, wrote exile novelist Alfred Döblin, felt like "committing suicide." Whoever lost the means to speak ("the world of my language having disappeared") lost the means to live, mourned exile writer Stefan Zweig in his suicide note. In a Lion Feuchtwanger novel, one German refugee in France put herself "at peace with Hitler, at peace with God, at peace with herself. . . . Was it a sin, what she was doing," committing suicide? A rhetorical question. In Klaus Mann's exile novel *Flight to the North*, the main character "would rather die than anything else." "The courage to die has become cheap," says the principal of Ernst Toller's last play. After Toller took his life in exile, his colleagues honored "a hero's death, the only one still open to a writer in our times: suicide." The more they consoled themselves with phrases like "a hero's death," the less was left to stop them from killing themselves.

It takes unearthing their suicides to feel the full effect of the exiles' eviction from the Reich. Like CS's "Epilogue," *The Moral Problem of Suicide* by Paul Louis Landsberg, another refugee in France, weighed suicide as "the best door left open, if life in such a society has lost all meaning." Landsberg always kept poison on his person, but who didn't? "In those days," wrote Arthur Koestler in 1941, "we all carried some 'stuff' in our pocket." In a French prison camp, inmates took heart that "the last emergency exit to unassailable freedom would always be open." They felt toward suicides "something like envy. Death restored men's private lives." When dramatist Walter Hasenclever decided to swallow poison, his fellow prisoners insisted that "life should not be forced upon him" and thought it "wrong to interfere in his decision."

Exiles were apt to condone a choice to die, and sharing poison was their final grace. Shortly before philosopher Walter Benjamin fled France for Spain in September 1940, he ran into Arthur Koestler, just out of punishment camp. "Have you got anything to take?" Benjamin asked, and "shared what he had . . . [though] he did not know whether the thirty-one tablets left him would be enough." Benjamin needlessly took his life when caught in Spain (some refugees did get through), but exiles could not hold out for a turn of events—not with the means in hand. Joseph Roth, well-known novelist and journalist,

tried to kill himself in Paris and failed to be cured on a charity ward. Austrian writer Ernst Weiss confessed: "I dread the hour when, out of exhaustion, there is no more hope left within me for anything." He sliced his veins the day the Nazis marched through Paris. German art critic Carl Einstein drowned himself near Bayonne as the Nazis moved south. Even if exiles imagined a break ahead, they had schooled themselves to suicide and could not stand deciding against it again.

Suicide was not just a question in their personal lives, it was *the* question. Most sanctions had simply expired, like their passports. More than fear, they felt compassion when someone went through that "door" and left it ajar. Koestler's 1941 autobiography ended with "unknown" people taking their lives in France:

> Old Jews and young anti-Fascists, cheating their guardians in an unobserved moment, killing themselves hurriedly, secretly; stealing out of life as they had stolen over barbed wire and frontier posts, after even this last exit permit had been refused to them. And the procession of despair went on and on, streaming through this last open port, Europe's gaping mouth, vomiting the contents of her poisoned stomach.

Furious words for the way each solitary suicide joined a continental craze. So Stefan Zweig's suicide note accused Western culture of taking its life and then his. So editor Franz Schoenberner lamented the rundown of Europeans' "instinct of self-preservation," blaming France's "suicidal non-intervention policy" in Spain as well as England's "suicidal appeasement" policy toward Germany. So Koestler laid bare "the suicide of France": "it was suicidal selfishness on the part of the French ruling class to prevent the war against Fascism from becoming an anti-Fascist war." So Heinz Pol's scorching 1940 critique, *Suicide of a Democracy*, indicted French profascists for sapping resistance to Hitler by cracking leftist groups. As France caved in to Germany in spring 1940, the metaphor that came to mind was "murderous suicide."

So Lotte Salomon lived through and recorded a crucial change of consciousness. Suicide no longer implied cowardice, certainly not sin. As destructive forces radiated outward, exiles could not escape their choice: You may kill yourself or you may watch yourself (your nation,

your people) be killed. Her own view added female defenselessness and family disorder to the "world ... filled with pain" that had crushed her grandmother. When Grossmama's nephew, fired because of his race, took gas in his laboratory, "the news of her nephew's suicide, the only surviving member of her family," caused fears that could not be outlived. A state could goad its subjects to suicide. A known and ordered world could die by its own hand.

In that world a desolate artist could certainly take her life. Or she could stand on her words the way Charlotte literally stands in the scenes, saying: "I am going to live for them all!"

7

PREMONITION

(1940)

⌐⌐

While exiles focused on suicide, a new Nazi plan was about to become the engine of genocide. It was a vast "resettlement" plan, and it started with a signature.

Adolf Eichmann had moved up to head Jewish affairs for the SS in Berlin, leaving his assistant to run the Central Office of Jewish Emigration in Vienna. Alois Brunner, age twenty-seven, arranged the first transport from Austria on October 20, 1939, heading for a so-called "Jewish reservation"—a wasteland near Lublin in Poland. With this first sealed convoy crossing national borders, Brunner switched on Europe's pilot project for mass deportation. His report went to Eichmann on October 18, 1939:

> The resettlement to Poland is under way. . . . Gypsies who are now in the Ostmark [Austria] are included in a separate railway car. . . . Further transports will be taking place every week, Tuesday and Friday, with 1,000 Jews.
>
> Signature: Alois Brunner.

These transports started a process that finally dispatched three million Jews. The first trains sent men that Brunner pulled from asylums and nursing homes; later he threw in women and children too.

His new work was set up by a brotherhood, born or bred in Austria, that took disproportionate charge of ending Jewish life in Europe: Hitler, Gestapo chief Kaltenbrunner, deportation experts Eichmann and Novak, death camp commandant Stangl, occupation heads Seyss-Inquart, Globocnik, and others. While such Nazi officials had visions of resettling every single Jew and "Gypsy" in a distant "reservation," it was a man in the field, Alois Brunner, who first actualized their fantasies of a pure-blood Reich.

So long as the Reich was expelling Jews one by one, most exiles had gone by choice to France. But when the SS shifted to mass resettlements in Poland, those in France had a premonition that even the land of *liberté* might fail to keep them safe. Like most of them Lotte Salomon saw signs of trouble as early as 1940—and she was one to store signs in her memory.

"Ordered to leave"

During May and June 1940, while Lotte was trying to resist the family fate, the French were failing to hold off invaders from Germany. This was practically the last time exiles could say *"Vive la France!"* without qualifiers. "Long live France, even now!" read the suicide note of Ernst Weiss, found in a squalid Paris hotel. "Even now" meant the livid French fantasy that German refugees were forming a "fifth column" (a term from the Spanish Civil War)—internal traitors causing France's defeat. In the region around Nice, journalists harped on the "legion of traitors" and blustered, "What an imprudence France commits . . . in receiving on her soil these so-called refugees." When a Jewish official shot back, "We should not confuse the victims with the assassins," the paper deleted most of his letter—to no one's surprise. "The French local newspapers called us all Nazis and Nazi agents, and if we protested, our letters were not published." As the German Army forced its way through France, French police searched refugees' lodgings, and the Nice papers bullied, "Is this enough? We think not." So the regime took another step. In May 1940 it arrested the whole "fifth column" of refugees, who knew why they'd been caught—"simply to put on a show for the French people, to divert public attention from the men who were really to blame for the French defeats." Despite the rush to mobilize fighting men, France locked thousands of mili-

tant antifascists into prison camps. When Walter Hasenclever committed suicide in one of them, exiles saw a fighter against fascism martyred by a government claiming to fight fascists.

The shock of betrayal pervades a painting by CS. In her haste and dismay she misletters the French verb *sont* as *sotnt*:

AVIS: TOUTES LES RESSORTISSANTES ALLEMANDES SOTNT TENUES DE QUITTER SANS DELAI LA VILLE ET LE DÉPARTEMENT.

[NOTICE: ALL GERMAN NATIONALS ARE ORDERED TO LEAVE THE CITY AND THE PROVINCE WITHOUT DELAY.]

Oddly CS's French phrase *"ressortissantes allemandes"* ("German nationals") is in the feminine gender. Decades later a translation of *Life? or Theater?* took this as another grammatical mistake and corrected the caption to masculine: *"tous les ressortissants allemands."* Masculine matched the situation eight months earlier, in September 1939, when France declared war and interned fifteen thousand German men. But was CS's usage a mistake, or did she see a new order concerning women?

In fact Nice newspapers printed one on May 27, 1940: *"Les femmes ressortissantes allemandes doivent se rendre au centre de Gurs"*—"Women who are German nationals must present themselves at the Gurs center"—a camp in the Pyrenees, on the other side of France.

Up to that moment only men were forced by the state into camps and work brigades. Naturally women, children, the ill, and the old were left at home. But in the period CS referred to, the French government "discovered that refugee women were not less dangerous than men," one exile writer quipped bitterly. When the exemption of women collapsed in May 1940, trust in rational policy collapsed too. No wonder this eviction order, alone of all orders at the time, struck CS enough to re-create it. If France does *this*—?

As refugees read (and misread) the portents that appeared, they tried to see why "all German nationals" had to leave a place not threatened by Germany but by Italy. The city of Nice had fought hard against Italian invasion till the armistice of June 25, 1940. But soon a French decree exempted all eighty thousand Italian residents

from the status of "undesirable aliens." The label still applied to Germans, though, the only alien group consisting largely of Jews—three-fourths of the eight thousand Germans arrested by France for collusion with the Reich. Few of CS's paintings marked political events, but they did take notice of the moment when "fifth column" became the new code phrase for "foreign Jew." If German nationals, even women, were marked as France's foe, this prefigured punishment by race.

"How to live in this desolated universe?"

After the eviction order, one scene shows a French evacuation train with "thousands of totally exhausted people" fleeing German air raids: "These people had to leave every possession in order to escape with just their lives," the caption says. Yet the difference between "these people" and Charlotte is unmistakable. While many of them are on the floorboards weeping, CS recalls herself *sketching*, learning to trace the distinct experience of exiles. If France could type her "German" (though Germany made her stateless) and then call her a "Hitler spy" (when she would have spied on *him*), that proved France could reverse reality.

Where the train took Lotte with her sketchbook and her grandfather was never specified in *Life? or Theater?* But her friend in Nice, Emil Straus, recounted later where she went, and the eviction order (reworked in her scene) specified "the Gurs center." Other reports, interviews, drawings, and photos can fill in experiences Lotte must have had as a German-born woman traveling toward the Pyrenees. "Fifth column!" French crowds shouted at these Jews. "Hitler pay you well?"

Lotte's friend Annie Nagler, living at l'Ermitage when the order came out, got money from Ottilie Moore and advice from a Jewish group: Go to the Pyrenees, where refugees are housed in garden chalets. Annie boarded a train with her infant son, then a bus to the worst place she had ever seen. Chalets with gardens? Barracks with nothing. Merely the place-name came to mean a menace to French liberties, "one stupid syllable, like a sob that gets stuck in the throat": Gurs.

The memory of survivors fixed on their first image. "A miserable

The camp of Gurs in the French Pyrenees.

cohort of women . . . saw something resembling a gray swamp, three kilometers long, barracks lined up against each other, behind the barracks other rows of barracks as far as the eye could see. Not a tree, not a spot of green. . . . How to live in this desolated universe?" The buses pulled to a stop from high speed, "to prevent the women from jumping out," one woman recalled. "Then it flashed through my mind, 'Gurs'—the old Spanish camp."

Gurs was where France put Spanish Republicans in 1939, when they backed across the frontier into a country that saw itself saturated with refugees. The site was judged by engineers' reports "suitable for a temporary camp," but within a year it housed nineteen thousand Spaniards and then made room for thousands of German women too. It was the largest concentration camp in France, known for a while as a "female" camp: Up to nine thousand women were interned there in June and July 1940, among them Annie Nagler and Lotte Salomon.

Sixty women in each barrack, a few square feet of floor space per person, a roof angled to the floor so you could stand only in the middle, nothing to sit on, no windows, only a door at each end, no lights,

just a few bulbs too faint to read by, no beds, just straw mats, some-
times just straw on the floor, rats that "marched around in full view in
the barracks" and "circulated everywhere at their ease," until forty-
nine of them met their end in one room in one day. Send something
to drink, one woman wrote home, since we can't drink the water here,
and send rubber boots. "The mud of Gurs. Nobody who passed
through here will ever forget it": One woman fell and died of suffoca-
tion, others slipped on the swampy ground and spilled the meals of
chick-peas, cabbage, and turnips. Infection moved in with hunger, as
women washed in horse troughs and vegetables rotted on the ground.

At Gurs it never troubled officials to throw German Nazis in with
German Jews, fascists in with Communists, pacifists with arms profi-
teers, but their "Instructions Concerning Discipline at Gurs" kept the
women's side of the camp rigorously off-limits to the men. This fussi-
ness about gender made the outrage of internment look faintly
proper. In 1940 inmate Gert Wollheim painted a man straining to
pass bread over a fence to his wife. Another painter, Karl Schwesig,
bitterly superimposed the word *Égalité* over a typical Gurs scene: a
father kept by barbed wire from a mother kept by barbed wire from a
wretched child.

As soon as inmates followed the officers' first order—This way to
the women's camp, that way to the men's camp—they took in the pri-
mary code: identity is formed at conception, untouched by personal
history. This code was used even before France's anti-Jewish laws of
October 1940 taught exiles their racial caste. Against it, an individual
had to *assert* a singular past. If CS's paintings looked unswervingly at
private history, this was because they took shape after Gurs.

"L'École de Gurs"

"The school of Gurs," as inmates called the camp, had a lot to
teach about being female, how comradely and how defenseless it
could feel. Inmates' paintings of 1940 show the men looking distrust-
ful, whereas the women turn toward each other in front of the bar-
racks, or at the shower or hanging laundry or promenading around
the water taps "as if they were at Biarritz." That women complained
about "little vile actions" or "mendacity," but not about theft, suggests
they expected to cooperate. Contrast the description by Lion Feucht-

wanger of the men's camp at Les Milles (a place where "the man who was your friend today became your enemy tomorrow") with his wife Marta's report on Gurs ("when a child was born there many women went without their coffee for breakfast [so] that their water rations might go to the young mother"). Another woman wrote from Gurs in 1940, "a neighbor is a relative. And one has the chance of helping a thousand times." A neighbor is a relative: women seemed to draw more readily on a concept they called "family."

They needed it in a place where femaleness put them in jeopardy. "The women are subjected to rough police agents who have the sole supervision over the women's camps," said one report. "Every night the officer in charge of our block came with his dogs to look for the prettiest girl to sleep with. In exchange, he gave her something to eat." Sex was hard currency, the way women and girls had to pay. Also the women's camp, as paintings and photos show, had to sustain all the newborns and children—in summer 1940 probably three hundred children—with nowhere to go. It is true that fathers wept for children they were not allowed to hold or help. An active man said he existed like a parasite from meal to meal. But when men referred to *l'école de Gurs*," they meant it taught them militance. Any woman like Lotte Salomon was absorbing a primer on women's burdens instead, and this may have slipped into her version of her mother's despair.

Yet "the school of Gurs" taught another lesson, this one about art: how to use supplies brought by charities, how to compose a dreary day into vignettes as Liesel Felsenthal did, or inject sunflowers into a barracks scene like Hertha Hausmann, or make lively drawings like Lou Albert-Lazard, or turn organisms inside out like Hans Reichel. "The camp is nothing but a sewer," with aspirin the hot item on the black market, one Gurs diary noted, but all day the prisoners paint and at night they sing. So many artworks took form during the summer of 1940 that they were called "the miracle of Gurs" by inmate Hanna Schramm: "The extraordinary thing . . . was the numerous works of amateurs, both artists and artisans. . . . One felt the joy of creating, the joy of fabricating an impeccable product, as the artisans of old must have known it." A few years later, outside the camp, Lotte Salomon tried to make another impeccable product, another miracle of Gurs.

"Set us free"

In the mornings, when village nuns chanted the *Libera Nos*, Jewish women heard the prayer as their own: "Set us free." Some begged the French commandant for release, as Lotte's friend Annie Nagler did: "I'll take my chance with Hitler," she told him, "but not with the rats of Gurs." He signed a release, but she handed it back till he let a friend and their two babies out too. Then suddenly "a German commission came to the office to examine the prisoners' papers," noted the diary of Léon Moussinac on July 12, 1940. That was the day they released Lotte Salomon (according to Emil Straus), in order to accompany her grandfather home. And that was the day she lost her protection by the French. The Franco-German armistice of June 1940 had divided France into a northern Occupied Zone under German control and a southern Unoccupied Zone under the Nazi-approved Vichy regime. One of the armistice terms, known as "the Sword of Damocles over all the refugees," ordered both zones "to hand over, on demand, all German nationals designated by the Reich government." The Reich could retake control of everyone who escaped Germany by entering France, everyone who was persecuted by France for being German. The lucky ones not handed over "on demand" in the summer of 1940 faced the "great question mark," as refugee Alma Mahler Werfel called it. "Where to?"

Spain? That required an exit visa from France, a transit permit from the Spanish government, and papers for another country. Unoccupied France? Few regions welcomed foreigners from camps. As the release of six thousand women proceeded in July 1940, "we learnt horrible news of those women who were already freed: outside, without money, they would find absolutely nothing to eat."

Lotte Salomon, by luck, by foresight, by privilege, had a permit and a place to live in Nice. Leaving Gurs in July 1940 quite simply saved her life. In the harsh winter that followed, Gurs improved only its chapel, added a crucifix, and populated its cemetery. Over the next years at least four thousand Jews lost their lives as the Vichy regime made Gurs a conduit to German murder camps.

Yet not many people now have heard its name. Many of its dossiers were burned, and some went into archive files opened only

by permit. For Gurs represents Vichy collaboration at its extreme: The files show, for instance, that Gurs prepared to imprison ten thousand German Jews in October 1940, even before the Reich had expelled them.

Once released, Annie Nagler never spoke with her friend Lotte or even with her own son about internment. Gurs was a syllable people stopped pronouncing if they got out. CS never put those weeks into her record, as if the time in camp formed a parenthesis. But it was also a genesis. Imprisonment gave her a premonition, release a reprieve, that spurred her to paint her life.

"The question"

Memory needs to pick through jumbled oddments for items to be used. What CS salvaged from summer 1940 was not her experience of a camp, though she was able to paint her father's time in Sachsenhausen. What she preserved was disgust with her grandfather—as if the rats, the sweat, the noise, the violations of a very solitary person all embodied themselves in him. Three weeks in the ratty barracks of Gurs, and not a single commemorative sketch. Eight full paintings

"My grandfather was a symbol of the people I had to fight."

devoted to where Grosspapa and Charlotte would sleep a few nights after they got out. Maybe those nights, recalled two years later, trespassed the deepest part of her self, where she had to fend off even her fellow exiles.

In scenes on the way back to Nice, Grosspapa crowds Charlotte's spirit and body, saying, "What's wrong with sharing a bed with me if there's nothing else around?" Charlotte, a mere refugee on the road, has to ask an innkeeper: "Would it be possible—I can't sleep beside my grandfather—for me to sleep somewhere else?" Then she meets a stranger looking for his family and tilts back in empathy ("We too are German refugees"), but he responds by putting an arm around her. She pulls away, he carps, she barricades her door for the "first sleep in three weeks," he forces his way in the window, she screams, "You get out of here"—the sentence of eviction aimed at every refugee. The innkeeper starts to eject him, but Charlotte pretends to take blame: "That would cause him such shame—and it's entirely, I assure you, dear Madame, my own fault, and we will leave today."

So it was not the camp of Gurs that CS's memory revived, but a wearying condition told in a made-up chant: "A little girl, a big bed, after so much suffered, so many dead. . . . A little culture, a few rules, a vacuum at the core. That's all that's left of human beings in these times of ours." By spelling *Datums* ("times") as *Datuum*, she rhymes the times with *"Vakuum,"* and by stamping the word "vacuum" on her body, she sets the hollowness inside herself. Only an epiphany saves her from the "vacuum at the core": two trudging exiles, Grosspapa and Charlotte, are suddenly irradiated by a sunset. Her arms break out and lift to it, her colors join its colors, her words reach into it:

"GOTT MEIN GOTT O IST DAS SCHÖN"

("God my God oh is that beautiful").

But Grosspapa cuts in: "Come on, we've got to find someplace to sleep tonight." His need for surface comfort, his need to "accept things the way things are and not try to search for hidden meanings," draws a stubborn reaction from Charlotte. This "two-sided creature is more and more eroded by being with her grandfather"—"two-sided" because she feels concern and then contempt for him. Some scenes puff him up till the frame chops off his head.

"For me, my grandfather was a symbol of the people I had to fight," the postscript says. *Kämpfen,* "fight," sets a strong word (often

used by Nazis) against "someone who has never felt true fervor for anything in the world" except himself. The final clash between the two of them comes to pass "in July 1940 on the way from a small town in the Pyrenees to Nice."

"Grosspapa, I've come to feel that one must piece the whole world back together again."

"Oh just do it, kill yourself too, so this yakking of yours can stop!"

Kill yourself too? The deadly jab brings Charlotte to a deep emergency. She calls it "the question: whether to take her life or undertake something wildly unusual" (*etwas ganz verrückt besonderes*).

When Lotte Salomon settled in Nice again in fall 1940, she had to think of something wildly unusual to undertake. Maybe an autobiography in art.

8

CONCEPTION

(1941)

〜

None of the paintings Lotte had made in France before 1941 led directly to her great graphic work. They showed rooftops overlooking the sea, a baby asleep, an orchard outside her grandparents' cottage with every leaf shivering in the light. They showed things she could see or could sell. Soft pastels of children at l'Ermitage were subsidized by Ottilie Moore, delicate storybook illustrations filled orders for a publisher, and hand-painted postcards went on sale. She "worked very industriously at some watercolor illustrations for a children's book of fairy tales," Mrs. Moore's nephew recalled. "In addition, she did dozens of pastels on many subjects: garden, countryside and oceanside scenes, my cousin and me, the gardener at work. They were quiet, conventional."

In 1940 she made motions toward more personal themes—portraits of Grossmama, sketches on the train toward Gurs—and she did a dozen self-portraits, all but one lost. It is a stunning three-quarter face, signed "CS 1940." Its eyes arrest and accuse and cannot be overlooked; but the skin, hair, clothes, and background stay utterly spare, giving no clue what this person might have been. Eventually it took a thousand scenes to magnify so expendable a face—a female, stateless, Jewish face.

What made her finally pick up a brush and give that face a past? By her own account in *Life? or Theater?*, the first source was "the ques-

Self-portrait in oil, 1940.

tion: whether to take her own life or undertake something wildly
unusual." "The question" grew from all the Epilogue's events: the
attempt to rescue Grossmama ("Instead of taking your life, you could
apply the same power to describing your life"), the uncovered secret
of family suicides that if it failed to kill her, could make her "live for
them all," the internment for being what she never was, a German
spy, the presentiment that exiles could be erased, the "vacuum at the
core," the newfound source of insight: "Dream, speak to me."

But her invention had even wider roots than those exposed in the
scenes or in the postscript. Certain local currents of 1941 made her
style take a sharp inward turn.

"Happy New Year, 1941": one of Lotte's cards.

During her two years in Villefranche and Nice, Lotte had learned the word *without*. All exiles learned it. A person without a state—the French term *L'Apatride*—became the obvious title for a book about exile; another was *Jean Sans Terre*, a man without a land; another was *Die Rechtlosen*, those without rights. By 1941 the exiles were without histories either, as their previous identities wore down. "Exiles," Lion Feuchtwanger said, "found it hard to obtain official confirmation that they were who they were." "When I had to depend upon identity papers," Stefan Zweig wrote, "I ceased to feel as if I quite belonged to myself." So they started to probe their pasts where they used to be who they were. They made memoirs and self-portraits, they rebuilt

profiles that had been flattened out. Estranged from the environment, they peopled their own minds. "What else is there left to us writers in exile but to nourish our memories and write memoirs?" wrote Ernst Weiss a year before his suicide. And Stefan Zweig not long before his: "Take refuge in your innermost self, in your work, flee to where you are no more than your own being, not the citizen of a state."

On alien ground, CS wrote, "the world disintegrated more and more" and her spirit "kept collapsing more and more." But "desperately unhappy," in summer 1941, "at this time, I began to work on the drawings in hand." She marked the moment in her private postscript as a downward search: "I had to go deeper into solitude, then maybe I could find—what I had to find! It is my *self*: a name for myself. And so I began Life and Theater."

"And so I began Life and Theater"

Few ways of starting a memoir strike a more irregular note than "Dedicated to Ottilie Moore, consisting of a Prologue, a Main Part, and an Epilogue!" The dedication takes the audience into a fiction through its only real name, implying that Ottilie Moore prompted the whole work. No image of Mrs. Moore made its way into *Life?* or *Theater?* but its moment of conception owed peculiarly to her.

Ottilie Moore "always saw herself as a kind of patroness of the

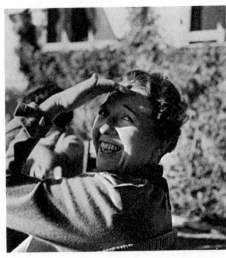

Ottilie Moore at l'Ermitage around 1940—in Lotte's eyes, a "somewhat unbalanced, rich American [who] wanted to reawaken joy" among her refugees.

Lotte tells a child frightened by a tree: "Let's make a painting of it."

arts," her nephew Wally Moore recalled, "and this is why she got Lotte to make sketches of all the daily life around Villefranche. In fact, she told me she thought that in Lotte she had discovered a genius." Mrs. Moore hired this genius to give drawing lessons to her nine-year-old daughter Didi, who remembered Lotte as exceedingly patient and kind. Once, on a dare from Wally, Didi tried to climb a tree at l'Ermitage, and told Lotte how terrified she'd been. To bring comfort, Lotte knew what to say: "Let's make a painting of it." Apparently Lotte had patched up the rift between herself and l'Ermitage, and begun to travel an hour or so from Nice, where she and Grosspapa lived, to keep in touch with Ottilie Moore's complex ménage. Mrs. Moore was "finding housing, work permits, false documents, medical care, etc., for a large number of Jewish families," her nephew recalled. She even disappeared from time to time for underground

Lotte's portrait of Wally Moore.

and Communist contacts—which may explain some curious entries in the U.S. government files. In October 1940 the State Department inquired into her whereabouts, and the Nice Consulate confirmed a two-thousand-dollar "payment to Mrs. Moore," most likely from her relatives in the U.S., for sheltering children whose parents were under arrest or killed. Wally Moore had once memorized the names of "all the children who lived at the villa from 1939 until we departed in October 1941. I do remember that they numbered over 300!"

Helping with the thirty-odd children in the house at any given time, plus the Jewish women about to give birth, Annie Nagler had occasion to know all about Madame Ottilie Moore. "She was a woman of two faces, *une femme de deux visages*. She forced my brother-in-law Alexander Nagler to drink with her though every drop was poison for his stomach. She threw him out of the house, literally, and she kicked out Lotte's grandparents too. She managed to do good deeds because she *knew* she'd done wrong. Ottilie Moore? Wicked." But Lotte's private postscript intuited a moral drive in Mrs. Moore:

> Terrible disappointment this woman must feel and have felt in all the many people to whom she had given a piece of herself, for almost everyone left her the way my grandparents did: with ingratitude contempt and scorn! . . . What a desire to be virtuous it takes in order to do what she did: the terrors of the time influenced her to take in poor and homeless children like us—to raise them in her own home, like her own child—and through gymnastics, music, pretty clothes, cleanliness, sports of all kinds, dance etc., to show and give back to them the joy of living. . . . Then came the death of my grandmother. This woman I've been describing came to us immediately and I slammed the door in her face. . . . Although I had thrown her out in the most hurtful way, she came back time and again. Frankly, she was the only person who got enjoyment from my drawings, so much so that she bought quite a few and hung them up, beautifully framed, in her house.

Maybe the first words of *Life? or Theater?*—"Dedicated to Ottilie Moore"—meant to pay off a debt, as Grossmama did with jewelry and Annie Nagler with housework, or to make up for slamming the door, or to prove she'd become the "genius" Ottilie imagined. Or to frame a morality play.

There were those who reached out to help, like Mrs. Moore, and there were those who never, thanks to the others, had to take such pains. In many scenes Grosspapa excuses himself from his wife's family, and even Albert retreats from his wife into work. There were those who studied others' lives, like Alfred Wolfsohn, and those who saw things "only from their own point of view." CS announced right from the start that she would "go out of herself entirely and let the

characters sing or speak in voices of their own." A fluid outlook was all she aspired to.

But just when the artist was ready to let the characters speak in voices of their own, Grosspapa's real voice stopped her short. The private postscript says:

> Living with my grandfather makes me sick and even though [Ottilie Moore] knew his character she took him back to her house—where he behaved himself very badly. He stole fruit from the cellar and accused the children of it and especially enjoyed vilifying his hostess to the servants. He quite forgot that all this did not suit his venerable beard and all his supposed education and culture. It couldn't be helped, he had to return to me!!!! . . . Being near him I was overwhelmed again by a paralyzing stupor. . . . To have had such insights and now back to this buffoon—to take care of him. . . . Everything I did for my grandfather made the blood rush to my face.

What brought her to such outrage, when all through childhood Lotte had adored her Grosspapa? In Berlin Herr Doktor Grunwald always showed himself a fine and charming man, living "on top of the world," in the eyes of an old friend. "Nothing unexpected was allowed to disturb the sacred daily routine" of his household there, Lotte recalled. But here in Nice in his seventies, he scrambled like the rest for papers, safety, and food. He'd been rich, exile impoverished him. He'd been loved, exile took his wife. He'd been respected, exile demeaned him. And his neediness reduced his granddaughter to keeping house for him, though she'd always kept clear of woman's work.

Then why did she stay? "I had a residence permit only in order to take care of him," the postscript says. Even "overwhelmed by a paralyzing stupor" in his presence, she paid this price for being able to settle safely in Nice.

"We stayed tranquil enough on the Côte d'Azur"

The city of Nice opened downward from the railway. Through the early 1940s, foreigners poured out of trains and stored their suitcases in each little hotel or seaside flat that kept itself, in those years,

open to Jews. They spent what they had in the shops, gathered in cafés along the Promenade des Anglais, talked aloud in all their tongues, took High Holidays at the synagogue, organized a Yiddish writers group, held rabbinic court in the Hotel Roosevelt, walked about town in Orthodox dress, exhibited artwork in the galleries, assembled youngsters in a Jewish choir, housed welfare services in main streets, and never once sewed on a yellow star. Refugees believed "things were bad in all the other places and we were the fortunate." Lotte thought, "While there were battles everywhere, we stayed tranquil enough on the Côte d'Azur." It happened to be one place in Western Europe where she still had the liberty to sit by the sea and look "deep into the heart of humankind."

But by the time she was reporting from the region in late 1941, she could see how a "tranquil enough" place starts to act besieged. Newspapers kept headlining shortages: rations down to sixteen hundred calories a day, bread allotment dropping, children's supplement slipping away; in the record freezes of 1941, no vegetables, no fresh milk, no canned milk for anyone over eighteen months. A resident recounted how "workmen and their families are literally starving, as the Alpes-Maritimes [Nice's province] is possibly the most denuded department in the whole of France." Women lived their lives in ration lines; children missed their growth there. Normal life slowed down to wasted time, black market, night hunger.

These were wartime disasters. But on the Côte d'Azur something took the blame besides the war. Each hardship pointed back to the same source—those called "the dependents," "the stateless," "the Israelites." Food wasn't scarce, people said, it was hoarded for profit by Jews. The "Jewish and foreign element," they said, was born to luxury and never could bear rationing. "As long as these elements continue to use the black market, the problem can only be solved at the national level," proclaimed the prefect of Police, who governed Alpes-Maritimes for the Vichy regime, in full collaboration with the Germans, and who wanted to imprison all the Jews.

The same tale applied to unemployment: not a general strain but a Jewish scourge. In fact the Riviera had always tapped Europe's tourist stream till wartime shut it off. When thousands of Nice inhabitants lost work, the refugees got blamed for taking away their jobs. In reality, by spring 1941, Vichy law limited all public employment to

French citizens, and by autumn it forced the "aryanization" of private property. Alpes-Maritimes confiscated 698 Jewish enterprises, many more than most locales. While "the cleansing of certain commercial areas ... met with general approval," the prefect reported that the populace had to depend on exactly what it despised, the "several thousand Israelites" who filled up the hotels.

Propaganda explained that degrading paradox: the lowly parasites were really cunning profiteers. "The peoples of Europe seem disposed to commit suicide," a local pamphlet read, "led by the pedagogues of Jewish high finance whose Normal School is in Moscow." The Jews are to blame for France's defeat in this war—and for Germany's in the last one, said the Nice papers: "This Jewish war will be Shylock's claw pouncing upon the world." "A Jewish problem already existed before the war, and that is exactly why we have had the war." "Workers of Nice! You have fought from 1936 to 1940 against 200 families," mostly Jewish, "the only ones responsible for a war they alone desired."

Refugees watched as movie posters advertised the vicious hit *Jew Süss* and gangs shoved Jews off ration lines. They watched as an antiforeign Veterans' Legion, the Légion Française des Combattants, was founded in Nice with ten thousand people applauding, and they saw it enlist sixty thousand local members by 1941. Lotte Salomon could not have missed the Légion displays of native hatred toward the Jews. When its elite SOL (Service d'Ordre Légionnaire) started up in Nice, the outdoor initiation of three thousand members took over the town:

> Are you against skepticism and for faith? Are you against democracy and for authority?
> All the SOL members: *OUI.* . . .
> Against Jewish leprosy and for French purity?
> *OUI!*

Still, alert refugees could follow countercurrents. Occasionally a tract appeared in the morning mailbox denouncing Nazis, or a Gaullist V showed up on a wall. Sometimes police curbed the squads that smashed up Jewish property. So refugees continued their lives above

ground, all the while wondering where they could go before the "tranquil enough Côte d'Azur" (as Lotte called it) closed them in.

"Case killed"

Only powerful sponsors could bring Jews out of Europe, a privilege Albert and Paula Salomon relied on for a good while. In Amsterdam they waited to be issued U.S. visas, living in the meantime with Kurt Singer, the Kulturbund idealist, who now gave lessons to children like Margot Frank and her sister Anne. With affidavits all in order, from Albert Einstein inviting Albert Salomon to Princeton, and from Rudolf Bing asking Paula Lindberg to the Metropolitan Opera, they would meet Lotte in Marseille and go to America, all three. But the U.S. consul in Rotterdam held fast: No visas for Jews. At the juncture when their exit plans ran aground, Lotte needed to try a way out by herself. Her confession in the postscript, "I was overwhelmed again by a paralyzing stupor," suggests that something—her grandfather and maybe the visa process—discouraged her just when more energy was required.

Waiting in southern France, refugees learned they needed a visa from France to leave, one from Spain and Portugal to cross, and one from the United States to get in. The first ran out before they got the last, which required a passport and consent from the U.S. vice consul in Nice—"but Jewish refugees," Franz Schoenberner wrote, "could rarely satisfy his sense of bureaucratic perfection." "Anyone from Germany finds it impossible" to get out of France, reported the Joint Distribution Committee; even with well-forged documents, "where there is the slightest suspicion, they are often refused." Schoenberner's visa finally came through, thanks to a recommendation by the Committee for the Protection of European Intellectuals—the only Europeans that FBI director J. Edgar Hoover thought "in urgent need of protection." Two thousand émigrés "of intellectual superiority" were accepted, five hundred of them labor leaders and five hundred rabbis and disciples. Almost without exception, the lucky ones were men, sometimes their wives—and how many slots for nobodies?

All fairness was reduced to form, or rather formula: "Entry of alien might be inimical to best interests of the United States," or "Unable

to present conclusive evidence as eminent intellectual." The State Department compiled an entire list of "aliens unable to present documentary evidence establishing eminences as intellectuals or labor leaders." When it denied a visa, as it did in almost every instance, the original request was stamped by some official in Washington: CASE KILLED.

Meanwhile in Nice the U.S. Consulate took in three thousand visa requests in early 1941 and granted eighty for "eminent intellectuals." American officials were "clean, polite, helpful," one applicant said, "but everyone knows they close the doors on German Jews." "Withhold visas from applicants who have members of their immediate families in areas where they may be subject to influences," the State Department ordered, meaning that Jews with relatives in Germany might succumb to spying for Hitler. This fear got so irrational that the FBI checked one hundred visa requests a day to pick out Axis agents, while in Nice alone, "every day two or three hundred persons, Jews for the most part, passed through the [U.S.] consulate for immigration visas," according to a French employee there: "We did all that was humanly possible to help them. Later we even procured false papers for them." But later was too late for most Jews. Lotte must have conceded her chance all along, for none of the thousands of requests to the U.S. Consulate came from her.

Nothing seemed likely to change, even when Ottilie Moore changed her mind about France. The approval of her visa request sprang out among all the rejections in the files: "19 August 1941. U.S. State Department to Nice Consulate. Visa case. Six children protégés of Mrs. Ottilie Moore may be approved." Her nephew Wally Moore recalled that in October 1941 Ottilie packed her car with himself and nine other children, two goats and a pig, and "set off across southern France, through Spain, to Lisbon . . . bound for New York." No hint emerges that Ottilie tried to get a visa for any adult. Probably she thought it out of reach. The United States was refusing to engage in "the bartering and sale of citizenship on public market" (said a letter from Undersecretary of State Sumner Welles to Eleanor Roosevelt), so no more visas would be issued to Germans in unoccupied France.

With regular channels closing, other measures might have worked. Could Ottilie have married Alexander Nagler, adopted Lotte as a daughter? These were things her nephew Wally Moore did thirty

years later when Saigon fell, to get a woman out of Vietnam. Perhaps Ottilie wanted Alexander at l'Ermitage and Lotte nearby, watching over the orphans left behind. Perhaps Lotte never actually implored Ottilie to take her along, not wanting to make a nuisance of herself or abandon Grosspapa in Nice, or force him again on Mrs. Moore, or locate forged identity papers for them both; not wanting to imagine the absurd—Nice turning Nazi like Vienna, like Berlin; not wanting to leave the continent where her parents were confined.

The day Ottilie Moore's car followed the road west, it took away Lotte's only chance of escape. From then on, at age twenty-four, she was on her own. Without a means to leave, she took off anyway, not westward but inward and backward, to forge her own identity document.

"Emigration has now been replaced"

By late October 1941 when Ottilie Moore left France, refugees felt themselves sealed in—though as far as they knew, the Nazis wanted Jews expelled. What they didn't know was that the SS was steering Jews to Poland, and the pilot was Alois Brunner in Vienna's Central Office of Jewish Emigration.

There Brunner invented a means to make the Jewish people destroy themselves. He commissioned a Viennese Jewish Order Service to raid apartments, old-age homes, and hospitals—even before the Nazis set up Warsaw's famous Jewish Council, the Judenrat. He announced that if Jews refused to round up Jews, he would do it himself, SS-style. He promised to keep orphans and war wounded off the transports as long as the Jewish Order Service put on someone else. This caused the community to split at every seam. Then Brunner started exceeding orders and deporting orphans, veterans, and spouses of Aryans, all exempt till then.

Suddenly the great question of fall 1941 was what to do with all the Jews in Nazi hands after the invasions of Western Europe, Eastern Europe, and the USSR—far too many now for the planned "Jewish Reservation" that Brunner had been sending transports to. So Nazi officials called it off. The path was clear by November 1941 for the mighty RSHA (Reichsicherheitshauptamt—Reich Security Main Office, combining SS and Gestapo) to call a high-level meeting and

make new plans. This meeting took place at a villa outside Berlin on the lake called Wannsee, where Lotte and Wolfsohn had floated passionately a few years before. There in the top-secret Wannsee Protocol of January 20, 1942, the SS reversed its drive to expel. Now no more Jews would leave the continent. No other solutions would be tried. This would be the final one:

> The Reichsführer SS [Himmler] . . . has forbidden the emigration of Jews. Emigration has now been replaced by evacuation of the Jews to the East [meaning, to death camps in Poland]. . . . Europe is to be combed through from West to East in the course of the practical implementation of the final solution. . . . In occupied and unoccupied France the rounding up of the Jews for evacuation will, in all probability, be carried out without great difficulties.

9

PRESENTATION

(1941–1942)

~

In unoccupied France, knowing nothing of Nazi plans, Lotte wrote: "My passion for drawing grew and grew—the more I felt my passion for it was blessed," and she hinted this passion was stretching her sense of herself: "The war raged on and I sat by the sea and saw deep into the heart of humankind. I was my mother my grandmother indeed I was all the characters in my play. I learned to walk all paths and became myself."

To allow this latitude, Lotte moved away from Grosspapa and out of Nice, three towns toward Italy. At the end of 1941 she found a little hotel called La Belle Aurore, "Beautiful Dawn," in the resort town of St. Jean Cap Ferrat, so high on a hill that the sea below looked flat and flecked like polished lapis lazuli. There she dipped her brush in blue and painted her vivid scenes. The task seemed to brighten her personality. Marthe Pécher, who owned the Belle Aurore, always recalled what this one guest was like:

> Charlotte was a sunny girl. She had something clear, sincere, I would say almost luminous about her. I never noticed any timidity. In any case she did not seem timid with me and why should she? We were living, both of us, through some very bad moments. She always painted in her room, Number 1, a little room carpeted in pink. Charlotte rented only the room, she did not take meals, so

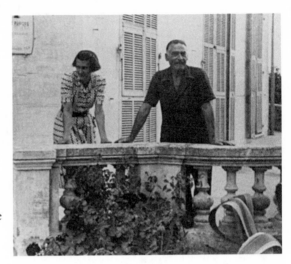

Marthe Pécher and her
husband at La Belle Aurore
in St. Jean Cap Ferrat—
Lotte's home in 1941–42.

> sometimes in the evening I used to take her a bowl of hot soup—
> rutabaga, that horrible rutabaga—practically our only nourishment
> at the time.

In a most revealing memory, Marthe Pécher described the way Lotte
"painted all the time, always while humming. We used to wonder
when and if she ate, when and if she slept." All the time painting.
Always humming, *"toujours chantonnant."*

"A musically colored mood"

Melodies before anything else inspired the scenes, before any ver-
bal texts, before the images. First Lotte hummed, then scribbled musi-
cal cues on the sheets, then turned them over and started to paint.
Her captions often say, "The painting arose from the same melody . . ."
or, "This picture actually came out of the melody . . ." or, "A fiery cur-
rent stirs his sensitive nerves—which is understandable, when you
realize this picture originated with the tune . . ." What original logic:
the song prompts the picture, and the picture fires the figure's nerves.
She was elated to make a transfusion from sound to sight:

> The origin of the present set of pages is to be imagined as follows:
> A person is sitting at the sea. And painting. A melody suddenly
> comes to mind. Starting to hum it, the person notices that the

melody exactly resembles what needs to go down on paper. A text takes form in thought, and now in a loud voice, the melody begins to be sung, countless times, along with the text being painted, until the page appears ready. Often, several pages are painted, and a duet arises, or it even happens that all the characters have different texts to sing, from which emerges a chorus.

Later in the work CS took pains to explain this experimental process again, through Daberlohn: "A musically colored mood governs him: from a confused swirling of lines a theatrical mask of Paulinka comes into his view." Often CS used bold expressionist streams, like the brushstrokes in Edvard Munch or Gustav Klimt, to squeeze colors out of sounds.

Paula Salomon-Lindberg's voice must have moved Lotte's brush, for most of the work's several dozen melodies flow straight from a German singer's repertoire. A number of scenes are accompanied by Bach's "Bist Du Bei Mir," a song Paula recorded before the Nazis stopped her career. A rare extant recording shows what Lotte actually heard as she painted—a rendition so slow and aching that it almost falls silent before the last word: "I go with joy toward death and to my—rest." Other melodies in the scenes feature crossings of music with poetry, like "Wanderer's Night Song" (Schubert and Goethe), "Wandering Is the Miller's Joy" (Schubert and Muller), "Lorelei" (Sücher and Heine), "Death and the Maiden" (Schubert and Claudius), "Zarathustra's Midnight Song" (Mahler and Nietzsche), "Ode to Joy" (Beethoven and Schiller). Into this sound-portrait of Germany, CS also injected political din—anthems like the Nazis' "Horst-Wessel-Lied," the French "Marseillaise," the German "Deutschland, Deutschland über Alles." None of this music was identified except by snatches of lyrics painted on the overlays. The audience that CS had in mind would know the language and the music and the aural resources of a German Jew.

Whether the lyrics appear on the overlays or later spread within the paintings, like *Orfeo ed Euridice* or "Death and the Maiden," music always takes part in the story. The moment "Charlotte begins to sing the song of farewell to her native land," music seizes the spirits from her past and brings them back: "All the melodies are repeated" from her childhood. Toward the end, when Beethoven's "Ode to Joy" hov-

ers over Grossmama, Charlotte calls on music to save a life and only then it fails.

"A three-color opera"

This was eccentric—to start the scenes from melodies, to label a memoir an operetta, to arrange it in acts, to introduce the people in her life as "the performers," to give them satiric fictional names, to transform the "I" of diaries into the "she" of stories, to narrate the scenes through an unnamed "author," to take a true account and treat it like a script—so eccentric that CS gave this unique form a name: *Dreifarben Singespiel*. This phrase has been translated as "tri-color opera," as if CS were among the wartime painters who used France's red, white, and blue as a resistance sign. "Three-color opera" seems better, since she was possibly making a bow to the *Threepenny Opera* by Brecht. Her three colors (red, blue, and yellow and blends of these) include little white, and astonishingly, no black—not in figures, texts, or outlines. She liked working with the middle range, the tones for light opera and satire.

The operetta had begun as a journey so private that CS confessed "its whole origin seems to me wrapped in obscurity." On the backs of early scenes she had penciled sketchy comments, usually the name of a melody or a character's words. But sometime later, she crossed these out, transferred them onto tracing sheets, and taped the sheets over the paintings: "In order to facilitate the reader's understanding, explanatory texts have been attached to many drawings," she explained. A crucial change occurred when she shifted the dramatic indicators (speeches, songs) from the backs of the paintings right out front. It would be hard to imagine a more graphic move for putting a story and its director on a set.

Wherever her "explanatory texts" still seemed too private, she revised again, penciling additions on the painted overlays, to identify a character, to indicate a new act, or sharpen a crucial scene. For instance, an early image laid out her parents' apartment at reeling angles, as if the roof had blown off as the painter was flying by. Only later did she sense the problem with the scene: Who could know what it was? So on a tracing sheet she jotted a detailed inventory describing every room. Another overlay covered Franziska's suicide

Tracing paper overlay for Franziska's suicide (compare with second color plate): the words fill the figure, the arrow leads her out the window, and the later pencil marks clarify the scene.

with the scanty words, "the nurse leaves the room," until CS added in pencil, "which Franziska made use of for this: namely, to throw herself out the window." Late in the process, her additions aimed to make the work clearer to an outside audience.

To the same end, the narrator's voice sometimes reviewed the progress of the tale. "Here a chapter had to be inserted to move the action along more clearly" or "Here comes another change in the visual conception" or "Here the author can't avoid leaving Daber-

lohn's soul and entering his partner's," or "The following pictures seem the strangest to the author. No doubt they go with the Michelangelo Rome scenes in the Main Part . . . of the whole opus." To reflect on the "whole opus" midway through it, CS must have added the narrator's part *after* finishing the paintings. A narrator made the ensemble work as theater.

She also bound together six special pages for her title, dedication, cast of characters, and list of acts—just like a playbill. Its announcement of all the sections, "a Prologue, a Main Part, and an Epilogue," suggests she made the playbill after the parts were in place. Late in the work she kept turning an introspection into a spectacle.

Even the title gained drama each time it appeared: *Leben und Theater*, "Life and Theater" in the postscript; *Leben oder Theater?* "Life or Theater?" in the last self-portrait; on the last overlay, *Das Leben oder das Theater???* and in the final playbill, *Leben? oder Theater?* with question marks for both the life and the work of presenting it.

"Change in the visual conception"

CS did not record at what date she started *Life? or Theater?*, what came first or later, when she changed it into a drama, or how she wrapped it up. The scenes suggest she began at least "a year later" than July 1940, so she must have worked on it steadily after summer 1941. According to Marthe Pécher of the Belle Aurore, Lotte was painting in her room at an astonishing rate through the winter of 1941–42. CS's postscript mentions "a winter such as few people could have experienced," and then "spring came" while she was still at work. Conceivably, from summer 1941 through summer 1942, she painted the bulk of the scenes and variants and overlays—a thousand sheets in the space of a year.

During that intense and unrecorded time from her first idea to her last self-portrait, the presentation of the past began to change. Bright and active scenes of her childhood in the 1920s also reflected her exuberance after returning in 1940 from Gurs to Nice. In contrast, paintings done later in winter 1941–42 look stripped down: musical cues and cartoon repetitions fall away, and the vibrant three-color palette contracts to heavier tones with casts of brown, gray, or rust. The story grows somber as it comes closer to the dark days when she

"Even when she was little, the girl was very fresh,
getting on her mother's nerves."

By painting her life, CS created an album that might survive. In it, she reached
back to herself as a little girl breaking away from her mother's hold during their
proper promenades (1), and imagined what the little girl had always misunder-
stood—that her mother had finally taken her own life (2). CS then recorded
those who became the magnets of her Berlin world: her stepmother Paula
Salomon-Lindberg (3), Kurt Singer, and her lover Alfred Wolfsohn (4) whose
desire overwhelmed her on a beach at Wannsee (5). Years later, she still felt the
wrench from him, from her family, from everything familiar, when she was
forced to leave Berlin (6). Resettling in Villefranche, finding her grandmother
desolate, she learned the family legacy, witnessed the suicide, and in that des-
perate moment thrust her sketchpad between the window and herself (7). In the
end CS closed her story with pages of compressed and pictureless words (8).

When Franziska says, " 'I cannot bear it anymore. I am so very alone,' the nurse leaves the room, which Franziska makes use of for this: namely, to plunge out the window."

"And this is the way their first quarrel took place."

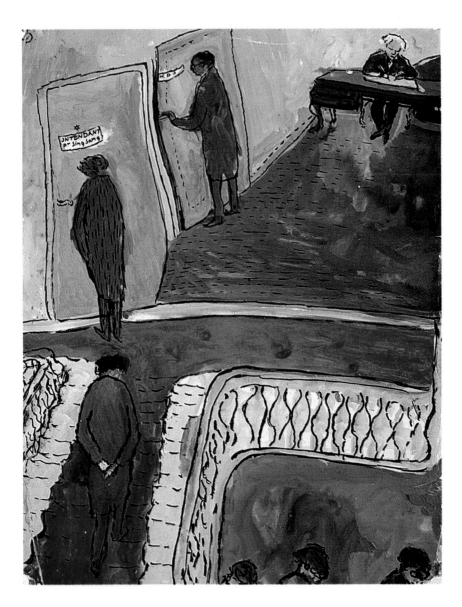

"Amadeus Daberlohn, prophet of song, enters to the theme of the toreador."

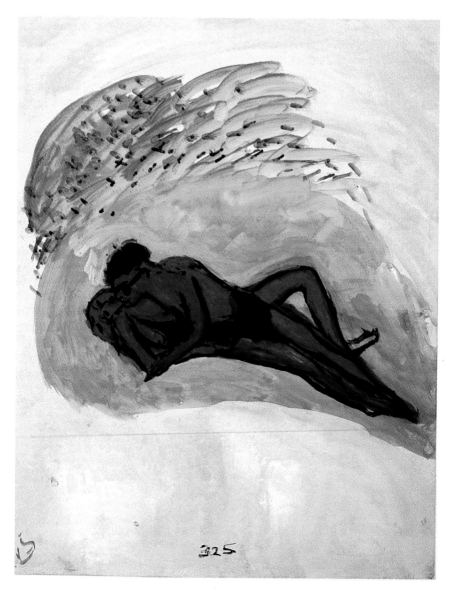

"Charlotte is lying there as if she never caused this fiery stream."

Charlotte's last night in her own room.

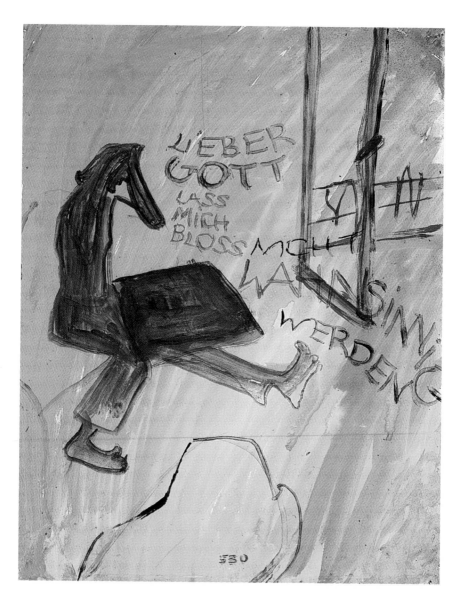

"Dear God just let me not go mad."

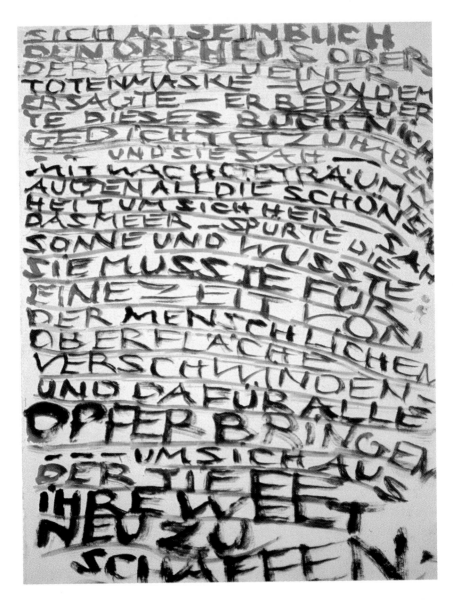

"...And with dream-awakened eyes she saw all the beauty around her, saw the sea, felt the sun, and knew: for a while she had to disappear from the surface of life and to that end make every sacrifice—so that from the depths she could create her world anew."

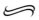

was painting it. Overlays shrink to hurried scraps that mark the acts and scenes. After the first two hundred pictures with their captions on the overlays, the artist stamps the script—now more dialogue and soliloquy than narration—right on the paintings' surface space.

From the *Kristallnacht* scenes on, the words themselves turn more foreboding, in a deeper register: "Dr. Kann, onetime professor, is forced to do hard labor." Grossmama "tries to hang herself in the bathroom." "Nobody ever told Charlotte how her relatives lost their lives." Words well up within the paintings, and language becomes the expressive graphic element. Finally words infiltrate all the spaces until the last pictures are pure letters devoid of images. Eight closing pages of *Life? or Theater?*—just syllables crammed more and more intensely in the frames—have no story left, nothing but reflections on how Charlotte put it into paint. "Drawing, as always, she fell asleep in the midday sun. And when she woke up, the painted picture of her once so dearly beloved Daberlohn lay before her. She tore the paper into a hundred thousand bits, threw them into the wind, fell asleep once more, and the experiment [with dream-painting] worked again." She tossed out a portrait of her lover, but the images kept streaming up to her. These last text pages seemed to answer the Epilogue's first lines: "Dream, speak to me. . . . What are you preserving me for?" Surely for letting uncensored memory flow into scenes.

By the end *Life? or Theater?* had outgrown its origins as a private account. To become a presentation piece in words and images, it needed a final shape. CS chose about 760 paintings, 360 overlays, eight final pages of text, and six playbill pages, putting aside around two hundred unnumbered variants and overlays. To decide between versions of a scene, she usually discarded the realism she'd been taught at the academy, and went for symbolic layouts. Among three versions of the infant Charlotte, she chose one that placed the child at the center and set up the revolving geometry of the early scenes. Among variants of Daberlohn saying "when we think we're loving one another, we ourselves are the subject and object," she chose a layout where the words squeeze him from both sides. She tried four versions of him speaking to his life mask, asking to be "suspended between life and death," and took the one where the words siphon from the mask up his arm. Even rough expressive sketchwork made the final cut, perhaps as a challenge to her audience: "Much that is artistic has been

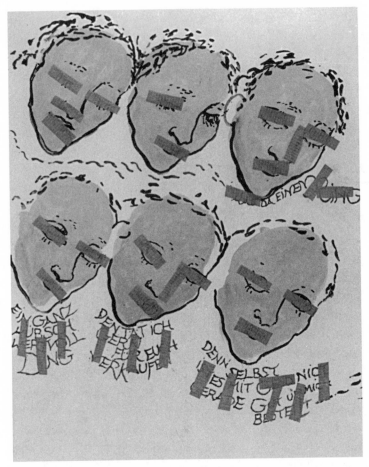

To silence a speaker, CS tapes Paulinka's powerful eyes and mouth.

renounced, which I hope will nevertheless be forgiven in view of the soul-piercing work achieved."

For a "soul-piercing work," she renounced anything that seemed too soft. Some of Paulinka's kindliness was taken out—pulling a blanket over a sleeping Charlotte who dreams of Daberlohn, or sharing an intimate breakfast, or grieving at her own mother's death. The stepmother of the final work grew easier to admire than approach. If the character of Daberlohn was to fill the stage as a prophet, CS had to leave aside pictures of his frivolous early life—cabarets, drinking, carrying women off to bed. Likewise, scenes of the grandparents' closeness to Charlotte were taken out. People turned into symbols

once CS altered a journal of the past into a *pièce à thèse*, a thesis-play. The final version placed all the characters into her major theme: how the threat of self-destruction leads to self-discovery, and secrecy to truth-seeking.

Once she had her aims in mind, CS could have thrown deleted pictures out. She did not do this. What she did was paste hand-cut paper tape, the kind she used for attaching overlays, onto the deleted scenes. Mosaics of tape block out the features of her characters, as if she were still vying with them for control. If a scene had five faces of Paulinka speaking, CS taped bits of paper over every single mouth: How particularly harsh to tape a singer's mouth! She left Daberlohn's mouth all free, but taped his eyes again and again—*that* would keep him from watching her. Saving every discarded scene, she never even thought of letting characters go or of covering her artistic tracks. She flaunted the editing. All those bits of tape would prove this was not a daily journal but a thought-out play.

By summer 1942 she was forced to edit just to move along. Paper must have run low, for the final sheets often have pictures on two sides: Painting a scene meant choosing another she could do without. One by one, she ceded scenes of Daberlohn and Paulinka to use the reverse side for the story of Grossmama and Charlotte in exile. As the war wore on, a three-way romance seemed less important than a woman trying to save two lives. Yet whenever she used both sides of a paper, she numbered only one for viewing: she imagined a moving tableau, a film—not a turn of page, not a private read.

It's in the numbering that the enigma lies. When CS completed the Prologue, she painted numbers on its overlays (1 to 211), then she let it lie. She confessed, "I myself needed a year to figure out what this singular work is about, for many of its texts and melodies, especially in the first sheets, have slipped my mind." After a while she picked up her brush and began again, with Paulinka, Daberlohn, and the grandparents—numbering the second series (the Main Part and Epilogue) on the paintings' surface, all in the same blue digits with the same brush at the same time. To put in order such a mass of new sheets (numbers 1 through 556) took a sure mind. She settled on a final version all at once.

But why had she started the Main Part again at number one? What happened in between? The break after the Prologue speaks

wordlessly of a depressed mind, and the postscript confessed as much:

> I was desperately unhappy. My old despair about certain people got the better of me again and threw me back into a slow death-like lethargy. If I can't find any joy in my life and my work I will kill myself. . . . I felt so hopeless—I had time enough to work and yet I couldn't. . . . I was overwhelmed again by a paralyzing stupor. My happiness was at an end. . . . From deepest sunny brightness to grayish darkness. . . . I was in despair. . . . It was a winter such as few people could have experienced. Extreme torpor, unable to move one finger. . . . I was ill, my face always red with dull rage and grief.

Unable to move one finger, she kept on painting, but any sense that her work was wanted seemed absurd. As she unwrapped a private story and put it onstage, she needed an audience in the German tongue—as if Germans counted her a human being or cared about her type. The truth, she knew, was that no one cared at all.

"Only colors, paintbrushes, you, and this"

In torpor, rage, and grief, CS slowly let her character exit from the center of the scenes. Halfway through the Main Part, the painter lost any focus on Charlotte's face, rotated the angle to show others instead of her, cropped her three-quarters out of the frame, portrayed her body without a head, and only twice delivered *her* words around repeated faces—and these faces in profile with one ear, no hair, one eye. By the Epilogue, the central character fuses with her grandmother and loses most features of her own. The last picture of Charlotte, painting beside the sea, makes a startling contrast to the brilliant close-up portrait done in 1940, before CS started *Life? or Theater?* It hides everything about her. Though an author's voice asserts itself awhile on the overlays, even the narrator slips out toward the end, leaving disembodied words filling the space. Where the signature had kept her present in many scenes, later even the CS drops off. A whole life history without her name signed to it. And imagine: an entire autobiography without that one word *I*.

If she was to retrieve the person known by her mother, her stepmother, her father, her lover, her grandmother—all absent—if she

was to have any "I" at all, she had to invent a "you." Midway through the play, obliquely at first, the narrator addresses an audience outside herself: "Please compare this position" (of Charlotte boating with Daberlohn) with three earlier paintings (of Franziska committing suicide); "Go on comparing." Please follow this "line of thought, after the next picture, where you will have a chance to be involved." Then an open address on an overlay: Daberlohn "would have noticed a family resemblance [between Charlotte and Grossmama]—just as *you* can once you've read the Epilogue." This last phrase means the "you" went into the script only after the artist had painted the scenes all the way through.

At that point, around the spring of 1942, CS tried to reach another absent audience. In twelve postscript pages not intended as part of the play, she spoke for once in a first-person voice. "There were trees and sky and sea, I saw nothing else. Only colors, paintbrushes, you, and this." "This" meant the work in progress, the journey into herself, which she called "my theme and yours, dearest friend." "You" had to be Alfred Wolfsohn, in the postscript, where she used the inimate *Du*. But in the drama, the "you" in its broader *Sie* form implied an imaginary common audience being summoned against the annulment of her self.

The insertion of a "you" pleads for someone else to learn this painter's "name for myself." Everywhere in Europe Jews held onto names for themselves, made portraits, kept journals, dropped messages from trains, always saying the same thing: Remember this. Often they had to imagine and then address someone outside. Anne Frank presented herself to the imaginary "Kitty." Felix Nussbaum showed the viewer an identity card—a portrait which his "real" face replicates. Historian Marc Bloch (out of home and work) wrote now, he said, for "the Muse," and journalist Bella Fromm kept notes for a mother who had died ("It was only that I felt the need to talk to someone about what was happening to Germany and to me"). Paul Celan's poem "Black Flakes" imagined a letter from his deceased mother and his answer to it, re-creating her to hear him. So many works conjured up a listener when there really could be none.

The aloneness of Lotte Salomon in 1942—the worst year in Jewish history—so matched the silence and suicide in her family that she had to break through it or give in. She had to conceive inconceivable

spectators, draw back the curtains, and enact what threatened her: the absence of an audience to speak to, the vanishing of identity. Any creative use of these conditions—and this three-color opera was ingenious!—pushed the fear of nonbeing a little farther away.

"This play is set . . . in Germany, later in Nice"

All the devices of drama—the overlays and flashbacks, the playbill and narrator—worked in CS's hands to convert real time into a span onstage. Of her own life she said, "This play is set in the period from 1913 to 1940 in Germany, later in Nice." Choosing a theatrical mode freed her from relentless facts. She attached an inexact caption, "War is declared," to "May 1940" (the date of Germany's invasion, six months after war was declared). She abstracted Xs and jots for planes and bombs. And she never gave a name to real places like her "home on the Côte d'Azur" (Villefranche), or the "little town in the Pyrenees" (Gurs) where the French put her away.

Why she never painted Gurs seemed obvious to her stepmother later on: "Ach, my dear, she couldn't make that into theater."

CS looked back on theater as a thing that might give her satiric sight. She reworked Kulturbund operas and recalled Wolfsohn praising films as idioms of modern life. Along with these memories, she learned a new dramatic irony in France, where being banished to the Riviera felt like being locked inside Eden. "And here we are" in the south of France, wrote Alma Mahler Werfel, "disoriented to the extreme," while Franz Werfel wrote his famous play of reversal, *Jacobowsky and the Colonel: Comedy of a Tragedy.* To exile writer Anna Seghers topsy-turvy felt like daily life: "You can stay here for any length of time only if you can prove that you intend to leave," and if you intend to leave, you are forced to stay. The paradoxes—helpless exiles in a world resort, unwanted refugees refused exit permits—made them see "elements of comedy . . . more and more clearly as a tragedy. This famous artistic trick," Franz Schoenberner said sharply, "was borrowed from reality."

Serious threats went hand in hand with squalid theatrics. Arthur Koestler saw himself in a "penny dreadful," a lowlife melodrama, "only reality was more dreadful." Schoenberner thought it "an agony to watch this bad show as a helpless spectator tucked away somewhere

in a corner of the balcony. . . . And while waiting for the end of the world you were counting the last pennies in your pocket and wondering whether you would be able to buy a sandwich in the next intermission." With the same sense of watching history at a cheap show, CS set the stage and addressed the spectator:

> You are hereby informed that you are located in an exclusively Jewish milieu which—for the honor of Germany—was assaulted by one party at that time, starting with our first picture of Act II [the first scene with a swastika]. It was the National Socialist Party and was so full of its own importance that no German was allowed to say "Good Morning" anymore but only "Heil Hitler." . . . That was the name of the founder and creator of this party. In common parlance the party's supporters were simply called Nazis. Their symbol was the swastika.

No European needed to be told this. This presents an inescapable fact as the prologue to a show.

Only a show, it seemed, would do justice to this peculiar exile. In the midst of war the Côte d'Azur kept putting itself on: Nice sponsored concerts in the Masséna Gardens, Cannes went out for Maurice Chevalier, Monte Carlo advertised its ballet, and the whole region treated politics like melodrama. Early on, local newspapers cast Germany and France as villain and virgin in an extravaganza: "Them or us. They say very clearly and prove ferociously what they want—the ravishing . . . of weaker nations." As soon as Vichy settled with fascism in 1940, the papers switched to a saccharine series called "Around Germany at War." Later every Nazi setback was staged in the press as a "counterattack." Every Allied air raid was "craven aggression" designed only to "massacre French workers." British advances were "repulsed" at El Alamein, Russians were always *losing* ground at Stalingrad, Germans were ever set to invade England, Mussolini was entirely beloved by the populace but "ravished by traitors."

The only other news for refugees to rely on was public ritual. No one could miss it on the Côte d'Azur, where stagy politics took up more and more communal space. On any given day, three thousand paramilitary troops knelt by torchlight to swear fealty; or flames were delivered from Notre Dame and the Arc de Triomphe in Paris to Nice's Monument for the Dead; or sachets of soil were brought from

all over France for ceremonial mixing at Nice. Much stagecraft was devoted to the yearly festival of "our great heroine" Joan of Arc, when women and children dropped to their knees in the streets and officials blessed "the most complete symbol of our race" (as against you-know-whose). In the 1939 *fête de Jeanne d'Arc*, Nice mounted an immense celebration; in 1940 the populace was so enthusiastic it had to be restrained; in 1942 officials made hoarse demands for loyalty, but after 1942, with growing doubt in a clean German victory, the festivities had to be marshaled into view.

From the stagings, refugees tried to guess how long the Côte d'Azur charade would last. On one side they watched the most virulent of French anti-Jewish movements try out their rhetoric in Nice. And on the other side they saw Jews act conspicuously safe. No matter how boldly the fascist groups paraded, refugees still found a haven there. No matter how viciously Nice mounted a Jew-hating exhibit in summer 1942, at least some spectators, like the American consul, reported its "cheap, tawdry and bankrupt appearance, neither striking nor convincing." No matter how often the prefect urged "massive internment of Israelites," in fact by summer 1942, refugees on the Côte d'Azur were not in prison camps for being Jewish, as they had been in Germany since 1938, as they were in 1940 for being German, as they were elsewhere in Occupied and Vichy France. Life in this periphery of persecution, with its military parades and its refugee élan, simply seemed surreal.

CS caught this balance of affairs just right. Not that she depicted the real locale—in fact she seemed barely conscious of it—but rather, she showed the way art permeated actuality in any place like Nice.

"It was correct to present myself"

In 1942, as the Côte d'Azur turned more overtly Nazi, as a big anti-Semitic exhibit enthralled the residents, as Lotte grew less sure what would become of her, she added penciled comments, she attached a narrator and playbill, she addressed an audience, and printed the script on the scenes—in a word, she summoned future viewers to her play. She was still painting in summer 1942 (and still humming) in the hotel of Madame Pécher, who remembered something risky she did just then: "A law at the time obliged foreign Jews

and I think French ones too, to present themselves to the authorities. . . . So she went to Nice to say she was Jewish. I asked her, 'Why go and present yourself?' She told me, 'Because there is a law, and since I'm Jewish, I thought it was correct to present myself.' So that was her conviction. That's how I learned she was a Jew."

Maybe her conviction ("it was correct to present myself" to the police) hints that her depression was giving way to destruction. Or maybe she was painting something she'd avoided when she lived it— a need to say, Here I am, count me among the Israelites. She'd been portraying Berlin just then, telling Madame Pécher of Paula Lindberg and Kurt Singer. Maybe she started imitating "correct" Jews who'd performed surgery or Schubert the way they were told, for she never understood her parents' illegal work (the less a child knew, the safer). Maybe correctness actually seemed to make sense in southern France, where refugees were lulled by the blandness of each anti-Jewish order, like "The Refugee Controller's hours will be extended just this week at the disposition of refugees who wish to see him."

What the Vichy government hid behind such orders in summer 1942 was Prime Minister Pierre Laval's pledge to deport foreigners from the southern coast instead of French-born Jews. He told a German Commissar, "the only Jews we have are *your* Jews. We will send them back to you anytime that you say." This plan filtered into the U.S. Consulate in Nice, which relayed it to the American Embassy at Vichy but not to the victims at hand. "The police here have instructions to arrest all Jewish refugees between the ages of 15 and 60 . . . regardless of sex." A little later: "as expected, the mass arrest of Jewish refugees was begun in Nice," but "no information is available as to the ultimate destination of those arrested." Reports reached the Joint Distribution Committee in New York that "seven hundred were rounded up" and sent to the Drancy camp outside Paris, then somewhere else. This roundup was so startling that one resident called it "a hallucinatory spectacle."

When Lotte presented herself to the authorities in Nice, Marthe Pécher remembered: "They put her in a bus which was already filled and ready to leave. At the last minute, a gendarme called to her. When she got out, he said: 'Leave right away, leave fast and don't come back; stay at home.'" Maybe he heard her speak French and thought, A native Jew; or favored her red-cheeked "German" look; or

just didn't like roundups and let one go. In any case, Madame Pécher recalled, "She returned here barely understanding" what she'd escaped.

None of the refugees on the Côte d'Azur understood the roundups now taking Jews from France to Poland to death. The arrests in Nice in summer 1942 only signaled to Lotte to bring her project to a close.

"I had to complete it! No matter what the cost."

With a sense of urgency to get the story told, she turned from images to words alone, then wrote with impatience in the postscript: "The months went by and I was long in finishing. . . . I had to complete it! No matter what the cost. What do I care about police or grandfather. I have to [go] back to"—and here the text breaks off and the last page or pages are lost.

Surmounting months of despair, she took up the playbill to correct its dateline: "1940/41" became "August 1941/42," perhaps to account for the time of "grayish darkness" when she could not "figure out what this singular work is about." At the bottom of the dateline she squeezed new phrases in, painting words of sarcasm in fierce blood red:

The author
St Jean August 1941/42
Or between heaven
and earth outside
our era in the year
1 of the
New Salvation.

All CS had left of history was the farce of a "New Salvation," and she had a tragedy for a family. With these as her realities, she found a way out only for the character in her drama. The play's final word-crammed pages send the character on ahead. Let Charlotte decide to paint the past and become the "living model" for Daberlohn's axiom, quoted four different times: "You must first go into yourself—into your childhood—to be able to get out of yourself." Let her discover what *"suddenly she knew. . . .* She did not need to do away with herself like her ancestors, since a person could and should rise up after hav-

ing died, to love life even more." Let her take her life history instead
of her life.

 This ending made sure she'd go on living in her story at least. The
last image of her, poised before an expanse of sea and sky, is a portrait
of the artist with her back turned, so her audience will have to watch
her doing a sketch. As she holds out her sketchpad, it takes the form
of an empty frame. The sea is flowing right through it to become her
seascape. The whole image sums her up: this is a person always trans-
forming real and changeable things (including herself) into art—a
person who makes her naked back into a placard for the words *Leben
oder Theater?* and knows her future could belong to either one. After
the words a faint trace of paint (visible only in the original) curves
along her side and joins her very being. It is the ?—the final question
mark.

10

ASYLUM

(1942–1943)

⌒

In the summer of 1942, as Lotte Salomon finished her drama, Alois
Brunner presented himself once more to the SS. After four years he
needed to submit another résumé, to have a marriage approved.
This time he took his 1938 SS form and ratcheted each detail up. If in
1938 he said his business efforts had simply failed, this time "I had to
give [them] up due to my political involvement." If then he was "a
member of the SA" like everyone, now he was "*aktiv*"—the key word.
And now he could say, "I was assigned to the Central Office for Jew-
ish Emigration in Vienna, where I am presently the director." By the
summer of 1942 "Jewish Emigration" meant that if any Jews managed
to present a passport at the Central Office, Brunner tore it up before
their eyes. They felt Brunner sucking them in instead of forcing them
out. They called him *Judenfresser*, "glutton for Jews." After snatching
forty-eight thousand Austrian Jews and five thousand Roma (Gyp-
sies), he could state that "On January 30, 1942 [one working week
after the Wannsee Conference], I was promoted to Hauptsturm-
führer," the respected SS rank of captain. He was worthy of Wannsee,
and his new résumé proved it.

He also proved, in hackneyed, lifeless words, that only when
imagining Jewish deeds did SS men reveal their true desires. Typical
Nazi statements about the Jews were always about themselves: "the
Eternal Jew will try to . . . annihilate all positive life." "The Jew was

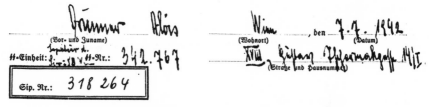

1942 marriage application from the SS Race and Resettlement Main Office, signed by Alois Brunner.

the first to introduce the lie into politics as a weapon." "Victims? Fomenters of the war," Brunner used to scream. "We lost the first Jewish [world] war, but the second Jewish war we will not lose." Nazis felt vindicated by foisting on an enemy whatever violence they themselves wanted to inflict.

On the lines of his new résumé Brunner presented even his personal life through a racial frame. In the summer of 1942, marriage by race was much on Brunner's mind. He helped make a film called *The Jews' Life in 1938*—that is, the year before the Nazis cut them down—in which old men (dragged from Jewish hospitals) held cigars in their mouths and pawed half-dressed young women (posing to survive). That was Jewish marriage.

And this was SS marriage: On lengthy forms the bride-to-be was vetted for racial flaws, her family tree pinned down and scrutinized. The family of Anni Röder looked clean. No illnesses, no suicides. Aspects of her health were probed: her age (twenty-one), her menstruation (regular), her nose (straight). "Likes children or not?" Likes children. "Domestic or fickle?" Domestic. Does she give her all to

National Socialism? "Her mental attitude is clear." She worked first as a secretary for the Hitler Youth, and then "as stenographer for the Vienna Inspector of Security Police and SD, Central Office for Jewish Emigration." In other words, she wanted to marry her boss. But first another form. This time Brunner declared his fiancée not just dependable but "very dependable," not just domestic but "decidedly domestic." The form asked, Is she suitable to marry a member of the SS? He answered *Ja*.

Then the SS member's ancestry was double-checked: Brunner's parents and grandparents were scanned for congenital defects and suicide attempts, with inquiries into the cause of every relative's death. A doctor signed. A finance form showed ten thousand Reichsmarks (four-thousand dollars) in assets, no debts. Good. This buttressed the claim that SS members never profited from exploiting Jews (though Brunner had long enriched himself in the SS, settling into a confiscated Jewish villa "with the most modish furniture," a Jewish survivor recalled, "like a museum"). On August 17, 1942, the SS Race and Resettlement Main Office granted Alois Brunner and Anni Röder a marriage permit.

To marry was no private act, as fifty pages of SS forms made clear. It was a justification of the individual to the SS and of the SS to the Reich. Clearly actions in the field were not enough. An SS man must get biologically *aktiv* too. SS chief Heinrich Himmler expected SS marriages to reverse the "suicide" of Germany—the reproductive torpor due to Jewish-fostered promiscuity, abortion, homosexuality, and of course *Selbstmord*. Any SS man who dared kill himself on personal grounds, Himmler swore, would afterward be stripped of SS membership. No man should have the private right to give or give up life. All a man should do is circle the proper type of nose and leave blank the space for family suicide—then marry like Brunner and ensure the better future of the Reich.

But the very center of that Reich, Berlin, still held fifty thousand Jews. Then, in the fall of 1942, Eichmann ordered Brunner there. He arrived in October with SS staff and Jewish aides from Vienna, to show "those damn Prussian pigs," as he put it, "how to handle *schweinhund* Jews." One Berlin Jew testified that "things changed completely [under] Brunner." As in Vienna, he leaned on Jewish leaders, promising to execute one of them for each deportee who got away. When

twenty ducked a transport, Brunner sent eight Jewish officials to be shot, then sent the ashes to their families, then sent the families to the East. Facing such terrors, one leader's heart stopped beating in front of Brunner, who yelled, "Get that Jew out of here, I don't like the way he's lying there." To school the Jews in jumping to their feet near any Aryan, Brunner kept five hundred of them standing at attention for hours in one room. Some who were there recalled him sitting casually in front, laughing with Eichmann, smoking, and looking "ridiculously young." Pure power over Jewish lives was not enough. In this telling moment, two small-minded men needed to act like big shots before their chosen audience of Jews.

From the time Brunner brought Vienna tactics to the heart of the Reich, the remnant Berlin community had no escape, and its spiritual guide, Rabbi Leo Baeck (who had always gone to Yom Kippur services wherever Paula Salomon-Lindberg sang) stayed there with his flock; only later did he find out "evacuation" transports led to death. In fall 1942 neither the captive Jews of Berlin nor the ones still free in southern France yet grasped the truth of Brunner's trains.

One Mediterranean sanctuary

From what the Jews around Nice could see, their prospects had unexpectedly improved. True, German troops had crossed into unoccupied France to defend the southern coast in November 1942, when Allied forces attacked French North Africa. But a crucial exception was Alpes-Maritimes, one of eight departments taken by Italy, not Germany. True, the Vichy regime was now under full German control, and ordered its prefects to take three steps against the Jewish refugees—isolation, segregation, deportation. But then, as the prefect in Alpes-Maritimes reported to Vichy, "The Italian authorities at the present time are putting a stop to the three great measures decreed by the French government against foreign Jews." True, Vichy wanted to ransom French Jews by supplying foreign ones, but suddenly the Italians were taking "Jews of all nationalities under their protection." Italians were Axis, but stayed dispassionate about deporting Jews.

In SS eyes the Final Solution "throughout France" was bound to stand or fall with the Italians' small, new zone, for "the influx of Jews into this zone—an influx which is only at its beginning—will assume

formidable dimensions." The SS complained that "Jewish influence
has already given birth to pacifist and communist rot in the mind of
the Italian soldiers" around Nice. But the most forceful objection
involved a kind of sexual disgust: SS reports told Eichmann how "par-
ticularly revolting" Italian protection had become, how "the best of
harmony prevails between the Italian troops and the Jewish popula-
tion," how "Italian officers show themselves openly in the company of
Jewesses," how "Jewish money, Jewish women and the fact that large
numbers of Italian officers were quartered in Jewish homes has been
playing a part in enabling a great many Jews to escape."

Here Germany's ally was sympathizing—no, fraternizing—with
Germany's archenemy. When Italian officials reported "a flood of
ardent gratitude from the Jews who find themselves in the Alpes-Mar-
itimes"—to the point that Jews raised three million francs for Italian
victims of Allied bombings—the SS was appalled. What was coming
to pass strained not just their plans but even their minds. "The atti-
tude of the Italians is and was incomprehensible," sputtered Jewish
Affairs expert Heinz Röthke, referring to Italy's commissioner for Jew-
ish affairs in Nice. What was Commissioner Lospinoso *up to*? He took
advice from an Italian-Jewish banker, Angelo Donati; he outlawed
Jewish crossing into the Italian zone, then granted asylum to every
Jew who managed it; he expelled Jews from the coast but sent them
to spas in the interior, where "they have been placed in the best
hotels." For the first time in France, SS hands were tied and plans
flummoxed. Heinz Röthke found it "intolerable that the final solution
of the Jewish question in the newly occupied territories should be
made more difficult—and to a certain extent collapse—because of the
Italians, who are Germany's allies."

The SS mistrusted the Riviera because it served the Jews as a
promised land when Germans had only Deutschland. More than a
strategic coast, this place had become a symbolic site where the Nazi
project could fail. SS sympathizers always used phrases like these:
"Nice seems a city particularly *enjuivée*"—"Jewed up." "The Jews gather
together on the Côte d'Azur, in this *ghetto parfumé*." "The Italian zone
of influence, particularly the Côte d'Azur, has become the Promised
Land for the Jews in France." "The Israelites have emigrated and con-
tinue to emigrate en masse to that promised land." "Nice [is] the new
capital of Palestine."

Refugees mistrusted the Riviera too, though it had felt safe so far. "The Germans would never get all the way to Nice," they said to each other. They watched while "Israelites arrived from every corner of France because the rumor was spread around that in Nice they would be protected by the Italians." They marveled as "Nice became the great assembly center for Jews coming from everywhere, from the Occupied Zone of France, from Holland, from Belgium, from Luxembourg." "Thousands of Jews [came] . . . to seek asylum in Alpes-Maritimes." "French Jews who at the moment were not persecuted were distrustful of this situation and they likewise procured an asylum in the Italian zone."

There could be no precise count of those who made Nice their "asylum." Back in 1941, a census reported 13,300 Israelites in and around Nice, and in March 1942, 12,873 (7,606 of them non-French). But in 1943, with Italian occupation, Jewish groups counted 20,000 in Nice alone, and at least 22,000 throughout the Côte d'Azur. To more interested parties, the SS for instance, any such estimate "constitutes only a third of the Jews who are staying there"—surely "tens of thousands of stateless Jews."

In the Italian zone Jewish groups were serving Jewish needs in welfare centers and synagogues, and Italian police were protecting them from harassment. There refugees only worried whether to trust a place so concentrated and exposed. They asked themselves, Would the Italians, *could* the Italians, keep them safe? The answer depended, uneasily, on how the French populace was handling this new influx to the coast.

"Aimez-vous les Juifs?"

"Do you like Jews?" Vichy's General Commission on Jewish Questions queried 318 Nice residents in early 1943. "*Non,*" answered almost half. Four-fifths (much higher than elsewhere in southern France) expected Vichy to intern more Jews. Though the investigators might have scared the people they questioned, their survey of 3,000 residents in southern France still reveals the hatred Jews contended with. Yet one point about the poll has gone unnoticed: It meant to survey men. Investigators were told to find 90 percent male respondents—that is, to find out if the more political sex would

accept harsher treatment of the Jews. When asked, "Do you like Jews?" 52 percent of the men said no, as against 38 percent of the women, and this differential in Nice applied as well to harder questions and other towns. Investigators noticed the gap, for they recommended a propaganda campaign targeting the female sex.

Vichy propaganda had always broadcast National Rectification vs. Jewish/Communist/foreign corruption in male-inclined images that no one had to invent. *Jew Süss*, distributed all over France, was about Lechery (Jewish and male) violating Purity (Aryan and female). A traveling exhibit, *Le Juif et la France*, featured a statue of "the Jew" (a twisted old wanton grabbing the globe from a very pure lady). One slogan ran: "The Jew is not a Frenchman. Why? He is a Jew." To switch gender—"The Jew is not a Frenchwoman"—would cancel the salaciousness in that word "Jew." A similar exhibition at Nice's Palais des Fêtes offered images of French victims (the disinherited son, betrayed soldier, dispossessed farmer) all abused by "Israelite meddling in French commercial riches, in our politics, theater, press, radio, cinema." Clearly all the contenders for these posts were men.

A woman refugee, seeing fewer insults to herself and dealing locally with other women, could imagine a buffer zone around the anti-Semites. Everyone knew that Jews like Lotte had lodged at Ottilie Moore's villa l'Ermitage, and on its walls graffiti always appeared (*À bas les juifs*, "Down with the Jews"). But Madame Moore had these slogans scrubbed away to spare her refugees. Likewise Madame Pécher, who ran her small hotel in St. Jean Cap Ferrat, found out Lotte was a Jew yet gave her a safe place to paint. Though no refugee was ever free of fear, Lotte still found in women's hands a hermitage or two.

Her dilemma at the end of 1942 was whether to stay longer in St. Jean Cap Ferrat or go back to Nice where her grandfather lived. The postscript says: "I often had letters from my grandfather, threatening disagreeable letters. Also the police would not let me stay away from him for long, since I had a residence permit only in order to take care of him. Back to my grandfather." And back to Nice, which seemed a reasonable choice by May 1943, when a new Vichy prefect entered the scene. The newspapers called Jean Chaignaux "a citizen of the elite," and Jewish leaders remarked how "the political climate in the

department radically changed." The new French prefect acted under Italian command to end that "extreme brutality" of August 1942, when Lotte was almost rounded up. Prefect Chaignaux even swore to one Jewish leader, "I would not leave to the Italians the privilege of benevolence and justice toward persecuted Jews."

There was no place like this on the Nazis' continent, where officials of the occupying and collaborating powers ended up working for the shelter of the Jews. In consequence an image of Nice as sanctuary began to outdo reality. As one refugee put it: "We lulled ourselves with illusions about the untouchability of the so-called Comté de Nice, the last safety plank surrounded by a sea rising in the Nazi flood." This strip of coast mattered vitally to both Nazis and Jews, for both saw it as the only shelter of a homeless tribe. When refugees rushed to where Lotte already lived, she rooted herself for good in the zone of contending symbols—the perfumed ghetto, the safety plank, the last resort.

Another Mediterranean sanctuary

Lotte Salomon had never been so safe. As she held to the western Mediterranean, the SS directed Captain Brunner to its eastern edge: to Salonika, the third largest city in Greece, where Moslem tolerance had attracted Jews expelled from Spain in 1492. Ever since, they had tended a world center of Sephardic culture and their own Judeo-Spanish language. At the peak of deportations in Europe, more than fifty thousand Jews still called Salonika home.

Then Brunner made his move. His secret order from Eichmann's office specified "the expulsion of Jews from the region of Salonica, as envisaged in the framework of the Final Solution of the Jewish Problem in Europe." Eichmann had already explained "Final Solution" to his agents: Jews were being "annihilated biologically . . . in the gas chambers." Brunner arrived from Berlin in February 1943 knowing what sort of community he was about to annihilate biologically. In turn one Salonika Jew easily identified "the Brunner who solved the Jewish problem in Vienna." No one quite knew how, but it soon became clear he carried his methods from site to site.

"With overwhelming speed," reported Germany's consul in

Salonika, the new arrival squeezed Jewish space into a ghetto, then spread out in a once-Jewish home. A death's-head flag floated over the upper floor, where the SS kept sumptuous quarters. On the ground floor Brunner forced Jews into arresting more Jews—and they complied in hopes of shielding others from his violence. This time he used the community's age-old cohesiveness against it: He took twenty-five Jewish leaders hostage, and nobody else tried to escape. Expose hostages to reprisal? Never, Salonika Jews said. In the cellar of SS headquarters, at the very base, Brunner kept the torture rooms. Survivors of the cellar linked its competitive cruelty to one man they all noticed there. With his "unbelievable ferocity . . . Brunner came across as the most sadistic." "The most ferocious of the twelve executioners was Brunner, who . . . flogged his victims with a horsewhip made of thin leather thongs threaded with iron wire. Then he terrorized them with a pistol which he aimed against their necks."

As soon as Eichmann cabled Brunner to start "compulsory evacuation" of the Jews, transports pulled out, loaded with Jewish goods, but not enough to last all the way to Poland from Greece. Mainly he supplied the transports with lies. "We were told that we will be living in communities"; "the men would work, the women would stay in the camps. . . . We would be received by the Jewish community of Cracow." But of course the Jewish community of Cracow had been liquidated just days before Brunner started sending transports out. After almost two weeks' travel in sealed trains, those still alive had so few vital signs that the Kommandant of Auschwitz told Eichmann, "All of the Greek Jews had been exterminated because of their poor quality."

The "technical conduct of deportations" was Brunner's job, and this was what it destroyed: a place called Mother City and Queen of Israel, an offshoot of medieval Spain alive for almost five centuries on the edge of Greece, a commune of 56,000 Jews before he took command. After the war there were 1,129. Eichmann's office had asked for speed, an operation lasting "six to eight weeks," and Brunner made it. Halfway through, after sending almost 20,000 people to Auschwitz, he turned thirty-one.

According to an SS account, "upon completion of the last shipment," Brunner was "transferred to his next assignment." It was Paris. He made his presence known on June 17, 1943.

Another marriage

On June 17, 1943, Charlotte Salomon was standing in the Town Hall of Nice with another refugee, from l'Ermitage.

She was twenty-six and nearly alone in the world. Paula and Albert had not sent word since the Nazis occupied Holland and all of France. Alfred Wolfsohn had vanished and could have been anywhere. Grossmama was dead. Ottilie Moore had left l'Ermitage almost two years before. After losing all those figures, Lotte turned to Alexander Nagler—once more, a man (like Wolfsohn) devoted to a woman Lotte loved. Ottilie's Alexander. Ottilie's refugee.

In 1938 Alexander Nagler had paid a fortune to vanish from Austria and reappear in France, a fortune from family banks in Romanian Czernowitz and Vienna. His parents had always spoiled him, sending

Alexander Nagler (*left*) and his brother (Annie Nagler's husband) in a work brigade of the French Army, around 1940.

CS's watercolor portrait of Alexander Nagler.

a servant whenever he wanted something, never descending to the street themselves till Brunner's staff brought them down. To leave Austria for France took all Alexander Nagler's spunk—and used it up. In March 1939 Alexander, with his brother Hans and Hans's wife Annie and their baby, took the illegal route over the Maritime Alps. Annie could hardly recover from the trip, or Alexander either, since he never went up-country again, no matter what the danger on the

coast. When a border guard turned soft, the Naglers then crossed to the Côte d'Azur, where Annie kept saying, "I forgive the French everything because they saved my son." She'd contacted Ottilie Moore who knew a friend of her mother's and on that tenuous basis invited them all to stay at l'Ermitage.

Why would Ottilie keep Alexander with her for two years and then let him stay on at l'Ermitage?

"Ottilie and Alexander Nagler were lovers," Wally Moore said. He knew because he'd stumbled on them together in his aunt's room.

Did they care about each other?

"He cared, being a gentle and loyal man," recalled Annie Nagler. "When Madame Moore threw him out, he came back. Out, back— anyone could see how weak Alexander was. He lacked energy. He lacked French. Even the French Army returned him with acute ulcers. An accident in childhood damaged his ear and hair. He had a terrible complex about his scar. *Pas très intelligent et pas très débrouillard*—not very smart, not very apt. And he drank."

And how did he treat the others at l'Ermitage?

"Like the boss, not the guest," Wally Moore recalled. "Monsieur Nagler—nobody knew a first name—sent out commands, but no one listened to him. After visiting Ottilie, he would stagger down the path near the pavilion where Lotte and her grandparents used to live—so drunk the children would shove him into the rosebushes. Nagler's ear was melting, his neck had scars, and he very obviously wore a toupee to cover them. But he was not ugly. A good-looking man, very charming. We didn't like him at all." He was recalled by Ottilie's daughter Didi as "a greasy, slimy sponger who just hung around my mother."

"*Un pauvre type*" (a sorry specimen), Emil Straus judged. "We never received him at our place. He had nothing to talk about."

Perhaps he was not on Lotte's level?

"He was not on any level," Straus said.

Lotte commented on Alexander Nagler only once. The twelve-page postscript on her years in exile ended with this: "The woman to whom this book is dedicated had gone away in the meantime. She left behind only one friend, and I had no idea how to deal with him."

And then Lotte married him.

This pair looked as far apart as German-speaking refugees could be, but only Grosspapa kept saying so, and he slowly ceased to count. Straus watched as "Nagler and Charlotte became dependent on each other; he was her companion, protector, and friend. Probably he was the first man in her life [apparently she kept her secrets]. She had made up her mind to become his wife, but while her grandfather was alive she had been unable to gain his consent. Professor Grunwald considered Nagler beneath the Grunwalds in social station." In turn, Lotte dismissed her Grosspapa as a poseur "playing his part in the drama of the educated man of culture." By then everything that held him upright had fallen away: an honored profession, a link to Gross-mama's elite family, a certain charm, a belief in his mental health com-pared to his wife's. Herr Doktor Ludwig Grunwald sagged and finally collapsed in the street on February 12, 1943. The man Lotte always "had to fight" appeared on a death certificate as an eighty-one-year-old widower without profession or title, deceased in a rented room, his own name misspelled.

By dying he freed Lotte to return to l'Ermitage, where Alexander lived. She was glad to. Emil Straus observed, "In these chaotic, uncer-tain times, he gave her a certain sense of security. They were living alone in the big house, and he was almost the only human being with whom Charlotte could speak." Straus watched them at their wedding too. "Nagler had procured a suckling kid for the wedding breakfast at the Hermitage. Vittoria Bravi, the faithful housekeeper, had set a magnificent table with company china and silverware. All were in high spirits. Charlotte looked fresh and happy."

But in this marrying and celebrating, they do seem willfully naive. Why not just remain lovers for the duration? To this question *Life? or Theater?* (finished ten months before) contributes nothing. Perhaps a marriage certificate could suggest her state of mind, but to search for one required a permit from Nice's Civil Registry, which looked unchanged since 1943. An elegant official kept each foreigner waiting a long time outside his office, then doubted he could help. Months later, however, a document turned up.

> License number 762. Nagler, Alexandre, and Salomon, Charlotte.
> [Only 762 marriage forms—it was a slow year in Alpes-Maritimes.]
> On June 17, 1943, at 9 o'clock in Our presence there appeared pub-

1943 marriage certificate from the Nice Town Hall,
signed by Charlotte Salomon and Alexander Nagler.

licly in the Town Hall Alexandre Nagler, Director of a Children's
Home [he had two orphans to look after] born in Czernovitz
(Romania) on August 25, 1904, thirty-eight years old, living in
Villefranche-sur-Mer (Alpes-Maritimes), Avenue Cauvin, Villa Her-
mitage. Son of Leibisch Nagler and Serka Brancia Nagler, this cou-
ple somewhere disappeared [Why give away his father's Jewish
name? And since he knew that couples vanished in those years, why
start a couple now?]. And Charlotte Salomon, with no profession
[why didn't she say painter?], born in Berlin (Germany), on April
16, 1917, twenty-six years old, living in Nice, Avenue Neufscheller,

Villa Eugénie, daughter of Albert Salomon, doctor of medicine, liv-
ing in Amsterdam (Holland) and of Françoise Grunwal, his wife,
deceased in another place [She believed her father alive though
they were out of touch, but she barely spelled out her mother's
name, let alone her suicide]. The future couple declares that they
have made no marriage contract [they had no property]. Alexandre
Nagler and Charlotte Salomon have declared one after the other
that they take each other for husband and wife and We have pro-
nounced them united in the name of the Law. In the presence of
Georges Moridis, medical doctor [who treated Grossmama and now
ran a resistance network, bicycling between contacts with his doc-
tor's bag], and in the presence of Odette Moridis, of no profession,
living in Villefranche-sur-Mer, Avenue Maréchal Joffre, principal
witnesses, who, having read this, signed with the married couple
and Ourself, Paulin Gastaud, Chevalier of the Legion of Honor
[official stamp], Military Medal [stamp], Adjutant to the Mayor
[stamp] of Nice. [Did Paulin Gastaud, Chevalier etc. etc. tell the
groom with the German name that he couldn't marry a Jew? And
did Nagler blurt out that both of them were Jews? So Emil Straus
said.] Signed by: Dr. Moridis, Odette Moridis, Alexandre Nagler,
Charlotte Salomon. [After seven hundred painted pages, this was
the only time she signed her name on anything.]

These two were acting like ordinary townsfolk at any June nuptial
in the Nice Town Hall. It was possibly daring. It was certainly dan-
gerous. Why marry each other, or marry at all?

Madame Moridis had one clear thought on this: "When Charlotte
discovered she was pregnant, Alexander with an old-fashioned sense
of duty had insisted on it."

Yet no marriage is made by simple cell division. Pregnancy roots a
woman's body in the field of politics. Alexander's "old-fashioned sense
of duty" was perhaps an attempt to meet the expectations of the
Vichy world, like spelling his first name in French or using the aus-
pices of the Town Hall. Annie Nagler recalled with a headshake that
whenever the police inspected foreigners' identity cards at 45 Giof-
fredo Street, "Alexander was always the first to run down to Giof-
fredo." Only his new wife, denied the "rights of pregnant women"—
that is, extra rations for non-Jewish ones—knew just how alien a
refugee could feel. The condition of a Jewish mother came to her
anew, not just painting one this time, but being one.

If she had hoped not to have a child, she found nothing by way of birth control under a regime "at the aid of French natality," a regime "resolved to bring the deepest energy to the repression of abortion," including twenty years' hard labor for anyone involved. According to a British intelligence report on Alpes-Maritimes, "an enormous number of women are all *enceintes* . . . because it means increased rations, and secondly, there is a complete lack of contraception." On the other hand, if she *wanted* to get pregnant—hearing the rumor that the French did not deport pregnant women or thinking that the Italians would surely respect them—still, the Vichy regime had no use for an unmarried foreign woman with a child. Only marriage made sense then.

By openly arranging for their future—registering real names and addresses, admitting Jewishness, celebrating a wedding, disdaining a life underground—these two refugees gave evidence of their faith in Italian control of the Côte d'Azur. Alexander even entertained Italian officers at l'Ermitage, smoking and drinking and watching together for signs of an American landing. The Italian presence, people said, offered refugees "a little courage and hope in their distress"—courage to believe that all the bad news was phony (German troops making a winning stand, the papers claimed, at Stalingrad), while the good news (RAF bombing Berlin) felt fresh and solid. By June 17, 1943, when Lotte and Alexander stood in the Nice Town Hall, two Jews could have taken heart.

CS might have painted this event—as she did Franziska's and Paulinka's weddings—if she had still been working on *Life? or Theater?* She'd finished it almost a year before but kept it with her. At any time she could have added scenes of Alexander Nagler. But only a separate portrait of her husband survives, and shows a planed unfocused face. She did not even round out the quick dismissal of him in her postscript: "[Mrs. Moore] left behind only one friend, and I had no idea how to deal with him." Nor did she add a new ending, wherein the woman orphaned, exiled, and dispirited gets married as a reward. Her story stayed with a less soothing result: The woman makes a work of art.

So the primary source on Lotte's life fell away from the life itself, which went on without report. Why she got involved with Alexander, then got pregnant, then married, nowhere came to light. It's always

possible that he forced himself on her once she went to live at l'Ermitage. But perhaps her marriage had more to do with finishing *Life? or Theater?* Once the painter brushed the ghosts of her mother and grandmother onto paper, moved Wolfsohn up onstage, called Albert and Paula back to view—then a space cleared in front of her for new ties, new life. It's even likely she took up with Alexander because he valued the artist in her. Straus noticed that he "took a keen interest in Charlotte's work." On the packages that wrapped up *Life? or Theater?* there were labels in Alexander's hand, reading PROPERTY OF MRS. MOORE—a useful ruse for keeping the artwork safe. The "not very intelligent, not very apt" "sorry specimen" was the one who saved it for us all.

III

TOWARD PITCHIPOI

11

COLLISION

(1943)

⤺

66 *A ll the characters presented have different texts to sing, from which emerges a chorus,"* announced CS's playbill, and she created roles for many voices, always knowing that her life was shaped by contradictory words. In summer 1943, a year after finishing her operetta, a different chorus of voices passed inaudibly over her head.

Whatever the voices planned in secret did come about, but not for the reasons people on the Côte d'Azur thought. They might have heard local crashes during the second week of September 1943—the second trimester after Lotte's marriage. But they could not hear the debates setting the SS and the Jews on a collision course that would end in Nice. In diaries hidden at the risk of life, in confidential minutes and correspondence among diplomats, in underground reports of Jewish organizations, in secret SS cables, each group thrashed out ways to prolong the Nice asylum or make it fail. As their voices come together here, two things stand out: That no place took a course quite like the Côte d'Azur, where the first mass exit from Nazi-occupied Europe was designed; and that genocide allows no neutrals but arrays everyone in its field as a rescuer, victim, strategist, resister, denouncer, or avenger.

Rescuers

"SS Hauptsturmführer Brunner reported that . . . a Jew by the name of Donati . . . was organizing the departure of Jews from the [Riviera] region and their transport by truck toward Italy." *Heinz Röthke, SS Jewish Affairs specialist, Paris.*

"Angelo Donati, an Italian Jew residing in Nice . . . has acted with the Italian government to let the Jews of France move into Italy. Counting on about 30,000 Jews who will come for refuge in Italy . . . we have planned to let these Jews pass into North Africa. . . . Could the Holy See charge its representatives in London and Washington to support and activate this enterprise?" *Père Marie-Benoît, Capuchin friar, to the Vatican.*

"My father, Angelo Donati, told me he would get support and money from the Americans and the English so that Jewish refugees in the south of France could be saved in Italy and North Africa. He told me he had gotten the agreement of the British and American delegates to the Vatican." *Marianne Spier-Donati, daughter of Angelo Donati.*

"Donati . . . was a simple man, accessible, but he was also perhaps a dreamer. He believed that it was possible to save all the Jews." *Ignace Fink, Jewish activist in Nice.*

Strategists

"[The] Italian Government [is] prepared to provide steamships . . . capable of transporting approximately 30,000 Jews from Italy to North Africa in three voyages. Expenses would be . . . borne by Jewish organization in the United States. . . . Early action should be taken while ships are still in condition to accommodate refugees." *U.S. delegate in the Vatican to the State Department.*

"The Department desires to commend the above [Donati plan] to the appropriate consideration of the Intergovernmental Refugee Committee [in London]." *State Department response.*

"It would be a profound mistake . . . to give the impression abroad that the [Intergovernmental Refugee] Committee existed mainly for the benefit of Jews, and that its proceedings were dominated or influenced by Jewish members." *Memorandum from Director of Intergovernmental Committee on Refugees.*

"Concern[ing] Jews in transit through ... Italy pending their reception in North Africa: ... The consent of U.S.G. [government] would have to be obtained, and we know the extreme reluctance with which the U.S.G. consented to the construction of a camp in North Africa for the accommodation of a mere 1,500." *British Foreign Office Memorandum.*

"I know, in fact, that there is plenty of room for them in North Africa but I raise the question of sending large numbers of Jews there. That would be extremely unwise." *President Franklin Roosevelt, Memorandum to Secretary of State.*

"The publicity [about refugees], equally critical of the U.S. and H.M. [British] governments ... naturally is grist to Zionist mills." *British Embassy in Washington to Foreign Office.*

"I fear that this scheme is quite impracticable. We cannot ship fuel to Italy when we are busy trying to knock her out of the war, even if we could find the shipping space. And I doubt if the Germans will bother about many of these people: they must have far more serious problems on their hands in Italy [Mussolini had been overthrown]." *Foreign Office Minutes.*

Rescuers

"In August 1943 Donati heard in Italy that an armistice would be announced in October with the landing of the Allies in Italy, and conceived the plan to take place before then." *Joseph Fisher, delegate of French Jewish organizations, Nice.*

"The governments of England and the United States give an affirmative response. We are at the beginning of September. Preparations are accomplished, there is nothing more to do but execute them." *Père Marie-Benoît, Nice.*

"With a certain obstinacy everyone repeated the rumors concerning numerous procedures made by the Italian government and the Vatican to evacuate certain categories of Jews." *Michel Ansky, Jewish official in Nice.*

"Donati is still in Italy, the only news we have had of him is a telephone communication two days ago saying 'everything is going fine.' Events are moving fast from one hour to another. Border may be

occupied by Germans; means of transportation are lacking; funds too. In these conditions, the possibility of evacuating foreign Jews becomes very problematic." *Joseph Fisher, report from Nice.*

Avengers

"Preparations for applying anti-Jewish measures in the Italian occupation zone: . . . Hauptsturmführer Brunner accompanied by Hauptscharführer Brückler will arrive in Lyon and Marseille on the 5th or 6th [of September] to prepare everything on the spot and to obtain an idea of the local conditions. When the capture of the Jews is completed, they will be transferred . . . to the Jewish camp in Drancy, whence after thorough examination of their citizenship they will be immediately evacuated to the East." *Heinz Röthke, SS Jewish Affairs specialist, Paris.*

Rescuers

"Marshal Badoglio himself flatly denied to Germany on September 7th that an armistice had been concluded between Italy and the Allies. A meeting of [Italian] ministries . . . decided which places [in Italy] could take Jews [from Nice], and formally confirmed the possibility of carrying out the operation, since several weeks would pass before the armistice would be known." *Angelo Donati.*

Strategists

"It is no longer possible to accept an immediate armistice [between Italy and the Allies] as this could provoke the occupation of the capital [Rome] and the violent assumption of the government by the Germans." *Marshal Badoglio to General Eisenhower, 8 September 1943, 1 A.M.*

"I intend to broadcast the existence of the armistice. . . . I do not accept your message . . . postponing the armistice." *Eisenhower to Badoglio, 8 September, 11 A.M.*

"This is General Dwight D. Eisenhower. The Italian government has surrendered its armed forces unconditionally." *Eisenhower, 8 September, 6:30 P.M.*

"At 6:30 P.M. without informing the Italian government, General Eisenhower publicized the news of the armistice—putting a stop to railway traffic, which immediately fell under German control. . . .

Only this premature announcement ... prevented our achieving a rescue of Jewish refugees in the Italian zone and transferring them to North Africa." "Eisenhower is a man who made a stupid mistake in making the armistice official while there was still a plan." *Angelo Donati.*

"The Allied invasion of Italy was set for the next day. In Nice people were celebrating on the streets, but the organizers of the Donati plan were crushed." *Philippe Erlanger, Nice.*

"A rabbi who arrived at Nice was delighted with the news of the armistice. His eyes lighted up with joy: Italy has signed the armistice! She has changed sides, we are now in Allied territory! . . . Several minutes later two German policemen in full uniform pushed through the door and set themselves before us." *Léon Poliakov, Jewish refugee.*

"It seems that all the best chances—they were never more than good chances—of rescuing considerable numbers of threatened victims [in the Italian zone of France] have been thrown away by the failure of the United States and British Governments to take sufficiently prompt and vigorous action and by the atmosphere of defeatism, half-heartedness and infinite leisureliness with which they have surrounded the whole subject." *Eleanor F. Rathbone, Member of Parliament, 8 September 1943.*

"Miss R. [Rathbone] . . . would just sit there trying to force her particular views down the throats of the committee. Anyway, the Americans won't have her." *Foreign Office Memorandum, 9 September 1943.*

"With regard to the refugees in southern France, it must be assumed that if this has not already happened, there will be full German control within a few days. The Italians will not be able to organize the removal of refugees from there into Italy." *Director of Intergovernmental Committee on Refugees, 9 September 1943.*

"I fear these Jews are, for the time being, caught, and like the Italians will have to wait for the Allies to deliver them." *Foreign Office Minutes, 13 September 1943.*

"If we did approach the German Government, and as a result Jews were allowed to leave Axis-controlled territory in large numbers, it would be very awkward. At the Bermuda Conference, however, it was agreed with the Americans that no approach can be made to Hitler and (from our point of view, fortunately) the German Government appear to be intending to persist to the last in their refusal to allow

Jews to leave Germany." *Foreign Office Memorandum, 17 September 1943.*

"There are many refugees in territory occupied until recently by Italians. . . . We don't want to instigate a demand from the surrendering enemy government [Italy] that we should assume responsibility for finding a new home for these people." *Foreign Office Minutes, 27 September 1943.*

Victims

This rescue was not a dream. Four ships were outfitted to cross the Mediterranean. Funding was to arrive as soon as American Jews received government permits to transfer it to Italy. Jews in Nice looked for the go-ahead, keeping in touch with the plan. Lotte waited with Alexander at l'Ermitage. She was most likely aware of Angelo Donati, who was so well known as a savior that many Jews in summer 1943 named their newborns Angelo. Rescue was at hand, the best project anyone in Europe had contrived. But nothing came to pass. No government hastened to lift Jews off the Côte d'Azur.

The Italians gave assurances of time that was not in their hands.

The Vatican was busy cajoling Germans into sparing Rome and standing fast against the common Bolshevik enemy; it never urged the rescue plan on Allied delegates.

The rescuers thought they had American and British approval, but it had been requested, not obtained.

The British accepted a small camp in North Africa only to relieve the pressure on Palestine. But they stalled any mass settlement of Jews outside Europe, in case it might spill over to London or Tel Aviv. They expected Jews to wait, just like the Italians, till Germany caved in.

The Americans wanted no Jewish camps in North Africa, where they relied on French nationalists and Arab goodwill. They also feared that anyone who rescued Jews might be stuck with them. The Treasury Department refused to let Jewish funds pass to Italy for outfitting the ships. The State Department shunted the rescue plan to the Intergovernmental Committee on Refugees (IGCR) in London, which it knew was underfunded and barely functioning.

The IGCR refused to admit any Jewish delegates and failed to call an urgent session when Italy looked ready to collapse.

The Allied commander made no inquiries about refugees but pub-
licized the secret armistice ahead of time so the Italians could not
back out of it or the Germans gain *force majeure* in Italy.

The brave-hearted resisters among the French sprang to save indi-
vidual Jews. Righteous groups, convents, villages, took collective risks
for groups of them. Heroes like Angelo Donati and Père Marie-Benoît
never stopped working to save them all. But mass rescue had failed by
fall of 1943. The plan to ferry thirty thousand Jews from Nice to
North Africa was the first promising project the Allies could have
tried. It was canceled out, literally, in a Foreign Office memorandum,
and the Jews of Nice were left to rescue themselves.

The Germans saw their chance to lay waste the "Promised Land"
of the Riviera and ordered Alois Brunner in.

Avengers

"Around 1 September 1943 Brunner disappeared from his camp of
Drancy, and was reported at a meeting on 15 September with his
adjutant Brückler, at the railway station in Nice. A team of 12 to 14
torturers under Brunner's command proceeded to arrest Jewish men,
women, and children, mostly at night. . . . Among the arrested there
were the ill and feeble, the elderly, nursing babies, pregnant women;
all underwent the violence and torture of these brutes." *Dr. Abraham
Drucker, Brunner's prisoner in Nice.*

"Under the direction of Brunner (the former chief of Drancy)
. . . the Germans are looking for any means of arresting all the Jews in
the area and deporting them as fast as possible." *Jewish report on southern
France.*

Victims

"In the face of roundups, day and night, in residences all over
Nice, in the street, in the station and on the roads, an atmosphere of
true terror has rapidly spread throughout the population." *French prefect
of police in Nice to Vichy.*

"The Germans posed as an absolute principle that circumcisions
were equivalent to the fact of being Jewish. Thus all papers largely
lost their value." *Jewish report from Nice.*

"Prisoners have to take down their pants. They are classified Jews

or Aryans by whether or not they are circumcised." *Philippe Erlanger, Nice.*

"A considerable number of children . . . submitted to an individual medical visitation and those who proved to be circumcised were immediately transported to the Camp of Drancy." *Report of OSE (Oeuvre de Secours aux Enfants), Children's Welfare Service.*

"A Catholic nurse . . . was rounded up solely because she had the name Esther. . . . Little children who could not even understand what was happening around them were beaten, abused, and brutalized under the eyes of their parents. . . . When the Gestapo found a young Jewish mother with a baby of six months, . . . the bandits who a moment before were playing with the smiling baby threw it against a wall and fractured its skull. . . . Young Jewish women imprisoned at the Excelsior [SS headquarters] were isolated from the rest of the prisoners. They were sterilized and expedited for the pleasure of German soldiers on the Eastern Front." *Union of Jews for Resistance and Mutual Aid, Nice.*

Denouncers

"At Nice we had to suffer not only the active persecution of the Gestapo, but the action of traitors. In particular a former employee of the UGIF [the principal Jewish organization] of Nice . . . walked through the streets pointing out to the Germans which ones were Jews." *Ignace Fink, Nice.*

"'Physiognomists' circulated to pick up anyone looking Jewish. . . . An army of denouncers . . . called 'false Gestapo' made a systematic hunt for rich Jews." *Jewish report from Nice.*

"Every day a pile of denunciations arrived. In addition to those addressed to the Hotel Excelsior, people were coming in person and saying: 'There are Jews at such and such a place.'" *Marguerite Becker, a secretary for the Gestapo, Nice.*

Resisters

"For each denunciation, the Germans paid two to three thousand francs. To put these people out of action, there was only one thing to do: kill them. . . . In three weeks we liquidated six or seven Russian informers." *Henry Pohoryles, Jewish resister, Nice.*

"The Sixth Section [Jewish Scouts] of Nice with the Zionist Youth and with the OSE Social Service were working like crazy. The primary concern was to help everyone get out of Nice; let them take care of themselves afterward. In several days we distributed 4,000 [false] identity cards." *Robert Gamzon, resistance leader, Nice.*

"As soon as the Germans arrived in Nice, they demanded from the [Italian] Consul the dossiers of Israelites in Alpes-Maritimes. . . . In reality these dossiers had been partly burned, partly hidden. *Antonio Aniante, Italian consular staff, Nice.*

"[French] Police officers and the Prefect managed systematically to close their eyes to false papers and cancel all control. No list was delivered to the Germans." *Jewish report from Nice.*

"Every day they threatened to shoot my kids. I knew that if I spoke, it would cost the lives of dozens of people. But when I returned to my cell alone I felt the same sensation of dividing in two pieces as when I was beaten. One part was saying: 'You pitiable woman! You must speak! They're going to shoot your kids!' . . . And the other: 'So let them shoot!' It was atrocious." *Andrée Clausier, resister, Nice.*

"Several handfuls of boys and girls braved the SS of Alois Brunner. The stakes were 25,000 Jews. . . . There lay the principal difficulty: it is not convenient to conspire when you have 25,000 accomplices." *Léon Poliakov, Nice.*

Avengers

"In Nice the Jews paid heavily for the tranquillity they had enjoyed under the Italian occupation, because Brunner, the hangman of Drancy, ran the operation there in person." *Jewish report on southern France.*

"The Gestapo punished everyone in this region with great vigor and hate because they wanted revenge for that tranquillity which the Jews had guarded for three years." *Ignace Fink, Nice.*

"Police officers . . . took vengeance on the Jews for being well treated by the Italians." *Elie Adler de Vultureni, Nice.*

"For the Nazis, Nice is the place where the last Jewish crime has just taken place. It is here that Angelo Donati was living, the banker who mobilized the Italian Army in defense of the Jews. It is on the

Côte d'Azur that the wealthiest Jews have chosen to settle. It is thus at Nice that world Jewry, aided by Churchill and the Pope, have concocted their plot against Mussolini. The SS believes itself at the scene of the crime." *Léon Poliakov, Nice.*

Collision

At the scene of the crime all the forces from far afield finally met head-on. The speed of the collision thrilled the avengers, but the catch dismayed them, for Brunner could not count on the French police and populace to meet the SS aim of taking fifteen thousand Jews in Nice. No one knows how many finally escaped like Emil Straus, hiding in the mountains, or like Annie Nagler, walking out of Nice before dawn on September 9; or how many were captured as they slipped into other towns. Only 1,820 names appear on the lists of railway passengers sent from SS headquarters at the Hotel Excelsior in Nice to the camp of Drancy in northern France. A look at one list—say, September 24, 1943—reveals precisely what an asylum the region had become. Two-thirds of the fifty prisoners came from outside France: from Vienna and Czernowitz, from Kiev and Coblenz, from Vilna and Berlin. Almost all had been picked up in Nice, just a few from Cannes and St. Jean Cap Ferrat, two from Villefranche:

NAGLER, Alexander	Villa Hermitage Villefranche
" *née* Salomon, Charlotte	" "

l'Ermitage

To hide with Alexander at l'Ermitage had been the hardest decision of Lotte's life. On the one hand she faced the risk of being recognized there as Madame Moore's resident Jew, or tracked there by means of Nagler's address on their marriage certificate. On the other hand at least at l'Ermitage they had the help of the grandparents' kindly housekeeper. And was there anywhere better to go?

Maybe they should have tried a hideout in Monaco, offered them by Dr. Moridis. (But then, Monaco was no longer safe for Jews.)

Maybe Lotte could have contacted Marthe Pécher in St. Jean, who kept a secret flat in Nice and would have helped. (But by then Nice was a hunting ground.)

Maybe they could have gone to the *maquis*, the uplands that gave resistance bands their name. (But then, those weren't uplands behind the Côte d'Azur, they were Alps. Anyone trying to get around guarded passes between France and Italy had to climb like a mountaineer in glacial cold. Besides, Alexander had an ulcer attack, and Lotte, who'd cared for her father after Sachsenhausen, who'd cared for Grossmama after a suicide attempt and Grosspapa in Nice, would not abandon Alexander just to save herself.)

Maybe she was no longer driven to survive after expending her strength against the family fate. (But then, she was giving her all to survive by staying near Nice where help was supposed to come.) All things considered, it surely seemed safer to hide than flee.

It was not. Someone must have denounced her to Brunner (Jews in the American lady's villa again!). A truck set out from the Excelsior to pick them up or at least to loot the place. It stopped at the Villefranche pharmacy to ask the way to l'Ermitage, up the switchback roads. At the pharmacy a wrong direction could have been given; a warning could have been given. A phone call.

An outbuilding of l'Ermitage, where Lotte and Alexander hid in 1943.

No warning. The truck pulled up in front of l'Ermitage. The house-keeper heard its doors slam shut and then heard Lotte, screaming.

Excelsior

At the Hotel Excelsior in just that moment, Brunner was testing himself once and for all. He had to destroy not just the Jews this time but the plain fact that Jews had found a sanctuary. That was why his "human hunt on the Côte d'Azur in the Autumn of 1943," wrote one eyewitness and historian, "surpassed in horror and brutality every-thing of this kind previously known, at least in Western Europe."

At the Excelsior Brunner refused to treat a prisoner's fractured skull—"He's faking, he'd better talk"—until the man died. At the Excelsior he patrolled the bedless rooms where prisoners piled up for trains. At the Excelsior he commanded a perfect locale for roundups. The hotel stood a short walk to the railway, and still has an inner courtyard where fifty people could fit tight, plus a central second-floor balcony where Brunner watched the trucks pull up. Down below on the street, "many men and women were crying when the convoys of victims passed before their eyes to stop at the threshold of this hotel-prison."

Enclosed courtyard of the Excelsior, where Brunner kept prisoners.

The convoy from the villa in Villefranche unloaded its two pris-
oners at the Excelsior in late September 1943. If one of them looked
up at the balcony, she saw Brunner at the high point of his life. But a
prisoner never looked at a commanding SS officer for long. While her
inner voice might be saying, The fate in his hand is *mine*—Brunner's
fingers were simply counting up the creatures down below. His eyes
were passing over Lotte Salomon and seeing nobody at all.

12

DECEPTION

(1943)

He lined up Lotte and Alexander and fifty others before the Excelsior and made them march up the street to the railway station, which looked like a casino, pure Côte d' Azur. The Nice-Paris train was waiting, with special guarded cars. Each prisoner, that day and every day, got on board in view of everyone.

That day, September 24, 1943, was almost two years after the secret Wannsee Conference had detailed a sweep of Europe's Jews to Poland—eleven million was the target figure. Yet observers in Nice could not grasp anything they saw. One of their letters (intercepted by the Gestapo) sounded dazed: "Whole families have been taken and shut up in various locations . . . waiting to be sent to Germany for forced labor. . . . A Jewish doctor highly respected in Nice . . . has been arrested with his wife and his four children. Why? And why his wife and his four children?" Residents and refugees watched Brunner's prisoners heading toward trains and still said they would "be sent to Germany for forced labor." This went beyond willful disavowal or desire "to live in a twilight between knowing and not knowing," as one sympathetic bystander wrote.

This was perceptual overload at work, too many new sights that residents were calling "transports." All they knew with certainty inside Nice was that every week another hundred Frenchmen were put on trains to fill up labor drafts in Germany. Vichy called it STO (Service

de Travail Obligatoire), Compulsory Labor Service. Whenever Nice newspapers reported twelve million foreign workers in Germany (8,811 drafted from Alpes-Maritimes in 1943), readers thought the Nazis were going after useful hands. As soon as every neighbor grimly waved a son off at the station for "compulsory labor in Germany," this familiar sight, it seems, screened out a rude insight. Even Brunner's most vicious roundups fit the STO frame. As long as "Israelites . . . continue to escape the [STO] obligations imposed on the other inhabitants," the prefect wrote, "the French bear a heavier burden, which they resent." So it served Jews right, some said, to lose at last their "scandalously privileged treatment."

Outside Nice, observers thought Brunner was sending his catch "to the vast ghetto the Nazis have set up" in Poland—the Jewish Reservation myth alive and well. Diplomats in Switzerland who had forwarded reports of Poland's death camps sounded baffled about Brunner's Nice: "Jews must submit to a medical examination with a view, it is believed, to recruiting men for forced labor." Jewish agencies cabled the State Department: MASS DEPORTATIONS MEN WOMEN CHILDREN ALL AGES [FOR] FORCED LABOR. Or, ALL JEWISH MEN REFUGEE GROUP NICE NOW DEPORTED. NUMBER CONSTITUTES APPROXIMATELY 3,000. WOMEN CHILDREN STILL THERE: the last part was untrue but fit the labor-draft idea. In fall 1943 a Vatican delegate declined to help a Jewish leader, saying it was "impossible to do anything when it concerns a non-Aryan person transferred to the camp of Drancy and from there, generally, transported to Germany." To Germany? Untrue again.

If well-informed bystanders let themselves be taken in, no better grasp could be expected of the Jews. "We all thought the prisoners in the Excelsior were going to the East—to an *État Juif*—a Jewish state; there were worse rumors but no one believed them, not after the 'war gossip' spread around in World War I." "A few million French prisoners of war had been kept in Germany and assigned to work. All we thought was: It matches the rest of the plan, they need people to work, and they got hold of us too."

What sources, after all, permitted a conceptual grasp of genocide? The witnesses at hand looked simply deranged. They were broken men, like two escapees who frantically described Auschwitz while a Jewish leader in Nice stood behind them circling a finger beside his

head. Or they were nameless women who passed a pamphlet through Nice asserting that seven hundred thousand Jews in Poland had been shot, drowned, or killed *by gas*, so "let us defend our Jewish neighbors when they come to arrest them, let us give shelter to those who are menaced, let us save children"—which sounded hysterical: this was *France*. Refugees retreated to past experience—in 1938 the men came back from Sachsenhausen, in 1940 the women from Gurs. Weren't roundups followed by release?

The only way to guess Nazi aims was to watch the SS chief of operations act, and the word *mad* occurred to many of those who did. "Brunner . . . is the very model of the degenerate Nazi, with the bearing of a mad sadist," wrote one Jewish leader after Brunner shouted "pig of a Jew," "filthy Jew," "Jewish scum," "evil Talmudic hair-splitting Jew," then grabbed him by the neck "and howled with blood in his eyes." Another reported that "Brunner has a change of mood twenty times in the space of an hour. . . . At first glance, it is hard to imagine that a man so young, thin, simple—I was going to say congenial—is an abominable torturer." They perceived him as a deranged and volatile man, not the archetype and agent of a consummate secret plan.

The way he presented himself seemed to stall each victim's train of thought. Often Nazi officers devised dual codes of conduct so they could hound their Jews and at the same time honor their prewar posts in medicine or law, so they could be proud to "have stuck it out and . . . remained decent fellows," as Himmler put it. But Brunner never had another code or career, so he never built false fronts to disavow his acts, only to double-cross his Jews. It was the "mad" second face that conned inmates of Drancy when he took over as Kommandant in June of 1943 and made the camp look like a way station for labor drafts. One minute he flew into wild rages, the next he paved the courtyard, planted trees, invited photographs. Though he left the camp awhile to run the operation in Nice, it remained all his—a creation of his skilled deceit.

Disinformation: Inside Drancy

At the end of September 1943 a "transport" took Lotte and Alexander Nagler from Brunner's Excelsior in Nice to Brunner's

Drancy, a few miles east of Paris. The camp of Drancy served during three years as warehouse and loading zone for the Jews of France. More than seventy thousand passed through its unforgiving cycle: registration, interrogation, internment, selection, evacuation to the East.

A collage of comments by inmates in September 1943 will have to take the place of sketches Lotte might have done (but then, she never painted Gurs either). Most inmates spent weeks; some, months; a few lasted years there; yet later many had trouble detailing it. Maybe harsher days crowded out their time in transit camp, since those who survived Drancy also survived what Drancy sent them to. "My memories of this period are thin and imprecise," one of them said. "The days in this camp, even if I have retained few traces of them, appeared to me to have been a sort of haven." Or, "I have no idea how long I was at Drancy. I was about twenty years old, but I could not remember Drancy even just after the war."

In questioning Drancy survivors it was easy to block out their disclaimers, but in the end those lapses of recall showed the trickiness of a transit camp. Drancy was meant to be a narrow passage that compressed what inmates knew. They felt less and less sure what the camp was for, and a heightened sense of not knowing became its mode of punishment. Though they later apologized for retaining so "few traces" of Drancy, they *were* remembering its inherent trait: Drancy (like other transit camps, like Westerbork in Holland or Sered in Slovakia) was designed to induce uncertainty.

Entering the camp on September 27, 1943, Alexander Nagler and "Ditto née Salomon," as she was called on every list, were assigned to the same entryway, number 19, in a three-sided, half-constructed block of flats that served as prison quarters. Lotte was put on the third floor with older married women and three others arrested in Nice. Alexander's room was two floors up. Going downstairs, they could glance through a window at the streets of Drancy and then step out of their entryway into a closed central yard.

This yard was where Lotte and Alexander passed into the SS state, and where they could hardly tell that they were still in France. French patrols circled the barbed wire to prevent escape, and yet none were allowed inside. One inmate noted that Brunner's "first act was to eliminate the Police Commissioner and French inspectors, in

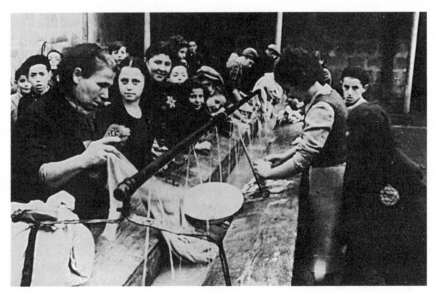

Women and children were brought to Drancy under Brunner's command.

whom he doubtless saw troublesome witnesses." Making an island within the country, off limits, this Kommandant finally wrested deportation from French control.

To newcomers, Drancy never looked entirely German-run either. "A band of thieves and pilferers from Vienna," "sworn body and soul to Brunner," was how they saw the dozen SS men that controlled all three thousand of them. Some incoming prisoners "submitted to a brutal interrogation by Captain Brunner or his acolytes," until "the walls of Captain Brunner's office were covered with bloodstains and bullet holes." Some watched him give orders "with a switch because he could not touch a Jew with his bare hand." But many others hardly saw the Austrian SS squad.

New arrivals learned fast who gave the orders to be obeyed. The "Jewish Order Service," mostly French Jews who supervised a hundred other inmates, ran the whole camp. The cooptation Brunner perfected in Vienna traveled with him to Drancy, where he had a way of "cultivating in some prisoners a spirit of servitude" by safeguarding their families from Category B—designated deportees. Prisoners coming into the camp hardly knew what to make of the Jewish Order

Service and its mild rules, so contrary to camps they'd heard about or known. Maybe Brunner's absence in Nice during September and October 1943 thinned the air a bit. In those months "Men and women were separated but could see each other all the time. The children had a school and people who played with them; in the afternoons they had a snack." "It was the greatest talking place I've ever known. Since the people had nothing to do, they would spend their days meeting for large discussions in the yard. This was September '43, Italy was already almost out of the war, the Germans were getting knocked on the Russian front, the landing was expected every day: the only thing that kept us alive was the hope of seeing signs that the end was near."

One sign could not be ignored, being so peculiar to a transit camp. The *carnets de fouille* were vouchers for confiscated cash, signed and filed by the Jewish Order Service after each prisoner was searched. Little that belonged to Drancy inmates ever lasted, for the transit process erased itself as it eliminated Jews from Europe; just a few photos, wallets, war medals stayed stored in archive boxes, unidentified. But a few dozen carbons of search vouchers survived (out of how many thousands?), as phantom witnesses to the deception of Drancy. One of the flimsy, faded vouchers reads:

> *Received from*
> *Monsieur Alexandre NAGLER*
> *Villa L'hermitage, Villefranche sur Mer (A.M.) [Alpes-Maritimes]*
> *the sum of two thousand francs.*
> *Drancy, 27 September 1943. Chief of Internal Police, Blum.*

Nagler's was the last name in a hand-lettered booklet of vouchers to be cashed later on. His voucher was labeled with his number, 5570; Lotte's was 5571, which meant they were registered and searched as a pair. The "sum of two thousand francs" (about fifty dollars), shows Alexander was ordered to take his money from l'Ermitage, since it was Brunner's policy to bring Jews to Drancy loaded with goods to confiscate. The signature "Chief of Internal Police, Blum" denotes their contact with Robert Blum, head of the Jewish Order Service, who persuaded Alexander to tell his real address (but of course he'd also offered it at his marriage in Nice). Most telling, the extant document is only a carbon copy. So we know precisely what Nagler carried in

his pocket, the one thing of value inmates kept as their own. From this scrap of paper they deduced just what Brunner meant them to: that receipts could be cashed at the labor camps when they arrived. While everyone inside Nice imagined those camps in Germany, here in Drancy the vouchers for zlotys were "how we found out" the camps must be "in *Poland*." "Since we heard about money which we would be receiving, we thought it would be a place where one could buy goods." Written numbers had such a look of fact that a voucher like Nagler's was Brunner's masterstroke.

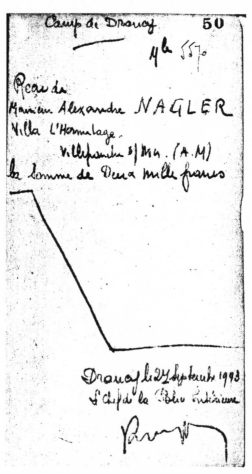

Voucher for cash confiscated from
Alexander Nagler.

All day long, grains of evidence were sifted by inmates trying to imagine a nowhere with a name—something like "Auschwitz." Rumors passed from one impressionable prisoner to another:

> The transports go to the ghetto of Auschwitz (Oszwienzia)? (Upper Silesia): a Council of Elders directs the ghetto where the old people do nothing, the children go to Jewish school, the able-bodied men and women labor in factories and mines. This reassuring information has all been gathered from a primary source—soldiers who escort the transports between Auschwitz and Drancy.

To sweep people from all of Europe to a few plots in Poland took so much more than terror. Victims had to be kept deluded, bystanders inert. Half of those the Nazis liquidated—three million persons—had to be shipped out of sight to be killed. Deception was the strategic resource that fueled the rolling trains and made this genocide succeed.

Deception was Drancy's specialty, Brunner's means of preempting all chance to resist. He promised mail service to and from the place called Auschwitz-Birkenau and showed inmates postcards from a labor detail there—working well, it seemed to them. He kept whole families together for the transports and ordered Jewish welfare to provide "enough supplies to meet their needs while laboring." So some of them felt reassured. For the first time, "deportees were also encouraged to take belongings with them and thus we thought that we were being taken to labor camps." When they fingered the vouchers in their pockets, they rushed toward a reason: the SS wanted their money and labor, not their lives.

At Drancy, closed to all surveillance, no news could sneak through the fences of deceit. French police could not penetrate. When a Swiss consul solicited a visit, Brunner called it "unheard-of impudence." Even German officials rarely tried. All this produced one effect: inmates said they "never had any idea where" they were going. "None of us had any idea what was awaiting us" except that it was "a place we know nothing about." Not even the official Jewish liaison with the SS got it straight: "none of us could comprehend" what the Kommandant had in store. One longtime inmate watched deportees enter transports from 1941 to 1944 with "no suspicion whatsoever

concerning their fate." Years afterward survivors found Drancy hard to keep in focus because they'd failed to pierce its mystery in the first place.

Faced with a sharp drop off the known world, the minds of inmates simulated a map. By naming their destination "*Pitchipoi*," they packed utopia and dystopia into the same strange syllables. For some, Pitchipoi was the nonsense name of a legendary village, "one of the Yiddish names used by the Polish Jews." For others, the word "resonated like an eternal curse, the place of pogrom or ghetto." "We were all persuaded that 'Pitchipoi' was a place of compulsory forced labor." "Pitchipoi . . . indicates a faraway and unknown country . . . where we would be sent to work and where we would become men, respected and free." "For inmates who feel their departure for Pitchi Poi approaching, nothing apart from food or sex is worth any interest at all." "Pitchipoi-Birkenau" was a variant that circulated through the camp—which is to say, whenever Drancy inmates heard the place-name *Birkenau* (an Auschwitz satellite with four mammoth gas chambers), they absorbed it into their mythical Pitchipoi.

One inmate said, "Information that in other circumstances goes through like electricity was stopped in front of every single consciousness for the simple reason that acceptance of such information was lethal." Another recalled:

> Had we known what lay before us [while still] in Drancy, we would have taken our lives then and there, as another family tried to do— father, mother and son. . . . We told ourselves at the time that they were hyper-sensitive people, hysterical, too highly strung. . . . We didn't know [anything, even when] . . . we were driven close up to a cattle-car and shoved into its rear opening which was nailed shut behind us. It was like being buried alive.

To pry open a transport now and hear the voices of its deportees is to reveal one hidden moving gear of a vast machine. A typical transport, Number 60, leaving Drancy on October 7, 1943, was filled with Jewish deportees, like 96.3 percent of the 76,000 sent from France. A transport like Number 60 was fitted to take away a neat 1,000 deportees. It arrived with 997 (which the Gestapo called a "Good Result!" considering that one or two prisoners had escaped

from each moving train that year). One-third of Transport 60—and this was not typical—came straight from Brunner's raids in Nice.

Though no one who survived this transport still remembers Lotte Salomon, a few of its deportees and documents tell in precise detail how the train of October 7 took her away.

Inside Transport 60, Drancy–"Pitchipoi"

I. PREPARATION

Paris 30 September 43. *URGENT!* Deliver immediately!
To: Reich Security Main Office, IV B4a Berlin
Re: Transport of Jews on 7 October 43
 A transport of Jews is being planned for Thursday 7 October 1943 from Bobigny-Paris station [near Drancy] to Auschwitz. The transport should comprise 1000 Jews. . . .
 Signed: RÖTHKE, SS-Obersturmführer

Berlin 1 October 43 . . .
To: SS-Obersturmführer Röthke, Paris. . . .
 The Reich Transport Ministry has directed the . . . preparation in Paris of the requisite special train for the deportation of 1000 Jews to Auschwitz on 7 October 1943. . . .
 Signed: RSHA 4B4, EICHMANN, SS Obersturmbannführer

DRANCY CAMP COMMAND OFFICE. Service Note. 5 October 1943. By Order of the German Authorities: The departure of the contingent of Category "B" will take place on the day and hour to be arranged. One hour before departure, groups of 50 persons will be assembled in their rooms under the orders of their group leaders. The leaders should be bearing the name lists of persons in their groups. Baggage should be prepared and carefully packed, legibly marked with the name and registration number of its owner.

JACQUES ZYLBERMINE: Our names as deportees were announced and our transport's thousand people isolated in a separate block. We lost the right to circulate outside. The door was closed on us.

PAUL STEINBERG: Our friendships were created in a couple of hours, of an intensity which you'd have a job imagining. I became friendly with another sixteen-year-old, and within three days we were like brothers.

DRANCY CAMP COMMAND OFFICE. Service Note.
For the departure units, the wake-up and coffee are fixed for 4:30 A.M. tomorrow morning, 7 October 1943. Sections 1 and 2 will begin to descend at 5 A.M.

ZYLBERMINE: Buses arrived at the camp, normal Paris buses with French police on them; then clothes were distributed and a small amount of food—bread, sausage, an egg. Groups of fifty were formed at Drancy to board the buses together, and the same groups boarded the trains.

GROUP NUMBER 17, LIST OF FIFTY DEPORTEES [with names, birthdates, and occupations]
 NAGLER Alexander 25.8.04 Bookkeeper
 NAGLER Charlotte 16.4.17 Draftswoman

II. JOURNEY

STEINBERG: The windows of the bus taking us to the station were open, and I managed to throw out a note for my parents saying, "I am being taken away but I don't know where."

MAURICE BIALEK: Leaving Drancy was a happy occasion for many of us because it was better where we were going. We believed that.

Paris 7 October 1943
 To: The Reich Security Main Office, for the attention of SS Obersturmbannführer Eichmann . . .
 To: The concentration camp Auschwitz, for the attention of Obersturmbannführer Höss
 On 7 October 1943 at 10:30 A.M. the transport train No. D901 left the departure station Paris-Bobigny in the direction of Auschwitz with a total of 1000 Jews. . . . The following provisions

were sent with the transport in one wagon: Meal, Potatoes, Chocolate, Coffee, Sugar, Macaroni, Lard, Salt, Beans, Canned Vegetables. I request that these highly valuable provisions not be used for KZ-Prisoners. . . .

Signed: RÖTHKE, SS-Obersturmführer

ZYLBERMINE: The trains were made up of freight cars marked "eight horses, forty men." We were sixty-five men, women, and children, with all our baggage. The weather was not yet cool and we started to suffocate: the people themselves gave off heat. Some had to stand up the whole trip, the rest could only sit inside someone else's legs. Only the elderly stayed seated. There were three containers of water, one sack with a little food, and one pail for a latrine.

BIALEK: Husbands and wives were allowed to be together in the wagons, but my wife was ill and was placed in the infirmary wagon.

ROBERT WAITZ: In two infirmary wagons with several mats on the floor, they placed old people, convalescents from typhoid or pneumonia . . . and nine madwomen taken by the Germans from an insane asylum, who screamed the whole way without stopping.

ROBERT FRANCÈS: Several young men brought tools with them which allowed them to dislodge a fragment of the wagon floor for escaping under the train. . . . The other travelers, older or more prudent . . . stopped the operation, protesting, "You want to get us all shot? You know an escape attempt condemns the whole wagon to death. . . . There are women and children and old people here who could not follow you. . . . Besides, none of us knows exactly what our fate will be in deportation." The quarrel stopped abruptly.

ZYLBERMINE: After we started to pull up the boards, the two daughters of the appointed wagon leader begged and cried; they overwhelmed us.

STEINBERG: On the second night we stopped for several hours in the railway station of Bielefeld. I saw kids in the station throwing stones at us. They're now over fifty years old and have probably forgotten what they did, but I never will. I was standing up against the window and I saw those kids aiming at us with stones.

From: KL Auschwitz . . .
For the attention of: Obersturmführer Röthke
Subject: Deportation of Jews from France
 The transport of Jews from France, train No. D901, arrived
here on 10 October 43 at 0530 A.M. 997 Jews were taken into this
camp.
 Signed: SS-Obersturmbannführer and Kommandant Höss
 Penciled acknowledgment by Röthke: "Good Result!"

III. ARRIVAL

WAITZ: After three days and three nights of travel, the train arrives
at a station platform around three in the morning on October 10,
and stays there till dawn. At six the doors are brusquely opened.

ZYLBERMINE: It is just daylight, we can see immense lights in the dis-
tance. Then the SS opens the doors and deals out blows with rub-
ber truncheons that could practically kill you.

WAITZ: Everything is piled in front of each wagon on the ramp and
abandoned there. The deportees not completely dazed by the jour-
ney understand that this baggage is lost to them.

STEINBERG: I see a few SS guards standing there with guns, and some
guys in blue-and-white striped costumes running left and right. I
think: convicts probably. At the end is a commission of officers, the
responsible one in the middle. People are passing in front of him
one by one, and he says right or left.

ZYLBERMINE: First order: "Women here, men there!" Little children
with the women. They take away the group which is old or preg-
nant or with babies, then they make the younger women, including
my sisters, get into trucks. I understand nothing about it, simply
that women and men are being separated.

FRANCÈS: So I am separated from my mother without a word, with
only a last look exchanged, of uncertainty and fatigue from that ter-
rible three-day trip.

STEINBERG: I see all the women taken away. When we ask where, we
are told that their only way out of here is up that chimney, but even
if we understand German, we have no idea what it means.

ARLETTE TOLEDANO: First thing right at the station, the SS separates the women from the men and says the separation is for work. A few of the women are sent to a large room to have our heads and bodies shaved. I am told, "You're pretty, but all that will change in half an hour." As we stand there completely naked, anyone can see our condition, anyone can see if we are pregnant.

IV. SELECTION

Some were motioned to the left-hand column, toward the labor camp, if they happened to be builders, chemists, or physicians, or could do calligraphy or stenography for the SS. Some were sent to the right-hand column if they happened to be women with small children, or disabled or pregnant or old or sick or short.

Alexander Nagler approached the table at the end of the ramp. In his favor: He spoke German, was not accompanying a small child, not over forty. Against: not youthful, not healthy, not in a useful trade, called himself a bookkeeper.

Alexander Nagler was waved to the left-hand column, tattooed number 157166 for the rest of his life, sent to Block 55 of the work camp called Auschwitz III, and recessed into a mass of slaves. Once, briefly, a month after arrival, his name appeared on admission to the camp infirmary, where he stayed six days, then was released. And it resurfaced at the very top of a clean new page, new year, first day of 1944, in the Register of the Dead.

Charlotte Salomon Nagler approached the end of the ramp. In her favor: not ill, not with a small child, German-speaking, German-looking, able-bodied, young, skilled in calligraphy, called herself a draftswoman. Against: at least five months pregnant.

Her name was entered nowhere in the records of the camp.

Discrimination: On the ramp

This much was clear: The critical selection was the first one, beside the train. At least a million lives were taken away in that place,

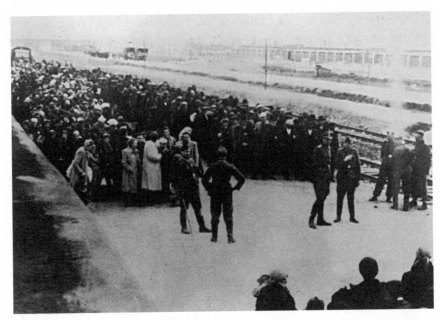

SS officers on railway ramp at Auschwitz, separating the women and children from the men.

waved to the right-hand column and sent straight to be gassed: no registration, no tattoo, no name on any list. Then at least 137,000 more died as prisoners. Altogether Auschwitz-Birkenau disposed of 250,000 Poles, 20,000 Roma, an uncounted number of homosexuals, 12,000 Soviet prisoners of war, and up to 1.3 million Jews, a quarter of all the Jews the Nazis killed. At the final count in January 1945, only 67,012 prisoners were still more or less alive, one-half of one percent of those arriving at the camp.

Any small chance of being registered—not sent straight from the ramp to the gas—depended on available space. When *Abtransport 60* arrived on October 10, 1943, one deportee observed that "a very large portion of men is being retained (about 330) as well as a few women. This figure is exceptional." Exceptional because Yom Kippur 1943 had fallen on October 9, and the SS made a point of gassing inmates on Jewish holidays—this time a thousand women and men. So the camp had vacancies on October 10. But it was not exceptional that "few women" relative to men were retained—an outcome far more common and complex than it appeared to anyone on the ramp.

How much it mattered to be born male in a punitive world has not, even now, passed into thinking on the Holocaust. It hints at privilege where we are at pains to show privation. It raises the divisive fear that women had it worse. But worse on what grounds? When a mother tried to keep a nursing infant fed? Or when a father lost the chance to help his child? When a man was dragged to a torture camp like Sachsenhausen or when a woman went frantic to get him out? When a woman got tossed a crust for enduring rape or when a man ran out of anything to trade for food? When a woman was waved toward the gas holding her child's hand or when a man was waved into slavery first? When a man was deported for being circumcised or when a woman was doomed due to pregnancy?

Still it must be said: In that crucial moment on the ramp, one sex was chosen disproportionately for death.

What helped make the Final Solution a *novum*—a "new thing" in the history of humankind—was not the open all-male propaganda against a Jewish race but the stealthy intentional murder of a Jewish female sex. Once we see that women did not die of inborn physical frailty—for they lasted longer than men in the Lodz and Warsaw ghettos—then the issue becomes clear. Along the stations toward extinction, from arrest through transport to selection, each gender lived its own journey. It was the weighting of many stages of the Final Solution against women that counted at the end.

Arrests and transports. Women were the ones more often left behind during emigrations from the Reich. In 1939, 32,278 more Jewish women than men remained in Germany, and got deported from there. In Austria, 28,077 women were forced into Brunner's seventy-one transports from Vienna, almost twice the 15,344 men. Women were the ones turned down when a few eminent refugees got visas to leave Europe; they were the ones left out of leadership in Jewish groups that stayed; they were the ones forced to have sex in internment camps like Gurs, the ones harassed on the road, the ones in want of contraception through the war, the ones deported for their pregnancies, the ones not part of any Jewish Order Service exempted from the trains.

Selections for slavery or death. For the same reason that Brunner deported more women than men from Austria, fewer were sent from

Drancy, because fewer women in the Reich had ever reached French soil. Of all 72,444 deportees of known gender from France, 43 percent were female. Had selections at Auschwitz been gender-neutral, then 43 percent of those saved for slavery would have been female too. But it was only 30 percent. To put it another way, half the men from France were taken straight from the ramp to their deaths, and three-quarters of the women. So two Jews like Lotte Salomon and Alexander Nagler stood at Auschwitz as two sexes.

Throughout the camp's existence from 1942 through 1945, the SS selected 381,455 deportees for labor: 67.5 percent were men, 32.5 percent women. The rest of the arrivals went straight to the gas. During 1943 alone, about 150,000 prisoners were pulled into the camp as slaves: 86,088 men, only 46,077 women. Up through 1944, 405,000 slaves were tattooed with numbers (and the recording of those numbers is one means of making a count), but only one-third of the tattoos were stamped on female arms.

Near the finish of Germany's war, on January 15, 1945, only 28 percent of the 714,211 slave laborers all over Reich-held territory were female. Of the Jewish prisoners still alive in 1945 when Auschwitz was finally cleared, 17 percent were women, against 83 percent men. A last fragmentary count: in the six Auschwitz warehouses still intact at the time of liberation, Soviet troops found 348,820 men's suits and 836,525 dresses.

Narrowing the focus to one typical transport, Number 60 from Drancy, arriving on October 10, 1943, with 564 men and 436 women: 60 percent of the men (340) but only 39 percent (169) of the women left the ramp with a temporary chance to live. At the war's end 29 men were left (3 percent of the transport) and 2 women. The 340 men selected for labor—among them Alexander Nagler—had gone off to Auschwitz III, called Buna or Monowitz, where the I. G. Farben company ran a chemical plant and paid the SS for use of its prisoners as slaves. With awful irony one man spared for Buna from Transport 60 said, "If by any chance you are a chemist, or a chemical engineer, you are in paradise."

But how many women had been trained as chemical engineers? The two incommensurate lines on the ramp stretched back decades. Centuries. Men with their unshared trades and their imagined strength could be pictured as slaves. And yet most Auschwitz jobs

took no special skill, and none were thought too hard for female hands. "The women in our camp were required to do the same work as we were. Obviously this only concerned young women, since the older women [forty years and up] were all assassinated." Kommandant Rudolf Höss, promoted to Auschwitz in 1943 after proving himself at Sachsenhausen against men like Albert Salomon, stated emphatically: "There were always more men fit for labor than women."

But "fit for labor" still leaves the disproportion unexplained. Why did the Nazis invert their announced aim, their promise in propaganda and the Degenerate Art Show and *Kristallnacht*—to eliminate male rivals in the economy and the arts?

On the ramp the *primary* secret purpose of deportation was finally acted out: to "deprive Jewry of its biological reserves"; to "obliterate the biological basis of Jewry," said Himmler to Höss; to eliminate "the germ cell of a new Jewish revival" ("*Keimzelle eines neuen jüdischen Aufbaues*"), said the Wannsee Protocol.

It was the Nazi view of all women as cell-bearers that condemned the Jewish ones. Even within the lowest life-form—the antirace— women ranked lower still, for spawning it. In Hitler's cliché, "Every child that a woman brings into the world is a battle, a battle waged for the existence of her people." Because women in their biology held history hereafter, one gestating Jewish mother posed a greater threat than any fighting man. To be father to a child had no impact on selection. To be a mother in fact or in future—that was the final sentence.

Whenever a transport arrived an SS doctor questioned women casually—anyone pregnant?—then proposed better food and they confessed. Promised "a lighter work load in the family camps," they asked about keeping children there and were quickly reassured. "I only found out," recalled one woman from Transport 60, "when I saw the pit. For burning the children. They were not even sent first to be gassed."

Here was the Auschwitz Kommandant, Rudolf Höss, at his post-war Nuremberg trial:

Q: And what about the children? Were all the children killed?

A: That depended upon their stature. Some of the 15- and 16-year-old children also went to work, if they were strong.

Q: In other words, children below 15 were exterminated.

A: Yes.

Q: Just because of Himmler's order?

A: Yes.

Q: And because they were dangerous to the German people?

A: Yes.

Q: So a child of three or four years old was dangerous to the German people.

A: No, it isn't quite that way. I should have elaborated perhaps a little more on my statement before, of Himmler's explanation. He said the German people would not have carried rights unless the Jewish people were exterminated.

Q: So that is really a confirmation of what you said. The German people could not rise at all because of the four-year-old Jewish children.

A: Yes.

No victim on the ramp imagined children as "biological reserves," "germ cell of a new Jewish revival," though the SS could see them as nothing else. No deportee had any idea of the true sense of this first selection. In a survivor's words: "One understood quickly that it concerned separating children, old people, sick people, from the robust and the young, but one imagined that the fate of the first group would be *easier*, more humane."

Genocide is the act of putting women and children first. Of all the deceptions a death camp settled on, this one went down deepest. This was the hard core of the Holocaust.

Knowledge

As Brunner's prisoners journeyed from the Excelsior to Drancy to the Auschwitz ramp, they progressed from delusion to disinformation

to disbelief. And within hours of arrival, "the Jews went into the gas chambers which were furnished with showers and water pipes that gave a realistic impression of a bathhouse. The women went in first with their children, followed by the men who were always the fewer in number." To keep the outside world beguiled, to make the inside work run smooth: these were the uses of deceit, flatly outlined here by Kommandant Höss. But he did not say why, with all their pulverizing power, Nazis needed to keep a whole world fooled about the victims' fate.

SS chief Heinrich Himmler had forebodings of the future when he ordered mass graves dug up, bodies burned, and trees planted to cover the ash. Deciding whether to "say something more about it to the German *Volk*, I believe it better that we . . . take the secret with us to the grave." One day only, Himmler did give voice to the overall plan and made the act of breaching secrecy ("Amongst ourselves, for once, it shall be said") more awe-inspiring than the secret itself ("Sure, it's in our program, elimination of the Jews"). That day, October 4, 1943, Lotte Salomon awaited her transport in the closed block of Drancy, and Himmler addressed his senior SS staff:

> Amongst ourselves, for once, it shall be said quite openly, but we will never speak about it in public. . . . I am referring here to the evacuation of the Jews, the extermination of the Jewish people. . . . Most of you men know what it is like to see 100 corpses side by side, or 500 or 1,000. To have stood fast through this and—except for cases of human weakness—to have stayed decent: that has made us hard. . . . We had the moral right, we had the duty towards our people, to destroy this people that wanted to destroy us.

Deception shielded this self-absolving mode. Secrecy let each SS man project on victims what he was doing to them, and on himself the innocence that belonged to them. The allure of killing, as Himmler knew, was to stand among the few "men" who "know what it is like."

Like Himmler, Brunner needed secrets as a form of potency. "Captain Brunner has a sickly terror of indiscretions with regard to the world abroad," Drancy inmates observed. "Every time a new fact comes out on British radio, or the name of another SS officer, he flies

into a fury." Conducting his own interrogations, creating his own ruses, patrolling his own camp, Brunner kept everyone, Jews or Nazis, from knowing as much as he did.

Knowledge *is* power, the sole power victims still held when Brunner never suspected a thing. At Drancy he thought only inmates were being duped when Jewish Order Service officials signed money vouchers each day; but they dug an underground escape from him with forks and spoons each night. He never learned details of the rescue plan from Nice, for even Angelo Donati's secretary spilled only what Brunner already knew in the cellars of the Excelsior. He thought his informers were being cured by Jewish doctors in a camp infirmary, but they were being given lethal injections there. He patrolled his camp at night to catch Jews meeting secretly, but they held a Passover seder with a lookout's password: *"Achtung! Pharaoh!"*

As a last resort, women and men undid Nazi knowledge by slicing their wrists in transit camps and transports, or "throwing themselves resolutely against the electrified barbed wire" around Auschwitz. Guards screamed, "You bloody shit, get it into your stupid head: *we* decide how long you stay alive and when you die." It was suicide, above all else, that undermined this SS need to know the hour of every death.

To reverse the secrecy at the source of Nazi power, victims hid whatever they could learn of genocide. Far below SS deceptions tunneled the secret counterintelligence of the Jews. Milk cans stuffed with documents were buried beneath the Warsaw ghetto by Emmanuel Ringelblum (who later refused to be saved so he could stay with his son); the epic "Song of the Slaughtered Jewish People" was buried in the soil of a French camp just before Brunner deported Yitzhak Katznelson, the poet, with his son. Forty delegates from Jewish organizations throughout France created an underground archive in 1943 that became the CDJC, the Centre de Documentation Juive Contemporaine, from which so many postwar prosecutors drew up dossiers against the killers. Each document that someone struggled to hide away left one more chance, if not for rescue or revenge—then for history.

This last form of struggle was the one that possessed Charlotte Salomon. What she made and what she hid, more than any account to surface so far, brought an artist's perception to a life that was shaped by deception. In telling a story of suicide and secrecy, CS traced a course from "I knew nothing of all that" to "Suddenly she knew." Here was a victim who scraped away secrets, thickened the lines around each hard-grasped truth, and painted her life knowing that knowing was all.

13

REPRISE

〜

The last image of her was set down by Nazi interrogators hours before the transport out of France:

Name? *Charlotte Nagler*

Birthdate? *16. 4. 1917*

Birthplace? *Berlin*

Occupation? *Zeichnerin*

It was as a *Zeichnerin*, a draftswoman or graphic artist, that CS mattered to herself and hoped to be reprieved—by presenting a useful trade for the labor camp to come. Her portraits had often shown her in the act of drafting—tracing the line of Paulinka's face, brush-stroking a meadow with flowers, outlining a desolate grandmother, gripping a sketchpad for safety, drawing with "dream-awakened eyes."

None of these portraits reached her parents. Paula and Albert Salomon went through 1943 without news of Lotte, as they tried to stay safe from camps themselves. Lying low in Amsterdam, they shared rooms with Kurt Singer until the Germans ordered him to the "model camp" of Terezin, which featured, they said, a kind of Kultur-

651	MOSSE Jules	17.II.9I	Advokat	5451
652	MOSSE Séphora	3. 4.90	Ohne	4824
653	MOSSER René	12. 2.02	Kaufmann	5I66
654	MULLER Georges	1. 8.I2	Kaufmann	4370
655	NAFTULOVICI Fanny	18. 2.I3	Schneiderin	4739
656	NAFTULOVICI Germaine4. 3.I2		Schneiderin	4740
657	NAFTULOVICI Manach	2.II.89	Troedler	4737
658	NAFTULOVICI Sarah	9. I.87	Schneiderin	4738
659	NAGLER Alexandre	25. 8.04	Buchhalter	5570
660	NAGLER Charlotte	I6. 4.I7	Zeichnerin	5571
661	NAHMIAS Adolf	30. 9.88	Buchhalter	4986
662	NAIDITSCH Fanny	9.I0.85	Ohne	5501
663	NAIDITSCH Max	29. 7.90	Angestellter	5500
664	NAIM Ephraim	26.II.85	Arbeiter	5628
665	NARWER Samuel	6. 9.97	Arbeiter	5490
666	NATHAN Mélanie	II. 2.67	Ohne	5220
667	NEMET Isa	20. 6.95	Ohne	5I34
668	NEMET Jean Claude	6.II.27	Student	5I35
669	NEUMANN Alexandre	4. 3.85	Kaufmann	5517
670	NEUMANN Dora	13. 9.94	Ohne	48I0
671	NEUMEISTER Max	9. 5.80	Schneider	5782
672	OBERSCHMUCKLER Arnold 30.II.76		Kaufmann	4835
673	OKRENT Daniel	I5.II.96	Juwelier	5I06
674	OLCHANSKI Jean	14.II.09	Angestellter	I6I6
675	OLIVENBAUM Albert	26. 9.27	Student	52I3

Page of Transport 60 list (by name, birthdate, occupation, and Drancy registration), including Alexander Nagler ("Book-keeper") and Charlotte Nagler ("Graphic artist").

bund. Terezin, the showplace of Czechoslovakia, spiffed up for visitors, then deported performers to death camps when the audience left. There Kurt Singer reviewed an opera sung by children for the Red Cross on September 23, 1943 (also the last night Lotte spent in Nice), praising its moral motif "and a singing line which is never

obscured or smothered by the instruments." His spirit, once and always impassioned by "a singing line," gave out within months. At age fifty-eight he was dead of contagion and of cold.

"Then in Amsterdam the Nazis came for us in the night," Paula recalled, "and burned all our belongings—Lotte's letters, everything." Paula and Albert ended up in the camp of Westerbork—Holland's Drancy—the place where two young diarists, Anne Frank and Etty Hillesum, were imprisoned on their way to Auschwitz. Paula began working night shifts at the camp infirmary so she could carry messages and help her husband. One day he was ordered to sterilize women in "Jewish-Aryan" marriages or face execution if he refused. He did refuse. But Paula stepped in, saying he needed his surgical instruments and a day's leave to get them. Once outside, her mobile full-range voice impersonated a Nazi's on the phone and ordered an official to validate a longer leave. They slipped underground. "And then came that dreadful time when we had to be somewhere different every night," passing from one pair of hands to the next, until they found a small country hideout (Paula slept in a bathtub) at the house of a man they never knew was a resistance chief all through the war.

They lost touch too with Lotte's much-loved Alfred Wolfsohn, who had lingered in Berlin with a sister until his sickly mother died, then had fled to London in 1939 with the help of his student Alice Croner. "I got him out in the nick of time," she recalled, horrified that she could find a sponsor only for him. In England he took a nickname from his initials, "A.W.," pronounced as in German, *ah'-vay*, and spelled "Awe." The prophetic overtones of awe, of Yahweh, somehow suited him.

The man who'd indicted war now enlisted at age forty-five in the Pioneer Corps, a unit for "enemy aliens," as the British government labeled German Jewish refugees till they signed on. Once more a nation's high command sent him to France, unarmed this time. One photo shows him in a soldier's cap and haircut, but the probing eyes and glasses still looked like CS's Daberlohn. He gave the photo to Alice Croner along with some advice: Record all your dreams, he said, even the ones of Jews crying, "Help us, Frau Croner, help us!" Write your biography, he said, as German planes bombed Britain every night. So "I worked for two years every day writing my life, with the enormous break in it when I left Ger-

many"—the same task that sustained another woman through those times. Wolfsohn, however, suffered badly from a second round of human losses in a second war.

Secrecy, 1944–1947

After five years of that war the Nazis started losing ground in France during summer 1944. At Drancy Alois Brunner worked faster to claim a victory over the Jews. Inmates observed him searching for "something to dig into when the provinces yielded nothing more." From nearby orphan homes "Brunner brought 500 children ages one to fifteen to Drancy" then packed them in a train—"cattle cars, you understand, and locked shut! Only one pot of drinking water and two or three adults to take care of the little ones." Drancy prisoners saw them "covered with sores and vermin, lacking all care. Deprived of their mothers, without any laundry, the littlest ones had not been washed or changed. How would they arrive alive at the end of their voyage?" How would the ones too small to know their names find their parents at the vast labor camp in Poland? Prisoners listened through the walls to hundreds of children crying, "Mama, Mama," and could only whisper, "You will see, you will not go far, you will not go to Pitchi Poi."

Brunner announced pointblank to a Jewish official, Kurt Schendel, why he arrested all these children: It was reprisal for one German soldier killed in France. Reprisals were so feared that young men in Transport 60 replaced the floorboards of the train, knowing, like the Jews of Salonika, that Brunner would kill everyone if some escaped. And now he held as hostages the children of Drancy. Schendel wrote at the time, in August 1944: "I tried in every possible way to change Brunner's opinion. . . . He countered in each response that these children were 'future terrorists.' There was nothing to do; it was impossible to move this man; no argument, no sentiment had any hold on him." In that "future terrorists" phrase, Brunner let slip his nightmare: a later generation might have its turn to act like him. His mind admitted only two alternatives—crushing or being crushed—so if he let those children live, they must avenge themselves on him. This dogma was the Nazis' deep obsession, surfacing in postwar trials: "Surely being children of parents who had been killed, they would constitute

a danger," defendants explained, and must be "shot as well, in order to prevent acts of revenge." Himmler swore he would not allow "avengers in the shape of children to grow up for our sons and grandsons." So Brunner moved mountains, as Allied armies approached, to get his last transports off, with hundreds more children, newborns all alone.

On August 17, 1944, when the Germans pulled out of Paris, he ordered the Drancy transport lists destroyed, evidence of more than 67,000 names. One full list—but almost no one named on it—escaped to tally his command. He had dispatched 23,471 prisoners in a year. Only 1,645 came back. Onto the last departing military train, Brunner hooked a final wagonload of Jews and headed out of France.

For the SS captain called by Eichmann "one of my best men," a new job waited: "Expel the Jews" of Slovakia. In a few months Brunner changed the labor camp of Sered into a transit site, fired all its officers, planted gardens there—and lies—then deported 14,000 Jews. An account by a Red Cross delegate gives a sense of Brunner's manner then.

> "So?" [asks Brunner]
>
> "So, I'm coming directly to you, since you have full power in Slovakia."
>
> He is visibly flattered and puffs up. I see with astonishment that, judging from his features, he could be Jewish. . . . It's with these features and manners that Brunner gives me a course in racism (another one!). . . . "Victims! Fomenters of the war. International Jewry." . . . He smiles broadly now, plays with words, lets himself banter, then suddenly, a new racist tirade: "All those who protect Jews stink."

In Sered as in Drancy, "nothing could bring him into mad anger so much as the escape of a Jew." The prisoners called him "Tiger"—stalking by night, roaring orders, beating to blood, "covering the camp like a dark nightmare," so that even SS guards thinned out before him. He kept trains running to Auschwitz up to the moment Russian armies closed in. But by early spring 1945 Eichmann's group was dissolving. The hand-picked deportation experts, the trusted special service, scattered into silence.

Fleeing to Vienna, Brunner adopted a false name and served a lit-

tle time in prison camps, where Czech, American, and British officers all processed him and let him go; he even drove trucks for a U.S. unit near Munich, where a fake identity hid his past. In 1947 the U.S. Army Counter Intelligence Corps gathered a dossier on the missing Brunner, labeled him "Wanted War Criminal—brutal type, said to have 'disinfected' Vienna"—and noted two leads on his whereabouts: his wife's current address in Vienna and an inn where he and Eichmann stayed in 1945. But he was not pursued, and his signal work in deportation, like his face, remained unrecognized.

Ironically, it was the 1947 trial of Nazi criminals at Nuremberg that made Brunner most secure. The French government's brief identified him, without a hint of his importance, simply as a "member of the Security Service in Paris." Nuremberg records confused him with a Viennese subordinate, Anton Brunner, who'd been sentenced to death "for execution of Jews." An influential early history created a composite: "BRUNNER, Anton Alois. Eichmann's most successful Jewish deportation expert. . . . Hanged by sentence of Vienna People's Court (Russian Sector), May, 1946." Other publications repeated this mistake for twenty years, leaving the impression that the Nazi named Brunner received his just deserts.

Affiliation, 1947–1949

In those early postwar years, Paula Salomon-Lindberg doubted if justice could ever be done. As soon as Holland was set free, she made trouble (without ever admitting how) for the U.S. consul who'd turned down their visa petitions, then returned to Amsterdam to see whether they could make ends meet. "I am one of the few who never wanted any reparations from Germany. We said to ourselves: We have two options—either we hang ourselves or we work."

A year or so later Paula and Albert Salomon made their way to Villefranche. For the first time they met Ottilie Moore. "Yes, she had come back from the U.S. to l'Ermitage in 1946," her nephew recalled. "She located her furniture and paintings among officials in Villefranche, who claimed to be 'keeping them safe.'" Paula instantly judged that "she had everything possible wrong with her"—among other things, she refused to part with Lotte's paintings. Ottilie pulled out packages with "Property of Mrs. Moore" written in Alexander

Nagler's hand, which had come to her from Dr. Moridis—the man who had treated Grossmama's depression, witnessed Lotte's marriage, and concealed her artwork till the war was over. Paula remembered:

> That whole house was full of pictures Lotte had done. And when I said, "These things belong to me," she dragged in *Life? or Theater?* and tore it open but didn't allow us to touch a thing. There must have been—how many?—over a thousand sheets, in three or four packages, the drawings on top of each other. She said: "You can have *that*, it doesn't interest me!" When she was told the city of Amsterdam would pay for other pictures, she said, "I'll get more money in America!" And then she just took away everything that had anything to do with herself, like the beautiful drawings of her daughter. From what I saw, there were at least ten self-portraits of Lotte. Mrs. Moore said I could have one of them. We had to *buy* it from her.

Most pictures on the walls of l'Ermitage slipped out of their owner's hands and disappeared ("she just took away everything that had anything to do with herself"). Ironically, only because *Life? or Theater?* included no portrait of Ottilie Moore, the artwork that preserved her name was preserved itself.

"In France we only saw the package," Paula remembered. "Then it had to go through the mail and customs to Amsterdam. We looked at it for the first time in our house." An unimaginable act.

No one could face, just after the war, a newly found account of pain and self-discovery. One day Paula and Albert Salomon were visited in Amsterdam by their close friend Otto Frank, with his daughter Anne's manuscript in his hand. He told them he couldn't bear to read it through. Would they? Was it of true value, did they think? It had to be, Paula said, surely with Lotte's thousand scenes in mind.

Obsession, 1949–1954

More than anything else, those scenes re-created Alfred Wolfsohn and his "Orpheus" manuscript, which in fact traveled with him to London, where he kept thinking about its themes. He said he'd heard Hitler's voice over loudspeakers so many times that he desired just one thing now: to create a *"menschliche Stimme,"* a *human* voice to mend the fractures of the past, whether Jew vs. Aryan or female vs. male. The support he needed to create this human voice never tired two German

Alfred Wolfsohn around 1947
with glasses and field glasses—
still looking ahead.

refugees, Ingrid and Fips Faraday, who befriended him in England and
gave him a home. Fips even took him to Amsterdam in 1947 to consult
the one physician Wolfsohn would trust, Dr. Albert Salomon.

Only on this first visit to the Salomons did all their wartime sto-
ries get exchanged. "Lotte had never heard from him all those years.
She never asked where he was. She never knew and he never knew,"
Paula realized then.

Seeing Paula may have opened a vessel in Wolfsohn's memory
that fed into a manuscript called "The Bridge." In it he described a
watercolor his young friend Lotte gave him in 1938: a birch tree. He
had carried it in his baggage from Berlin.

> No doubts could dissuade me from seeing in this picture a self-por-
> trait corresponding to her essential being. . . . I remember two of
> her dreams and would like to relate them to help you understand
> her painting even more clearly. The first dream: *"I floated in the air,
> bound by a thousand shackles, a larva with the one burning desire to be freed one
> day from these shackles."* The second dream: *"I was walking in the busiest
> street of a city. I was naked, but this is not really the right expression; I ought to
> say I was stripped of my clothes, exposing myself to every passer-by."* . . . You
> need only think of her drawing of the gently colored, rootless birch
> that seems to float in the air, in order to estimate her incapacity to
> stand on her own feet.

Astonishing how he remembered Lotte's mind mixing nightmare, landscape, and portrait, and even recalled her dreams from twelve years past; but he saw in their shackles and nakedness the archetypes of a psyche, not the strains of a Jew. He brilliantly deduced self-revelation in her "rootless birch," yet imagined her unable "to stand on her own feet." Nor did he realize she must have sketched this tree in the academy's closed and quiet courtyard, where one just like it was growing fifty years later. Her self-portrait of a birch tree was taking shelter near a place of art.

The deep attention Wolfsohn gave to Lotte he repeated with many other students after the war. When one of them, Marita Günther, came from Leipzig to England in 1949, Wolfsohn offered her his manuscript "The Bridge"—just as he'd once handed Paula and Lotte "Orpheus"—and asked for fifty pages of response. "I wrote my own life story, and he replied, 'I am so pleased that you have thrown overboard your faculties as a critic and announced yourself.'" Still pressing his texts on women, he hoped they'd make space, beside his words, for their own life tales.

"Longing for the overthrow of boundaries belongs to the nature of young people," Alfred Wolfsohn wrote, and young people came to him as Lotte had years before. By helping them reach the female/male sounds in their minds, Wolfsohn invented "a multi-octave voice" with its "beauty of the dared expression," recalled Marita Günther. "Trained by Alfred Wolfsohn" (*The Guinness Book of World Records* reports), Marita herself "covered the range of the piano from the lowest note A [to] seven and one quarter octaves" above.

Despite Wolfsohn's advances in vocal range and music therapy, the judgment of Paula Salomon-Lindberg never changed: "A brilliant dilettante," she called him. While teaching at the Salzburg Mozarteum, she resumed her role as helpful patroness and arranged for Wolfsohn to address the faculty there. It turned out they had no use for "everyone singing low as Sarastro and high as Queen of the Night."

"If you made a new sound or looked at a tree, he would want to know why. The purpose was always self-revelation," recalled Sheila Braggins, a lively, independent woman who spent years, along with others, looking after Wolfsohn—"because he gave me everything."

"He belonged to all his students," Alice Croner said, and they all belonged to him, typing and cooking and taking singing lessons and listening to him talk. But when Alice called him "the great fertilizer," there was more to it than she knew.

All these women missed the truth—that partners in deception get deceived. So Paula helped hide Wolfsohn's passion for herself from his fiancée. But she overlooked the fact that Wolfsohn and Lotte used her rooms when she was out. So Lotte, lying to Paula as she met secretly with him, never guessed he was involved with Alice Croner too. So Alice, keeping this secret in London as in Berlin, never suspected he was also Ingrid Faraday's love. So Ingrid failed to see in sixteen years as what she called "his wife" that his singing lessons with students involved sexual rapport. In the years when Wolfsohn lived with Ingrid, Fips, and their child Mucki Faraday, all four pretended he was just their friend. One day in the 1950s Marita looked hard at ten-year-old Mucki: "My God, Awe, he looks just like *you*!" No one said a word. Mucki was told, Awe is your father, only never let on. Each person was always told, "Your relationship with me is special, you must keep it to yourself."

Years later the secret son Mucki tried to come to terms with his sense of Wolfsohn, during an interview at his home in rural western France. Suddenly a window happened to frame him like a picture, and for a breathtaking instant precisely Daberlohn's face came to view. Mucki spoke of his father as a cult figure finally seen through and escaped. But CS's paintings also restored the luminousness of the man, and when Mucki's daughter was born—Wolfsohn's grandchild long after he died—she was given the name Charlotte.

Deception, 1954–1961

The name of Alois Brunner slipped from sight. For a false identity Brunner contacted one Georg Fischer, a Nazi he'd met in wartime France. The two looked so alike that Brunner flashed Fischer's undoctored passport as his own and got out of Austria to Amsterdam, where anyone on the street—even Albert Salomon—might have seen a close-cropped man, too young and hunched to do much harm during the war. Then the man, too, disappeared.

How Nazis got away counts less in the long run than how they got covered up. In the deepest battle of the Holocaust—perception vs. deception—Brunner was still leading the field a decade afterward, as Nazi defendants simply erased him from the war. Here was Helmut Knochen, the former Gestapo chief in France and Brunner's closest colleague, being interrogated in 1954:

"Was Brunner a member of the Gestapo?"

"I don't know."

"Did he come from Bureau IV [Eichmann's staff]?"

"I cannot affirm that with certainty."

"Did Brunner have rights of control and surveillance over Drancy?"

"That I cannot say."

By 1954 Brunner was sentenced in absentia, without any press, by the Armed Forces Tribunal in Paris and the Military Tribunal of Marseille, whose slim indictment listed a scattering of crimes, such as "Villefranche-sur-mer, arrest of the Nagler couple and pillage of their goods." No one, of course, had any idea who they were.

Then Brunner slipped out of public memory and Europe at the same time, with more than one reason to leave. Arab leaders in Egypt, Syria, and Jerusalem were coordinating a struggle against Israel, and Americans were setting up Middle East branch offices for anti-Soviet spies. Both were casting about for ex-SS men. Following well-worn escape lines, Brunner got to Cairo where he was advised that officers of his sort, like the commandant of Treblinka death camp, were safe in Syria. In 1954 Brunner settled in Damascus under commercial cover. The real work included making a manual on anti-Jewish terrorism for use by Egypt's security force, which the CIA supported to promote U.S. interests in the Arab world. In the Cold War's free-for-all, CIA networks used the services of Reinhard Gehlen, head of West German intelligence, to sub-contract Germans with a need, so to speak, for jobs abroad. In the late 1950s, Gehlen's man in Damascus looked a lot like Alois Brunner.

To stay in Syria meant to live apart from a wife and a daughter born in Vienna in December 1945. Anni Röder, approved in 1942 as

an Aryan mate, divorced her former SS man in 1958 and stayed in Vienna, blocking any trail from her to him. Yet three events around 1960 peeled off Brunner's cover. First the Syrians arrested him under his alias, for currency transfers to Austria, which seemed to spell drug trade. As soon as he revealed his true name, they spun around and hired him to make interrogation devices and anti-Jewish propaganda. Then a second jolt: In 1960 Israeli agents captured Adolf Eichmann in Argentina. Simon Wiesenthal, a prominent researcher in Vienna, learned that Brunner was at large, organizing Germans and Algerians to kidnap the head of the World Jewish Congress. Brunner's plan, though it failed, was to ransom Eichmann by exchange. Then a third shock came in a letter from Vienna (possibly sent by Israeli agents, possibly by French) that exploded in Brunner/Fischer's hands and destroyed an eye. So he found out he had been found out.

Just as it emerged in Israel's High Court that Eichmann had used a handful of experts to engineer deportation, the man in the glass booth stumbled over everything: "I keep mixing the two Brunners up," Eichmann testified. "As far as I know, as far as my memory serves, Brunner was not the commander of Drancy." When Israel's Attorney General coaxed that Brunner "organized deportations from Drancy," Eichmann responded: "That's also news to me." To disprove his testimony, eyewitnesses tried to bring his underlings to light, but Eichmann protected his own. Then the trial transcripts stayed unpublished, and several studies of Eichmann reported that Brunner was "executed in Austria, 1946."

When he planned a trip to Europe for eye treatment in 1967, helpful warnings (allegedly from the German Foreign Ministry and an Austrian veterans group) reached him first: Don't set foot in France, arrest warrants await you. Protected and forewarned, he was not likely to activate the French sentence for crimes like the "arrest of the Nagler couple and pillage of their goods."

Tenacity: 1961–1971

In 1961, when Eichmann stood unransomed in Jerusalem—a year of sharp focus on the Nazi catastrophe—the Stedelijk Museum in Amsterdam mounted the first selection from *Life? or Theater?* The curator, Ad Petersen, visited Villefranche in search of other works

still held by Ottilie Moore. "She owned some pastels of the garden, and some landscapes done in a traditional way. I missed the expressionism of *Leben? oder Theater?*" Meanwhile *Life? or Theater?* had lost the careful order her hands had given it: The numbered scenes got mixed with the unnumbered ones, the overlays detached and slipped out of their places. For some years the work's complex theatricality was not so evident, which may be one reason it got labeled a "diary." Albert Salomon's essay for the 1961 exhibit called it an "analytical diary done from memory." Even Ad Petersen saw it as a "curious document," and only much later as a "unique work, with nothing else of its conception and size in art history." What astounded him in 1961 was the vividness of CS's recall: "How was it possible for her to have all the colors, all the interiors, all the faces, like photos, in her head?"

A first book with eighty reproductions, *Charlotte: A Diary in Pictures*, came out in 1963 and was welcomed to confirm the lesson of Anne Frank: humane spirits outlast monstrous ones. In the righteous mood after the Nuremberg trials, Anne Frank's "I still believe that people are really good at heart" became the victims' most quoted phrase. Her accusations went unnoticed, like CS's irony. The 1963 book omitted the skeptical title *Life? or Theater?*, ignored the irreverent captions, and closed with a picture exulting, "God my God oh is that beautiful" in place of CS's somber finale—"She knew: for a while she had to disappear from the surface of life."

In an uplifting preface to *Charlotte: A Diary in Pictures*, theologian Paul Tillich gave readers a reason to value CS: "There is something universally human, something that bridges the distance between man and man . . . in the almost primitive simplicity of these pictures." The "universally human" diary governed views of *Life? or Theater?* for the next twenty years: it answered needs left over from the war. In fact the work was neither universal nor a diary, and the "primitive simplicity" that many saw there bordered on wishful thinking. CS brought out of jeopardy not a journal but an opera, bold in artistry, short on innocence.

When Paula and Albert Salomon chose paintings for the 1963 book, they insisted on softening the suicide motif, which still shamed them (their colleagues observed). Charlotte's speech to Grosspapa appeared ("Grosspapa, I've come to feel that one must piece the

Charlotte: "Grosspapa, I've come to feel that one must piece the whole world back together again." Grosspapa: "Oh just do it, kill yourself too, so this yakking of yours can stop!"

whole world back together again"); but in a fantastic intrusion on art, his response ("Oh just do it, kill yourself too") was airbrushed off the scene. The family that once hid its suicides in hopes of muffling noise about the Jews still had to keep quiet: Too many were waiting for proof that Jews had destroyed each other and themselves.

Before the book came out, Paula Salomon-Lindberg sent a brochure for the 1961 Amsterdam exhibit to Alfred Wolfsohn. At last

The same picture as reproduced in 1963.

he saw his influence on Lotte, after assuming his ideas had never gotten through. One picture in the brochure—Charlotte and Daberlohn on a park bench in Berlin—left him mute for hours.

By that time he was suffering from tuberculosis (caught possibly in the trenches of 1918). His breath was getting short and his mood suicidal. Though he valiantly conducted singing lessons from a sanatorium bed, he finally gave Marita Günther his manuscripts without

writing about Lotte's paintings as he'd hoped. Then in 1962 at age sixty-five his lungs completely closed.

"The sky came down. I thought that life had finished. But he prophesied my dreams would have a use, so I kept recording them for twenty years more," Alice Croner said. His prophecy came true when Zurich University started "searching for someone who saves dreams but has not been psychoanalyzed" and launched a research project based on her lifetime supply. Marita Günther spent years after Wolfsohn's death typing and translating his manuscripts, for "he was the source," she said simply, with his voice in the deepness of hers. She and Roy Hart, as former students of his, moved in 1974 to the south of France, where twenty members of their theater took hard farm jobs and rationed their bread by the slice, so they could rebuild a château called Malérargues and continue Wolfsohn's voice research. In snapshots of those years they all look very thin. Now they use his techniques in avant-garde performances and workshops around the world, carrying brochures everywhere with photos of Wolfsohn that look remarkably like Daberlohn.

Just as often, his name has been heard by way of Charlotte Salomon, acting on his prophecy in 1938: "Someday people will be looking at the two of us."

Someday people were able to look only because *Life? or Theater?* had slipped away from Mrs. Moore. When her villa l'Ermitage was torn down to build condominiums, she lost the rest of what she had—including other small works by Lotte—and "ended up mornings lying drunk in front of her refrigerator," where Annie Nagler found her "just days before she died. She offered me any painting by Charlotte, and I chose a view of l'Ermitage." That was in 1972, when Ottilie was "fighting the Fates and the rest of the world, much as she had done most of her life," her nephew recalled. Refusing to stay in bed with a collapsed hip and a full cast, "she fell down the hospital steps and broke her neck."

Generous cadger and close-fisted patroness, Ottilie Moore was always what Annie Nagler said—"a woman of two faces"—both of which vanished whole, like l'Ermitage. Only a garden wall and a watercolor of the orchard, orange in hue, orange in scent, remained of such a fruitful place.

The place where Albert Salomon spent the second half of his life

was Amsterdam. There he went on living till the age of ninety-four, learning new medicine for a Dutch practice and a new language to give talks. Paula came back to life as a voice teacher, her opera career interred. Pupils from the postwar years remembered her strength, her standards, "that marvelous blond hair," her husband a few steps behind—just like Paulinka Bimbam and Albert Kann.

Teaching each year at the Salzburg Festival, Paula met up with Marc Chagall, and showed him the CS paintings that had been repro-duced by 1963. Chagall treated the paintings "so tenderly. He was very touched by them and said—good, they were good." When the artwork returned in the 1960s from exhibits in Tel Aviv and Germany, it stayed in Ad Petersen's museum office, encased in five handmade cartons, while its subjects tried to get on with life.

With great care, in 1969, Albert brought out a book of essays that summed him up: Jewish culture in Germany, Kurt Singer and the Kul-turbund, the art of Persian carpets. He turned out to be a broader humanist than CS ever allowed her Dr. Kann, who "thought only of his career." By then Albert's own Persian rugs were underfoot in some "Aryan" household of Berlin, and by then the Kulturbund had to be explained as another ancient artifact. But here were better listeners than he had lived among before, and in gratitude he and Paula gave away their only legacy from a former world. *Life? or Theater?* went to the Joods Historisch Museum, the state-subsidized Jewish Historical Museum, so that visitors could look at it alongside other Jewish handi-works. In 1971 Charlotte Salomon ceased to belong to one family; they trusted her care to Amsterdam.

Five years later Albert Salomon passed away. At the end he wanted only to hear Paula recite the lyrics of a Schubert song, and to squeeze her hand if she missed a word. It was a song CS had attached to Paulinka when she'd finally decided to marry Albert Kann: "There's a road that I must follow from which no one has returned."

Presentation

When Albert Salomon died, his daughter's paintings, texts, and overlays had finally been put in order. In 1981 the Joods Historisch Museum presented 250 scenes in narrative sequence—and found it had never mounted a more popular show. In the same year a poignant

feature film (*Charlotte*) by Judith Herzberg and Frans Weisz recon-
structed her life and art, guided by interviews with Paula. In this film,
Daberlohn (played by Derek Jacobi) appeared entrancing to Char-
lotte yet overblown to the audience, whereas a play at the Jerusalem
Drama Workshop (*Life? or Theater?* by Joyce Miller and Mark Ritten-
berg) embraced Daberlohn more closely than Paulinka: the tensions
of the triangle had not yet come to rest. Also in 1981 a splendid edi-
tion of *Life? or Theater?*, with all the numbered paintings and captions in
769 color plates, was produced by art historian Gary Schwartz. Paula
put her copy on the piano, closest to her heart, and rarely opened the
book when she was alone.

Then critics finally credited CS's paintings. She had "an emo-
tional pitch rarely attained in the work of artists of much wider repu-
tation"; she "possessed an astonishing visual recall, evoked under the
duress of events and the need to summon her existence before her
eyes"; "Rarely an autobiography comes along that speaks with an
arresting voice of its own which seems to owe nothing to anyone
else." But other reviewers looked at *Life? or Theater?* and saw something
"not quite document and *not yet art*," or a "*psycho-artistic self-investigation*
. . . that indicates a keen *intuitive* understanding of depth-psychology."
Or: "It's unlikely that she *wanted* to produce a wholly new kind of per-
formance art. . . . A simpler explanation of the *confused* fictionality and
reality of her book is just that Charlotte Salomon, with her range of
talents, was *naive* enough to employ them all in *trying* to record her
life" (All italics added). If no longer a "diary in pictures," it had
become a transcript, unedited, from the heart.

Still, the full edition of *Life? or Theater?* circulated, and selections of
paintings radiated to Jewish museums in the United States and Israel.
Then they went to Berlin, where fifty years after the academy
expelled the artist, it exhibited her—along with documents on art
education in the Third Reich, gathered by the academy's courageous
historian Christine Fischer-Defoy. For the opening in 1986 Paula trav-
eled to Berlin, the first time since 1939, and kept a forearm over her
eyes as her taxi sped through the streets. With care Christine brought
Paula back together with the city, by publishing German interviews
and essays in *Charlotte Salomon—Leben oder Theater?* and helping Han-
nelore Schäfer produce a fine TV documentary, *Die eigene Geschichte*,
that put Paula's lively face on screen.

Paula Salomon-Lindberg in her
Amsterdam kitchen, 1986.

By the early 1990s the paintings had also been shown in Norway, Japan, and finally in France. For a 1992 exhibit by Claire Stoullig at the Pompidou Center, Paula traveled to Paris at the age of ninety-four, still sparing nothing of herself. She watched a moving French film by Richard Dindo and Esther Hoffenberg that introduced the artist to the country where she'd created *Life? or Theater?* The film (*C'est toute ma vie*) sent music flowing through the paintings, and true to CS's vision, delivered all the characters' lines in the artist's voice.

Life? or Theater? has still to reach other major museums of modern art, where all its inventions ought to place it with the avant-garde: it layered a drama over real events, trespassed single frames, infused colors with sounds, exposed a script on see-through overlays, mixed words into images. Its uniqueness has captivated some art historians, and future exhibits might feature not just the scenes but also those tragicomic overlays, or the taped-over studies, or the hidden life behind the characters, or the world of exile that weighed CS's arm down as she sketched, or the mystery of her method: "Dream, speak to me," she said, and closed her eyes so she could see to paint.

Premonition

Nothing could be seen of Alois Brunner for two decades after Eichmann seemed to forget who he was. Dossiers about him had been tirelessly collected by Simon Wiesenthal and by Serge Klarsfeld,

whose father he deported from the Excelsior in the transport after Lotte's. But even by the 1980s no one had written about the man—his range, his main force, his place in history. Then his name surfaced during research (on Lotte's arrest) for this biography. Piece by piece, archives like Yad Vashem in Jerusalem, YIVO in New York, and the warmhearted CDJC in Paris, founded underground in 1943, started yielding a portrait of him, and it was of no minor figure. Brunner could answer for deporting some 129,000 people: 47,000 from Austria, 44,000 from Greece, 23,500 from France, and 14,000 from Slovakia. That Brunner was not just archived but alive felt like a premonition: his SS work had not yet run its course.

His few surviving victims recalled, "It was impossible to move this man; no argument, no sentiment had any hold on him," and "There was nothing I could do," and "None of us could comprehend." He always pulled the loopholes tight to fill his trains; he always bristled with deceit. He always was one to torture the weak, track down the children, and exploit the credulity born of despair.

Only top echelons ordered genocide, but this middleman taught Nazi leaders just how far their fantasy—a world with no Jews!—could travel on the ground. An SS colleague sketched Brunner as "one of the best tools of Eichmann," as the servile and canny device that gave the hand its power.

Nazis like this one were never forced to lose their war. In fact Brunner and his SS colleagues in France fared nicely afterward. The Paris Gestapo chief, Helmut Knochen, was condemned to death in 1954, had his sentence commuted in four years, and was freed in eight. Heinz Röthke, who signed the Transport 60 list and many more, lived a long life in Germany, practicing law. From 1945 to 1986 the Germans sentenced only 160 Nazi criminals to life in prison, only 12 to death; the Austrians dealt out shamelessly soft judgments. In the maldistribution of human pain, Germans and Austrians stayed free of war for fifty years, whereas Jews were hedged into Displaced Persons camps and could not return home, find visas elsewhere, or settle legally in Israel till 1948, for which they had wars in 1948, 1956, 1967, 1973. Brunner's safe existence in that part of the world kept on proving how geopolitics counts much more than genocide.

Who was to extract him from a country no one dared touch? The Mossad? Not after the outrage against Israel for kidnapping Eichmann,

not with the danger of Syrian revenge, not if Damascus might make peace. The CIA? Not when the United States owed Syria for compliance in the Gulf War, not when it expressed gratitude each time Syria refrained from adding trouble to Lebanon. The European Community? Not as it struggled for stability and for leverage in the Middle East, not as it faced homegrown hatred aimed at Muslims, foreigners, and Jews. The historical profession, then?

Brunner's safety in Syria seemed a posthumous victory for the Reich. Syria always denied his presence, disdained international queries, and held him out of reach. A photo showed his frail figure bullishly guarded by Syrian soldiers, apparently to keep him from attack—but also from telling tales about his postwar work. Reporters whom he probably mistook for Nazi sympathizers published Brunner's unrepentant words in 1985: All Mideast violence results from the fact that "Jews with their Christian and Islamic sects are the crowning achievement of the devil." Always Jews start wars to conquer the world. Nothing the SS did should cause regret. The German govern-

Alois Brunner in Damascus, 1985, his hand damaged by a letter bomb.

ment should pay a pension for his services. And in 1987: "All of them deserved to die because they were the devil's agents and human garbage. I have no regrets and would do it again."

Quarantined by Syria and hardly leaving his Damascus rooms, Brunner could see his views confirmed whenever the Arab press called the Holocaust a Zionist plot, or when news came in from Germany: Thousands of attacks on foreigners each year, 6,500 armed neo-Nazis who would "form the battalions to save Germany from the Jews" and who called the death camps "lies of the century" and denied "there was a Holocaust or that we should feel eternally guilty toward the Jewish race." Only in the early 1990s, with urging from Serge and Beate Klarsfeld in France, did European authorities begin to call aloud for Brunner's arrest. A German prosecutor gathered wartime witnesses, and extradition requests were renewed, but always with grace toward Syria, whose favor was needed in dealings with Iraq, with Israel, with Iran. The decline of Soviet support might have tempted Brunner's hosts to toss him like a stone into the proverbial stone soup and draw in tasty ingredients like armaments or cash. But neither Syria nor any government with interests in the Middle East dared empty its political stores for an old man missing some fingers and an eye. Word went out in 1993 that he had died, at age eighty, but no one could say how, no body appeared, and the régime guarding his identity stayed silent, having denied his existence all along.

Reprise

"History is not the simple and cold recital of what happened but a lesson in living, eminently useful to those who take it to heart." These words came forty years after the war, in a letter from Père Marie-Benoît, the man who worked with Angelo Donati to save Nice's Jews. What "lesson in living" could be taken from those who risked their lives as rescuers, and failed?

Above all, that killers have not been stopped from destroying so-called enemies of the state or even enemies of the blood—a threat so abstract that no exclusion, no expulsion could do away with it. Against this threat a man like Alois Brunner erased 129,000 lives, and the memory in them, and the faith that memory allows. Years later a handful of his Drancy deportees returned in spite of him, but stayed

haunted by unfinished harm. One survivor from Transport 60 couldn't bear recalling the "human degradation" of victims attacking each other for bread. Another thought himself only "intact in the eyes of the world" and wrote about Auschwitz under a pseudonym. Another whispered for fear of renewed anti-Jewish attacks, and never mentioned any survivors' names. And yet: When two friends from that transport of October 7–10, 1943, met after forty-five years, they started cuffing one another, snapping out SS commands, then bursting into hoots. The Nazis, they said just once, had been had.

Another lesson: It was easy to build deceit on a base of human trust. A Jewish painter who accepted that her mother died of influenza, took all her lover's words as truth, married openly under her real name, presented herself on orders to authorities—that person was bound to believe the lie of Pitchipoi. And yet: The SS killer who believed the Reich would thrive minus the Jews—the new war won, the last war reversed, the world in Deutschland's debt, the nation whole, the children safe, the Germans' blood too pure to spill again— that person was by far the more deceived.

Whole nations deceived themselves when they made decisions to forget. France dismantled the camp of Gurs and turned Drancy into public housing. Very few people now realize that all the structures from one of Europe's largest transit camps remain just half an hour from Paris. And yet: Groups of youngsters are starting to visit the small museum in Drancy. In Berlin a children's school now carries Charlotte Salomon's name; a plaque marks the apartment house where she lived, and Germans gathered for a memorial there.

Last lessons: When Brunner crossed the continent to where Lotte was painting her past, one life was cut short by one that went on. The active anti-Semite continued to cause harm. And yet: His eye and hand were lost in letter bombs. His wife and daughter were half-estranged from him. His Damascus home was cleared when the Syrians moved him to an isolated place. His whole significance, not hers, got stuck within the Holocaust.

Nor was she the one to take her life. It was not the Jews or women or exiles who made an art of suicide, but SS men themselves. When Eichmann kept trains rolling to deport Jews, he knowingly denied crucial transport to the German troops. He even told his SS staff, "If things go wrong [for Germany], I will . . . shoot my wife,

my children, and myself." It seems that genocide is suicide let loose.

Alfred Wolfsohn had a premonition of this, once his second war was over:

A birch, 1937–38, which Wolfsohn called Lotte's "self-portrait—a portrait of her essential being.... It almost seems without a root to rest on.... Only the tree's topmost crown is trying not to give up but to keep going on."

> Already mankind is beginning to forget and by forgetting I fear that raped humanity will not be equal to the new onslaught being prepared for it. Humanity itself will renounce life and commit suicide.

Humanity had almost renounced life in Nazi Berlin, where Lotte sketched a *Birke*, a birch, a self-portrait of fear and rootlessness. Her nightmares there were ones of being "naked in a street, stripped of clothes."

And yet: Whenever fear stopped up her breath, the act of turning inward filled her lungs again. When she couldn't stop the destruction in and of her family, she could show the shape it gave to all their lives. When she couldn't answer "the question: whether to take her life," she could still take up her brush and find "my self, a name for myself." For her own eyes she wrote, "I am going to kill myself," but she could turn and tell her audience, "I am going to live for them all." No one knows whether she'd have committed suicide if given time. And yet: The artwork committed survival.

To paint her life was to prolong it. That is what she meant in 1943 at age twenty-six when she put the paintings into the hands of Dr. Moridis. "Keep this safe" was what she said: "*C'est toute ma vie.*" (It is my whole life.) She closed her "whole life" at just the moment when her main character was ready to put it into paint. Then the story folded back on itself and started over. "And now begins the end or the beginning of our song which is a folksong in verses and therefore like a film can be repeated again and again." No end, but a perpetual reprise.

"*And with dream-awakened eyes she saw all the beauty around her, saw the sea, felt the sun, and knew: For a while she had to disappear from the surface of life and to that end make every sacrifice—so that from the depths she could create her world anew.*

"*And out of this arose Leben oder Theater???*"

OVERLAY

⌒

October 10, 1943. The right-hand column—women, children, the old, the sick—turns from the ramp toward Birkenau. *Birkenau, birch tree: self-portrait.* The column is not recorded, not even counted. *What I had to find: my self, a name for myself.* It stops before a building marked as showers. An ambulance pulls up. Inside the building beatings start. *The dream: I was naked, but I ought to say I was stripped of my clothes.* Put them on the hooks, remember where. The room is vast. Hold the towel, here, soap. *The question: whether to take her life or undertake something wildly unusual—*

Doors thunder shut. Everyone looks up at the shower heads *for a while she had to disappear from the surface of life.* Vents in the ceiling let loose pellets from the ambulance. It is Zyklon B—rat poison for the holds of ships. Gas diffuses off the floor. The lungs seize up and burn. Small children suffocate *from the depths she could create her world anew* then pregnant women go into labor—last, fingernails claw the concrete at the vents *and out of this arose Leben ? oder*

NOTES

∽

ABBREVIATIONS

AN Archives Nationales, Paris
CDJC Centre de Documentation
 Juive Contemporaine, Paris
CS Charlotte Salomon
FO Foreign Office Archives,
 Kew, England
JDC Joint Distribution Committee,
 New York
JHM Joods Historisch Museum
 (Jewish Historical Museum),
 Amsterdam
LBI Leo Baeck Institute, New York
LT *Leben? oder Theater? (Life? or
 Theater?)*

MLF Mary Lowenthal Felstiner
NARA National Archives and Records
 Administration, Washington,
 D.C.
PRO Public Record Office, Kew,
 England
SS *Schutzstaffel* (Protective Squads
 of Nazi Party)
YIVO YIVO Institute for Jewish
 Research, New York
YVA Yad Vashem Archives,
 Jerusalem

INTERVIEWS

Unless otherwise noted, quotations come from the following interviews conducted by the author: Bernhard Blumenkranz, Berkeley, Calif., May 1983; Ilse Blumenthal-Weiss, Long Island, N.Y., 15 November 1982; Ottilie ("Didi") Gobel Bourne, by telephone, Langley, Washington, 7 November 1993; Frances Bregman, Palo Alto, Calif., 11 August 1987; Sheila Braggins, London, 6 May 1985, 15 June 1988, 14 June 1993; Hugo Buchthal, by telephone, London, 5 May 1985; Maurice Bialek, by telephone, Paris, 1 May 1985; Alice Croner, London, 30 March 1984, 6 May 1985; Hilde Goldmann Elcock, by telephone, London, 5 May 1985; Ingrid Faraday, Blanquefort, France, 28 April 1985; Michel ("Mucki") Faraday, Lacapelle, France, 28 April 1985; Thomas ("Fips") Faraday,

Blanquefort, France, 28 April 1985; Marita Günther, Malérargues, France, 6–7 April 1984, 26 April 1985; Stanford, Calif., 14 November 1986; Paris, 20 July 1993; Igna Beth Heiden, by telephone, Vancouver, B.C., 12 May 1990; Hilde Littauer Himmelweit, London, 28 March 1984; Arnold Horwell, London, 29 March 1984; Valerie Kaempf, New York, 14 December 1994; Marian Lackler [Marianne Schlesinger], by telephone, 17 March 1984; Washington, D.C., 17 August 1985; Stanford, Calif., 17 November 1985; Lisbeth Landsberg, by telephone, Ithaca, N.Y., 12 November 1982; Miriam Merzbacher, by telephone, Greenwich, Conn., 13 January 1992; Wallace Moore, Woodbridge, Va., 18 August 1985; Wallace Moore to MLF, 13 October 1984, 1 September 1985, 29 October 1993; Annie Nagler, Villefranche-sur-Mer, France, 5 April 1984, 22 April 1985; Ad Petersen, Amsterdam, 7 July 1988; Léon Poliakov, Massy, France, 2 July 1988; Ellen Rosowsky, with Ben Sonstein, San Francisco, 8 August 1987; Helene Salomon, London, 30 March 1984; Paula Salomon-Lindberg, Amsterdam, 23–26 March 1984, 15–20 April 1985, 6–8 July 1988, 14 July 1993; Kurt Singer's daughter (name withheld by request), Israel, September 1987; Marianne Spier-Donati, Paris, 30 June 1988; Paul Steinberg, Paris, 29 April 1985; Stanford, Calif., 7 August 1987; Emil Straus, Nice, 4 April 1984; Arlette Toledano (name changed by request), Paris, 2 May 1985; Georges Wellers, Paris, 1 May 1985; Jacques Zylbermine, Paris, 30 April 1985, 2 July 1988.

SOURCES ON *LIFE? OR THEATER?*

The "numbered" paintings that Charlotte Salomon arranged in *Life? or Theater?* as well as "unnumbered" paintings—overlays, sketches for the work, variant scenes, a playbill and a postscript—are located in the JHM archives of Amsterdam. My citations use the inventory numbers of the JHM archives for all "unnumbered" sheets, overlays, and postscript; none of these have been published before and only a few have been exhibited. For the "numbered" paintings, in addition to the JHM inventory numbers, my references list the page numbers in the full edition of *Life? or Theater?* published in 1981; this edition of 769 paintings (referred to hereafter as *LT*) appeared in German as *Charlotte Salomon, Leben oder Theater? Ein autobiographisches Singspiel in 769 Bildern* (Cologne: Kiepenheuer & Witsch, 1981), and in English as *Charlotte: Life or Theater? An Autobiographical Play by Charlotte Salomon*, trans. Leila Vennewitz (New York: Viking Press [and London: Allen Lane] in association with Gary Schwartz, 1981; there was also a Dutch edition). Along with introductions by Judith Belinfante, Gary Schwartz, and Judith Herzberg, the 1981 editions include all the "numbered" paintings, in sequence, with their captions. Translations from Charlotte Salomon's original German texts in the JHM are my own, with the assistance of Ursula Berg-Lunk and John Felstiner.

A first selection of eighty reproductions appeared as Charlotte Salomon, *Ein Tagebuch in Bildern, 1917–1943* (Hamburg: Rowohlt, 1963), and in English as *Charlotte: A Diary in Pictures* (New York: Harcourt, 1963), with an introduction by Emil Straus; an Italian edition also came out. A larger selection of paintings was produced with captions in Dutch and English: *Charlotte Salomon: Leven? of Theater? Life? or Theater?* (Amsterdam: JHM, 1992); it includes introductions by Ad Petersen, Christine Fischer-Defoy, and Judith C. E. Belinfante. Christine Fischer-Defoy compiled a book of essays and interviews called *Charlotte Salomon—Leben oder Theater?* (Berlin: Das Arsenal, 1986), and the Centre Georges Pompidou put out an exhibition catalogue, *Charlotte Salomon, Vie? ou Théâtre?* with essays by Claire Stoullig, Luc Long, Judith Belinfante, Christine Fischer-Defoy, and Ad Petersen (Paris: Éditions du Centre Pompidou, 1992). For other interpretations see the following essays by MLF: "Taking Her Life/History: The Autobiography of Charlotte Salomon," in *Life/Lines: Theorizing Women's Autobiography*, ed. Bella Brodzki and Celeste Schenk (Ithaca: Cornell University Press, 1988); "Artwork as Evidence: Charlotte Salomon's 'Life or Theater?'" in *Remembering for the Future: The Impact of the Holocaust on the Contemporary World* (Oxford: Pergamon Press, 1988); "Engendering an Autobiography: Charlotte Salomon's 'Life or Theater?'" in *Revealing Lives: Autobiography, Biography and Gender*, ed. Marilyn Yalom and Susan Bell (Albany: State University of New York Press, 1990); and "Charlotte Salomon's Inward-Turning Testimony," in *Holocaust Remembrance: The Shapes of Memory*, ed. Geoffrey Hartman (London: Blackwell, 1993). See also Dalia Elbaum, "Analyse esthétique de l'oeuvre de Charlotte Salomon," in *Charlotte Salomon: Leben oder theater?: Catalogue de l'exposition* (Brussels: Consistoire Central Israelite, 1982); Gary Schwartz, "Life? or Theater?: The Autobiography of Charlotte Salomon," *ARTnews* (October 1981); and the important interpretation by Katja Reichenfeld, "*Leben? oder Theater?* Regie: Charlotte Salomon," *JongHolland* 4 (1991). Beautiful evocations also appeared in a book on war: Susan Griffin, *A Chorus of Stones: The Private Life of War* (New York: Doubleday, 1992); and in four films: Judith Herzberg and Franz Weisz, *Charlotte* (1980); Kees Hin, *May You Never Forget My Faith in You* (1986); Hannelore Schäffer, *Die Eigene Geschichte* (1987); Richard Dindo and Esther Hoffenberg, *C'est toute ma vie* (1992).

The organization responsible for Charlotte Salomon's artwork is the Joods Historich Museum of Amsterdam. Copyright is owned by the Charlotte Salomon Foundation of Amsterdam, consisting presently of Paula Salomon-Lindberg, who has spent years encouraging interest in her stepdaughter's artwork; Ad Petersen, former head curator at the Stedelijk Museum, who (along with Will Sandberg) first recognized the artistic importance of the work, exhibited it, photographed paintings and sites, and helped arrange and interpret it; and Judith Belinfante, director of the JHM, who has written of the collection's meaning and history, allotted it significant staff time and exhibition space in the

JHM, and helped organize exhibits. One of the collection's early curators, Katja Reichenfeld, made significant contributions in gathering material, identifying and locating the musical references, analyzing the paintings, and assisting researchers. Later curators such as Steven Hartog, assisted by Peter Lange, have also given outstanding attention to the work, and recent cataloging was undertaken by Martin Mansoor. Marita Günther and Christine Fischer-Defoy have contributed materials to the JHM library. The signal contribution of publishing and interpreting the artwork was made by art historian Gary Schwartz.

ILLUSTRATIONS

Page numbers are followed by each illustration's JHM inventory number or other source. Page x: JHM 4155; 8: JHM 4175; 10: JHM 4291; 11: JHM 4294; 12: Igna Beth Heiden; 13, 21: JHM; 26: Marian Lackler; 28: JHM 4304; 36: JHM 4351; 38: JHM 4353; 41: JHM 4475; 42: JHM 4476; 44: JHM 4539; 45: JHM 4573; 48: JHM 4670; 49: Yad Vashem; 50: JHM; 56: JHM photo and 4597; 58: JHM 4605; 63: JHM 4360; 68: JHM 4311; 69: Christine Fischer-Defoy; 74: JHM 5023; 76: JHM 4762; 80: JHM 4798; 82: JHM 4769; 83: JHM 4802; 90: Berlin Document Center; 95: JHM 4829; 100: Wallace Moore; 103: Wallace Moore; 105: JHM; 106: JHM 4857; 108: JHM 4865; 110: JHM 4886; 120: CDJC; 124: JHM; 128: Paula Salomon-Lindberg and JHM; 129: JHM photo; 130: Wallace Moore; 131: Annie Nagler; 132: Wallace Moore; 142: Marthe Pécher; 145: JHM 4179; 148: JHM 4417 verso; 157: JHM 4925; 159: Berlin Document Center; 167: Annie Nagler; 168: JHM 5116; 171: L'État Civil de Nice; 187: Wallace Moore; 188: MLF; 194, 196, 204, 213: CDJC; 219: JHM; 225: JHM 4920; 226: JHM 4920, *Charlotte: A Diary in Pictures* [n.p.]; 230: Christine Fischer-Defoy; 232: *Bunte* Magazine; 235: Marita Günther from Alfred Wolfsohn, "Die Brücke"; 238: JHM.

Color plates. 1: JHM 4285; 2. JHM 4179; 3: JHM 4243; 4: JHM 4371; 5: JHM 4701; 6: JHM 4808; 7: JHM 4907; 8: JHM 4924.

PROLOGUE

"**The war raged on**": from the textual postscript not included in *Life?* or *Theater?* and most likely written in 1942, JHM 4931. "**Out of this arose**": overlay JHM 4925, *LT* 783. "**If I can't find**": postscript JHM 4930–31; "**Keep this safe**": Charlotte Salomon's words in 1943, recalled by Madame Moridis of Villefranche and told to Judith Herzberg, *LT* vii. "**Singespiel**": JHM 4155, *LT* 1–2; The eighteenth-century *singspiel* tradition evolved into light operas that played often in Berlin in Charlotte Salomon's time. **Overlays**: these are archived in the JHM but are now detached from the paintings. The term "overlay" is my own, as is the term "postscript." "**Something so wildly**

unusual": JHM 4922, *LT* 777. "I was all the characters": postscript JHM 4931. Charlotte Salomon's face: self-portrait in oil in the collection of Paula Salomon-Lindberg, Amsterdam. Alois Brunner: see the earliest studies, by MLF, "Alois Brunner: 'Eichmann's Best Tool,'" *Simon Wiesenthal Annual* 3 (White Plains, N.Y.: Kraus, 1986), 1–41; "Commandant of Drancy: Alois Brunner and the Jews of France," *Holocaust and Genocide Studies* (Spring 1987), 21–47; "Commandant de Drancy: Alois Brunner et les Juifs de France," *Le Monde Juif* (Winter 1987), 143–72. See Simon Wiesenthal, *Justice Not Vengeance*, trans. Ewald Osers (New York: Grove, 1989), 240–51; and Didier Epelbaum, *Alois Brunner: La haine irréductible* (Paris: Calmann-Lévy, 1990).

CHAPTER 1: SECRECY

"They and their children": postscript, JHM 4928. Ludwig Grunwald (1862–1943) married Marianne Benda Grunwald (1867–1940) in 1889. The Grunwalds lived at Kochstrasse 53, Berlin, and the Salomons at 15 Wieland-strasse, Charlottenburg, where the new middle class settled and where Albert Salomon listed himself as "University Professor, Physician for Surgery," in the Jüdisches Adressbuch für Gross-Berlin, 1929/30 (courtesy of Simon Srebrny). See Marion A. Kaplan, *The Making of the Jewish Middle Class: Women, Family, and Identity in Imperial Germany* (New York: Oxford University Press, 1991); "mourning forever" through "delicate and fragile": Buchthal, Helene Salomon, and Croner interviews. Albert Salomon (1883–1976) was born in Robel, Mecklenburg, of a commercial family. At age seventeen he started studying medicine in Berlin, Heidelberg, Munich, and Würzburg; in 1921 he became an associate professor and in 1927 a full professor at Berlin University; "introvert" through "taciturn": Blumenthal-Weiss, Landsberg, Horwell, Buchthal interviews; "Doctor and Mrs. Knarre": JHM 4155, *LT* 6.

"Am I the one to blame for her death?" through "ach, so sad": JHM 4277, 4158, 4160–61, 4163, 4861, 4273, *LT* 126, 9, 11, 12, 14, 708, 122; the family might have diagnosed manic depression, as this disease was widely discussed in their period, but no psychopharmacology was available to control it. "But this reflection" through "Franziska often took the child": JHM 4164–66, 4169–73, 4176, 4280–96, *LT* 15–17, 20–24, 27, 129–45. "But what kind of business" through "Why isn't she coming": JHM 4177, 4288, 4179, 4185, 4188, *LT* 28, 137, 30, 36, 39. The Jewish Weissensee cemetery of Berlin has no records of this burial.

"A hex" through "After a short but difficult": JHM 4294, 4184, *LT* 143, 35; *Berliner Tageblatt*, no. 94, 25 February 1926; possibly the grandparents had the announcement with them in France where CS saw it.

"Free death": Friedrich Nietzsche, "On Free Death," in *Thus Spoke Zarathustra*, trans. Walter Kaufmann (New York: Penguin, 1983), 72–73; Weimar period

films: Siegfried Kracauer, *From Caligari to Hitler: A Psychological History of the German Film* (Princeton: Princeton University Press, 1947), 99–246; Urich Gregor, "Film in Berlin," in *Berlin, 1910–1933*, ed. Eberhard Roters, trans. Marguerite Mounier (New York: Rizzoli, 1982), 181, 200; on "the morbid infatuation with death in German culture" see Richard Friedenthal, *Goethe: His Life and Times* (London: Weidenfeld and Nicolson, 1965), 132; **Whither Germany?** Kracauer, 243–44; Ernst Toller, *Hoppla! Such is Life!* trans. Hermon Ould, in *Seven Plays* (New York: Liveright, n.d. [ca. 1936]), 268, 272; Vicki Baum, *Helene*, trans. Ida Zeitlin (New York: Doubleday, 1933), 180. On suicide cult see Peter Gay, *Weimar Culture: The Outsider as Insider* (New York: Harper, 1968), 140. **"Franziska had a marked partiality"**: unnumbered JHM 4933; **suicide rate, Germany and Berlin**: Frederick Hoffman, *Suicide Problems* (Newark: Prudential Insurance, 1927), 241, 375, 405; Maurice Halbwachs, *The Causes of Suicide*, trans. Harold Goldblatt (London: Routledge & Kegan Paul, [1930] 1978), 97–99; *Statistisches Jahrbuch für den Freistaat Preussen*, vol. 27 (for 1929) (Berlin: Preussischen Statistischen Landesamt, 1931), 120; a city of comparable size, London, had 1,786 suicides in 1925–27; suicide was the fifth most frequent cause of death in Berlin: *Statistique internationale des grandes villes* (The Hague: Van Stockum, 1931), 133, 139; **suicide among professionals**: Georg von Mayr, *Statistik und Gesellschaftslehre*, 3 vols. (Tübingen, Germany: von Mohr, 1909), vol. 3, 331; Hermen Lebovics, *Social Conservatism and the Middle Classes in Germany, 1914–1933* (Princeton: Princeton University Press, 1969), 43; **female suicide in Berlin**: *Statistisches Jahrbuch für das Deutsche Reich* (Berlin: Hobbing, 1926); *Statistisches Taschenbuch der Stadt Berlin 1924* (Berlin: Stollberg, 1924), 9; in 1919–1920 women accounted for 57.8 percent of all German suicides, and throughout this period, women *attempted* suicide as often as men: Halbwachs, 45–47, 54; **suicide rate among Jews**: Hoffman, 16; Halbwachs, 349; Louis I. Dublin and Bessie Bunzel, *To Be or Not to Be: A Study of Suicide* (New York: Smith and Hass, 1933), 117. In 1925 there were 79 Jewish female suicides in Prussia, by far the highest rate of any religion: Konrad Kwiet, "The Ultimate Refuge: Suicide in the Jewish Community under the Nazis," *LBI Yearbook* 29 (1984), 141.

　　"Suicide epidemic": *Jüdische Rundschau*, 9 February 1926; **Dr. Albert Salomon's specialty**: Albert Salomon, *Histologisches über Pseudoleukämie, Lymphosarkome und Syphilome*, Faculty of Medicine, Julius-Maximilians-Universität Würzburg (Würzburg: Staudenraus, 1905), and "Über die Behandlung von Angiomen und Nävi speziell mittels Kohlensäureschnee," *Berliner Klinik* 284 (February 1912); courtesy of Simon Srebrny; **"degeneration in fine old"**: Salomon-Lindberg interview, 1984; **"psychopaths usually descend"**: Kurt Singer, *Diseases of the Musical Profession: A Systematic Presentation of Their Causes, Symptoms and Methods of Treatment* [Berlin, 1926], (New York: Greenberg, 1932), 177, 9–10; **eugenic sterilization**:

in 1927 the German Criminal Code deleted involuntary sterilization as a state crime; in 1933 German law authorized it: Hans Harmsen, "The German Sterilization Act of 1933," *The Eugenics Review* 46, no. 4 (January 1955), 227; by 1939 the state had sterilized over 320,000 people: Gisela Bock, "Racism and Sexism in Nazi Germany: Motherhood, Compulsory Sterilization, and the State," *Signs: Journal of Women in Culture and Society* 8, no. 3 (Spring 1983), 413. **Jews and suicides:** Louis I. Dublin, *Suicide: A Sociological and Statistical Study* (New York: Ronald Press, 1963), 102–9, 117–19; Ruth Shonle Cavan, *Suicide* (Chicago: University of Chicago Press, 1928), 41–44; Maurice Fishberg, *The Jews: A Study of Race and Environment* (New York: Scribner, 1911), 353; Thomas Masaryk, *Suicide and the Meaning of Civilization* [1881] (Chicago: University of Chicago Press, 1970), xxii, 3, 214–19; the most influential source was Emile Durkheim, *Suicide: A Study in Sociology* [1897] (Glencoe, Ill.: Free Press, 1951); **Rate per Million, 1923–27:** Sigismund Peller, "Zur Statistik der Selbstmordhandlung," *Allgemeines Statistisches Archiv* 22 (1932), 358. The exclamation point in German is equivalent to a [*sic*], meaning the surprising number is accurate; **"suicide catastrophe":** Arthur Ruppin, *Soziologie der Juden*, 2 vols. (Berlin: Jüdischer Verlag, 1930), 248–49; "Jüdische Selbstmordstatistik," *Jüdische Rundschau*, 21 October 1927; **"Such an appalling increase":** Fishberg, 353–54; **"growing alienation":** Max Sichel, "Der Selbstmord bei den Juden—einst und jetzt," *Zeitschrift für Demographie und Statistik der Juden* 5/6 (August–December, 1924), 104–5; **"suicide epidemic," "We accuse ourselves":** "Die Selbstmordepidemie unter deutschen Juden," *Jüdische Rundschau*, 9 February 1926. **Jewish female suicide:** "Selbstmorde in Preussen im Jahre 1907," *Zeitschrift für Demographie und Statistik der Juden* 5, no. 1 (January 1909), 93; Sichel, 100; Peller, 358; one-third of the non-Jewish labor force was female, 10 percent higher than for Jewish women, in Prussia as of 1925: Arthur Ruppin, *The Jews in the Modern World* (London: Macmillan, 1934), 150–51; Marion Kaplan, "Jewish Women in Nazi Germany: Daily Life, Daily Struggles, 1933–1939," *Feminist Studies* 16, no. 3 (Fall 1990), 581. Influential German studies of the 1920s attributed female suicide to insanity more often than male: Dublin and Bunzel, *To Be*, 301; **"The relatively high suicide rate ... organism":** Sichel, 97–98; **"Jewish lunatics":** Fishberg, 338, 344–45; Sander Gilman, "Jews and Mental Illness: Medical Metaphors, Anti-Semitism and the Jewish Response," *Journal of the History of the Behavioral Sciences* 20 (April 1984), 152; Kwiet, 144–45; in the 1920s the most influential works on inbreeding and insanity were Emil Kraepelin, *Manic-Depressive Insanity and Paranoia* (Edinburgh, 1921; reprint, New York: Arno, 1976), and Max Nordau, *Degeneration* (New York: Appleton, 1895).

 "She imagines a terrible thing": "JHM 4189, *LT* 40; **influenza in Germany:** A. A. Hoehling, "*The Great Epidemic* (Boston: Little, Brown, 1961), 19; **"Mommy is now," "Whenever she has to walk":** JHM 4186, 4189, *LT* 37, 40.

CHAPTER 2: AFFILIATION

"a gift for drawing": JHM 4196, *LT* 47.

"Thank God I started to sing early": Paula Lindberg (Paula Levi) was born in Frankenthal Germany in 1897. After 1925 she studied at the Academy of Music in Berlin, under Siegfried Ochs. All quotes come from my interviews at her Amsterdam apartment (1984–93); since these did not contradict each other, I have blended them without separate citations. In 1985 I invited Christine Fischer-Defoy of Berlin's Hochschule der Künste to the JHM; she and Katja Reichenfeld of the JHM also joined my interviews. Christine published selections from them in her German anthology, *Charlotte*, 37–58, and her own interviews in *Paula Salomon-Lindberg—mein "C'est la vie"-Leben: Gespräch über ein langes Leben in einer bewegten Zeit* (Berlin: Das Arsenal, 1992). **Zetkin** was a feminist and Communist politician; Kollwitz, a radical artist; Ochs, Klemperer, Walter, and Furtwängler were famous German conductors. **Kurt Singer** (1885–1944) is described in his book, *Diseases*, xi–xiv; and *Baker's Biographical Dictionary of Musicians*, ed. Nicolas Slonimsky, 6th ed. (New York: Schirmer, 1978), 1608. "**A man like that**," through "**duty**": JHM 4225, 4231, 4233, *LT* 75, 81, 83.

"Love is a rebel bird": JHM 4253, *LT* 102; "bear the thought": *Grimms' Tales for Young and Old*; trans. Ralph Manheim (New York: Doubleday, 1977), 184; "to be tenderly" through "even envied": JHM 4235–37, *LT* 84–86; "our daughter Lotte": Blumenthal-Weiss interview; "Paula was much nicer": Singer's daughter, interview; "their first quarrel": JHM 4241–44, *LT* 90–93.

"A melancholy age": JHM 4202, *LT* 53; "Lotte's relations with me": Horwell interview; "uncommonly inarticulate": Hugo Buchthal to Gary Schwartz, 30 November 1981; "She had no definite": [Marianne Schlesinger] Lackler interview, 1984; "Lotte Salomon!": [Hilde Littauer] Himmelweit interview; the suggestion came from Chimen Abramsky. **Another student**: [Hilde Goldmann] Elcock interview; "a quiet girl": Edith Simon to MLF, 2 June 1986; "had no idea": [Igna Beth] Heiden interview; **85 percent**: Clifford Kirkpatrick, *Nazi Germany: Its Women and Family Life* (Indianapolis: Bobbs-Merrill, 1938), 236; **half of Lotte's class was Jewish**: Lackler interviews; **her grades**: Religion, German, Physical Education, Drawing: good; French, English, Latin, History, Geography, Mathematics, Chemistry, Music: satisfactory; Report card, 29 September 1933, courtesy Sophie-Charlotte Oberschule, Berlin; "the art training": Heiden interview; "smothered every natural" through "tragic, stirred-up life": JHM 4245–47, 4254, *LT* 94–96, 103; grandmother's story, JHM 4254–302, *LT* 103–51.

"German men and women": JHM 4304–5, *LT* 152–53; **Adolf Eichmann** (1906–62) eventually became SS chief of operations for the "extermination" of the Jews. **Nazi Party manipulates gender**: See Claudia Koonz, *Mothers in the*

Fatherland: Women, the Family and Nazi Politics (New York: St. Martin's, 1987), 177–219; **Nazis playact politics**: See George L. Mosse, *The Nationalization of the Masses: Political Symbolism and Mass Movements in Germany from the Napoleonic Wars Through the Third Reich* (New York: Fertig, 1975), 1–2; **swastikas in reverse**: JHM 4305, 4312–18, 4353, *LT* 152, 160–66, 195.

"**Human-Jewish minds**": JHM 4304, *LT* 152; "**Albert Salomon, of the Jewish faith**": *Lebenslauf*, inaugural dissertation, 35; **Salomon family sat shiva** through "**Deutschland**": Helene Salomon interview; unnumbered JHM 5022; **Paulinka in synagogue**: JHM 4207–9, 4233, 4367, *LT* 58–60, 83, 209. Leo Baeck (1873–1956) was a famous rabbi and philosopher of Progressive Judaism whom Paula called "my best friend." **Bat mitzvah**: Helene Salomon interview; "**What is man**": JHM 4155, *LT* 4; CS's epigraph combined Psalms 8:4 and 144:3 with Job 7:17. "**If anyone asked me**": Solomon Liptzin, *Germany's Stepchildren* (Philadelphia: Jewish Publication Society, 1948), 201; "**The Jews have an important mission**": LBI, *Perspectives of German-Jewish History in the 19th and 20th Century*, trans. Hanna Schmorak (Jerusalem: Academic Press, 1971), 85; **genre of biography**: see George L. Mosse, *German Jews Beyond Judaism* (Bloomington: Indiana University Press, 1985), 25–26, 38.

"**They were all let go**": JHM 4304, *LT* 152. **Economic position of German Jews**: See Walter Laqueur, *Weimar: A Cultural History 1918–1933* (New York: Putnam, 1974), 24–25; Leni Yahil, *The Holocaust: The Fate of European Jewry, 1932–1945*, trans. Ina Friedman and Haya Galai (New York: Oxford University Press, 1990), 21–22; Donald L. Niewyk, *The Jews in Weimar Germany* (Baton Rouge: Louisiana State University Press, 1980), 13, 15; Otto Friedrich, *Before the Deluge: A Portrait of Berlin in the 1920's* (New York: Harper & Row, 1972), 110–11. "**Raus**": JHM 4304–8, *LT* 154–56. On 29 March 1933 Albert Salomon was fired from the University Hospital; from 1936–39, he directed the surgical clinic of the Jewish Hospital in Berlin: Fischer-Defoy, *Charlotte*, 158; "**unpolluted by Jews**": JHM 4309–16, *LT* 157–64; "**endless visits**": Kurt Singer, 1934, quoted in Herbert Freeden, "A Jewish Theatre under the Swastika," *LBI Yearbook* 1 (1956), 146; "**perform for Jewish public**": Boris Schwarz, "The Music World in Migration," in *The Muses Flee Hitler: Cultural Transfer and Adaptation, 1930–1945*, ed. Jarrell C. Jackman and Carla M. Borden (Washington, D.C.: Smithsonian Institution, 1983), 136. "**She didn't make a ripple**": Heiden interview; "**I won't go back**" JHM 4318, *LT* 166; to stress her determination to leave school, CS penciled on the overlay, "Charlotte Kann [says these words] time and time again." "**All education**": Adolf Hitler, in Peter Odegard, "Propaganda and Dictatorship," in *Dictatorship in the Modern World*, ed. Guy Stanton Ford, 2nd ed. (Minneapolis: University of Minnesota Press, 1939), 254; "**Law to Prevent Hereditarily**": Gertrud Scholtz-Klink, address to 1935 Reich Party Congress, Hoover Institution Pamphlet Collection; "**we had to bring baptism certificates**": Heiden interview; on Jewish

intermarriage, see Marion Kaplan, *The Jewish Feminist Movement in Germany: The Campaigns of the Jüdischer Frauenbund, 1904–1938* (Westport, Conn.: Greenwood, 1979), 56; **school resisted rules**: Elcock, Heiden, and Lackler interviews; **"Our school supported," "Zionist youth"**: Kurt Singer's daughter, interview; The Fürstin-Bismarck *Gymnasium* on Sybelstrasse, Charlottenburg, where Lotte started in 1927, was built for a thousand students, with music room, large well-lighted art room, and theater; it changed to the coeducational Sophie-Charlotte Oberschule in 1954; **"to receive private instruction"**: Charlotte Salomon's Departure Certificate and Conduct Report, 29 September 1933, courtesy Sophie-Charlotte Oberschule. **Jewish quota of 1.5 percent**: (Law of 25 April 1933), Solomon Colodner, "Jewish Education under National Socialism," *Yad Vashem Studies* 3 (1959), 161–62. Only 25 percent of female graduates (as against 90 percent of male candidates) obtained teaching positions, even in all-girls' schools: Jill Stephenson, *Women in Nazi Society* (London: Croom Helm, 1975), 116, 157–59; Kaplan, *Jewish Feminist Movement*, 184.

"I'll learn to draw": through **"She worries me"**: JHM 4319–24, *LT* 167–71; **scenes of Rome**: JHM 4324–33, *LT* 172–81; unnumbered JHM 5037; Martin Mansoor showed that CS portrays Michelangelo's *Pietà*, *Rondanini Pietà*, *Sistine Ceiling*, and *Last Judgment*. **"Drawing is a difficult art"** through **"This time I've got it"**: JHM 4334–36, 4349, 4352–53, *LT* 182–84, 191, 194–95. Lotte probably heard myths of van Gogh being called ungifted.

"The full Jew Fraülein Salomon," "The artistic abilities": Report of Admissions Committee (Kutschmann, Bartning, and Scheunemann), 7 February 1936: Archive of the Hochschule der Künste Berlin, courtesy Christine Fischer-Defoy. In October 1935 Lotte Salomon started at the Vereinigte Staatschulen für Freie und Angewandte Künste (the name of the Art Academy from 1924–38) on Hardenbergstrasse, Berlin. She was provisionally admitted in fall 1935, then confirmed in this meeting; the class lists show only one or two "full Jews" attending the academy at a time. She worked with Professors Ernst Böhm (fired in 1937 for having a Jewish wife) and Ludwig Bartning; see Christine Fischer-Defoy, "Die Rolle der Berliner Kunsthochschulen in den Jahren 1933–1945," in Hochschule der Künste Berlin, *Kunst Hochschule Faschismus* (Berlin: Elefanten Press, 1984), 216–18; Fischer-Defoy, *Charlotte*, 102–4.

CHAPTER 3: OBSESSION

"Amadeus Daberlohn": JHM 4371, *LT* 213. It is hard to know how closely CS's Daberlohn resembled Alfred Wolfsohn (1896–1962) in the 1930s. The only sources from the time are Paula Salomon-Lindberg and Alice Croner. Others who knew him after the war found CS's portrayal uncannily accurate, and even those who did not share CS's irony or the importance I attach to it, shared

her great desire that Wolfsohn not be forgotten and unknown; Lotte probably met him in fall 1937, for the subsequent events CS described seem to take one year, till fall 1938. **1935 laws:** Yahil, *The Holocaust*, 72–73; **"And now our play begins,"** through **"let me shape you":** JHM 4374–75, 4384, 4389, 4392–93, 4412, 4441–4, 4433, 4450–51, 4455, 4491, *LT* 216–17, 225, 230, 233–34, 253, 282–83, 274, 291–92, 296, 332.

"Art is deeply united with love" through **"You are very hot-blooded":** JHM 4485, 4413, 4456, unnumbered JHM 4956, *LT*, 326, 255, 297. **"Charlotte Kann whom you will recall"** through **"Among all your friends":** JHM 4443, 4470, 4459, 4465, 4516, *LT* 284, 311, 300, 306, 357. **135 faces:** JHM 4481–89, *LT* 322–30; **"my nights of blackness"** through **"to create the world anew":** JHM 4498, 4530–31, 4924, *LT* 339, 371–72, 782; **"none other than herself"** through **"Oh Madonna":** unnumbered JHM [n.p.], 4538–39, 4571–76, 4582, *LT* 379–80, 412–17, 423. These scenes represent a performance of *Orfeo* in Mannheim, which Lotte did not attend.

"Is it jealousy or something else?" through **"Are you actually":** JHM 4639, 4595, 4623–26, *LT* 481, 436–37, 465–68. **"Charlotte isn't sure"** through **"Ich liebe dich":** JHM 4639, 4645, 4641, 4649–53, 4663–66, unnumbered JHM 4995; *LT* 481, 487, 483, 491–95, 505–8; **"To live life,"** through **"Charlotte does not move":** JHM 4677, 4694, 4697–707, unnumbered JHM 4998, *LT* 519, 536, 539–53.

"Between being alive and dying": Unless otherwise indicated, this and all quotations come from Alfred Wolfsohn, "Orpheus oder der Weg zu einer Maske" (Orpheus or the Way to a Mask), ca. 1937–38, manuscript in collection of Marita Günther, Malérargues, France; Marita Günther's 120-page typescript is in the JHM. See also Alfred Wolfsohn, "Notes on 'Orpheus'" [ca. 1941], *Spring: A Journal of Archetype and Culture:* 50 (1990), 76–79. **Charlotte reading war memoir:** unnumbered JHM 5060, 5065, 4984–86. **"The doctor":** Wolfsohn quoting Friedrich Hebbel, "Orpheus"; **"fragile and delicate":** Alice Croner to MLF, 21 February 1984; **"Do you remember your dreams?":** Croner interview, 1984.

"The Orpheus path": Wolfsohn, "Orpheus"; **deleted erotic scenes:** unnumbered JHM 5005–8, 5090, 4989–90, 5054–55; **Charlotte reads "Orpheus":** JHM 4746–50, *LT* 592–96; unnumbered JHM 5060, 5080, 5085. It is not known whether Lotte took notes on the "Orpheus" manuscript or simply remembered its words some four years later. **Professor Y:** like Wolfsohn, CS associated her father with Orpheus, letting Albert Kann say Orfeo's lyrics, "Oh I have lost her," when his wife Franziska dies: JHM 4183, *LT* 34, unnumbered JHM 4935. **"The story of Orpheus":** Wolfsohn's "Orpheus" was based on Jung; among critiques of Jung's androgyny see Naomi R. Goldenberg, "A Feminist Critique of Jung," *Signs*, vol. 2, no. 2 (Winter 1976), 445. On decline of German feminism, see Richard J. Evans, *The Feminist Movement in Germany, 1894–1933* (London: Sage Publications,

1976), 258–67; Renate Pore, *A Conflict of Interest: Women in German Social Democracy, 1919–1933* (Westport, Conn.: Greenwood, 1981), 40, 61; Marion Kaplan, "Sisterhood under Siege: Feminism and Antisemitism in Germany, 1904–38," in *The Jewish Response to German Culture*, ed. Jehuda Reinharz and Walter Schatzberg (Hanover, N.H.: University Press of New England, 1985), 257–62; **"the wall she erected"**: Alfred Wolfsohn, "Die Brücke" [ca. 1946–49], manuscript in the collection of Marita Günther, translated by her with the assistance of Sheila Braggins; **"The Prophet"**: JHM 4597, LT 439; Wolfsohn kept a photo of the etching; **"I saw one drawing"**: Wolfsohn, "Die Brücke," excerpt in Fischer-Defoy, *Charlotte*, 77.

"To make his prophecy come true": JHM 4599–4600, LT 441–2. The birthday paintings may have been fairy tales: JHM 4615–17, 4708–11, LT 457–59, 554–57; **"he himself almost becomes"** through **"hopes rest"**: JHM 4607, 4726, 4731, 4733, 4743, 4729, unnumbered JHM 4893, LT 449, 572, 577, 579, 589, 575.

"Someday people will be looking at the two of us": JHM 4744, LT 590. **Wolfsohn's healing hands**: Croner interview, 1984; **stigmata**: Braggins interview, 1988; **"the concept of crucifixion"**: Günther interview, 1985; **"Christ 1940"**: JHM 4691, 4773, LT 533, 619; **"lively and jolly"**: Croner to MLF, 5 September 1984. **"Death and the Maiden"**: According to Paula Salomon-Lindberg, Lotte "liked the words and liked the composition, and she heard me sing it even before I was her mother." *LT* shows Charlotte reluctantly lending "Death and the Maiden" (ca. 1937) to Daberlohn: JHM 4605, LT 447. Perhaps Wolfsohn photographed the picture before returning it, for he placed its photograph in "Die Brücke." **"From the deeply moving"**: Wolfsohn, "Die Brücke;" one student of Wolfsohn's recalled him saying in the 1950s that he'd learned the secret of Lotte's mother's suicide, and though he never revealed it to Lotte, he worried about her potential for suicide, especially her fascination with "Death and the Maiden": Braggins interview, 1993. **"That's the two of us," "one of her old drawings"**: JHM 4604, 4923–24, unnumbered JHM 4978, LT 446, 780–81.

CHAPTER 4: TENACITY

"Here—Heil Hitler": JHM 4358, LT 200; **scenes of the Art Academy**: JHM 4354–66, LT 196–208. **"Barbara" scenes**: JHM 4363–64, 4366, LT 205–6, 208; overlays JHM 4356–57, 4359, 4363. **"She was not the kind"**: this and other quotes are excerpts from Christine Fischer-Defoy, "Gespräch mit Barbara [Frisch] Petzel," in Fischer-Defoy, *Charlotte*, 59–75; there is also an interview with Barbara Petzel in Schäffer, *Die Eigene Geschichte* (film). **Barbara and Lotte illustrated fairy tales**: These may be "Jorinde und Joringel," depicted in JHM 4708–11, LT 554–57; and/or pictures owned by Thérèse de la Corre of Brittany,

photos in JHM. "**Lotte was so moved**": Petzel to MLF, 30 January 1994; Barbara Petzel showed these drawings to Katja Reichenfeld of the JHM in 1986, who kindly showed copies to me. "**Since they forbid her**": unnumbered JHM 4998; see JHM 4747–48, *LT* 593–94; though her name was registered in the summer term 1938, apparently Lotte stopped attending in spring 1938: *Klassenlisten*, Hochschule der Künste Berlin archives, courtesy Christine Fischer-Defoy.

"**Appalling visual defects**": Hitler in Robert Darnton, "The Fall of the House of Art," *New Republic*, 6 May 1991, 30; "**Degenerate Art**": guide to exhibition, *Entartete Kunst* (Berlin: Verlag für Kultur- und Wirtschaftswerbung, 1937); Stephanie Barron, "1937: Modern Art and Politics in Prewar Germany," in *"Degenerate Art": The Fate of the Avant-Garde in Nazi Germany*, ed. Stephanie Barron (Los Angeles and New York: Abrams, 1991), 9–23; among modern artists exhibited were: Georg Grosz, Ernst Ludwig Kirchner, Max Beckmann, Paul Klee, Wassily Kandinsky, and others; "**I certainly assume**": Petzel to MLF, 30 January 1994; "**syphilis . . . bastardizations**," "**Jews, nothing but Jews**": quoted in Franz Roh, *German Art in the 20th Century* (Greenwich, Conn.: New York Graphic Society, 1958), 152; "**forestall any further**": Darnton, 30; this statement has been called the first announcement of the euthanasia program: Berthold Hinz, *Art in the Third Reich*, trans. Robert and Rita Kimber (New York: Pantheon, 1979), 42; "**merciless war**": Hitler in *"Degenerate Art,"* 17; "**neither politics**": Max Liebermann (1847–1935) in Hinz, 233; on Aryan requirements for artists, see Hellmut Lehmann-Haupt, *Art under a Dictatorship* (New York: Oxford University Press, 1954), 173–76. "**We had no access**": notes on Barbara Petzel's conversation with Katja Reichenfeld, 29 December 1986, courtesy Katja Reichenfeld; **modern art wing**: Annagret Janda, "The Fight for Modern Art: The Berlin Nationalgalerie after 1933," in *"Degenerate Art,"* 105–6.

"**Jewish Art Just for Jews**": Hans Hinkel speech, reported in *Israelitisches Familienblatt*, 1 August 1935; "**wake up**," "**virtually everything**": Kurt Singer in Freeden, *LBI Yearbook* (1956), 147, 151; on Kulturbund, see Yahil, 76; Michael Meyer, "A Musical Facade for the Third Reich," *"Degenerate Art,"* 177–78; "**cultural island of relief**": Kurt Baumann, "Der Kulturbund deutscher Juden, der Juedische Kulturbund in Berlin," 1977, typescript, LBI Archive; **Judas Maccabaeus flyer**: courtesy Christine Fischer-Defoy; Kulturbund to Gestapo, about *Judas Maccabaeus*, 7 September 1934, LBI Archive, 1210, 3100; other flyers and playbills in LBI's Kurt Singer Collection. **Any Aryan word**: Kurt Düwell, "Jewish Cultural Centers in Nazi Germany: Expectations and Accomplishments," in Reinharz, *Jewish Response*, 300; "**enough material**," "**Who knows**": Singer in Freeden, 150, 152; "**Chorus of Kurt Singer**": Paula Salomon, "Chor von Kurt Singer," 13 February 1938, LBI Archive, 1200, 3100. **Dr. Singsang**: JHM 4369, *LT* 211.

"**Everyone in illegal work**": Salomon-Lindberg interview, 1985; **emigration activities**: Abraham Margaliot, "The Problem of the Rescue of German Jewry

during the Years 1933–1939: The Reasons for the Delay in Their Emigration from the Third Reich," in *The Nazi Holocaust: Historical Articles on the Destruction of European Jews*, ed. Michael Marrus, vol. 6 (Westport, Conn.: Meckler, 1989), 553–93. **"She's got an exalted":** JHM 4367–69, *LT* 209–11. **Kulturbund had given Lotte access:** Kulturbund art exhibits listed in Düwell, 305, 308; a 1933 exhibit included Max Liebermann and Marc Chagall: Christine Fischer-Defoy and Reinhard Meerwein, "Zur Geschichte des Kulturbundes Deutscher Juden, 1933–1940," *Charlotte*, 143; programs for operas include Gluck's *Orfeo*, Bizet's *Carmen*, Weber's *Freischütz*: Baumann file, LBI Archive, 5299.

"As long as we are needed": Salomon-Lindberg interviews, 1984, 1985; **Lotte's schoolmates:** Himmelweit, Lackler, and Elcock interviews, 1985; **Jewish doctors:** Geoffrey Cocks, "Partners and Pariahs: Jews and Medicine in Modern German Society," *LBI Yearbook* 36 (1991), 198; Konrad H. Jarausch, "Jewish Lawyers in Germany, 1848–1938: The Disintegration of a Profession," ibid., 181; Doron Niederland, "The Emigration of Jewish Academics and Professionals from Germany in the First Years of Nazi Rule," ibid. 33 (1988); 291–92; Werner Rosenstock, "Exodus 1933–1939: A Survey of Jewish Emigration from Germany," ibid. 1 (1956): 377–84; Herbert A. Strauss, "Jewish Emigration from Germany: Nazi Policies and Jewish Responses," ibid. 25 (1980), 331, 340; on response of Jewish organizations, see Margaliot, "The Problem of the Rescue," 556–69. **Women urging Jewish emigration:** see Sybil Milton, "Women and the Holocaust: The Case of German and German-Jewish Women," in *When Biology Became Destiny: Women in Weimar and Nazi Germany*, ed. Renate Bridenthal, Atina Grossmann, and Marion Kaplan (New York: Monthly Review, 1984), 301; Kaplan, "Jewish Women in Nazi Germany," 592; Koonz, *Mothers in the Fatherland*, 363–66; **"Not a minute longer":** unnumbered JHM 5023; **"My mother wanted to leave":** Eva S., 1979, Fortunoff Video Archive for Holocaust Testimonies, Yale University, T-235; list of Kulturbund officers, LBI Archive.

"The German people will have their revenge," "Cowardly devious": JHM 4761, *LT* 607. **Synagogues:** Martin Gilbert, *The Holocaust: A History of the Jews of Europe during the Second World War* (New York: Holt, 1985), 69–70; Anthony Read and David Fisher, *Kristallnacht: Unleashing the Holocaust* (London: Michael Joseph, 1989), 75. **"When class started":** "Schauplatz Fürstin-Bismarck-Schule" [n.d.], courtesy Marian Lackler. **"I hope to be sent":** Bella Fromm, *Blood and Banquets: A Berlin Social Diary* (Garden City, N.Y.: Garden City Publishing, 1944), 281; **"but his friends in Rotterdam":** Salomon-Lindberg interview, 1984; on last days of Kulturbund, see Baumann, "Der Kulturbund," LBI Archive.

"Enough of this life": JHM 4790, *LT* 636. **"You have to hide" through "We want to know":** JHM 4763–67, *LT* 609–13; unnumbered JHM 5020; **"I'll pull every string" through "I've had enough of this life":** JHM 4768–83, 4786–90,

LT 614–29, 632–36; another version shows Charlotte's shoulders and head pressed down by "I've had enough": unnumbered JHM 4904.

"**Papa**": JHM 4798, *LT* 644. "**Wandering Is the Miller's Joy**": JHM 4267, *LT* 116; "**we were not going**," "**I am a low perverter**": Ralph Sanford, "Punishment Without Crime: The Time I Was Dead," ca. 1940, trans. Anne Basson, LBI Archive; "**their skulls smashed**": Gilbert, 74; "**if one man**": quoted in Read, 126; "**Dr. Kann**": JHM 4818, *LT* 664. "**This concentration camp**": Rudolf Höss in Rita Thalmann and Emmanuel Feinermann, *Crystal Night, 9–10 November 1938*, trans. Gilles Cremonesi (New York: Coward McCann, 1974), 124–25. **Jewish suicides** from 1932 through 1934 increased to 7.2 per thousand compared to the overall rate of 4.8: Kwiet, 148; Weissensee cemetery figures (1933–39) in Dublin, *Suicide*, 76; "**absolute condemnation**": Henry Romilly Fedden, *Suicide: A Social and Historical Study* (London, 1938; New York: Blom, 1972), 285; **Aryan women**: Eichmann's SS booklets claimed that Jewish rape aimed to render Aryan women "forever lost to their Volk": Peter Padfield, *Himmler: Reichsführer SS* (London: Macmillan, 1991), 199. "**This was the time**": Witness Cohn, Session 15, Bb 1, Eichmann Trial, The Attorney General of the Government of Israel v. Adolf, the Son of Adolf Karl Eichmann, Criminal Case No. 40/61, Sessions 1–121, mimeograph, 11 volumes, Jerusalem, 1961; "**enough charm**," "**You're discharged**": JHM 4800–82, *LT* 646–47. **123,104 women**: Monika Richarz, *Jüdisches Leben in Deutschland: Selbstzeugnisse zur Sozialgeschichte, 1918–1945*, 3 vols. (Stuttgart: Deutsche Verlags-Anstalt, 1982), vol. 3, 61.

CHAPTER 5: EXPULSION

"**I must say**": Göring and Heydrich meeting, 12 November 1938, Nuremberg document 1816-PS, *Trial of the Major War Criminals before the International Military Tribunal* (Nuremberg: IMT, 1948), vol. 28, 524–25, 532. **Jews committed suicide**: Yahil, 111; *Encyclopædia Judaica* (Jerusalem: Keter, 1971), vol. 3, 899; "**The Viennese have managed**": quoted in George E. Berkley, *Vienna and Its Jews: The Tragedy of Success, 1880s–1980s* (Cambridge, Mass.: Abt Books, 1988), 306; "**example of Vienna**": *Eichmann Interrogated: Transcripts from the Archives of the Israeli Police*, ed. Jocken von Lang (New York: Farrar Straus & Giroux, 1983), 58.

A life history for the SS: SS Questionnaire, 15 November 1938, from the SS File of Alois Brunner, courtesy Berlin Document Center; unless otherwise noted, quotations come from Brunner's SS file. **Austrian Nazis**: Gerhard Botz, "The Changing Patterns of Social Support for Austrian National Socialism (1918–1945)," and Peter H. Merkl, "Comparing Fascist Movements," in *Who Were the Fascists: Social Roots of European Fascism*, ed. Stein Ugelvik Larsen et al. (Bergen, Norway: Universitetsforlaget, 1980), 207, 210, 214, 768–69; Bruce

Pauley, "The Austrian Nazi Party before 1938," in *Conquering the Past: Austrian Nazism Yesterday & Today*, ed. F. Parkinson (Detroit: Wayne State University Press, 1989), 42; Herbert Ziegler, *Nazi Germany's New Aristocracy: The SS Leadership, 1925–1939* (Princeton: Princeton University Press, 1989), 70–73; **"tireless . . . colleague"**: Wilfried Hoffer to NSDAP, 11 May 1937; NSDAP Report, 17 May 1939: Brunner's SS file. **Graz police:** F. L. Carsten, *Fascist Movements in Austria: From Schönerer to Hitler* (London: Sage, 1977), 287; Robert Lewis Koehl, *The Black Corps: The Structure and Power Struggles of the Nazi SS* (Madison: University of Wisconsin Press, 1983), 144.

Reparations: Nazis resented the reparations that Germany and Austria paid to the Allies for the costs of World War I; **"our own death warrant," "bartering away"**: quoted in Berkley, 142; Carsten, 190. **SS requirements relaxed:** Koehl, 48; Ziegler, 55. **"Brunner had an insignificant"**: Georges Wellers, *De Drancy à Auschwitz* (Paris: CDJC, 1946), 94; **"small, dark, nervous"**: Témoignage de A. Drucker, 15 February 1946, CDJC: CCXVI–66; **"Physically, he is not at all"**: one of Brunner's prisoners, quoted in Jacques Darville and Simon Wichène, *Drancy la Juive ou la Deuxième Inquisition* (Cachan, France: Breger, 1945), 62; **"To judge from his features"**: Georges Dunand, *Ne Perdez Pas Leur Trace!* (Neuchâtel, Switzerland: Éditions de la Baconnière, 1950), 149; **"bad posture," "Among his SS cohorts"**: Deposition of Dieter Wisliceny, 11 February 1947; Deposition in trial of Anton Brunner, 3 October 1945; both depositions courtesy Serge Klarsfeld; **"conveyor belt,"** through **"The Prague Central Office"**: *Eichmann Interrogated*, 52, 56, 58; Herbert Rosenkranz, "The Anschluss and the Tragedy of Austrian Jewry, 1934–45," *The Jews of Austria: Essays on Their Life, History, and Destruction*, ed. Josef Fraenkel (London: Vallentine-Mitchell, 1967), 500; Witness Benno Cohn, Eichmann Trial, Session 15: Ggl.

"Charlotte sings the song of farewell": JHM 4821, *LT* 667; **"so self-concerned," "That's not sure yet"**: JHM 4804–7, *LT* 650–53. **"The Departure"**: JHM 4809–24, *LT* 655–70; **"God knows"** through **"Now then"**: unnumbered verso (drawings on the backs of scenes), 4814–15, 4470, 5036, JHM 4834, *LT* 680.

CHAPTER 6: DESOLATION

Ottilie Gobel Moore (1902–72) was born in Brooklyn, where her German immigrant father became a wealthy meatpacker during World War I. She moved to the Riviera, settling at l'Ermitage in 1929: Wallace Moore to MLF, 13 October 1984; **twelve-page postscript**: unnumbered JHM 4928–34; **"Epilogue"**: JHM 4835–925, *LT* 682–784; **"Dreams are foam"** is a German proverb that CS reverses. **Annie Nagler**, born in 1908, lived in Villefranche from 1939; she was first contacted by Judith Herzberg and Frans Weisz during research for their film *Charlotte* (1980). **Wallace Moore** lived at l'Ermitage from 1934 through 1941.

"Deeper into solitude": postscript JHM 4931; one-way street: Straus interview; "She detested": Emil Straus, "Biographical Note," *Charlotte: A Diary in Pictures*, [n.p.]. All quotations from Straus, unless otherwise noted, come from this source. Grossmama at l'Ermitage: Moore interview. "I could not bear," "They made the same": postscript JHM 4929–30; "The old lady": Wallace Moore to MLF, 13 October 1984.

"Grossmama, look at the sun" through "The world is filled": JHM 4842, 4791, 4793–94, *LT* 689, 637, 639–40; drawing of Grossmama, photographed by Ad Petersen, JHM; Gilbert Badia, "L'Émigration en France: Ses conditions et ses problèmes," *Les barbelés de l'exil: Études sur l'émigration allemande et autrichienne (1938–1940)*, ed. Gilbert Badia et al. (Grenoble, France: Presses universitaires, 1979), 15, 17, 21. A 1943 study showed Jewish welfare mainly went to male heads of families: Entr'aide Française Israelite, Jewish Theological Seminary Archive, Box 13. "Why shouldn't she" through "Let art": JHM 4836–37, 4846, 4842, *LT* 683–84, 693, 689; Booklet JHM 2114, 2113. Lotte also created a 1939 photo album of her grandparents that set their rather grim faces in a paradise of suns and boats. "Let me die" through "You go strangle": JHM 4848–58, 4860–66, 4850, 4875–76, 4882, 4885–87, postscript JHM 4930–31, *LT* 695–705, 707–13, 697, 722–23, 729, 732–34; "No one kills [her]self": Wilhelm Stekel in Paul Friedman, *On Suicide: Discussions of the Vienna Psychoanalytic Society*, *1910* (New York: International Universities Press, 1967), 87; two fatal falls: JHM 4181, 4900, *LT* 32, 748; this similarity observed by Amy E. Levine, "Charlotte Salomon: Psychological Resolution through Art" (M.A. thesis, Smith College, 1984), 22; "Never forget" through "Lieber Gott": JHM 4899–907, *LT* 746–55. CS's text may come from *King Lear* (1.5.50): "O! let me not be mad, not mad, sweet heaven," though popular German translations read somewhat differently.

"I will create a story": Salomon-Lindberg interview, 1984. "I hate," "Dear Grosspapa": JHM 4910–11, *LT* 758–59; letters between Lotte and her parents traveled via a relative in Switzerland, at least till summer 1940. Wolfsohn heard (perhaps in 1947 from the Salomons) that Lotte was almost pulled out the window by Grossmama and suffered a nervous breakdown: "Die Brücke"; "a family resemblance": JHM 4702, *LT* 546. Death Certificate of Marianne Grunwald: Courtesy municipality of Nice. Emil Straus told me she was buried in Caucade Cemetery, but it had no record of her. Whenever a family fails to pay for a plot, the remains are removed to a common grave.

"Breaking to pieces": JHM 4846, *LT* 693; see Walter A. Lunden, "Suicides in France, 1910–43," *American Journal of Sociology* 52, no. 4 (Jan. 1947), 321–34. Exiles on suicide: Tucholsky in Harold L. Poor, *Kurt Tucholsky and the Ordeal of Germany*, *1914–1935* (New York: Scribner, 1968), 205; Döblin in Frederic V. Grunfeld, *Prophets Without Honor: A Background to Freud, Kafka, Einstein and Their World* (New York: Holt, 1979), 228; Stephan Zweig, *The World of Yesterday: An Autobiogra-*

phy (New York: Viking, 1943; reprint, Lincoln: University of Nebraska, 1964), vi, 437; Lion Feuchtwanger, *Paris Gazette*, trans. Willa and Edwin Muir (New York: Viking, 1940), 577, 582; Peter T. Hoffer, *Klaus Mann* (Boston: Twayne, 1978), 79; Ernst Toller, *Pastor Hall*, trans. Stephen Spender (London: John Lane, 1939), 83; **"a hero's death"**: Walter Mehring, *The Lost Library: The Autobiography of a Culture*, trans. Richard and Clara Winston (Indianapolis: Bobbs-Merrill, 1951), 187; **"the best door"**: Paul-Louis Landsberg, *The Experience of Death; The Moral Problem of Suicide*, trans. Cynthia Rowland (London: Rockliff, 1953), 83; **"In those days"**: Arthur Koestler, *Scum of the Earth* (New York: Macmillan, 1941), 278; **"last emergency exit"**: Franz Schoenberner, *The Inside Story of an Outsider* (New York: Macmillan, 1949), 126; **"something like envy"**: Gustav Regler, *The Owl of Minerva: The Autobiography of Gustav Regler*, trans. Norman Denny (New York: Farrar Straus, 1959), 334; **"life should not be forced," "wrong to interfere"**: Schoenberner, 129; Alfred Kantorowicz, *Exil in Frankreich* (Bremen: Schünemann, 1971), 128; Hasenclever's suicide took place in the camp of Les Milles; **"Have you got anything?"**: Koestler, 278; **"I dread the hour"**: Ernst Weiss, *The Eyewitness*, trans. Ella McKee (Boston: Houghton Mifflin, 1977), 200. **"Old Jews"**: Koestler, 280; Koestler took his life years later; **"instinct . . . appeasement"**: Schoenberner, 35, 40–41; **"suicide of France"**: Koestler, 67, 83; **"murderous suicide"**: Heinz Pol, *Suicide of a Democracy*, trans. Heinz and Ruth Norden (New York: Reynal, 1940), 292–95; **"world filled with pain," "news of suicide"**: JHM 4794, 4864, *LT* 640, 711; unnumbered JHM 5024–25; Grossmama's nephew committed suicide in the Technische Hochschule of Berlin. Suicides also occurred among well-known women in Germany, but the history of female suicide in exile has not been written. **"I am going to live"**: JHM 4877, *LT* 724.

CHAPTER 7: PREMONITION

"The resettlement to Poland": Jonny Moser, *Die Judenverfolgung in Oesterreich, 1938–1945* (Vienna: Europa, 1966), 16; see Jonny Moser, "Nisko: The First Experimentation in Deportation," *Simon Wiesenthal Annual* 2 (1985), 1–30. **Austrian brotherhood**: Simon Wiesenthal estimated that Austrian officials were accountable for three million Jewish deaths, half the total killed in the Final Solution: Radomir Luza, *Austro-German Relations in the Anschluss Era* (Princeton: Princeton University Press, 1975), 226–27.

"Ordered to leave": JHM 4914, *LT* 762; **"Long live France"**: Weiss, *Eyewitness*, 200; **"legion of traitors"**: *Le Petit Niçois*, 14 and 15 May 1940; **"What an imprudence"**: *L'Éclaireur de Nice et du Sud-Est*, principal newspaper of the Nice region, hereafter cited as *L'Éclaireur*, 17 May 1940. Nice papers in Bibliothèque Nationale, Annexe des Périodiques, Versailles. **"We should not confuse"**: The. Kahn, *L'Éclaireur*, 20 May 1940; **"The French local"**: Kantorowicz, *Exil*, 40; **"Is

this enough?": *L'Éclaireur*, 23 May 1940; "simply to put on": Lion Feuchtwanger, *The Devil in France: My Encounter with Him in the Summer of 1940*, trans. Elisabeth Abbott (New York: Viking, 1941), 39–40, 251; "Avis": JHM 4914, *LT* 762. The French was "corrected" in the 1981 English-language editions. "Women who are German": *L'Éclaireur*, 27 May 1940; "discovered that refugee women": Schoenberner, 112; "undesirable aliens," three-fourths of eight thousand: Barbara Vormeier, *Die Deportierungen deutscher und österreichischer Juden aus Frankreich, 1942–1944* (Paris: Solidarité, 1980), 49–50; Préfet des Alpes-Maritimes à M. le Ministre Secretaire d'État à l'Interieur (hereafter cited as Préfet des Alpes-Maritimes), report of July–August 1942, AN: F1CIII 1137.

"How to live in this desolated universe": Hanna Schramm and Barbara Vormeier, *Vivre à Gurs: Un camp de concentration français, 1940–1941* (Paris: Maspero, 1979), 12; "thousands of totally": JHM 4915, *LT* 763. "Fifth Column!": *Exilés en France: Souvenirs d'antifascistes allemands émigrés, 1933–1945*, ed. Gilbert Badia (Paris: Maspero, 1982), 303; "one stupid syllable": Louis Aragon in Adam Rutkowski, "Le camp d'internement de Gurs," *Le Monde Juif* 101 (January–March 1981), 22; "A miserable cohort": Schramm and Vormeier, 11–12; "to prevent the women": Yolla Niclas-Sachs, "Looking Back from New Horizons," June 1941, LBI Archive; "suitable for a temporary camp": "Note sur le camp de Gurs," August 1940, and "Rapport de l'Ingénieur," 7 May 1942, AN: F7151C4; "female" camp: "Aperçu Général du Camp de Gurs," CDJC: CCXVII–51; "Les Gursiennes de l'été 1940," *Gurs: Souvenez-vous* 15 (September 1984), 4; Conditions at Gurs: Claude Laharie, "Histoire du camp après juin 1940," *Les Barbelés*, 260; Claude Laharie, *Le Camp de Gurs, 1939–1945: Un aspect méconnu de l'histoire du Béarn* (Pau, France: Infocompo, 1985); Rats "marched around": Rutkowski, "Le camp d'internement de Gurs," *Le Monde Juif* 100 (October–December, 1980), 139; Léon Moussinac, *Le Radeau de la Méduse: Journal d'un prisonnier politique, 1940–1941* (Paris: Éditions Hier et Aujourd'hui, 1945), 170, 206; Maria Krehbiel-Darmstadter, *Briefe aus Gurs und Limonest, 1940–1943* (Heidelberg: Lambert Schneider, 1970), 22; "the mud of Gurs": Niclas-Sachs, 17; Gerald F. Newman, "Miraculous Survival," 1981, LBI Archive; photographs of Gurs are collected in AN: F7151C4; "Instructions Concerning Discipline": Hanna Schramm, *Menschen in Gurs* (Worms, Germany: Heintz, 1977), 341; Gurs paintings: in Janet Blatter and Sybil Milton, *Art of the Holocaust* (New York: Routledge, 1981), 105–11.

"L'École de Gurs": Laharie, *Camp de Gurs*, 111; see Barbara Vormeier, "Les internés allemands et autrichiens en 1939–1940," *Les Barbelés*, 224–42; "at Biarritz": Schramm and Vormeier, 24; an active man: Blumenkranz interview; "little vile actions," "mendacity": Niclas-Sachs, 14; Schramm and Vormeier, 25; "the man who," "when a child": Feuchtwanger, *Devil*, 80, 251; "a neighbor": Krehbiel-Darmstadter, 22; "women are subjected": Memorandum, March 1941, and Report of Dr. Weil, LBI Archive 3987; "Every night": Eisner in Badia, *Exilés en*

France, 303; **Gurs artwork:** Felsenthal's drawings, LBI Archive; Schramm and Vormeier, 142–45; Blatter and Milton, 107; **"The camp is nothing but a sewer":** Moussinac, 174; **"miracle of Gurs":** Schramm and Vormeier, 144–45.

"Set us free": Niclas-Sachs, 15; **"a German commission":** Moussinac, 182; **they released Lotte:** This date, July 12 1943, cannot be verified, though it is specific enough to suggest that Straus heard it from Lotte herself. While the records (mostly burned) cannot prove she was in Gurs, the evidence suggests she was: others in her position went there; her phrase "the first sleep in three weeks" suggests a camp barracks; she was unlikely to stay in the Pyrenees if not interned; and the newspaper notice she partly reproduced specified Gurs. **"Sword of Damocles":** Kantorowicz, 136; **"to hand over":** 22 June 1940, Vormeier, *Die Deportierungen*, 49; **"great question mark":** Alma Mahler Werfel, *And the Bridge is Love* (New York: Harcourt Brace, 1958), 248; **"we learnt horrible news":** Niclas-Sachs, 19; on desperate condition of women, see American Friends Service Committee in France, Annual report, 1940–1941, LBI Archive, 3987; Report from Gurs, 8 August 1940, JDC: Box 618. **chapel and cemetery:** Conseiller d'État au Préfet des Basses-Pyrénées, 27 December 1941, AN: F7151C4; *Sie Sind Nicht Vergessen* (Karlsruhe, Germany: Verlag und Druckerei, 1958); Laharie, *Camp de Gurs*, 219; **10,000 German Jews:** Préfet des Basses-Pyrénées, 30 September 1940, AN: F7151C4; Jews were deported from Germany to Gurs on 22 October 1940; **people stopped pronouncing:** Juliette Minces, *Je hais cette France-là* (Paris: Éditions du Seuil, 1979), 93.

"The question": JHM 4922, *LT* 777; **"What's wrong":** through **"Grosspapa, I've come":** JHM 4915–21, 4264, 4296, postscript JHM 4928–29, 4920–21, *LT* 777, 764–73, 775, 113, 145, 773–75.

CHAPTER 8: CONCEPTION

Early works belonging to Paula Salomon-Lindberg, the JHM, or Thérèse de la Corre, Ottilie Moore's chauffeur, were exhibited at the JHM in 1981; orchard watercolor, signed "CS 1939," is in the possession of Annie Nagler; others belong to Wallace Moore and Ottilie Bourne; **CS 1940 portrait:** in the collection of Paula Salomon-Lindberg; **exile titles:** Yvonne Escoula, *L'Apatride* (Paris: Gallimard, 1951); Iwan Goll, *Jean sans Terre* (San Francisco: Grabhorn, 1944); Walter Hasenclever, *Die Rechtlosen* [1939–40], in *Gedichte, Dramen, Prosa* (Hamburg: Rowohlt, 1963). **"Exiles found it":** Feuchtwanger, *Paris Gazette*, 127–28; **"When I had to depend," "Take refuge":** Zweig, *World*, 412. **"What else":** Weiss, *Eyewitness*, 204; **"the world disintegrated," "I had to go deeper":** postscript JHM 4928, 4930–31; JHM 4921, *LT* 775.

"And so I began Life and Theater": postscript JHM 4931. **"Dedicated":** JHM 4155, *LT* 2; the 1981 English edition translates *Vorspiel*, as "Prelude"; I prefer

"Prologue," to stress CS's theatrical reference; **on life at l'Ermitage:** Moore, Bourne, Nagler interviews; U.S. Consulate Nice to State Department, 29 March 1940, 5 November 1940; State Department to Nice Consulate, 31 October 1940: NARA, Nice Consulate Card File; **"Terrible disappointment,"** through **"Living with my grandfather":** postscript JHM 4929–30, JHM 4155, *LT* 6. **"on top of the world":** Buchthal interview; **"Nothing unexpected," "I had a residence":** postscript JHM 4928, 4931.

"We stayed tranquil enough on the Côte d'Azur": postscript JHM 4928; **"things were bad":** Rosowsky interview. **On Jews in Nice:** Zanvel Diamant, "Jewish Refugees on the French Riviera," *YIVO Annual* 8 (1953), 265–66, 272; Michael O. Marrus and Robert O. Paxton, *Vichy France and the Jews* (New York: Schocken, 1983), 100–7; Jean-Louis Panicacci, "Nice pendant la deuxième guerre mondiale: de la déclaration de guerre à l'occupation italienne (septembre 1939–novembre 1942)," Diplôme d'études supérieures, Université de Nice, 1967, 62–65, 96; **"workmen and their families":** Lisbon to Foreign Office, 13 April 1943, PRO, FO371/36017, France file 52. **"Jewish and foreign element," "cleansing," "several thousand":** Préfet des Alpes-Maritimes, 4 October, 4 August, 6 March 1941, 5 January 1942, AN: F1CIII, 1137; **698 Jewish enterprises:** Joseph Billig, *Le Commissariat Général aux Questions Juives (1941–1944),* 3 vols. (Paris: CDJC, 1955–60), vol. 3, 301; **"The peoples":** Nice, 23 October 1925, Jewish Theological Seminary, Box 17; **"This Jewish war":** Georges Claude in *Le Petit niçois,* 26 July 1943; **"A Jewish problem":** Xavier Vallat in *L'Éclaireur,* 17 March 1942; **"Workers of Nice":** Parti Populaire Français, October 1943, CDJC: pamphlet 10.151; **"Are you against":** *L'Éclaireur,* 23 February 1942; the SOL was founded in Nice on 10 August 1941; see Raymond-Raoul Lambert, "La propagande antisémite en France depuis la guerre," [1941], *Le Monde Juif* no. 55 (July–September 1969), 8; Préfet des Alpes-Maritimes, 4 October 1941, and Report #5376 [n.d.], 1 July, July–August 1942, AN: F1CIII, 1137.

"Case killed": State Department stamp on visa requests, NARA, Suitland, Md.: 811.111/Refugees. **"I was overwhelmed":** postscript JHM 4931. **"Jewish refugees":** Schoenberner, *Inside Story,* 161; Schoenberner's visa, Nice Consulate Card File, NARA, 811.111; the vice consuls in Nice were Basil F. Macgowan, Walter William Orebaugh, and Francis M. Withey. **"Anyone from Germany":** "Report on the situation in Free France," Lisbon to American JDC, 27 November 1940, JDC, Box 618. **"in urgent need":** J. Edgar Hoover, 31 January 1941, NARA: 811.111 Refugees/908; **"of intellectual superiority":** Lindley Beckworth, 19 December 1940; Breckenridge Long, 6 January 1941: NARA: 811.111 Refugees/929. **"Entry of alien," "unable":** NARA: Marseille Consular Card File; **"eminent intellectuals":** U.S. Embassy, Vichy, 12 February 1941, NARA: 811.111 Refugees/959; **"clean, polite":** Bregman interview; **"Withhold visas":** A. M. Warren, Chief, Visa Division, 18 June 1941; **one hundred visa requests:**

Evening Star, Washington, D.C., 19 July 1941; **"every day two"**: Témoignage de M. Maurice Blanchard, 6 May 1945, CDJC: CCXVIII–90. After November 1942, when Axis forces occupied southern France, the Nice consulate closed. It is possible that Lotte's application for a visa was lost or destroyed, but usually there were several references in the card files; none appear in existing files from Nice and Marseille, or in the lists compiled every month or so by the State Department's Visa Division. **"19 August 1941"**: also 14 August 1941, NARA: Nice Consulate Card File; **"bartering and sale"**: 10 January 1941, 811.111 Refugees/970; 8 July 1941, 811.111 Refugees/1623. A French plea to issue more visas had just been rejected by the State Department with the rationale "that no distribution shall be made of refugees on the grounds of race," *New York Times*, 1 September 1941. See also Richard Breitman and Alan M. Krout, *American Refugee Policy and European Jewry, 1933–1945* (Bloomington: Indiana University Press, 1987); David S. Wyman, *The Abandonment of the Jews: America and the Holocaust, 1941–1945* (New York: Pantheon, 1984).

"Emigration has now been replaced": Wannsee Conference protocol, Berlin, 10 January 1942, Nuremberg document NG-2586-G, in *Genocide: Critical Issues of the Holocaust*, ed. Alex Grobman and Daniel Landes (Los Angeles: Simon Wiesenthal Center, 1983), 441–49. **Brunner's Jewish Order Service:** Reports of Dr. Löwenherz, 17 October 1939, 1 February 1941, 24 August 1942, NARA: Nuremberg document RG 238, PS 3934; Herbert Rosenkranz, "Austrian Jewry: Between Forced Emigration and Deportation," in *Patterns of Jewish Leadership in Nazi Europe* (Jerusalem: Yad Vashem, 1979), 65–74; Raul Hilberg, *The Destruction of the European Jews*, 3 vols. (New York: Holmes & Meier, 1985), vol. 2, 433; **"Jewish Reservation"** called off: Brunner to Löwenherz, 5 November 1941, NARA: RG 238, PS 3934; **The Reichsführer SS:** Wannsee Conference protocol, 444, 446.

CHAPTER 9: PRESENTATION

"My passion for drawing," **"the war raged on"**: postscript JHM 4928, 4931. **"Charlotte was a sunny girl"**: Marthe Pécher to MLF, 1 August 1991; **"painted all the time"**: Marthe Pécher to Gary Schwartz, 27 September 1981, courtesy Gary Schwartz.

"A musically colored mood" through **"The origin"**: JHM 4591, 4686, 4239, 4701, 4155, LT 432, 528, 88, 545, 5–6; **German singer's repertoire:** Musical citations were compiled and taped by Katja Reichenfeld for the JHM; most are listed by Vincent Hammer and Mark Rosinski in Fischer-Defoy, *Charlotte*, 91–93; see also Reichenfeld, "Leben? oder Theater?"; tape of Paula Salomon-Lindberg's recorded songs, including Bach's "Bist Du Bei Mir," courtesy Ad Petersen.

"A three-color opera": JHM 4155, LT 3. A JHM restoration study revealed that almost all her pigments are mixes of red, yellow, and blue; each of these

colors dominates one part of the work: Reichenfeld, 61. "Tri-color opera" is used in the 1981 English edition of *LT*; see Michèle C. Cone, *Artists Under Vichy: A Case of Prejudice and Persecutions* (Princeton: Princeton University Press, 1992). Brecht used songs in plays Lotte could have seen; **"its whole origin"** through **"In order to facilitate"**: JHM 4155, 4168, *LT* 4, 19, unnumbered JHM 4932; CS clearly conceived pictures first, then overlays, perhaps well afterward, for their texts sometimes end mid-sentence and resume on the next see-through sheet; **penciling additions**: e.g., overlay JHM 4369 indicates the "Prologue," but only at the end of it; overlays on inferior tracing paper were probably added later; the pencil additions were also applied later, since they sometimes cover the tape that attached the overlays; **"the nurse leaves"**: overlay JHM 4179. **"Here a chapter"** through **"The following pictures"**: JHM 4240, 4821, 4651, 4685, *LT* 89, 667, 493, 527. In fact the "Michelangelo Rome scenes" (JHM 4324–33, *LT* 172–81) are not in the "Main Part," which suggests that CS's final numbering shifted some of the chapters; **playbill**: JHM 4155, *LT* 1–6. Some of the playbill is closely connected in color and motif (hearts and circles) to the "Prologue," but its references to the "Main Part" and the whole structure suggest it was created at the end of the work; the playbill's last two pages resemble the work's final pages in their jammed-up handwriting and yellow underlined words. Both the playbill and the postscript were lettered on four-piece attached sheets of cheap paper, most likely painted later; **variant titles**: JHM 4155, 4925, postscript JHM 4931, *LT* 1, 783, 784.

"Change in the visual conception": JHM 4821, *LT* 667; **"a year later"**: JHM 4921, *LT* 775; **"Drawing, as always"**: JHM 4923, *LT* 780. **760 paintings**: There is no way to make an exact count, since some paintings have probably been lost, and CS said she inserted some pages in the final version, though not which ones or how many. The 1981 published edition includes 769 paintings, but these include some unnumbered ones, overlays, and the playbill. The unnumbered paintings too are difficult to count, since they range from small scribbles on the backs of paintings to full variant versions. Martin Mansoor, retained by the JHM to inventory the collection, has also not been able to determine a precise count; **versions of the infant**: JHM 4172, *LT* 23; unnumbered JHM 4934, 4860–61; **"when we think"**: JHM 4594, *LT* 274; unnumbered JHM 4963, verso 70; **life mask**: JHM 4594, *LT* 435, unnumbered JHM 4975–77, 5029, 5037. **"Much that is artistic"**: JHM 4155, *LT* 6; **deleted pictures of Paulinka, Daberlohn's early life, grandparents**: unnumbered JHM 5096, 5098, 5103, 5065–70; **"I myself needed"**: JHM 4155, *LT* 4. **"I was desperately unhappy"**: postscript JHM 4930–31.

"Only colors, paintbrushes, you": postscript JHM 4931; **in profile**: JHM 4875–76, *LT* 722–23. **"Please compare"** through **"just as you can"**: JHM 4698, 4704, 4479, 4702, *LT* 541, 549, 320, 546; **postscript pages**: JHM 4928–31;

these have a similar look to the last text pages, and conceivably were painted just after; "**There were trees**," "**my theme**": postscript JHM 4931, 4930. **Nussbaum portrait**: in Emily D. Bilski, *Art and Exile: Felix Nussbaum, 1904–1944* (New York: Jewish Museum, 1985), 18; "**the Muse**": Marc Bloch, 13 September 1942, in Natalie Davis, "History's Two Bodies," *American Historical Review* 93:1 (February 1988), 29. "**It was only**": Fromm, *Blood and Banquets*, 2; "**Black Flakes**": "Schwarze Flocken" (1943) in Paul Celan, *Gesammelte Werke*, ed. Beda Allemann et al., 5 vols. (Frankfurt: Suhrkamp, 1983), vol. 3, 25.

"**This play is set in Germany**": JHM 4155, *LT* 3. "**War is declared**" through "**little town**": JHM 4913 and overlay, *LT* 761, postscript JHM 4928, JHM 4921, *LT* 775; "**And here we are**": Alma Mahler-Werfel, September 1938, in *Barbelés*, 74; Franz Werfel, *Jacobowsky and the Colonel: Comedy of a Tragedy in Three Acts*, trans. Gustave O. Arlt (New York: Viking, 1944); "**You can stay here**": Anna Seghers, *Transit*, 50; "**elements of comedy**," "**an agony to watch**": Schoenberner, *Inside Story*, 120, 45–46; "**penny dreadful**": Koestler, *Scum*, 278; "**You are hereby**": unnumbered JHM 4927; "**Them or us**" through "**ravished by traitors**": *Le Petit Niçois*, 12 September 1943; *L'Éclaireur*, 10 March, 19 July, 28 August 1942; **public rituals**: *L'Éclaireur*, 23 February 1942, 29 August 1943, 26 August 1941, 24 August 1942; **Joan of Arc festivals**: *L'Éclaireur*, 10, 12 May 1940, 12 February, 10–11 May 1942; 10 May 1943; *Le Petit Niçois*, 9, 19 May 1943; "**cheap, tawdry**": Leslie Weisenburg, U.S. Consulate, Nice, 21 August 1942, NARA: RG 59, Vichy Confidential File, 1942, Box 18, 841.1-Jews; the exhibit opened in Nice on 9 August 1942, and "proved" that Franklin Delano Roosevelt was of Hebrew origin; "**massive internment**": Préfet des Alpes-Maritimes, 6 September and 4 October, 1941, AN: F1CIII, 1137.

"**It was correct to present myself**," "**A law at the time**": Marthe Pécher, interview with Bert Haanstra, 20 September 1985, São Paulo, included in Kees Hin, *May You Never Forget* (JHM film); "She spoke to me of a theater-director [Kurt Singer], she spoke to me of a great singer [Paula Lindberg]. Each time she was in the midst of doing another painting." I place this episode in late August 1942, when Vichy authorities ordered roundups throughout the Unoccupied Zone. Putting Jews on buses suggests a transport rather than an identity check; summer 1942 makes sense, since Madame Pécher dated Charlotte's arrival in St. Jean Cap Ferrat as late 1941 or early 1942 and CS dated *LT* as "St. Jean, August 1941/42," which suggests she finished it just after this episode. "**Refugee Controller's hours**": *L'Éclaireur*, 26 August 1942. **Laval's pledge**: 2 July 1942, in Serge Klarsfeld, *Le Calendrier de la persécution des juifs en France, 1940–1944* (Paris: Klarsfeld Foundation, 1993), 249, 256; "**the only Jews**": Laval quoted by Donald Lowrie to YMCA World Committee, 10 August 1942, JDC: Box 614. "**The police here**" through "**no information**": Nice Consulate, 21 August 1942, NARA: RG 59, Box 18, 841.1-Jews; "**seven hundred**": Rapport sur la situation des Juifs en France,

September 1942, JDC: Box 614; see also Rapport du président du Consistoire E. Montel, CDJC: CCXX–12; **"hallucinatory spectacle"**: C. L. Flavian, *De la nuit vers la lumière* (Paris: J. Peyronnet, 1946), 62; **"they put her in a bus"**: Pécher in Hin film.

"I had to complete it" through **"The author"**: postscript JHM 4931; JHM 4155, *LT* 4–6; **"living model"** through **"suddenly she knew"**: JHM 4923–4, 4533, 4693, 4723, *LT* 780–1, 779, 374, 535, 569.

Chapter 10: Asylum

Another résumé: July 1942, SS file of Alois Brunner, Berlin Document Center. The 1942 SS form shows Brunner's rank as Hauptsturmführer, his position as Inspector of the Sipo and SD (Security Police) in Vienna, his address, Gustav Teschermakgasse 14/1, his SS number 342,767; **"Judenfresser"**: Witness Regina Wiener in the 1945 trial of Anton Brunner (Alois Brunner's subaltern): Vienna Volksgericht Vg2 4574/45, Dokumentationsarchiv des österreichischen Widerstandes (hereafter cited as DÖW): 9359. **"Eternal Jew,"**: Gerda Bormann in Koonz, *Mothers*, 404; **"Jew was the first"**: Joseph Goebbels in Joel Dimsdale, *Survivors and Perpetrators* (Washington, D.C.: Hemisphere, 1980), 311–12; **"Victims?"**: Brunner in Dunand, *Ne perdez pas*, 148–50; **"We lost"**: Brunner quoted by Witness Albert Welt, Anton Brunner trial, DÖW, 9359. **"The Jews' Life in 1938"**: Epelbaum, *Alois Brunner*, 87. **Anni Röder**: SS Questionnaire, 31 July 1942, SS file of Alois Brunner; **"most modish furniture"**: Witness Max Waldemar, Anton Brunner trial, DÖW: 9359. **Himmler on SS marriage, suicide**: Koehl, *The Black Corps*, 51, 118, 226, 359; William L. Combs, *The Voice of the SS: A History of the SS Journal "Das Schwarze Korps"* (New York: Peter Lang, 1986), 141, 344–45; **"damn Prussian pigs"**: "Leben der Juden in Berlin in den Jahren 1940 bis 1943" [anonymous accounts ca. 1943], CDJC: LXX–70; these testimonies placed Brunner in Berlin from September 1942 till the end of February 1943, holding him responsible for the massive "Factory Action" of 27 February 1943 that swept up thousands of exempted Jewish workers: See also Dr. Mosse, Bovensiepen indictment, LBI microfilm 239: 203–4; Peter Wyden, *Stella* (New York: Simon & Schuster, 1992), 105–7, 111; **"things changed completely"**: Hildegard Henschel, Eichmann Trial, Session 37: Vv1, Ww1; **"Get that Jew,"** **"ridiculously young"**: "Leben der Juden," CDJC: LXX–70.

One Mediterranean sanctuary: see Léon Poliakov and Jacques Sabille, *Jews Under the Italian Occupation* (Paris: CDJC, 1955); Marrus and Paxton, *Vichy France*, 315–21; Meir Michaelis, *Mussolini and the Jews: German-Italian Relations and the Jewish Question in Italy, 1922–1945* (Oxford: Clarendon, 1978); Susan Zuccotti, *The Italians and the Holocaust: Persecution, Rescue, and Survival* (New York: Basic Books, 1987), 74–100; **"The Italian authorities"**: Préfet des Alpes-Maritimes, 14 January 1943,

CDJC: XXVa–324/325. "Jews of all nationalities" through "the best of harmony": Knochen to RSHA Bureau IV, Berlin, 12 February 1943, in Poliakov and Sabille, 60; "Italian officers" through "intolerable": Nazi correspondence in spring and summer 1943, reproduced in ibid., 63, 62, 112, 71, 24, 106, 109, 116, 65; "Nice seems a city": Commissariat Général aux Questions Juives, "Rapport et conclusions sur l'enquête d'opinion effectuée en zone libre dans le 1er trimestre 1943, pour le compte du service de propagande," [CGQJ Rapport] CDJC: CIX–59, 45; "Jews gather": phrase from Vichy press, Michel Ansky, Témoignage, 9 August 1945, CCXV–24; "Italian zone of influence": Röthke, 21 July 1943, in Poliakov and Sabille, 106; "Israelites have emigrated": Prefect of Lyon, in Marrus and Paxton, 315; "Nice is new capital" from a French denunciation, 23 November 1940, in Zosa Szajkowski, Analytical Franco-Jewish Gazetteer, 1939–1945 (New York: Shulsinger, 1966), 156; one Italian general called the Jewish flight toward Nice a "Biblical Exodus": The Righteous Enemy, film by Joseph Rochlitz, Italy, 1987. "The Germans would never": Rosowsky interview; "Israelites arrived": Déposition de Monsieur le Pasteur Gagnier, Nice, 18 May 1945, CDJC: CCXVIII–85; "Nice became assembly": Ignace Fink, interview with Anny Latour, CDJC: DLXXXVIII–10; "Thousands of Jews": Ansky Témoignage, CDJC: CCXV–24; "French Jews": Report to the American JDC, 15 July 1943: JDC, Box 621. 1941 census: Z. Szajkowski, "Glimpses on the History of Jews in Occupied France," Yad Vashem Studies 2 (1958), 156; 1942 census: Billig, Commissariat Général, vol. 2, 209; 20,000, 22,000 Jews: Fink interview, CDJC: DLXXXVIII–10; Joseph Fisher to Consistoire Central, August 1943, YVA: P–7/10; "constitutes only a third": Röthke to IVB Berlin, 28 July 1942, CDJC: XXVb–96.

"Aimez-vous les Juifs?": CGQJ Rapport, CDJC: CIX–59; historians have overlooked or discounted this survey; throughout the southern zone, 53 percent of the men said they did not like Jews, as against 40 percent of the women; the reasons given were most often Jewish control of the economy; 19 people recommended murdering all the Jews, and 750 advocated compulsory labor. "Jew is not Frenchman": exposition catalog, CDJC pamphlet collection; "Israelite meddling": L'Éclaireur, 17 August 1942; graffiti appeared: Moore interview. "I often had letters": postscript JHM 4931; Lotte had lived at l'Ermitage from January 1939 till spring 1940; she returned for several months in summer 1941 but probably went back and forth more than any concrete evidence shows; "a citizen of the elite": L'Éclaireur, 29 April, 12, 16 May 1943. "political climate" through "We lulled ourselves": Ansky, CDJC: CCXV–24. According to Ansky, Chaignaux was "deeply devoted to the idea of Resistance" and suffered for it in a German concentration camp.

Another Mediterranean sanctuary: see Michael Molho, In Memoriam: Hommage aux victimes juives des Nazis en Grèce, 2 vols. (Salonika: Nicolaides, 1948–49), vol. 1,

3–25; Cecil Roth, "The Last Days of Jewish Salonica," *Commentary* 10 (July 1950), 49–50; Joseph Ben, "Jewish Leadership in Greece during the Holocaust," in *Patterns of Jewish Leadership*, 339; Eli Rosenbaum, *Betrayal* (New York: St. Martin, 1993), 145–50; **"expulsion of Jews"**: RSHA memorandum, 25 January 1943, Israeli Police, Documents of the Prosecution in the Eichmann Trial, No. 1000, Hoover Institution; **"annihilated biologically"**: Dieter Wisliceny testimony, 3 January 1946, *Trial of the Major War Criminals*, vol. 4, 366; **"Brunner who solved"**: Yom Tov Yacoel, quoted in Eichmann Trial, Session 47: M1. **"With overwhelming speed"**: Consul General Schoenberg, 26 February 1943, Israeli Police Document 1003, **Jewish hostages**: Eichmann Trial, Session 49: Bbb1, Session 51, Rr1; **"unbelievable ferocity"**: *Le Passage des barbares: Contribution à l'histoire de la déportation et de la résistance des juifs grecs*, ed. Miriam Novitch (Israel: Ghetto Fighters House, 1982), 57. **"The most ferocious"**: Molho, vol. 1, 78; **"We were told,"** **"the men would work"**: Eichmann Trial, Session 47: V1–V2; Novitch, 59; **"compulsory evacuation"** through **"upon completion"**: Wisliceny affidavit, *Nazi Conspiracy and Aggression*, 8 vols. (Washington, D.C.: U.S. Government Printing Office, 1946–48), vol. 8, 612–13; **"technical conduct"**: Wisliceny testimony, *Trial of the Major War Criminals*, vol. 4, 363; **"six to eight weeks"**: RSHA Memorandum, 25 January 1943, Israeli Police Document 1000.

Another marriage: Alexander Nagler (1904–44), according to his sister-in-law Annie, first tried to enter France by getting off and on a train from Italy, saying his passport had been checked. On Nagler: Moore, Nagler, Bourne, Straus interviews; **"The woman to whom,"** **"playing his part"**: postscript JHM 4931. **Death certificate**: "Ludwig Grunvald [*sic*], No. 763, 12 February 1943, Registres de l'État Civil, Nice." Emil Straus said Dr. Grunwald was buried in Caucade Cemetery outside Nice, but my search there proved fruitless. A brief death announcement appeared in *L'Éclaireur*, 15 February 1943. **Marriage license**: Département des Alpes-Maritimes, Ville de Nice, Registres de l'État-Civil. The number of marriages in Alpes-Maritimes decreased to 2,627 in 1943, the lowest since 1939: Jean-Louis Panicacci, *Les Alpes-Maritimes de 1939 à 1945* (Nice: CRDP, 1977), 38. **"When Charlotte discovered"**: Madame Moridis, quoted in Herzberg, foreword, *LT*, xii. I carefully contacted Madame Moridis on several occasions, but she refused to talk about CS; **"rights of pregnant women"**: *Le Petit Niçois*, 5 January 1943; **"at the aid,"** **"resolved to bring"**: *L'Éclaireur*, 14 January, 12 August 1943; **"enormous number of women"**: Lisbon Consulate to Foreign Office, 13 April 1942, PRO FO 371/36017: France file 52; **Alexander entertained Italians**: Nagler interview, 1985; **"a little courage"**: Report to American JDC, 15 July 1943, JDC: Box 621. **"I had no idea"**: postscript JHM 4931; **portrait of her husband**: unnumbered JHM 5116; **"PROPERTY"**: Nagler's writing on the packages was described by Paula Salomon-Lindberg.

CHAPTER 11: COLLISION

"All the characters": JHM 4155, LT 6.

Rescuers. "SS Hauptsturmführer": 26 September 1943, Poliakov and Sabille, *Jews Under Italian Occupation*, 25–26. "Angelo Donati": Père Marie-Benoît, 16 July 1943, in *Actes et documents du Saint-Siège relatifs à la Seconde Guerre Mondiale*, vol. 9 (Rome: Libreria Editrice Vaticana, 1975), 401–2. No note has been found in Vatican papers to British or U.S. delegates, as requested by Père Marie-Benoît. "My father": Spier-Donati interview. "Donati . . . was a simple man": Fink interview, CDJC: DLXXXVIII–10.

Strategists. "Italian government," "The Department desires": Harold Tittman to U.S. Secretary of State, 30 August 1943; Secretary of State Hull to U.S. Ambassador Winant, London, 8 September 1943, NARA: 848 Refugees/4426. "It would be a profound mistake": Sir Herbert Emerson, 31 August 1943, included in U.S. Embassy London to State Department, NARA: 840.48 Refugees/4483. "Concerning Jews in transit": Ian Henderson, 26 August 1943, PRO FO 371/36665/W12321/49/48. "I know, in fact": Roosevelt Memorandum, 14 May 1943, quoted by Division of Emergency Affairs to Secretary of State, 22 June 1943, NARA: 840.8 Refugees/4029. "The publicity": British Embassy Washington to Foreign Office, 9 August 1943, PRO FO 371/36665/W12066. "I fear": Foreign Office, 26 August 1943, PRO FO 371/36665/W12321.

Rescuers. "In August 1943": Joseph Ariel, "Le sionisme et le Kéren Kayémeth en France pendant la dernière guerre: Souvenirs" [n.d.], YVA: 09-7, 569. On 26 July 1943 Benito Mussolini was replaced by Pietro Badoglio, who negotiated a secret armistice with the Allies in the first week of September 1943, to be announced much later. "The governments": Père Marie-Benoît, "Résumé de mon activité en faveur des Juifs persécutés," CDJC: XI–18. "With a certain obstinacy": Ansky, CDJC: CCXV–24. "Donati is still": Fisher, Nice, to Consistoire Central, Lyon, 1 August 1943, YVA: P-7/10.

Avengers. "Preparations": Röthke to Hagen, 4 September 1943, Poliakov and Sabille, 119–21.

Rescuers. "Marshal Badoglio": Angelo Donati, "Exposé: la situation des Juifs dans la zone italienne," CDJC: I–65.

Strategists. "It is no longer possible," "I intend," "This is General": Peter Lyon, *Eisenhower: Portrait of the Hero* (Boston: Little, Brown, 1974), 241–43; Eisenhower opposed any Jewish camps in North Africa, as did most U.S. officials who wanted to protect U.S. relations with Arab nations; see Breitman and Krout, *American Refugee Policy*, 175–78. "At 6:30 P.M.": Donati, Exposé, CDJC: I–65. "Eisenhower is a man": Donati quoted in Spier-Donati interview; "The Allied invasion": Philippe Erlanger, *La France sans étoile: Souvenirs de l'avant-guerre et du temps de l'occupation* (Paris: Plon, 1974), 276–78. "A rabbi": Léon Poliakov,

L'auberge des musiciens: Mémoires (Paris: Mazarin, 1981), 122. **"It seems that all"**: E. F. Rathbone, 8 September 1943, PRO FO 371/36665. **"Miss R"**: penned addition to Foreign Office Memorandum, 9 September 1943, PRO FO 371/36666/W12841/49/48. **"With regard to refugees"**: Reported by Winant, U.S. Embassy in London, to State Department, 9 September 1943, NARA: 848 Refugees/4462. **"I fear these Jews"**: 13 September 1943, PRO FO 371/36666/W13047/49/48. **"If we did approach"**: A. W. G. Randall, 16 September 1943, PRO FO 371/36666/W13228/49/48. **"There are many refugees"**: 27 September 1943, PRO FO 371/36666/W13938/49/48.

Victims: The Donati plan was the first specific mass evacuation project, though the World Jewish Congress had earlier approached the Foreign Office with an abstract idea of evacuating two million Jews to North Africa, which the Foreign Office called "quite impossible" because of the military operations there. Richard Law Memorandum, 6 January 1943, FO 371/36648/W415/49/48. The diplomacy behind the Donati plan has not been brought out elsewhere, though the plan itself is mentioned in R. Anthony Pedatella, *Jewish Frontier* (April 1985), 14, 29; Susan Zuccotti, *The Holocaust, the French, and the Jews* (New York: Basic Books, 1993), 180–83; Zuccotti, *Italians*, 88–89; Fernande Leboucher, *Incredible Mission*, trans. J. F. Bernard (Garden City N.Y.: Doubleday, 1969); Marrus and Paxton, 320; Serge Klarsfeld, *Les Transferts de Juifs de la région de Nice vers le camp de Drancy en vue de leur déportation* (Paris: Klarsfeld Foundation, 1993), 51–52. On Treasury Department, see NARA: 848 Refugees/4036; on IGCR excluding Jewish members, see correspondence of World Jewish Congress and Rabbi Stephen Wise with Sir Herbert Emerson, 19 and 24 August 1943, NARA: 848 Refugees/4186 and /4483; 25 November 1943, YVA: M-2/362. On British policy, see Bernard Wasserstein, *Britain and the Jews of Europe* (Oxford: Clarendon, 1979). It was canceled out: penciled inscription with red line, Foreign Office memorandum [n.d. early September 1943], PRO FO 371/36666/W12893/49/48.

Avengers. **"Around 1 September 1943"**: Dr. A. Drucker, 15 February 1946, CDJC: CCXVI–66. **"Under the direction of Brunner"**: "Rapport sur l'évenement survenu à Lyon, le 10-XII-43," YVA: P7/37.

Victims. **"In the face"**: Préfet des Alpes-Maritimes, 20 October 1943, AN: F1CIII 1137. **"The Germans posed"**: "Rapport, 10-XII-43," YVA: P7/37. **"Prisoners"**: Erlanger, 289. **"A considerable number"**: Geneva OSE to American OSE, 25 November 1943, YIVO Archive: OSE-20. **"A Catholic nurse"**: Union des Juifs pour la Résistance et l'Entr'aide, "Cinq Mois de Persécutions anti-Juives à Nice" [ca. February 1944] CDJC: pamphlet 10.143.

Denouncers. **"At Nice"**: Fink interview, CDJC: DLXXXVIII–10; **"Physiognomists"**: Nice file, YVA: P7/37 (8–10). **"Every day a pile"**: Déposition de Marguerite Becker, April 1945, CDJC: CCXVIII–92.

Resisters. **"For each denunciation"**: Henry Pohoryles, interview with Anny

Latour, CDJC: DLXI–29, 4. "**The Sixth Section**": Robert Gamzon, diary, 1940–44, YVA: 033-216. "**As soon as the Germans**": Déposition de Dr. Antonio Aniante, 11 July 1945, CDJC: CCXVIII–88b. "**Police officers**": Nice file, YVA: P7/37 (8–10); the prefect reported popular outrage when French paramilitary units helped the Gestapo: Préfet des Alpes-Maritimes, 10 October 1943, AN: FICIII 1137. "**Every day they threatened**": Andrée Clausier, Témoignage [n.d.], CDJC: CCXVIII–91. "**Several handfuls**": Poliakov, *l'Auberge*, 128.

Avengers. "**In Nice the Jews paid**": "Grenoble sous la Terreur" [1944] YVA: P7/37. "**The Gestapo punished**": Fink interview, CDJC: DLXXXVIII–10. "**Police officers took vengeance**": Elie Adler de la Vultureni, testimony, 15 March 1966, YVA: 03/2964. "**For the Nazis**": Poliakov, *l'Auberge*, 124.

Collision. **fifteen thousand Jews**: IVB-BdS Paris, 14 June 1943, CDJC: XXVII–16; **1,820 names**: Jean-Louis Panicacci, "Les Juifs et la question juive dans les Alpes-Maritimes de 1939 à 1945," *Recherches Régionales: Côte d'Azur et contrées limitrophes*, No. 4 (1983), 274; Annie Nagler knew nothing of deportations but was afraid to stay in Villefranche; with false Algerian papers from a French official, she walked to Nice and took a bus to an outlying town; Nagler and Straus interviews; **list of September 24, 1943**: CDJC: DLXXI–7; Nice departure lists (CDJC: DLXXI–1) show fewer arrests than the seven thousand that Jewish leaders calculated after 8 September 1943. Ansky, CDJC: CCXV–24, 5; E. Montel, 10 December 1945, CDJC: XX–12; see Klarsfeld, *Transferts de Juifs*, 74–75.

Ermitage, hideout in Monaco: Nagler interview, 1985. On the dangers of Monaco, see Denis Torel, "Réflexions sur le traitement particulier de la 'question juive' en Principauté de Monaco durant la seconde guerre mondiale," *Le Monde Juif* 116 (October–December 1984), 179–82; **alpine passes**: "Rapport sur le passage et les conditions de vie de nos gens en Italie," 10 March 1944, YVA: P7/37; **secret flat in Nice**: Marthe Pécher to Gary Schwartz, 18 March 1983, courtesy Gary Schwartz. Marthe Pécher may not have mentioned this flat to Lotte, as it was used for resistance activities; Alexander had been hospitalized, then spent a week with Lotte at the home of Dr. Moridis: Herzberg, foreword, *LT* xii; **help was supposed to come**: Rumors spread that the Italians and the Vatican would take all the refugees to Menton; under torture, Germaine Meyer, Angelo Donati's secretary, produced this information for Brunner: Police de Sureté, Interrogatoire, Germaine Meyer, 20 October 1943, CDJC: I–59; meanwhile, Jewish committees had been bringing Jews by the thousands *toward* Nice, so Nice appeared the safest spot in the region: Jewish organizations in Nice stayed in close touch with Donati and with their constituents: Joseph Ariel, "Le sionisme," YVA: 09-7; Ansky, CDJC: CCXV–24, 5. Details of the Naglers' arrest come from the l'Ermitage housekeeper, Vittoria Bravi, told to Emil Straus and Annie Nagler. Nagler and Straus interviews.

Excelsior. "**human hunt**": Poliakov and Sabille, 43; "**He's faking**": Drucker, CDJC: CCXVI–66; "**many men and women**": Joseph Ariel, "Scènes de la Résistance Juive en France: Souvenirs et évocations" [n.d.], YVA: 09/6.

Chapter 12: Deception

"**Whole families**": 23 September 1943, CDJC: XXVa–314; "**to live in a twilight**": Secretary of World Council of Churches, in Walter Laqueur, *The Terrible Secret: Suppression of the Truth about Hitler's Final Solution* (New York: Penguin, 1982), 100; **12 million**: *L'Éclaireur*, 2 July 1943 (the first STO group had left Nice for Germany on 29 June 1942). "**Israelites continue**": Préfet des Alpes-Maritimes, 8 September, 12 July 1943, AN: F1CIII 1137; "**scandalously privileged**": anonymous report to the Préfet des Alpes-Maritimes, 4 June 1943, CDJC: XXV–300; "**to the vast ghetto**": report from American consul, Geneva, 27 August 1942, NARA, RG 59, Box 18, 841.1-Jews; "**Jews must submit**": Federal Political Department to American Legation, Bern, 18 September 1943, NARA: 851.4016/161. "**Mass deportations**," "**All Jewish men**": Lisbon JDC to New York JDC, 3 November 1943, 7 October 1943, JDC: Box 516, 621; "**impossible to do anything**": Papal nuncio in Vichy to Vatican, 26 October 1943, *Actes du Saint Siège*, vol. 9, 499; the Jewish leader was André Baur, killed in April 1944. "**We all thought**": Poliakov interview; "**A few million**": Steinberg interview, 1987;. **two escapees**: Haim and Honig Salomon were never believed; Fink interview, CDJC: DLXXXVIII–10; "**let us defend**": Circular enclosed in dispatch from American Consulate in Nice to U.S. Embassy in Vichy, NARA: RG 59, Box 18, 841.1-Jews. "**Brunner is the very model**": Témoignage de Gaston Kahn, 20 January 1945, CDJC: CCXVI–50; "**pig of a Jew**": Kurt Schendel, "Rapport," 31 August 1944, CDJC: CCXXI–27; "**Brunner has a change**": Darville and Wichène, *Drancy la juive*, 62; "**to have stuck it out**": Himmler speech to SS officers, 4 October 1943, Nuremberg document PS-1919. On SS double personalities, see Robert Jay Lifton, *The Nazi Doctors: Medical Killing and the Psychology of Genocide* (New York: Basic Books, 1986).

Disinformation. "**My memories**": Pierre Francès-Rousseau, *Intact aux yeux du monde: Récit* (Paris: Hachette, 1987), 156; "**I have no idea**": Toledano interview; **entryway number 19**: list of Drancy quarters, courtesy Serge Klarsfeld; "**first act**": Situation au 15 juillet 1943, CDJC: CDXXV–19(5); "**band of thieves**": Témoignage d'un revenant, 15 October 1943, CDJC: DLVI–63; "**sworn to Brunner**," "**submitted to a brutal**": Drucker, CDJC: CCXVI–66; "**the walls**": Darville and Wichène, 76; "**with a switch**": Zylbermine interview, 1988. "**Jewish Order Service**": Situation au 15 juillet 1943, CDJC: CDXXV–19(5); "**cultivating in some prisoners**": Georges Wellers *De Drancy à Auschwitz* (Paris: CDJC, 1946), 92; "**Men and women were separated**": Wellers interview; "**It was great-**

est talking place": Steinberg interview, 1987. **"Received from Nagler"**: "Carnets de fouille," 23–27 September 1943; the few extant vouchers are kept in the CDJC; other items from Drancy can be found in YIVO Archive, Records of UGIF; **"how we found out"**: George Wellers, "Birkenau, qu'est-ce que c'est?" *Le Monde Juif* 68 (October–December 1972), 25; Wellers interview; **"Since we heard"**: Georges Wellers, Eichmann Trial, Session 32: W1, Aa1. **"The transports go to the ghetto"**: Témoignage d'un revenant, CDJC: DLVI–63; **"enough supplies"**: UGIF Minutes, 30 July 1943, CDJC: XXVIII–184a; **"deportees were also encouraged"**: Wellers, Eichmann Trial, Session 32: W1; **"unheard-of impudence"**: annotation by Brunner, RSHA to Röthke, 18 May 1944, CDJC: XLVI–3; **"never had any idea"**: Zylbermine interview, 1988. **"None of us"**: Toledano interview; **"a place we know"**: André Baur to Angelo Donati, 2 July 1943, YVA: 09-25; **"none of us could comprehend"**: Kurt Schendel, quoted in Beate Klarsfeld, *Wherever They May Be!* (New York: Vanguard, 1975), 234; **"no suspicion"**: Georges Wellers, "Auschwitz," *Le Monde Juif* 25, no. 56 (October–December 1969), 5; **"one of the Yiddish names"**: Steinberg interview, 1987; **"resonated like an eternal curse"**: Francès-Rousseau, 157; **"We were all persuaded"**: Wellers, "Birkenau," 28; **Pitchipoi indicates,"** **"for inmates who feel"**: Etienne Rosenfeld, "Pitchipoi ou l'Espoir et le Néant," YVA, 033/2070, 32, 58–59. **"Information"**: Steinberg interview, 1987. **"Had we known"**: Erna Low, "I was in Oswiecim," typescript [n.d.], YVA: 033-1346; escapes: Adam Rutkowski, "Les évasions de Juifs de trains de déportation de France," *Le Monde Juif* 30, no. 73 (January–March 1974), 11; **One-third of the transport**: I calculated this from addresses on the transport list of the Ministère des Anciens Combattants, Paris; several victims in the train with Lotte Salomon from Nice to Drancy were placed two weeks later in Transport 60.

Inside Transport 60. To find survivors of Transport 60, I used the original thousand-person list in the CDJC, then looked up the names in French phone books, and found five. Transport lists from France were edited and published by Serge Klarsfeld, *Memorial to the Jews Deported from France, 1942–1944* (New York: Klarsfeld Foundation, 1983). All quotations from Transport 60 survivors come from interviews, from Francès-Rousseau, 160–64, and from Robert Waitz, "Auschwitz III (Monowitz)," in *De l'université aux camps de concentration: témoignages strasbourgeois* (Paris: Belles Lettres, 1954), 468–69. **Paris, 30 September 1943** through **"Paris, 7 October"**: CDJC: XLIX–49, XLX–50, DLXIII–88–89, XLIX–52 (1). Exactly four years earlier, on 7 October 1939 Eichmann and Brunner had worked out the pilot project for deportations (and on 7 October 1900, Himmler, the man responsible for the Final Solution, was born). The Jewish goods Brunner placed on transports circled back from Auschwitz to Germany, while the deportees received no food or water during the journey; **"From: KL Auschwitz"**: 13 October 1943, CDJC: XLIX–53: *KL* is an abbreviation for

Konzentrationslager, concentration camp. On criteria for first selection, see Sybil Milton and Henry Friedlander, "Surviving," in Grobman and Landes, *Genocide*, 234. **Alexander Nagler:** 10 November 1943, Häftlings Krankenbau KL Auschwitz III, 2: 138; 1 January 1944, Totenbuch KL Auschwitz III, 26. Courtesy Panstwowe Muzeum Oswiecim; **five months pregnant:** I calculate Lotte Salomon at least one month pregnant at her marriage, 17 June 1943; she arrived at Auschwitz four months later.

Discrimination. Number of deaths at Auschwitz: *Encyclopedia of the Holocaust* (New York: Macmillan, 1990), vol. 1, 117; Hilberg, *Destruction*, vol. 3; 894, 982; Georges Wellers, "Essai de détermination du nombre des morts au camp d'Auschwitz," *Le Monde Juif* 112 (October–December 1983), 141, 158; Michael Burleigh and Wolfgang Wipperman, *The Racial State: Germany, 1933–1945* (Cambridge, England: Cambridge University Press, 1991), 126. Figures are approximations, because the SS did not register those gassed on arrival; **"very large proportion":** Waitz, 470; **one sex chosen disproportionately:** On Jewish women in general during the Holocaust, see Milton in Bridenthal, *When Biology*, 297–333; Koonz, *Mothers*, 405–13; Joan Ringelheim, "Women and the Holocaust: A Reconsideration of Research," *Signs*, vol. 10, no. 4 (1985), 741–61, and "The Holocaust: Taking Women into Account," *The Jewish Quarterly* (Autumn 1992), 19–23; *Different Voices: Women and the Holocaust*, ed. Carol Rittner and John K. Roth (New York: Paragon House, 1993), especially Joan Ringelheim, "Postscript," 391–418. Filip Friedman, director of the Jewish Historical Commission in Poland, stated at an early date: "The Hitlerists preferred to leave alive men rather than women, especially women with children": *This Was Oswiecim: The Story of a Murder Camp*, trans. Joseph Leftwich (London, United Jewish Relief Appeal, 1946), 15. But statistical and sociological analysis of male-female imbalance has hardly taken place. The 1941 female/male survival ratios from Lodz were 3:2 and from Warsaw, 17:12: Hilberg, vol. 3, 269. **32,278 more Jewish women:** Richarz, *Jüdisches Leben*, vol. 3, 61; **In Austria, 28,077:** Rosenkranz, in Fraenkel, *Jews of Austria*, 526. **Of all 72,444 deportees:** my calculations are based on figures in Klarsfeld, *Memorial*, xxv, xxvi. The same disproportion appears in twenty-eight transports from Belgium: 10,247 men and 9,917 women were deported, about half and half, but 51 percent of the men as against 31 percent of the women were registered in the Auschwitz camp. Calculated from *Mémorial de la Déportation des Juifs de Belgique*, ed. Serge Klarsfeld and Maxime Steinberg (Brussels: Union des déportés juifs en Belgique, 1982), [n.p.]. **150,000 prisoners:** Danuta Czech, *Kalendarium der Ereignisse im Konzentrationslager Auschwitz-Birkenau, 1939–1945* (Hamburg: Rowohlt, 1989), 373. **405,000 slaves were tattooed:** tattoo numbers were used only once; Hermann Langbein, "Auschwitz: The History and Characteristics of the Concentration and Extermination Camp," in Marrus, *The Nazi Holocaust*, vol. 6, no. 2, 1131. **28 percent of**

714,211 prisoners: Yehuda Bauer, *A History of the Holocaust* (New York: Franklin Watts, 1982), 220–21; 9,418 women and 46,182 men survived Auschwitz, according to Friedman, 15. See also Gudrun Schwarz, *Die nationalsozialistischen Lager* (Frankfurt: Campus Verlag, 1990), 146–48; **Auschwitz warehouses**: Walter Laqueur, in *Kalendarium*, 17. **Transport 60**: those selected for work were 34 percent male and 16.4 percent female; whereas 413 were gassed on arrival from Transport 60, 914 were gassed on arrival from Transport 61; **"If by any chance"**: Steinberg interview, 1987; he was selected as slave labor for I. G. Farben because he passed himself off as a chemistry student ("I didn't even know the formula for benzene, but on mineral chemistry, I was an *encyclopedia*"); **"women in our camp"**: Paul Kuziner, Nice, 1945, CDJC: CCXVI–91. **"There were always more men fit"**: Höss interrogation, 1 April 1946, in John Mendelsohn, ed., *The Holocaust: Selected Documents in Eighteen Volumes* (New York: Garland, 1982), vol. 12, 92; **"deprive Jewry"**: Otto Six of the RSHA, April 1944, *Trials of War Criminals* (Nuremberg Green series), vol. 4, 525; **"obliterate the biological basis"**: Himmler, 13 July 1942, in Richard Breitman, *The Architect of Genocide: Himmler and the Final Solution* (London: HarperCollins, 1992), 189; **"germ cell"**: Wannsee protocol, 20 January 1942, Mendelsohn, vol. 11, 10. **"Every child"**: Hitler, in Leila J. Rupp, "Mother of the *Volk*: The Image of Women in Nazi Ideology," *Signs*, vol. 3, no. 2 (1977), 363–64; **"a lighter work load"**: Testimony of Sima Weissman [n.d.], YVA: 033/1535. Pregnant women were often taken away for medical experiments and then killed. **"I only found out"**: Toledano interview. **"And what about the children"**: Höss interrogation, 1 April 1946, in Mendelsohn, vol. 12, 91–92; **"One understood quickly"**: survivor quoted in Wellers, "Essai," 135.

Knowledge. **"Jews went into the gas"**: Rudolf Höss, *Commandant of Auschwitz, The Autobiography of Rudolf Hoess*, trans. Constantine Fitz Gibbon (Cleveland: World, 1959), 222; **"say something more"**: Himmler, 6 October 1943, in Padfield, *Himmler*, 469–70. **"Amongst ourselves"**: Himmler, 4 October 1943, Nuremberg document PS-1919, in Grobman and Landes, *Genocide*, 454. **"Captain Brunner"**: Kahn, CDJC: CCXVI–50. **"Every time a new fact"**: Drancy inmate in Darville and Wichène, 63; **tunnel**: photo in Jean Chatain, *Pitchipoi via Drancy: le camp (1941–1944)* (Paris: Messidor, 1991). When the tunnel was discovered, sixty-five Jewish Order Service members were deported, guilty or not: Darville and Wichène, 88. **Donati's secretary**: Meyer interrogatoire, CDJC: I–59; **"Achtung! Pharaoh!"**: Jirmejahu Oskar Neumann, *Im Schatten des Todes: Ein Tatsachenbericht vom Schicksalskampf des slovakischen Judentums* (Tel Aviv: Olamenu, 1956), 275; **"throwing themselves"**: Survivor testimony in *Documents pour servir à l'histoire de la guerre*, vol. 4 (Paris: Office français, n.d.), 112. **"You bloody"**: Filip Müller, *Eyewitness Auschwitz: Three Years in the Gas Chambers*, trans. Susanne Flatauer (New York: Stein & Day, 1979), 114; **Forty delegates**: *Le Monde Juif* 13 (November 1948), 1. **"I knew nothing," "Suddenly she knew"**: JHM 4866, 4923, *LT* 713, 780.

Chapter 13: Reprise

Name? Charlotte Nagler: name list of Transport 60 was typed at Drancy, then a copy was handed over on arrival at Auschwitz, where it was later destroyed; the original is now in the CDJC; **"and a singing line":** Kurt Singer in Joza Karas, *Music in Terezin, 1941–1945* (New York: Beaufort, 1985), 101; Singer died in Terezin on 7 February 1944. **Pioneer Corps:** Thomas ("Fips") Faraday interview; Fips Faraday to MLF, 9 November 1992.

Secrecy. **"something to dig into,"** **"cattle cars":** "Récit d'un rescapé de Drancy" [M. Etlin], n.d. CDJC: CCXVIII–7; **"covered with sores":** Comité d'unité et de défense juive, July 1944, YVA: P9; **"You will see":** Victoria Saban, "Drancy à Auschwitz," YVA: 033-1415. **"I tried in every way":** Schendel report, 31 August 1944; he met with Brunner on 20 July 1944, CDJC: CCXXI–27; **"Surely being children":** Erwin Schulz and Otto Ohlendorf, in Michael Musmanno, *The Eichmann Kommandos* (Philadelphia: Macrae Smith, 1961), 112; **"avengers in the shape":** Himmler, 6 October 1943, in Padfield, 469; **23,417 prisoners:** from figures in Klarsfeld, *Memorial*, xxvi; **"one of my best men":** Wisliceny interrogation, 15 November 1945, in Mendelsohn, vol. 8, 91; **"Expel the Jews" of Slovakia:** Eichmann Trial, Session 16: D1; **"So?":** Dunand, *Ne perdez pas*, 148–50; **"nothing could bring him":** Neumann, *Im Schatten*, 254, 267. **"Wanted War Criminal":** Counter Intelligence Corps, Land Salzburg section, 24 February 1947, Investigative Record, U.S. Army Intelligence and Security Command. According to a 1985 interview with Brunner in Damascus, he served the U.S. Army from 1945–47: *Bunte* 45 (30 October 1985), 26–27; **"member of the Security":** *La persécution des juifs en France et dans les autres pays de l'Ouest, presentée par France à Nuremberg,* ed. Henri Monneray (Paris: CDJC, 1947), 407; **"for execution of Jews":** *Trial of the Major War Criminals,* vol. 24, 321; **"Brunner, Anton Alois":** Gerald Reitlinger, *The Final Solution: The Attempt to Exterminate the Jews of Europe, 1939–1945* (London: Vallentine, 1953), 507.

Affiliation. Paula Salomon-Lindberg claimed she described the consul to the underground which shot him, or told a high U.S. official who had him hanged; the Salomons never accepted reparations, though they had lost everything, including Albert's youngest brother, killed in Auschwitz.

Obsession. **Hitler's voice:** Ingrid Faraday interview; Wolfsohn's sister Nelly had remained in Germany and been killed. **"No doubts":** Wolfsohn, "Die Brücke" [ca. 1946–49]; Lotte evidently gave Wolfsohn the original watercolor of a birch, because he referred to its colors, but only a photo remains; he wrote "Die Brücke" before seeing *LT.* **"I wrote my own":** Günther interview, 1985; **"Longing for the overthrow":** Wolfsohn, "Die Brücke"; **"beauty of the dared":** Marita Günther, "The Human Voice: on Alfred Wolfsohn," *Spring* 50 (1990), 71; **"Trained by Wolfsohn":** *Guinness Book of World Records,* ed. Donald McFarlan et al.

(New York: Bantam Books, 1990), 32; see "The Omnitone," *Time*, 19 March 1956; **"The purpose was self-revelation"**: Braggins interview, 1988; **"great fertilizer"**: Croner interview. **"My God, Awe"**: Günther interview, 1985; **"Your relationship with me"**: Ingrid Faraday interview; Ingrid Faraday to MLF, 9 February 1989; **his secret son**: Michel Faraday interview.

Deception. **"Was Brunner a member"**: Knochen interrogation, in *Monneray*, 340–41. In France, Knochen was chief of the Security Police, Röthke headed the Gestapo section dealing with Jews, and Brunner was Eichmann's agent in charge of deportation; he co-signed with Knochen the crucial order to deport French as well as foreign Jews. **"Villefranche-sur-mer"**: Tribunal Permanent des Forces Armées de Marseilles: Acte d'Accusation, 19 December 1953; Jugement, 1 February, 19 March 1954. Courtesy Ministry of Defense, Dépôt Central d'Archives de la Justice Militaire, Le Blanc, France; **men safe in Syria**: Franz Stangl, Commandant of Treblinka death camp, had been welcomed at a German center on Georges Haddad Street, Damascus, where Brunner also kept an address. See Gitta Sereny, *Into That Darkness: An Examination of Conscience* (New York: Vintage, 1983), 341. **CIA networks**: Gehlen had been chief of Eastern Front Intelligence for the Third Reich. See Mary Ellen Reese, *General Reinhard Gehlen: the CIA Connection* (Fairfax, Va.: George Mason University Press, 1990). Gehlen apparently used ex-SS officer Otto Skorzeny to recruit Brunner in Cairo; see Christopher Simpson, *Blowback: America's Recruitment of Nazis and Its Effects on the Cold War* (New York: Weidenfeld, 1988) 249–52; E. H. Cookridge, *Gehlen: Spy of the Century* (New York: Random House, 1972), 354, 357. The CIA connection to Brunner cannot be tightly established, for the CIA dossiers on this whole episode are closed. On Brunner's work in Syria during the 1950s and 1960s, see Epelbaum, *Alois Brunner*, 268–90; Brunner said (*Bunte*, 7 November 1985, 33) that Skorzeny refused to help him escape Europe, which may argue against their having worked together. **Wiesenthal learned, letter bomb**: Dokumentationszentrum des Bundes Jüdischer Verfolgter des Naziregimes, *Bulletin of Information* 6 (June 1967); Wiesenthal to Rutkowski, 18 April 1975, CDJC: DLVI–61; Wiesenthal, *Justice*, 251. **"I keep mixing," "news to me"**: Adolf Eichmann testimony, Eichmann Trial, Session 103: X1; Session 100: UI; **"executed in Austria"**: Léon Poliakov, *Le Procès de Jerusalem* (Paris: Calmann-Levy, 1963), 382. The primary investigator for the Eichmann Trial, Avner Less, also confused the careers of Alois and Anton Brunner: see *Eichmann par Eichmann*, ed. Pierre Joffroy and Karin Königseder (Paris: Grasset, 1970), 281–82; **helpful warnings**: William Stevenson, *The Bormann Brotherhood* (New York: Harcourt Brace, 1973), 226–27.

Tenacity. In 1959, the paintings went to the Stedelijk Museum; in 1961 they were exhibited at the Fodor Museum, part of the Stedelijk, with Petersen as exhibit curator, and in Locarno, Switzerland; in 1962 in Tel Aviv and Kibbutz Ein Harod; in 1965 in Berlin and nine other German cities; in 1972 at the JHM;

"She owned pastels," "curious document": Petersen interview; "analytical diary": Ad Petersen, "The History of the Collection, 1943–Present," JHM, *Charlotte Salomon*, 47; "I still believe": Anne Frank, 15 July 1944, *The Diary of a Young Girl* (New York: Doubleday, 1952). "There is something universally": Tillich preface, *Charlotte: A Diary in Pictures*; the 1963 book was compiled by the Salomons, Kurt Wolff, Ruth Liepman, and Ad Petersen. Paula Salomon-Lindberg sent it to her old friend Albert Schweitzer: "Schweitzer understood the book. Tillich thought it was a warning," she said in 1988. Exhibition brochure: Fodor Museum, Amsterdam, February 1961; park bench in Berlin: JHM 4670, LT 512; Braggins interview, 1993; Marita Günther recorded in her diary that Wolfsohn saw a Charlotte Salomon catalog; the account of Wolfsohn's last days comes from this diary, read aloud to the Roy Hart theater in 1986; "the sky came down": Alice Croner to MLF, 5 September 1984; she collected 10,500 dreams; "Someday people": JHM 4744, LT 590; "fighting the fates": Wallace Moore to MLF, 13 October 1984; "marvelous blond hair": Merzbacher interview. Paula Salomon-Lindberg had a faculty position at the Salzburg Summer Festival for 33 years. Albert brought out a book: Albert Salomon, *Vorträge und Artikel, 1950–1967* (Amsterdam: privately published, 1969), courtesy Paula Salomon-Lindberg. "There's a road that I must follow": Schubert, "Was vermeid ich denn die Wege"; JHM 4233, LT 83.

Presentation. Ad Petersen, Judith Belinfante, and Judith Herzberg began putting the paintings in order before 1972; Herzberg and Weisz film: *Charlotte* (1980). In her memoir of making the film, *Charlotte: dagboek bij een film* (Amsterdam: De Harmonie, 1981), Judith Herzberg shows the struggle to evoke characters more than represent biographical facts; Herzberg and Weisz were responsible for the first interviews about Charlotte Salomon's life. a play: script courtesy Joyce Miller (1984); rewritten in 1985 for Harvard's Loeb Experimental Theater; "an emotional pitch": Mark Stevens, *Newsweek*, 14 September 1981, 97; "possessed": MLF and John Felstiner, *Moment* (May 1982), 42; "Rarely an autobiography": Peter Gay, *New York Times Book Review* (8 November 1981), 14; "not quite document": Thomas Albright, *San Francisco Chronicle-Examiner*, 2 February 1983; "psycho-artistic": John Dugger, *Art Monthly* (London), September 1982, 28; "It's unlikely": Robert Taubman, *London Review of Books* (4–18 February 1982), 19. Israel: it was the first original art show at the Beth Hatefutsoth Museum, Tel Aviv (1985); German and French films: courtesy Hannelore Schäffer, Esther Hoffenberg; "Vie ou théâtre," *Paris Vogue*, October 1992.

Premonition. Numbers deported by Brunner: see Felstiner, "Alois Brunner," *Simon Wiesenthal Center Annual* (1986), 11–31; "It was impossible . . . None of us": Schendel, CDJC: CCXXI–27; "one of the best tools": Dieter Wisliceny interrogation, Mendelsohn, vol. 8, 91. Nazi trials: *Encyclopedia of the Holocaust*, vol. 4, 1508; photo from 1985: *Bunte* 45 (30 October 1985), 22–23. The phrase

"posthumous victory" comes from Emil Fackenheim in *Holocaust: Religious and Philosophical Implications*, ed. John K. Roth and Michael Berenbaum (New York: Paragon House, 1989), 294. **Syria denied his presence:** *Bunte* interviewers found evidence that Brunner had worked as security adviser to Syria until he received a second letterbomb in 1981. In 1982 Serge Klarsfeld, a French lawyer instrumental in Nazi trials, traveled to Damascus to protest Brunner's presence there, as did his wife Beate Klarsfeld in 1991; both were detained by the Syrian police. See Peter Hellman, "Stalking the Last Nazi," *New York*, 13 January 1992, 28–33; Peter Michelmore, "Why Are They Shielding This Nazi?" *Reader's Digest* (June 1990), 143–48; Gilles Gaetner, "Après Klaus Barbie, Alois Brunner?" *L'Express* (10–16 June 1988), 42–45. The prosecutor's office in Frankfurt gathered evidence against Brunner, Simon Wiesenthal in Vienna kept the case alive, as did the Klarsfelds in Paris, aided by Epelbaum's significant study. In 1988 France issued an international warrant for "crimes against humanity"; in 1991 two New York congressmen called for U.S. pressure, and the European Parliament demanded Brunner's extradition, but Syria refused to discuss the case. **"Jews with their Christian":** *Bunte*, 30 October 1985, 23; **"All of them deserved":** Brunner interviewed by telephone, *Chicago Sun-Times*, 31 October 1987. In the conversation he confirmed his alias Georg Fischer; **"form the battalions":** German neo-Nazis quoted in *New York Times*, 2 November 1992.

Reprise. "History is not simple": Père Marie-Benoît to MLF, 21 November 1985. **"If things go wrong":** Eichmann quoted by Wisliceny, 14 November 1945, in Mendelsohn, vol. 12, 21. **"Already mankind":** Wolfsohn, "Die Brücke"; **Birke, "naked in a street":** ibid., referring to Lotte's drawing of a birch, and her nightmare in 1938. **"Keep this safe":** *LT* vii. **And now begins:** unnumbered JHM 5033. **"And with dream-awakened eyes":** JHM 4924, *LT* 782.

OVERLAY

Right-hand column: description from Transport 60 survivor, Waitz, *De l'université*, 470–71; **Birkenau, birch tree, The dream:** *Birkenau* means "birchwood" in German; a birch was Lotte Salomon's self-portrait, as Wolfsohn said. **What I had to find:** postscript JHM 4931; **The question . . . out of this arose:** JHM 4922, 4924, *LT* 777, 782.

ACKNOWLEDGMENTS

↩

The writing of this book relied on two readers who kept all its needs in mind, more than I could have myself. John Felstiner committed massive time and thought to urging it on, cheering me up, going over (and over) CS's pictures and my chapters for more than a decade. Then for a year, Adam Hochschild entered a search for meanings and an exchange of manuscripts that I wish on every writer I know. In the last stages, a lively exchange took place with Joan Weimer too. Other friends and colleagues pitched in with astute readings: Eunice Lipton and Ken Aptekar, Marilyn Yalom, Estelle Freedman, Ruth Rosen (who also gave weekly support and advice), Alan Rinzler, Aron Rodrigue, Gerda Lerner, Gary Schwartz, Marita Günther, Sheila Braggins, and Alek Felstiner. Their ideas pushed me forward; all shortfalls are my own. I'm very grateful to agents Charlotte Sheedy and Regula Noetzli. And I cannot imagine a smarter, saner, more supportive editors than Wendy Wolf, and Terry Karten, too.

Many institutions made my research possible: the Charlotte Salomon Foundation and the Joods Historisch Museum of Amsterdam (whose director Judith Belinfante, curators Katja Reichenfeld and Stephen Hartog, plus staff members Anton Kras and Peter Lange helped me understand CS and assisted me with the collection); the Centre de Documentation Juive Contemporaine of Paris, with Vidar Jacobsen, Sarah Mimoun and Sara Halperyn; the Archives Nationales of Paris; the Joint Distribution Committee, Leo Baeck Institute, YIVO Institute, and Jewish Theological Seminary Archives in New York; the Yad Vashem Archives in Jerusalem, and Bronia Klibansky; the Hoover Institution at Stanford, and Agnes Petersen; the National Archives in Washington; the Simon Wiesenthal Center of Los Angeles; and the Archives of Auschwitz.

Nothing would have been possible without the enthusiastic cooperation of Paula Salomon-Lindberg and others who shared their recollections of Charlotte Salomon with me, especially Alice Croner, Annie Nagler, Marian Lackler, Edith Simon, Igna Beth, Marthe Pécher, Ottilie Bourne, and Wallace Moore. Many

people talked about matters they were reluctant to discuss, for those who relive the Nazi era take personal risks. Among the survivors who helped me understand Drancy and Transport 60 I would like particularly to thank Paul Steinberg, Robert Francès, and Jacques Zylbermine. Serge Klarsfeld was also exceptionally helpful. It touched me how Europeans aided an American who used their archives without having to live through the events she was researching there, a Jewish woman born safe a year before the Wannsee Conference.

I have had the benefit of discussions with those who came before or alongside me in examining Charlotte Salomon: Gary Schwartz (who encouraged me from the outset), Ad Petersen, Mark Rittenberg, Joyce Miller, Esther Hoffenberg, Judith Herzberg, Franz Weisz, and Hannelore Schäffer. In particular, I am grateful to Christine Fischer-Defoy of the Hochschule der Künste Archives in Berlin, for all her help in finding materials. The Roy Hart Theatre in Malérargues made me welcome, and Marita Günther spoke with me over many years about Alfred Wolfsohn, offering his wisdom and her own. Sheila Braggins also gave numerous days to discussions with me, and the Faraday family was always ready to help. Of everything that came my way through Charlotte Salomon, I value most the circle of people who started as informants and remained as friends.

My trust in biography came from five years with the Biographers Seminar at Stanford, which sustained this project's growth: Barbara Babcock, Susan Bell, Anita Feferman, Joseph Frank, Edith Gelles, Pam Herr, Diane Middlebrook, Susan Sibbet, and Nancy Unger deserve special thanks. At earlier stages Geoffrey Hartman, Sybil Milton, Henry Friedlander, Susan Griffin, Claudia Koonz, Chinosole, Whitney Chadwick, Carol Zemel, Carl Djerassi, and Joan Ringelheim all assisted in important ways.

For fellowship support, I am grateful to the American Council of Learned Societies Fellowship Program, the Memorial Foundation for Jewish Culture, and the American Philosophical Association. For travel grants in the U.S. and Europe, I thank the National Endowment for the Humanities, the American Council of Learned Societies Grant-in-Aid Program, the Federal Republic of Germany, and San Francisco State University. The Institute for Research on Women and Gender at Stanford provided office space and colleagues during a sabbatical, as well as a grant from the Marilyn Yalom Fund. The Djerassi Foundation gave me a time and place to write, and a chance to work among visual artists.

This book literally would not exist without the skills of Pablo Faraon, my righthand (and lefthand) man, who transcribed and keyboarded for three years, as arthritis disabled me. We were able to work together thanks to the State of California Disability Program—an indispensable resource that can be cut any time. Teal Lake, Lisa Fenwick, Pam Mosher, and Vida Maralani also typed won-

derfully well. I worked with an excellent translator, Ursula Berg-Lunk; any mistakes are my own. Most of all I counted on close friends and helpers—those mentioned above as well as the Thomas, Yalom, and Bendor families, Margo Horn, Shirley and Bill Daleski, Nina Jo Smith, Marion Hunt, Adele Simmons, Alice and Moshe Shalvi, Dai Hua Zhou, Melvin Britton, Judy Squier, and Nan Link.

Many times I have turned to John Felstiner, by day and by night, and will turn to him again, as the constant ally who understood what to say about the Nazi era and when to fall silent with me. Our children, Sarah and Alek, stayed sympathetic to my work throughout years of their lives. To them I owe my utmost thanks, and to the students in my courses on genocide at San Francisco State and Yale. I hope they take to heart what Charlotte Salomon said: First and last, find the "power to describe your life."

INDEX

Page numbers in *italics* refer to illustrations.